# SURFING
## THE MANUAL *Advanced* JIM KEMPTON

A **WAVE**FINDER Publication

**Steve Pezman**

*As long-time editor at Surfer's
Journal, Steve has done more
than most to shape the culture of
surfing as we know it today.*

*"It's simple. The ocean is the most wondrous thing on our planet, and the
breaking wave is the single most exciting thing happening in the ocean."*
Dave Rochlin, surf pioneer and earliest of the surfwear manufacturers.

High performance surfing has been evolving continually since the birth
of the sport. Grace, speed, and length of ride were the original criteria.
The then experts exhibited a Zen-like knowledge and skill level by
performing the longest, fastest, and most critical ride possible with the least
amount of movement. Less movement indicated superior wave judgment
and control. Perfection was achieved if a rider took off impossibly deep,
trimmed up, took up a committed position on both board and wave, and
then stood nonchalantly while the curl snapped off just past their body.

Modern surfing presents a different challenge, in part due to more
maneuverable equipment, but mainly because of the powerful biological
drive of each generation to surpass the previous. Style has largely been
abandoned to function, and we now ride way deeper, and maneuver ever
more severely to stay in the critical section. Deep tube rides and skate-
inspired aerials and tricks are now commonplace.

This book assumes that the reader possesses basic skills from which
to launch into creativity, but that is not necessary in order to benefit.
Gaining perspective on what exists at a higher level than you currently
operate on is the start to attaining that level.

The author, Jim Kempton, has thought analytically about surfing for
decades, as a long-time, vastly traveled recreational surfer, as editor
and publisher of Surfer magazine, and in various capacities for large
surfing corporations, including Billabong, his current place of work.

Kempton has crafted a stimulating book to help propel you into the next
realm of advanced wave riding. Whether it will serve to push you to actually
achieve that lofty goal is entirely up to the individual. If you have the desire
and a modicum of skill, it will certainly point you in the right direction.

I must say to my dear friend, the author, well done.

Respectfully,

*Steve Pezman*

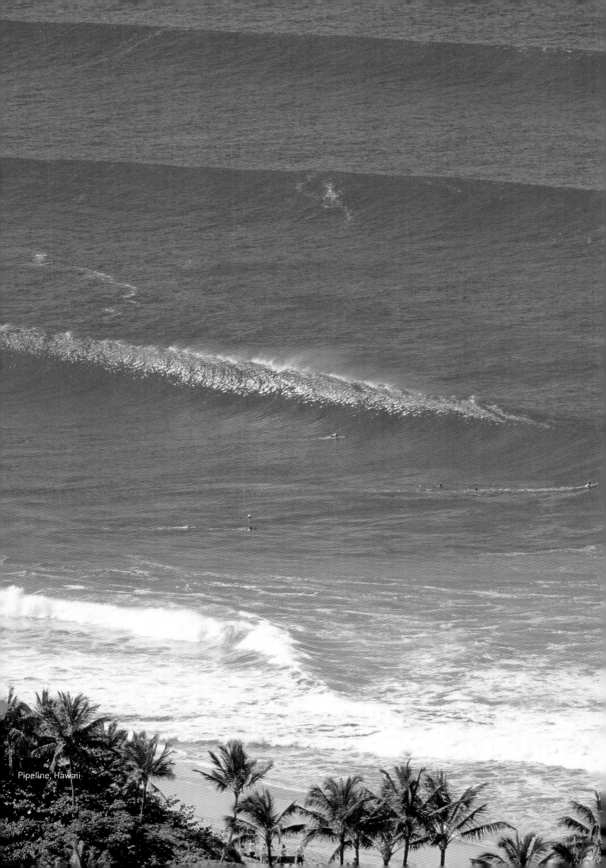

Pipeline, Hawaii

# LEARNING FROM THE BEST

"THE MOST IMPORTANT ADVICE I CAN GIVE SURFERS TODAY IS TO ALWAYS REMEMBER TO GIVE BACK. FOR THE GUYS LIKE KELLY AND ANDY AND ALL THE REST, THEY NEED TO TEACH THE NEXT GENERATION ABOUT NOT JUST HOW TO SURF BUT HOW TO BE THE PEOPLE SURFERS ARE SUPPOSED TO BE. I CHALLENGE THEM TO SHOW THESE KIDS THE WAY. THIS IS THE HERITAGE THAT MAKES SURFING THE SPORT OF KINGS." GEORGE DOWNING, ONE OF SURFING'S GREATEST WATERMEN AND CARDINAL OF HAWAIIAN SURFING

Andy Irons, waiting and weighting. The new generation is challenged to pass the torch

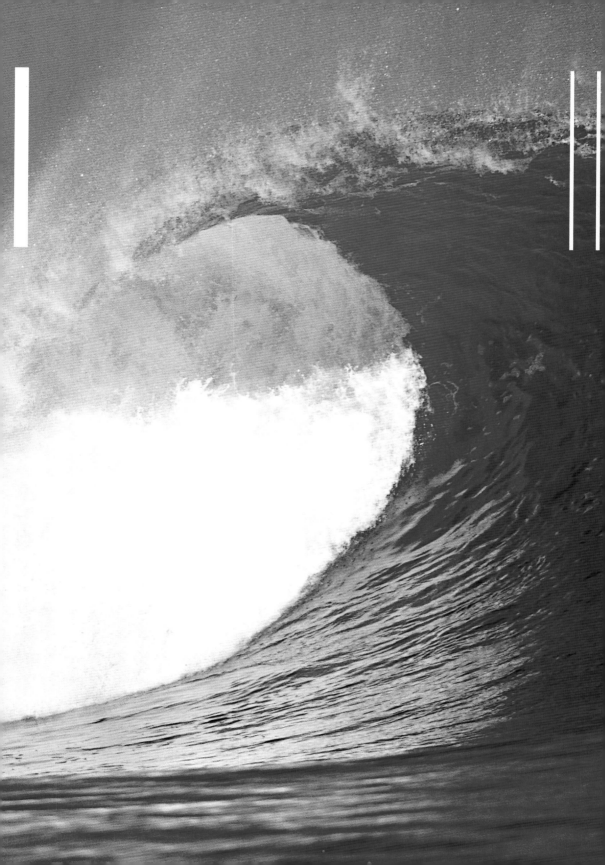

**Jim Kempton**

*Jim Kempton's gregariousness and lifetime of observation has allowed him to assemble this volume with a little help from a lot of friends.*

When I was asked to write this book I knew that I would merely be a collector of knowledge, funneling the experience provided by the pantheon of great surfers that have made this sport what it is today. In that sense this is their book, and I have simply condensed and disseminated the wisdom they possess.

Over the years, I have witnessed countless sessions on the North Shore, and in Indonesia, California and Europe. In my tenure at Surfer, I probably studied 80,000 photographs of the best surfers in the world doing every possible maneuver on a wave face. I traversed the globe in search of good waves, first as a surfing sojourner in Australia, France and the South Pacific; later as a travel writer working for the surf magazines; and recently on the Crossing Project, exploring for waves on the Indies Trader I, in Europe, Africa, Latin America and the Caribbean.

In those many years of riding waves, I've been out in the line-up next to Andy Irons at Hossegor, Kelly Slater at Sunset, Mark Richards at Off-the-Wall, Tommy Curren at Santa Clara Rivermouth, Tommy Carroll in Panama, Shaun Tomson in El Salvador, Peter Townend at Trestles, Rabbit Bartholomew in Tahiti, Barton Lynch at Haleiwa, Sunny Garcia in Spain - in short, nearly every world champion, in nearly every wave condition there is.

Not that I was catching many waves - they were catching the waves - but I was literally looking down the sights of their barrels, and in so doing I have seen what they do, as close-up as you can get. I was out there to watch them ride waves, so I could write about it. In detail.

This knowledge, passed along, is part of the
age-old surfing tradition of 'giving back'.

Some of the information presented is from the extensive reading I
have done, and many of the surfer contributions are from interviews
or conversations conducted over the past 25 years. In the course of my
most recent research, I interviewed dozens of expert surfers by phone
including Shane Dorian at Tavarua, Dave Rastovich in Alaska, Taj Burrow
in Indonesia, Luke Egan and Mark Occhilupo in Australia, Joel Parkinson
in South Africa, Andy Irons in Bali, Mike Parsons in Mexico, Ricky Grigg
in Hawaii, and Brad Gerlach on another planet. What these experts have
to say carries far more weight than anything I contribute, and their
expertise is unimpeachable - and as sharp as the tip of a trailing fin.
My responsibility has been nothing more than to get the words down
and try to connect the dots.

One of the other things I made an effort to do was to invoke the proud
heritage we possess, and infuse it into today's constantly expanding
realm of amazing wave-riding advancements; drawing on surfing's
great watermen in the quotes and stories that introduce each chapter.

The most important thing to be gained from this book is to read it with the
intent to learn something from each chapter that truly makes you a better
surfer. Often the most essential points are the simple and seemingly
obvious ones. But remember, these are coming from the best pro-
fessionals in the world - and they are nuggets of gold that have been
gleaned from years of water-borne experience. My hope is that any
surfer can absorb these pieces of advice, and in so doing, raise their level.
I hope I give my mentors, like George Downing, the satisfaction of knowing
that this knowledge, passed along, is part of the age-old surfing tradition
of 'giving back.'

*Jim Kempton*, *San Clemente, California, 2008*

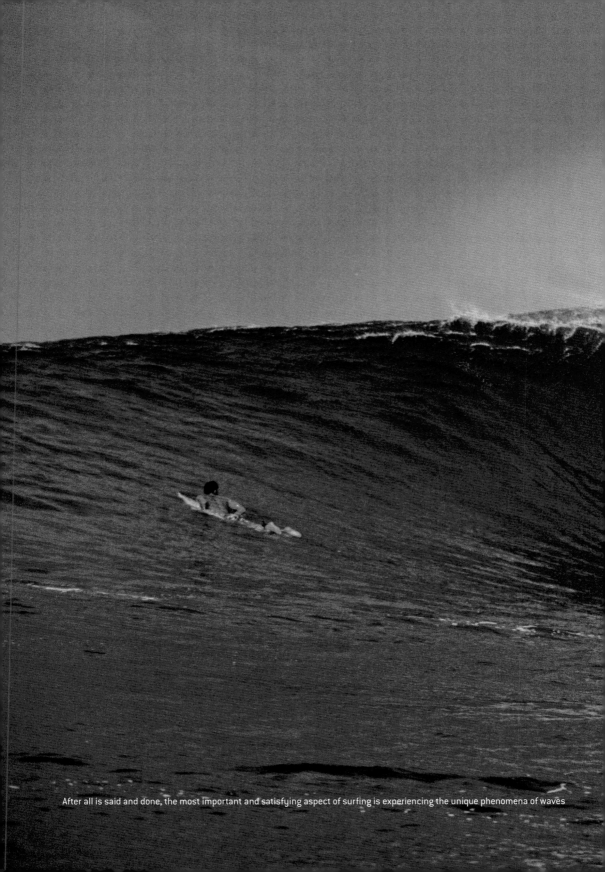

After all is said and done, the most important and satisfying aspect of surfing is experiencing the unique phenomena of waves

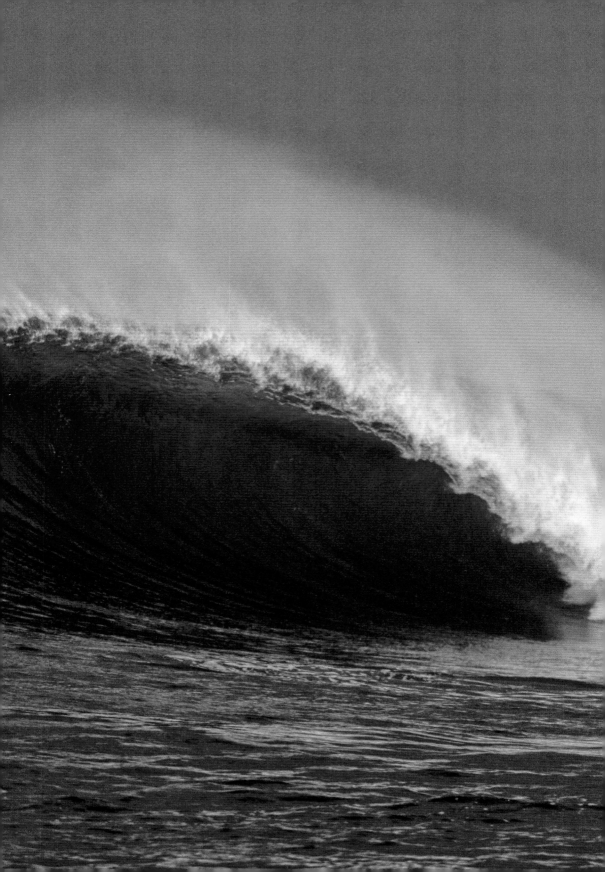

### Jeff Divine

One of the world's most renowned surf photographers since the late 1960s, Jeff Divine has been documenting the personalities and performances of the surf world for four decades. His unruffled, easy-going style, coupled with a keen sense of surfing's history and culture, has made him as legendary as the subjects he shoots. Between trips to Indonesia, Hawaii and other warm places, Divine currently serves as photo editor of *The Surfer's Journal*, and is happily raising his family in San Clemente, California.

### Tom Servais

A prolific lensman, Tom Servais is a master of color and composition. He's spent more winters on the North Shore than he can count, and it's really not fair how much time he has logged on Tavarua. An all-round waterman and natural sportsman at heart, Servais is one of the elite crew who've had their own book of surf photography published. For those few weeks a year that he's not on the road, Servais calls Dana Point home.

### Jake Howard

Currently the senior editor of *Surfer Magazine*, Jake Howard grew up surfing on the cold northern coast of California, before relocating to the warmer and much less sharky waters of San Clemente. His prolific output and gregarious nature has allowed him to experience the surfing personalities of the day first hand. Be it a good south swell at Trestles or hunkered down on a fishing boat in Sumatra, he does his best to sneak out of the office every chance he gets.

### Brad Gerlach

There have been quite a few acts in Brad Gerlach's theatrical surfing life: Hot California up-and-comer, world title contender, wandering soul surfer, rock'n'roll music man, creator of 'the Game,' and (in a hugely successful third act) as a big-wave hell-man. At his competitive peak, rated number two in the world, he quit the tour to find himself, taking on a string of fascinating roles. Regardless of the outcome, Gerlach has always been in it for the love of the sport. A colorful personality masks a keen, almost prescient sense of the physical mechanics and artistic body language of surfing. Today, when the swell's not pulsing at 30 feet, Gerlach's to be seen up in the Hollywood hills, acting coach in tow.

### Joel Parkinson

Easily the most stylish surfer on the ASP World Tour today, 'Parko' emerged early from the ultra-talented hotbed of surfing in Coolingatta on the Gold Coast of Australia. After returning from a side-lining leg injury in 2005, Parko is on the hunt for his first ASP World Title. The star of several surf movies including his own biographical Free As a Dog, and Trilogy, he is considered by many of his peers as the finest all-round talent in surfing today, able to push the limits while maintaining a graceful physicality. And when he's not traveling the globe, he's a good family man, raising two young daughters with his wife.

### Peter Townend

One of the original 'Bronzed Aussies,' Peter 'PT' Townend, with cohorts Mark Warren and Ian Cairns, helped Mark Richards, Shaun Tomson and Rabbit Bartholomew bust down the door when the boys from down under first showed face on the North Shore. Surfing's first professional World Champion, PT was an instrumental figure in professional surfing's birth in the mid 1970s and later coached the American amateur teams to many victories over the decades. Lately he's been splitting his time between trips to Australia and his Active Empire business in Huntington Beach.

### Mike Parsons

Articulate, calculating, yet as crazy as they come, Mike Parsons is a waterman's waterman. After spending the first half of his distinguished career donning a competition jersey, he has since stretched out his wings and taken to riding the world's biggest waves. From pioneering Cortes Bank 100 miles off the Southern California coast, to massive days at Jaws, Todos Santos and Maverick's, the understated Parsons, along with his tow partner Brad Gerlach, have done it all, including winning the XXL Award in 2002. Parsons is currently applying his competitive experiences towards his Surf Academy, and helping Billabong as a contest director.

### Andy Irons

It's hard to summarize the array of talent possessed by Andy Irons. Three world titles speak to his competitiveness, but don't totally capture his prowess in any and all waves. From the most massive days at Pipeline to fun days in France, Irons thrives in all conditions. But as good as he is and for all the opportunities he's had to test himself against the world's best, there's nothing he enjoys more than being back home on Kauai, surfing with his friends and spending time with his family. If you grew up in paradise you probably wouldn't want to leave either.

### Shaun Tomson

Dubbed the 'gentleman surfer,' Shaun Tomson grew up in Durban, South Africa, becoming one of the pioneers of the deep tubes at J-Bay. Considered the finest barrel rider of the Free Ride Generation, Shaun proved it by winning the world title in 1979. Today Tomson winters in Santa Barbara, where he has produced the documentary *"Bustin' Down the Door"* and received the Environmentalist of the Year award from SIMA. As perhaps the sport's finest ambassador, he makes appearances promoting the Surfer's Code, a book defining the essence of being a wave rider. He also tends to his tastefully understated surf label Solitude, while penning the occasional story for various surf publications.

### Tony Moniz

A North Shore heavy since the '70s, Moniz made a name for himself out at Pipeline and Sunset, when those were still the world's premier proving grounds. No one better exemplified the new school approach of deep radical backside tube riding than Moniz. Today he's the owner of a successful surf school in Waikiki, raising his family in very much the same way he grew up - in the water. All his children are talented young water people, and there's no question the Moniz name will be a staple in Hawaii's line-ups for years to come.

### Taj Burrow

One of the most progressive surfers on the planet, Western Australia's Taj Burrow has made a name for himself by making the impossible look easy. Touted as one of Australia's most likely future world champions, all eyes have been on him since his debut on the World Tour. To date he's flirted with a world title, but has yet to bring the elusive crown back down under. An innovator and master of new moves, he pioneered an acrobatic attack that has inspired a whole new generation of surfers, as well as starring in a string of highly acclaimed surf films. At 30, he remains one of the most exciting surfers of his generation.

### Dave 'Rasta' Rastovich

Putting the soul back in surfing, Dave Rastovich, the quiet, low-key Australian is on his own journey of enlightenment. Experimenting with all types of surf craft, Rasta is renowned for his open-mindedness and ability to adjust to the nuances of his equipment. Not only one of the most stylish surfers of his era, he's also an extremely accomplished musician and an articulate and committed environmentalist. Most recently he has taken up the fight to save the world's dolphin population with the very active and vocal Sea Shepherd organization.

### Shane Dorian

Since stepping away from life on the ASP World Tour, Shane Dorian has made it his mission to ride some of the biggest, nastiest waves the world can whip up. His accomplishments at Teahupoo are the stuff of legend, and when Jaws starts pushing 30+ feet, he's on it. He equally excels at gnarly Backdoor and Waimea: a hell man if ever there was one. Yet Dorian remains a centered, understated and most respected waterman. When he's not throwing himself in harm's way, Dorian has a nice plot of land nestled up in the Big Island hills, raising a family and doing a bit of farming on the side.

### Ken Bradshaw

The epitome of a big-wave surfer, Ken Bradshaw's deliberate, focused, and almost obsessive approach to the world's biggest waves has gained him a respect from even those who begrudge him for his sometimes dominating persona. From charging Waimea Bay with Mark Foo to riding the biggest Wednesday ever at Outside Log Cabins, to this day he is considered one of his era's most accomplished - if intimidating - surfers. Mercurial in nature, and a loner by choice, Bradshaw never fitted in with the bright jerseys and grandstands of competition, opting to make his mark in size. A talented surfboard shaper, he lives at Sunset, still pursuing his love of big waves.

### Mark Occhilupo

The celebrated senior member of the ASP World Tour, Occy's backside surfing set a standard as yet unmatched, and his gregarious personality has made him one of the sports most beloved stars. Emerging on the scene at the tender age of 15, Occy has been right in the mix when the likes of Tom Curren, Tom Carroll, Kelly Slater and Andy Irons were all charging through their world title campaigns. Not to be outdone, after briefly falling off the map in the mid 1990s, Occy was back on fighting form and won his own title in '99. Today, at 40 years old, he's still a force to be reckoned with.

### Ricky Grigg

In our humble sport, nobody has done more to forward the cause of understanding the seas in which we surf than Ricky Grigg, surfing's first true oceanographer. Breaking ground with contemporaries Fred Van Dyke, Pat Curren and Greg Noll, he was one of the first to tempt fate in the early days of the North Shore, charging Waimea, and winning the prestigious Duke contest in 1966. He later received his PhD in Marine Biology, as well as becoming a very accomplished author. He still lives in Hawaii today, having served as a professor in the University of Hawaii Oceanography Department since 1970.

### Drew Kampion

Author, surf historian, and an inspiration to surfers worldwide, Drew has been the editor of *Surfer* and *Surfing* magazines and written several books, including The *Book of Waves* and *Stoked: A History of Surf Culture*. Back in the day, Kampion fused the revolutionary themes of the Sixties with the emerging surf culture, which influenced a generation of surfers and surf writers. Currently U.S. editor of *The Surfer's Path* (a 100% 'green' surf magazine), he lives on an island in Washington State.

### Sean Collins

Voted one of the most influential persons in surfing in *Surfer Magazine*'s poll, Sean's knowledge of modern oceanography and swell forecasting is second to none. His Surfline forecasting service is simply the most advanced there is, so much so that the world's top big wave surfers never make a move without checking it, and no major big wave contest is held without him giving the go-ahead.

### The Wavefinder Team:

**Jeremy Goring**
*Production*
**Stéphane Rouget**
*Art Director*
**Huw Williams**
*Editor-in-chief*
**Adam Coxen**
*Mister Fixer*

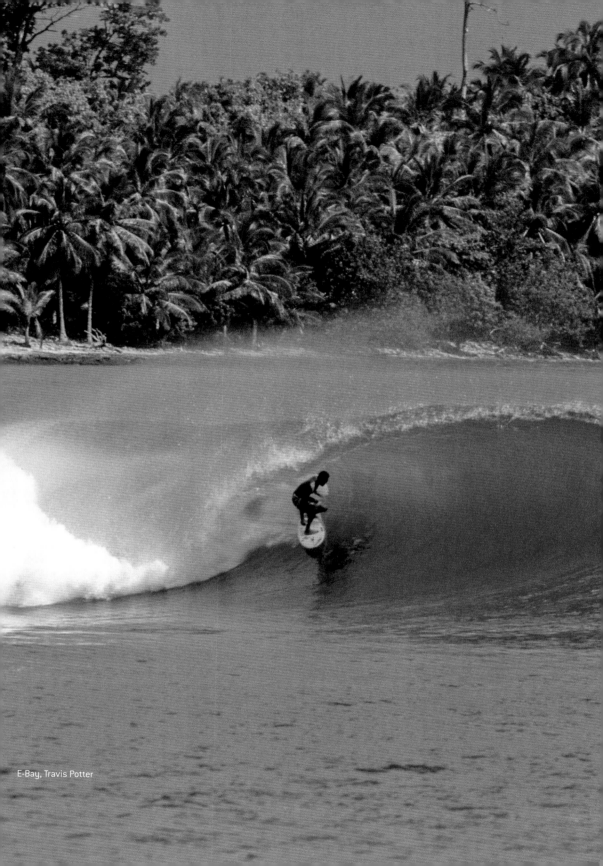

E-Bay, Travis Potter

## 014    CONTENTS

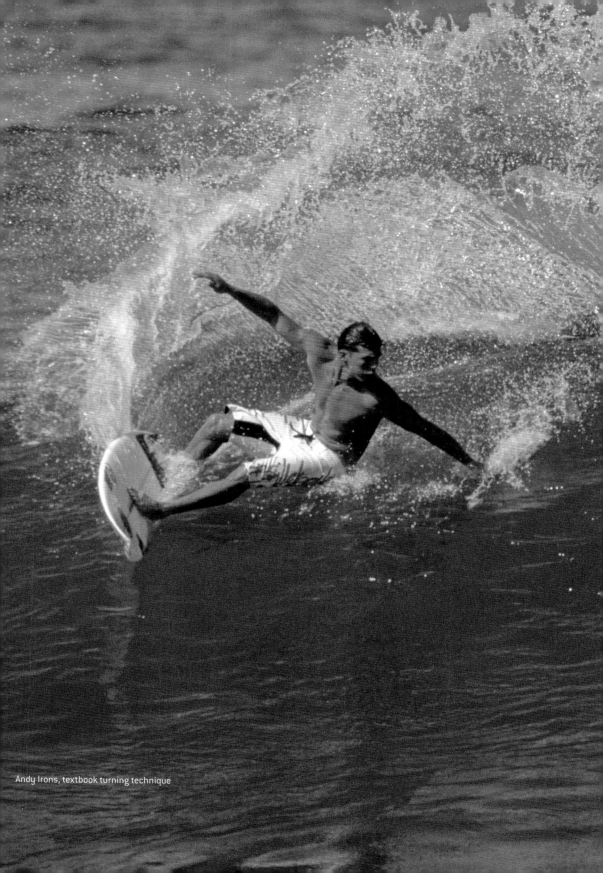

Andy Irons, textbook turning technique

**PART THREE.** | # PERFORMANCE

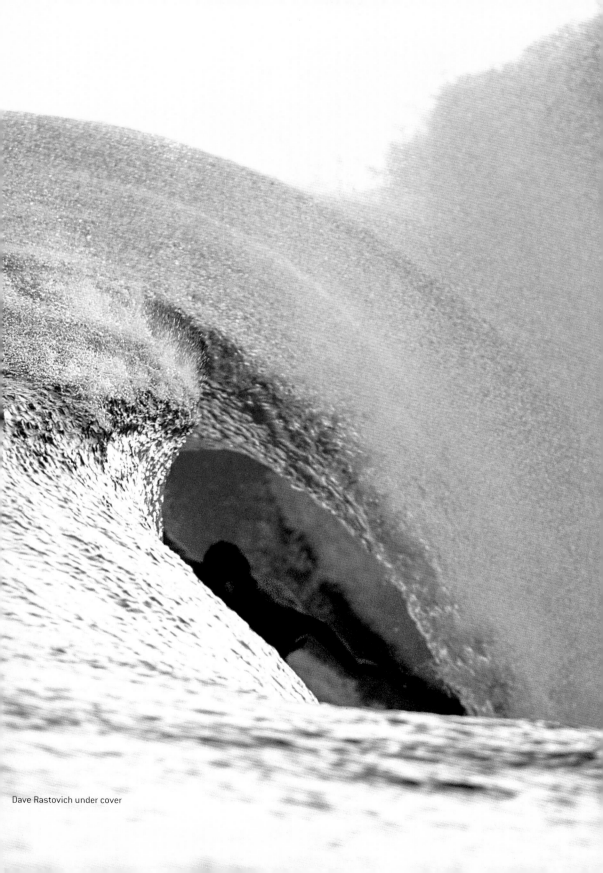

Dave Rastovich under cover

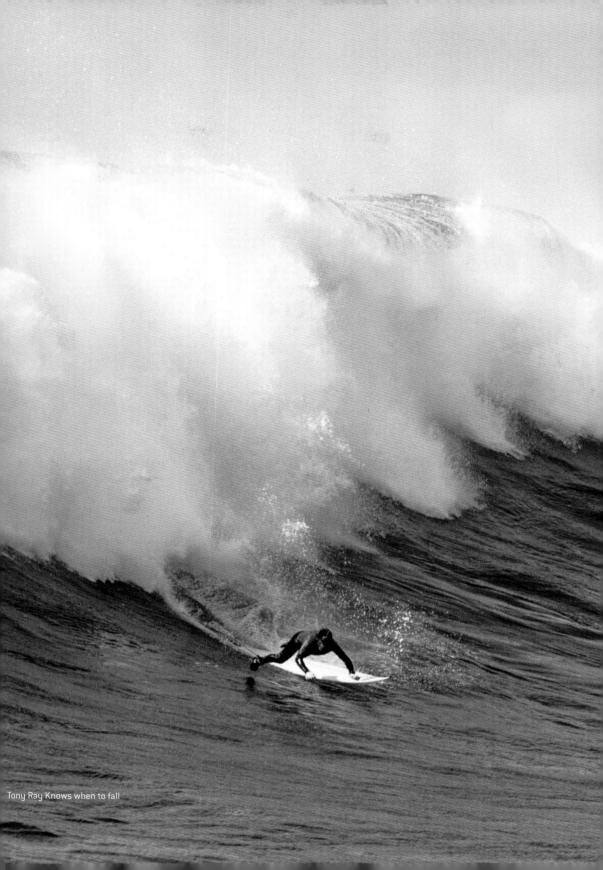

Tony Ray Knows when to fall

**"NATURE = GOD"**
TOM BLAKE. THE LEONARDO DAVINCI OF
SURFING; INVENTOR OF THE FIN, WATER
CAMERA, HOLLOW BOARD, SURF LEASH AND
FIRST HAWAIIAN LIFEGUARDING SERVICE,
ALL BEFORE 1936

Tavarua from the air: tides, wind, swell direction, refraction and bottom contours are showing

# KNOWLEDGE

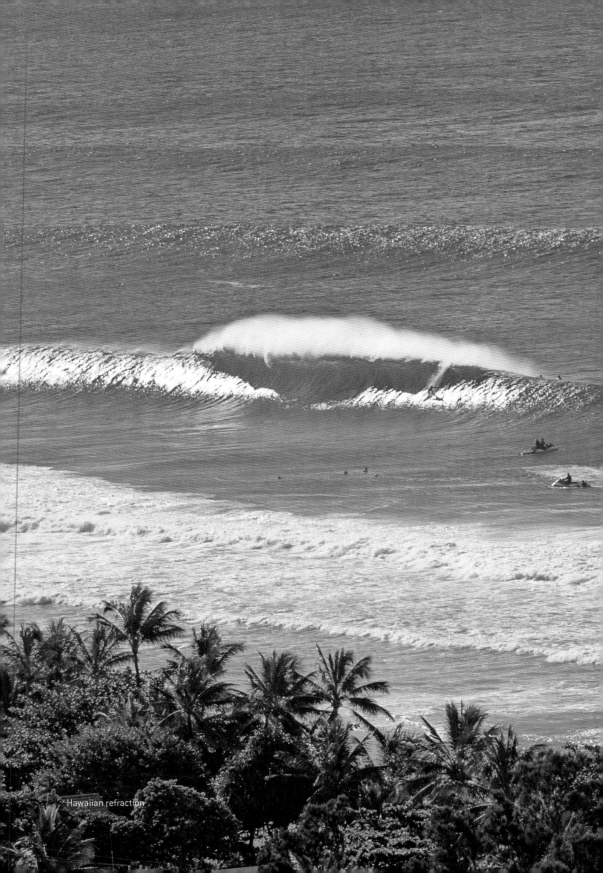

Hawaiian refraction

# MOVING WITHOUT MOVING
## The Life Cycle of Ocean Waves

**Drew Kampion researched ocean science for his definitive work The Book of Waves. The following three chapters are edited and focused on the wave-making process, with his kind permission and wonderful style. No surfer should pass by this wisdom - it is a foundation for understanding all the rest that we do**

Appearances can be deceiving. Standing on a pier or jetty, or sitting astride a surfboard, the swift approach of an ocean wave gives the impression of a wall of water moving in your direction. In actuality, although the wave is moving toward you, the water is not. If the water were moving with the wave, the ocean and everything on it would be racing into the shore with catastrophic results. Instead, the wave moves through the water, leaving the water where it was.

## STAGE 1. CREATION

Undulating ocean surface waves are primarily generated by three natural causes: wind, seismic disturbances, and the gravitational pull of the moon and sun.

For surfers, wind is of most interest because this is what creates rideable surf. Whilst the process is not completely understood even by oceanographers, in essence, wind moving over the surface of the sea creates small waves. The longer and stronger the wind blows, and the larger the area over which it blows, the bigger these waves will become.

## STAGE 2. PROPAGATION

Oceanographers call all three of the above wave types 'gravity' waves, since once they have been generated, gravity is the force that drives them onwards, in an attempt to restore the ocean surface to a flat plain. Spread a blanket on the floor. Kneel at one end and take one edge of the blanket in your hands, then snap waves down its length. The blanket doesn't move; the waves ripple through it. The energy crosses the blanket in an oscillating wave pattern, diminishing (or decaying) as it moves toward the opposite end. The waves move through the blanket, but when you have finished snapping waves through it, the blanket remains in your hands.

It is similar for a wave moving through water. An ocean wave passing through deep water causes any single molecule of water on the surface to move in a roughly circular orbit, drawing the particle first towards the advancing wave, then up into the wave, forward with it, and finally, as the wave leaves the particle behind, back nearly to its starting point.

Because the speed is greater at the top of this orbit than at the bottom, the particle is not returned exactly to its original position after the passing of a wave, but has moved slightly in the direction of the wave motion. The radius of this circular orbit decreases with depth. In shallower water the orbits become increasingly elliptical until, in very shallow water (i.e., at a beach), the vertical motion disappears almost completely.

**There are two notable variations on this principle of wave travel:**

### Internal Waves:

At the boundaries of cold and warm currents, submarine streams of different density undulate past each other in slow-moving 'internal' waves. The evidence of these internal waves can sometimes be seen in calm conditions since their currents affect the reflectivity of the ocean's surface, producing alternating areas of glassy slickness and ruffled texture.

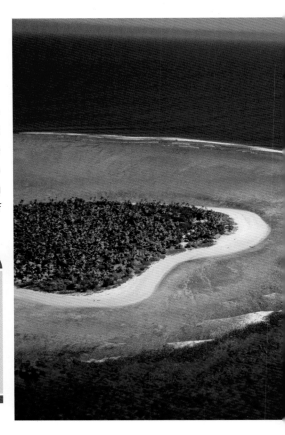

### DREW KAMPION

*Albert Einstein said that all the universe is waves. They manifest on all scales, and some of them are just the right size for surfing.*

### The Tides:

Although significant seismic-wave disturbances (tsunamis) are still popularly known as 'tidal waves,' the term more accurately describes the daily cycles of high and low tides. The greatest ocean waves of all, with a period of 12 hours and 25 minutes and a wave length of half the circumference of the Earth, travel around the world at up to 800 miles per hour. The tides are created when the massive gravitational pulls of the moon and the sun actually lift the oceans while the earth rotates by underneath. The crests of these waves are the high tides, the troughs low tides. The circle scribed by the tidal orbit is the earth.

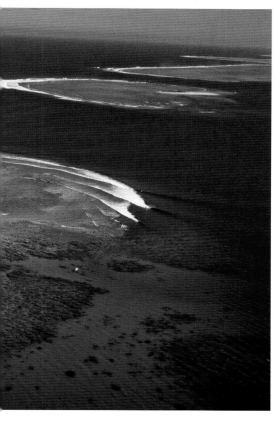

## STAGE 3. REFRACTION
### *Feeling the Bottom*

When long, fast, smooth open-ocean swells move into shallower water, their character begins to undergo a significant transformation. It is at this point that ocean swell changes to ground swell, and the wave begins to 'feel' and be affected by the bottom.

Just as white light passing through a crystal prism is bent into the colors of the rainbow, so ocean swell passing though shallow water (a depth less than half a wavelength) is bent, or refracted, into the shape of breaking waves.

Because the speed of a wave in shallow water is a function of the depth, swell refracts as it responds to and aligns with submarine contours. Because waves slow as the bottom shoals, swells moving laterally towards a sloping coast are bent towards the shore. Similarly, energy in waves moving over a ridge or reef tends to be focused, while energy in waves moving over a submarine depression is dispersed.

### RABBIT KEKAI

*Considered Hawaii's finest high-performance surfer of the '30s and '40s, and perhaps still today the finest surfer over the age of 80.*

**Never turn your back on the ocean.**

From top to bottom:

Swell refracting, bending, aligning itself with submarine contours

Low tide Upper Tretles, California

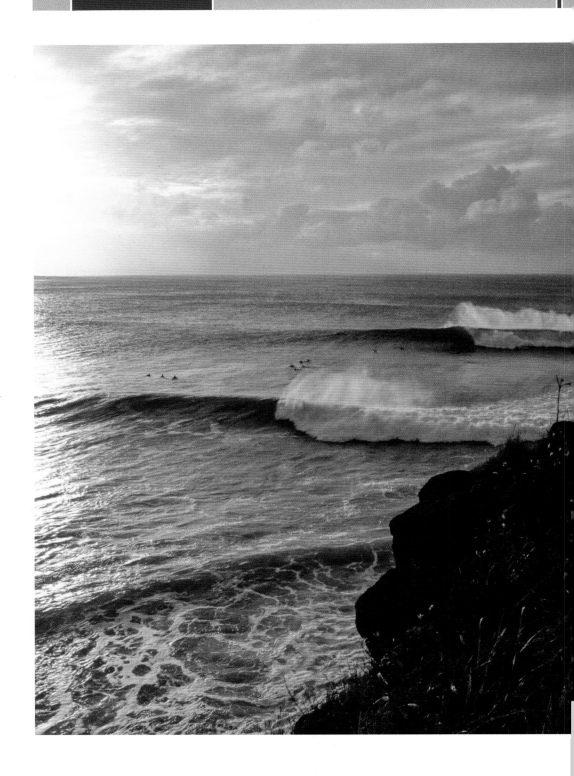

Refraction as applied to Honolua

In the approach to shore, another refraction phenomenon is the shortening of wave length as front waves are slowed more than those at the back of the group. As length decreases, wave steepness increases, tending to make the waves less stable. A swell approaching the ridge of a reef slows at the point where it first 'feels' the shoaling bottom. The 'sides' of the swell do not slow so much, however, and continue to advance towards the shore. This causes them, in effect, to wrap in towards the shallow reef.

This same refracting curve can be seen at point breaks, as a swell approaching from due west may wrap over a shallow cobble apron causing waves to peel off to the east as they swing around a headland. Conversely, swells entering a deep bay will refract towards the sides of the bay, often creating excellent tapering waves at either end of the crescent, while a small beach break crumbles over in the center of the cove.

Reefs further offshore can have the effect of focusing or disbursing swells before they reach reefs more inshore. This focusing effect helps to explain why some beaches, like Huntington in California, regularly have larger waves than other beaches in the area.

Bob Simmons predicted the location of the best surf in Hawaii before he ever went there by studying charts of the reefs and applying the principles of refraction.

**RICKY GRIGG**

*Pioneer big-wave rider and professor, University of Hawaii Oceanography Department.*

*The best thing about studying oceanography all my life is that it's made me smarter about riding waves.*

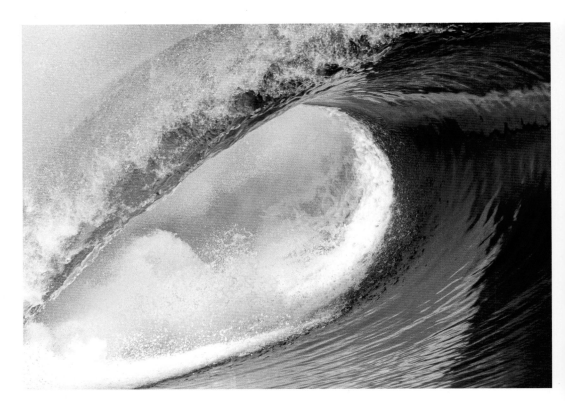

## STAGE 4. **BREAKING**

While storms spawn waves far beyond the horizon, most of us will only become aware of them when they emerge out of the distance, touch bottom, rise, and finally burst into their final glory as breaking waves.

As waves move into yet shallower water, they begin to slow further, the wave length shortens yet again, and the low, sloping mounds begin to rise up out of themselves, that is, their height increases rapidly. At the same time the shallow water causes the wave length to decrease (because as a wave is slowing, the waves behind are catching up); the result is a suddenly steepened wave. Therefore, in a very short distance, the crest angle decreases below the critical 120 degrees, and the wave becomes unstable. The crest, moving more rapidly than the water below, falls forward and the wave form collapses into turbulent confusion, which uses up most of its energy.

The energy released in a breaking wave is tremendous. All of that stored wind power, transported silently for so many miles, at last bursts out of its liquid confines. The total energy of a wave ten feet high and 500 feet long can be as high as 400,000 pounds per linear foot of its crest. The impact pressure for such a breaking wave can vary from 250 to as much as 1,150 pounds per square foot. Larger waves have been recorded to exert a force of more than three tons (6,000 pounds) of pressure per square foot in the surf zone!

## TYPES OF BREAKING WAVES

In general, there are three forms of breaking waves.

### 1. SURGING WAVES

Surging waves are associated with relatively deep-water approaches to steep beaches. The wave peaks up, but surges onto the beach without spilling or breaking.

### 2. SPILLING WAVES

Spilling waves are generally produced by a very gradually sloping underwater configuration. The wave peaks up, the crest angle shrinks to less than 120 degrees, but the release of energy from the wave is relatively slow. Spilling waves typically have concave surfaces on both front and back sides.

## WILLARD BASCOM

For surfers, the most important part of a wave's life Cycle is the form it takes as it breaks near shore. Willard Bascom, author of Waves and Beaches, offers a clear picture of the dynamics of these breaking waves.

" As a wave crest moves into water whose depth is about twice the wave height [...] the crest 'peaks up.' That is, the rounded crest that is identified with swell is transformed into a higher, more pointed mass of water with steeper flanks. As the depth of water continues to decrease, the circular orbits (the movement of a particle of water within the wave) are squeezed into a tilted ellipse and the orbital velocity at the crest increases with the increasing wave height. [...] Finally, at a depth of water roughly equal to 1.3 times the wave height, the wave becomes unstable. This happens when not enough water is available in the shallow water ahead to fill in the crest and complete a symmetrical wave form. The top of the onrushing crest becomes unsupported and it collapses, falling in uncompleted orbits. The wave has broken; the result is surf. "

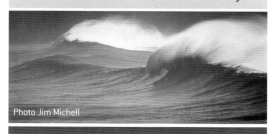

Photo Jim Michell

Left page: Plunging personified, Tahiti

Right page:

Golden Surge

San Onofre demonstrates spilling, California-style

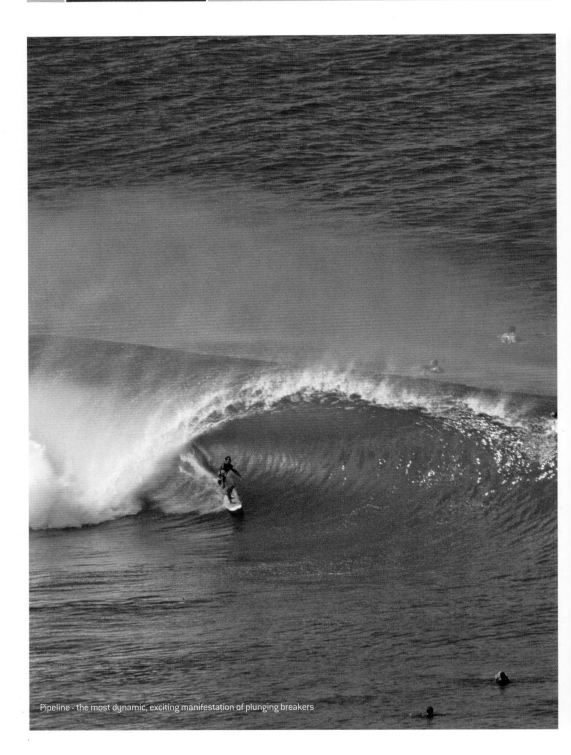

Pipeline - the most dynamic, exciting manifestation of plunging breakers

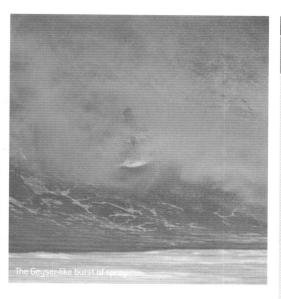

The Geyser-like burst of spray

## 3. PLUNGING BREAKERS

Plunging breakers are the most dynamic, exciting manifestations of wave action on the ocean. Their rounded back and their concave, hollowing front result from an abrupt shoaling of the bottom that creates a sudden deficiency of water ahead of the wave, which can be moving at near open-ocean velocity; water in the trough rushes seaward with great force to fill the cavity in the oncoming wave. When there is insufficient water to complete the wave form, the water in the crest, attempting to complete its orbit, is hurled ahead of its steep forward side, landing in the shallow trough. The resultant curling mass of water surrounds a volume of air, often trapping and compressing it.

When the trapped air bursts through the curtain of water that surrounds it, there is often a geyser-like burst of spray and mist. Often, too, the mist is expelled out of the open end of the tube, like smoke from the barrel of a gun. Riding ahead of such a blast of vapor is where a lot of surfers would like to be .

### PRO TIP BY RICKY GRIGG

Ricky won the Duke contest at Sunset after studying the bottom on dive trips for years.

*One of the things very few surfers do is carefully observe the terrain they use every day. But if you really know what the bottom looks like, you will know the real reason a wave breaks in the way it does, and you will know how the swell you ride will be affected. Go for a swim along the reef you surf. Scrutinize every ridge and hole, every spur and groove. Note where the shallow sections actually begin and where the deep water drops away. Memorize the contours of your reef or lava flow. Bathymetry is a fancy word for a map of the ocean floor. If you want to know a place really well, look at the map. Your surfing will have an edge over everybody who doesn't.*

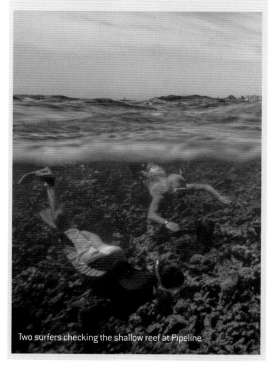

Two surfers checking the shallow reef at Pipeline

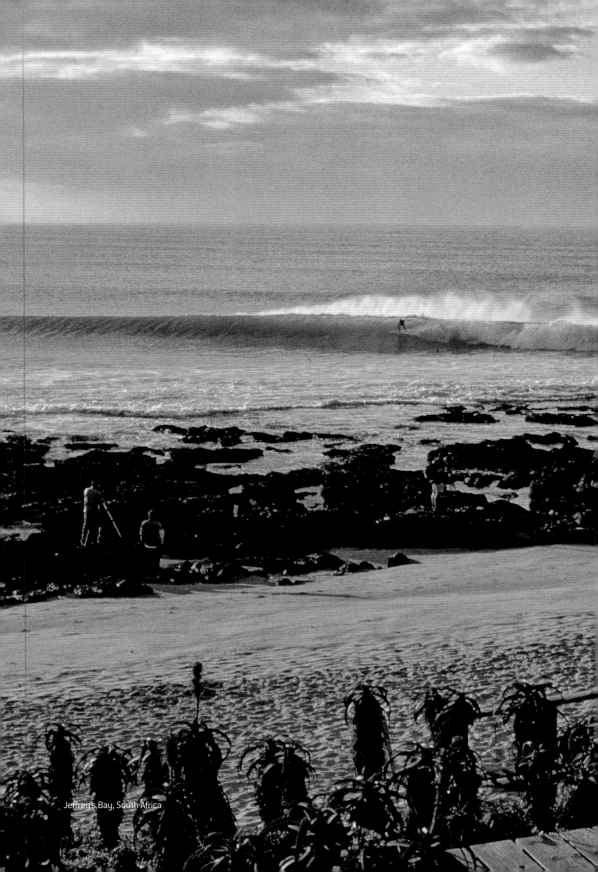

Jeffrey's Bay, South Africa

# HITTING THE BREAKS
## Why Different Sea Bottoms Make Different Waves

While many waves are created equal, as far as surfers are concerned, local conditions ensure they don't stay that way. A perfect wave for surfing is one that refracts in such a way as to concentrate its power in a given area of the wave band, then peels off laterally over a relatively abrupt, shallow bottom to create an extremely concave (hollow) face. When the crests of such waves pitche out towards the troughs, they form the tunnel-like "barrels" that surfers travel the world to find.

Local topography and bottom configuration (bathymetry) determine the classification of a surf spot and the final form of the breaking waves.

### NAT YOUNG
*1966 World Champ and short board pioneer*

*They call us 'men who ride mountains.' But we're really just kids who play in the ocean and I dig it and I'm stoked.*

Underwater Canyon at Blacks, La Jolla, California

## BEACHBREAKS

Relatively straight sandy or gravelly beaches with a gentle slope create "beachbreak" waves: a pattern of peaking waves with periodic channels to carry the advancing water back out through the surf zone. Such waves break on sand or gravel bars, deposits of material mobile enough to be arranged and rearranged by the shifting whims of swell, tide, and wind.

Often the beach face is scalloped in a regular pattern of "cusps" reflecting the regularity of the coastline, the subsequent regularity of the refraction that concentrates and disperses the wave energy, and the mathematical relationship between the advancing force of waves and the receding flow of water.

The outgoing currents of water between the areas of breaking waves are called "rips" or riptides; in large surf these are capable of becoming overwhelmingly powerful channels back out to sea - frightening locations for swimmers, but ideal on-ramps for surfers wishing to make it through the shorebreak to catch rides in deeper water.

Very steep sand or gravel beaches are likely to produce surging breakers, where the depth immediately offshore is insufficient to greatly diminish the potential energy in the breaking waves. In such cases, most of the wave energy is released directly up onto the beach face or reflects back at the incoming waves, where the outgoing sheet of water can create a "backwash" effect, which can double or triple the size of an approaching wave, with spectacular effect.

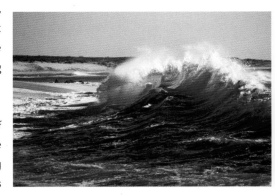

Top: Puerto Escondido, a premiere beachbreak in Mexico

Above: Backwash, Cabo San Lucas, Mexico

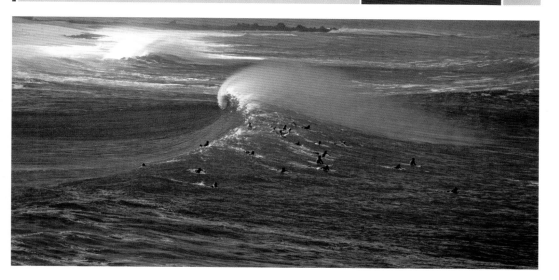

## REEFS & PASSES

Submarine formations like coral reefs, rock reefs, sunken ships, and other stable structures in shallow water areas create reef-break surf - waves that break more or less abruptly and with this or that shape depending on the shape, depth and size of the obstacle.

The famous Banzai Pipeline off Oahu's north shore is a reef break. Swells radiating down from North Pacific storms come out of very deep water to touch coral reefs more than a mile off shore. This outside reef bends the wave lines, focusing them in on the near-shore Banzai reef with little loss of energy. There, these swells that have come so far are forced up out of themselves by the sudden wall of battered coral. Immediately there is insufficient water in the trough of the wave, and the face goes as concave as a storm pipe. The crest becomes a "lip" of plunging water that leaps beachward to complete the cylindrical shape of the wave, creating the spectacular hollow within, and is followed by the familiar blast of mist as the wave collapses around this pocket of trapped air.

Reef breaks are best for surfing if one or more seaward faces are angled to the approaching waves, creating a "shoulder" effect, where the wave can peel along the angled edge of a shallow reef. A triangular-shaped reef, with its apex pointing to sea, will tend to create an initial peak wave with sloping shoulders peeling in either direction as the lines of swell refract and converge towards the reef.

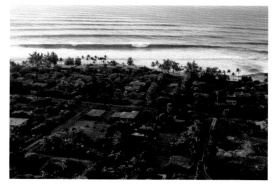

Top: An Aerial view of Pipeline

Above: An overview of the reef field on Hawaii's North Shore

Such peeling waves can be formed by reef "passes" - channels created in the living coral by the runoff of fresh water from nearby landmasses. Here, the typical surfable wave will wind off the end of one shallow shoulder of reef, peeling towards a deep channel. Such waves can be a mile or more out from shore, and because the reef itself is usually submerged, these walls of water have an isolated and unpredictable beauty.

## POINTS & RIVERMOUTHS

The one-directional peeling of the reef-pass wave is similar to the peeling of a typical point wave, created when a line of swell wraps around a protruding coastal feature and breaks (sometimes with zipper-like regularity) in a peeling action, while remaining at a relatively constant distance from the curving shoreline.

One classic example of such a wave is at California's Rincon Point near Santa Barbara, a beautiful triangle of cobble-stoned shoreline extending roughly a half mile from the inside cove to the apex of the point where a creek spills out into the Pacific. The machine-like regularity with which the swells fan in around the point and trace the shape of the shallow bottom with a surging carpet of white water creates an impression that has been likened to "spokes on a wheel."

Whereas the exposed tip of such a point or promontory will generally have a rocky, gravelly or boulder-strewn beach, the bay into which point waves peel is typically a repository of plenty of fine sand, due to the strong beach-ward current, which transports large amounts of sand along the point and into the bay. As energy, momentum, and wave speed dissipate, the sand drops to the bottom or washes ashore. For this reason, peeling point waves will often end in an abrupt beach break "close-out."

Reef pass, Mentawai Islands

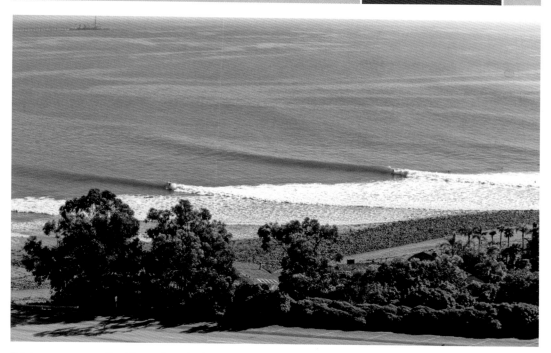

Rincon Point overview

Point waves generally offer surfers the longest rides, and the most famous of them (like Jeffrey's Bay in South Africa, Rincon in California, Noosa Heads in Australia, and Honolua Bay in Maui) are among the best surf spots in the world.

Excellent surf is also created by deposits that build up at the mouths of rivers or streams, such as at Mundaka in Spain, which offers some of the longest rides in the world on the right day. In essence, banks of sediment create reef-like formations that can produce excellent surf. The drawbacks of rivermouth waves can include poor water quality and increased shark activity, depending on large-mammal populations. Unlike a reef break, however, the rivermouth break is prone to seasonal variation; in this respect, they can be more like a shifting beach break than a predictable point break. No matter where a wave breaks, however, the dynamics remain the same, and a good wave is always a good wave.

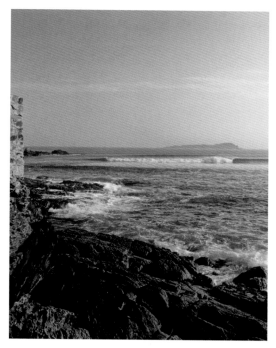

Rivermouth, Mundaka, Spain

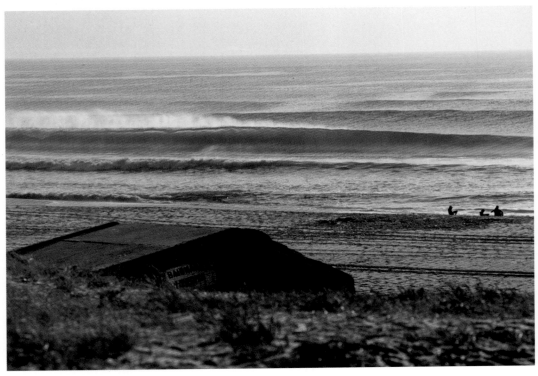

Top: Hossegor France, groomed beach, groomed lines; Below: North Shore aerial view, Hawaii

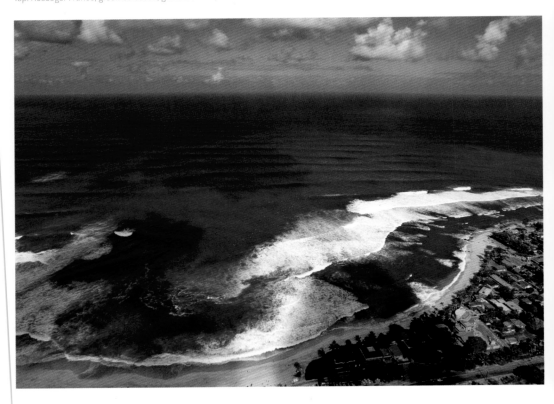

# FINAL CONSIDERATIONS
## The Impact of Local Conditions

## GROOMING

Whatever the wave, it will only be at its best when the wind is right. When it is coming from the land and blowing towards the approaching wave, this has the effect of smoothing the face and actually holding it up longer, allowing it to grow even hollower before breaking and making it a much better wave for surfing. In effect the breaking process is delayed for a critical moment, compressing wave energy like a spring.

## SWELL DIRECTION

Sometimes, when swell is in good supply and tide and winds are just right, you can turn up at a spot and be infuriated to find it just isn't "right". This is more often than not a swell direction problem. A classic example is the cobblestone point break at Rincon, California. This is a righthander that faces south into the Pacific, very much in the lee of the prevailing northwest winter swells. However, this northwest direction is exactly what Rincon needs to produce its long, perfect wrapping lines. Refraction has, in effect, turned the swell round almost 180 degrees and, in the process, combed the waves into organized walls that peel evenly across the bay. South swells that hit the point head-on just don't create the same result, producing peaky, messed up lumps. Surfspots with a narrow swell window don't have the same problem; they are either "off" or "on". Nemberala in East Timor is an example; In an offshore wind it is either perfect or flat because only a solid southwest swell will get in.

## TIDE

The depth of water at any given surf spot will vary according to tide, and have a major impact on the shape of the surf. In Northern Europe and other high latitudes where tides are extreme, the impact is significant even for most beach breaks. Some European surf spots (and anywhere in the higher latitudes which experience great tidal variation) are literally flat on one tide, and pumping perfection half an hour later on another, when the bottom of the incoming wave starts to feel the contours of the correct banks.

Certain reef shapes, in particular flat table top ledges, can be extremely sensitive to the smallest variation in tide. Bali's Bukit Peninsula is a classic example; tide charts are measured in tiny increments here for this very reason. Even though Bali's tropical latitude means lesser tide movement, the reef shape is so flat, and drops away so vertically that a few inches make a big difference. Some reefs however, slope or step away with land contours and just break further out as the tide drops.

As a rule of thumb therefore, reef breaks and steeply shelving beaches tend to be more tide sensitive, and high latitude high tide movement surfing areas mean wider variables (and thus a greater need to arrive at the right time!).

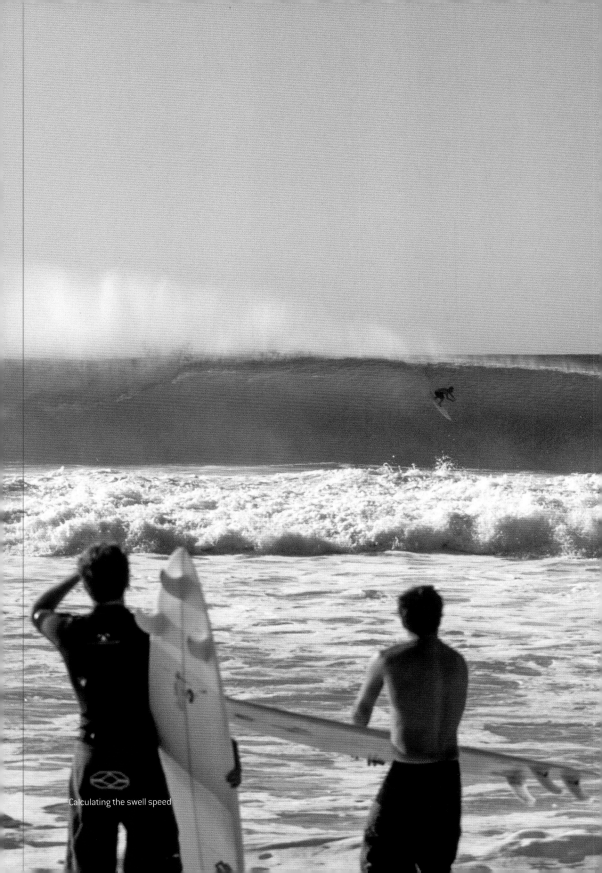

Calculating the swell speed

# DO THE MATH
## The Science of Surf Forecasting

In the privacy of your own home, you sit down behind your computer. With nobody around, the magic box warmly greets you as it glows to life. In an instant you're online, and almost immediately you're bombarded with a flood of decisions. No, not whether you should download the latest release in art-house cinema or invest in a prescription that promises not only to lengthen, but also "add girth"; what we're talking about here are all of those seductive surf forecasts and sexy swell models. With unlimited access to the world's most provocative storm maps, satellite images, and up-to-the-minute buoy readings, how does a plain old surfer who grew up with nothing but a weather radio for companionship make sense of all this sensory overload? Basically, it comes down to your ability to do the math, and for that we offer you four simple suggestions:

### SWELL SPEED

First and foremost, your buoys are your lifeline. Commit to memory things like how far offshore they are and what all of the various readings mean. This is where mathematics first comes into the picture, so pay attention. The speed of a swell can be calculated by multiplying the swell period by 1.5. For example, a swell with an 18 second period travels at 27 knots because 18 x 1.5 = 27. Individual waves move much more quickly; twice as fast, in fact. So, in that same 18-second swell - the one traveling at 27 knots - each individual wave is speeding by at a brisk 54 knots. Knots are nautical miles per hour, and 1 knot equals 1.2 miles per hour on terra firma.

The application of all these numbers goes something like this: If you were in Hawaii, patiently waiting for waves on the North Shore, and a 20 second swell started to show on the 51001 buoy (located 170 nautical miles northwest of Kauai), you can figure that it's traveling at 30 knots and will take just shy of eight-and-a-quarter hours to hit Sunset Beach, which is slightly further away than Kauai's northern shore. According to U.S. National Weather Service forecasters, a 17 second swell travels at 26 knots and takes nine-and-a-half hours to hit the North Shore; a 14 second swell moves at 21 knots and hits in 12 hours; and so on and so forth.

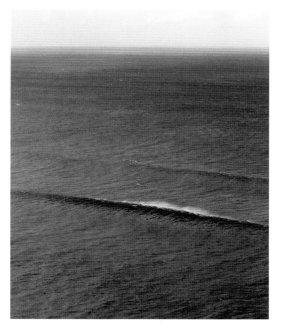

Outer Reef North Shore, Oahu

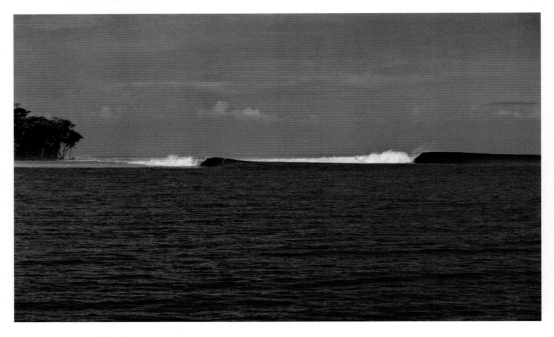

**SEAN COLLINS**

*Know before you go.*

## BASIC BATHYMETRY

As any good student of the sea knows, swell alone does not make the wave. Bottom contour - or bathymetry, as it's academically known - plays a major role in what we ride. A key number to consider is when the swell first starts to hit the seafloor. This can be found by taking the swell period, squaring it, and then multiplying the answer by 2.56. The final answer is the depth at which the waves begin to be affected by the bottom. A 15-second swell will begin to feel the ocean floor at 576 feet of water. Why? Because 15 x 15 = 225, and 225 x 2.56 = 576 feet deep. This is where the difference between long-period groundswell and short-period windswell becomes apparent. Because of the way it works off the bottom, a 16-second west swell will hit Rincon and bend perfectly around the point, while an eight- or ten-second swell may pass by the famed Queen of the Coast altogether.

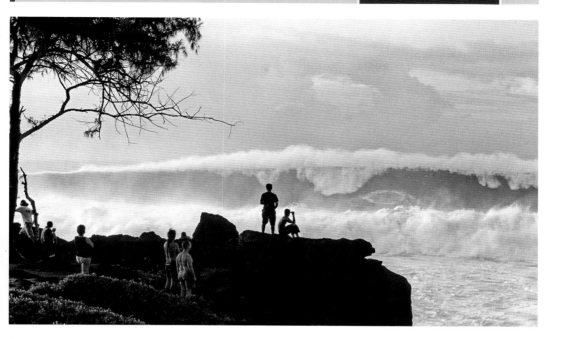

## SIZE MATTERS

Plain and simple, long-period waves are considerably more powerful than short-period waves. Because there is more energy stored under the water's surface, as a wave moves into shallower water, becoming much more unstable in the process, the long-period wave is more apt to grow in size. Three feet of windswell with a ten-second interval may turn into a four-foot breaking wave, while three feet of groundswell with a 20-second interval can reach upward of five times its deep-water height depending on the bathymetry. Waves break in depths approximately 1.3 times the height of the wave itself, which means that a six-foot wave will break in about eight feet of water, and a 20-foot wave will break in about 26 feet of water.

## DEALING WITH DECAY

Finally, pay attention to where the swell is coming from and how far it has traveled. Basically, thanks to decay, the height of a swell decreases as the swell advances, losing roughly one third of its height each time it travels a distance in miles equal to its wavelength in feet. As the swell moves into shallower water, the speed of the waves slow down and the wavelength decreases - although the period remains the same. The further waves travel through shallow water, the higher the likelihood that they will be mushy and weak, which is why there's such a discrepancy between places like the North Shore and the Gulf Coast. On the North Shore the swell arrives straight out of deep water, while Gulf swells must traverse long shoals before eventually hitting the beach.

Right page: The view from the point at Waimea. They say when you get a really long hold down you can hear the boulders getting bumped around on the bottom

Left page from top to bottom: Sumatra, Indonesia

Cloudbreak, Fiji: View from a helicopter

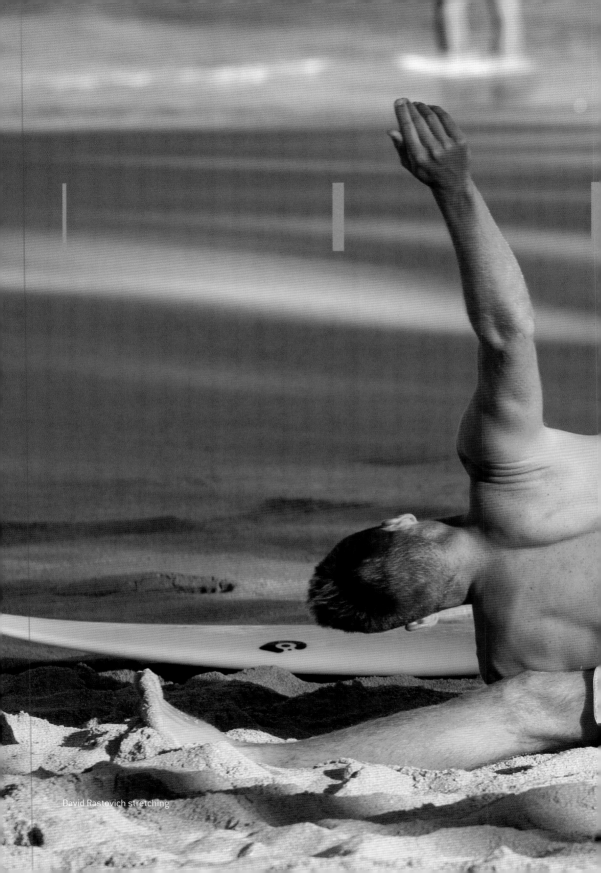

David Rastovich stretching

PREPARATION

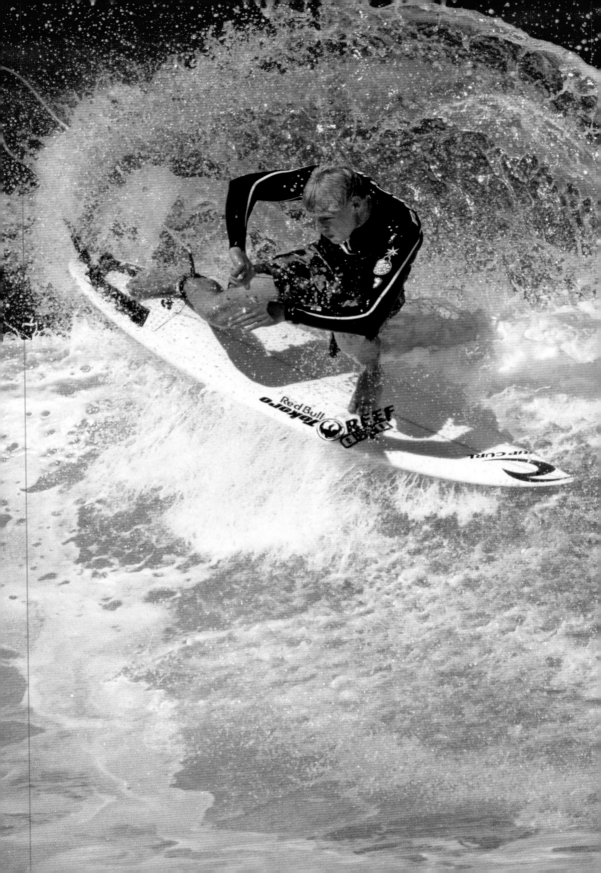

# BE LIKE BAMBOO
## The Key to Success Lies
## In Your Fitness Levels

In 2004, after tragically mis-timing a landing in the flats of what, for him, would have to be considered a relatively routine floater, Mick Fanning saw any shot of ever winning a world title ripped from him in a ball of knotted, torn muscle. Skeptics called his career over when his hamstring pulled clean off the bone, but for Fanning it was an opportunity to re-examine exactly where he'd been and where he was going. It was the slap in the face every young man needs to get their head in the game. In 2005 he returned to the tour, winning the first event he surfed in, which happened to be at home on the Gold Coast. By 2007, in unquestionably the best form of his career, he'd come back to win the world title and be called *"the closest thing surfing has to a true professional athlete."* How did he stage such a remarkable comeback? Already a brilliant surfer, his adoption of a strict fitness and diet regimen is what's taken him to the next level.

*I was surprised that I could come back that quickly. The whole event I felt really, really good,* **Fanning** told Surfer Magazine after his '05 victory. *I changed my diet, and my energy levels were pretty much ridiculous thanks to that.*

But diet is only half of Fanning's story. His workout program borders on ludicrous. He looks more like a prize-fighter than a surfer, and could probably find part-time work as a contortionist. Adopting the mantra of **Bruce Lee**, *he's like bamboo: strong but flexible - alive.*

## THE BEST EXERCISE FOR SURFING IS SURFING

Just like a golfer has to dedicate most of his time to hitting balls, a successful surfer's time is best spent in the water riding waves. There simply is no substitute for honing your timing, quickness, and ability to react. Ask just about anybody on the ASP World Tour what the mainstay of their fitness regiment is and they'll tell you it's just simply surfing as much as possible. With all of the travel and seemingly being somewhere different every week, access to proper exercise equipment and facilities isn't always possible, which puts even more of a premium on water time.

Left page: Mick Fanning cites stretching and fitness as two keys to winning his first world title

# BEFORE YOU SURF

### 1 FOCUS

From the moment you pull into the parking lot to check the surf you should be thinking about your body. Is your neck still tweaked from pulling into closeouts the night before, or is your lower back bent from paddling too much? If there's a muscle group that's particularly bothersome take an extra couple of minutes warming it up.

### 2 FEEL THE PULSE

A good way to get the heart rate going before entering the water is to run from the parking lot down to the surf break. Just a light jog starts to get the blood moving and signals to the rest of the body that it's exercise time.

### 3 STRETCH IT OUT

When you feel the blood starting to move it's the optimum time to get into your stretching. Start with easy repetitions of arms and legs twisting them and rotating them to get them loose. Then move into the back and legs, stretching the larger muscle groups. If you know any yoga, now is the time to break out your sun salutation and downward dog. The deep stretches in yoga will warm up the body and spine, which in turn will help you ride out of your next full-speed, layback hack.

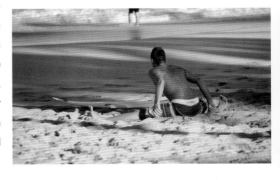

# BACK ON TERRA FIRMA

Surfing is generally a low stress, repetitive motion, and does not necessarily produce the highest fitness level possible. To develop the requisite power needed to increase the explosiveness in maneuvers, a moderate level of strength training is very helpful. *There are two parts to fitness in surfing,* explains **Andy Irons**. *You need to be strong, but you also have to be totally loose.* Here are a few essential hints to help get you on your way:

## 1 SET GOALS

It's pretty simple really, figure out what you want to achieve and go after it. There's no point in working out if you don't know what you're working out for. You'll see much better results if you set both short-term and long-term goals for yourself. Say you want to be a better paddler when you show up on the North Shore next winter, well, you're going to have to take a variety of steps to get there.

## 2 WARMING IT UP

The cornerstone of any good workout is a good warm-up. As your muscles can take a more gradual time stretching out as opposed to being put under immediate strain, it's the single best way to avoid injury. Take your time stretching and warming up all the major muscle groups in your body, from your calves, hamstrings and quads in your legs, to your lower back, shoulders and neck. Remember to slowly ease into a stretch, focusing on breathing into it, gradually getting deeper. Holding the stretch for 30 seconds or more is ideal. Keep the stretch consistent, trying not to lunge forward or bob up and down just for the sake of it. If it hurts too much, ease off.

## 3 WORKING IT OUT

There are a variety of exercise programs out there. More than anything it just depends on what you're after. If you're having trouble making it out the back on big days you may want to log some extra water time either swimming or paddling. If you find yourself getting tired and struggling to recover, it's time to get on a cardio program. And if the lip's hitting you, instead of you hitting the lip, pumping some weights may be just what you need. For best results hook up with a trainer who knows how to help you achieve the goals you've set.

## 4 USE AN INDO BOARD

Indo boards have a great advantage - they use all the muscles, movements and balance that surfing does. You can do all the warm-up or stretching type moves while using an Indo board which gives you twice the workout in the same amount of time, and puts the balance aspect into every move you make.

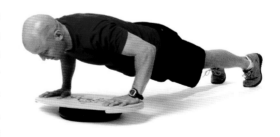

Left page from left to right:

Shane Dorian runs to warm up

David Rastovich stretching

Above:

The all-in-one Indoboard

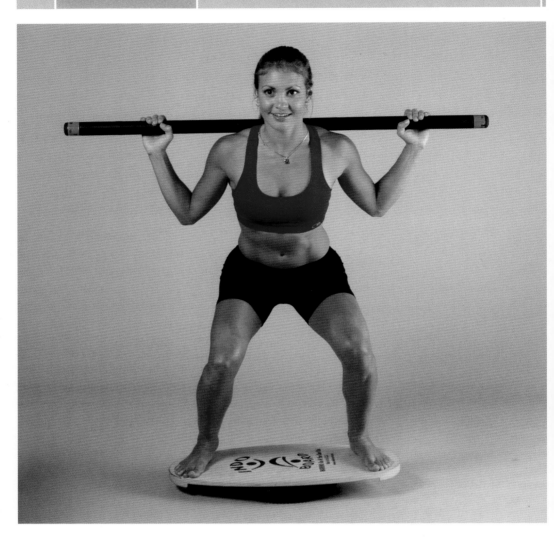

### 5.COOLING IT DOWN

Extensive exercise studies have demonstrated that while you want to warm up first, it is equally important to end your workout with a series of stretches and easy movements. This will flush some of the lactic acid out of your muscles and minimize soreness the next time you exercise.

The Indo-board can be used for warm-ups, stretching and balance at once

## WARM UP RIGHT

Three Surf-Specific Exercises Worth Doing .

As surfers, it's not uncommon for us to treat our boards better than we do our own bodies. You can spot the proof of this everywhere, especially at the water's edge, where only a small percentage of surfers engage in any pre-surf warm-up exercises. While it's not only important to warm up - it's even more important to warm up correctly. With that in mind, we thought it a good idea to seek out the proper advice.

*The single most common mistake I see is lack of dynamic movement,* says **Scott Adams**, a professional trainer and co-creator of Surf Stronger, a workout designed specifically for surfers. *Warming up means actually getting your body warm, and stretching alone doesn't do that. When you stretch, you decrease the elasticity in your muscles at a time when you need them to move quickly. Being flexible is good, but not right before you paddle out.*

The best warm-up movements are actually those that resemble surfing. Popping to your feet a few times or moving your arms in a paddling motion sends signals to the muscles that this is what you're about to do, and it helps optimize your performance.

While surfing keeps you pretty fit, the problem is it only works some parts of your body. *It's the center where all movement comes from,* says **Adams**. *The front part of the core tends to be underused in surfing, and strengthening that will give you more snap, and help you prevent injury.*

**Adams recommends the following three pre-surf routines to specifically target the surfing muscles.**

**1 EXERCISE:** CHEST AND BACK ACTIVATION
Purpose: Warms up the paddling muscles.
Relax your arms in front of your body, with your palms toward your thighs. Inhale deeply through the nose, and bring your arms backward until you feel your shoulder blades pinch together. Do not shrug your shoulders toward your ears; instead, pull your shoulders downward and together, and rotate your shoulders so your thumbs turn outward. Gaze slightly upward and let your chest expand. Exhale through your mouth as you bring your arms forward, rounding your upper back and dropping your chin toward your chest. Rotate your shoulders so your thumbs turn inward. You should feel your chest muscles tighten. Repeat in each direction ten times. Increase the speed of your movements gradually to get blood flowing to your chest and back.

**2 EXERCISE:** REVERSE LUNGE AND TRUNK TWIST
Purpose: Warms up the core and leg muscles.
Stand with your legs shoulder-width apart and your knees slightly bent. Take a big step backward with one leg until your back knee is close to the ground and your lead leg is bent at a 90-degree angle, without letting your knee move in front of your toes. As you move into this position, simultaneously rotate your upper body and arms across your lead leg. Allow your head to rotate with your shoulders, and then repeat on the other side. Keep the motion fluid and balanced. Repeat ten times on each leg. Breathe in as you switch sides, and exhale as you rotate your torso.

**3 EXERCISE:** LEG REACH AND BALANCE
Purpose: Increases circulation and balance.
To complete your warm-up, stand on one foot placed flat on the ground. Reach high overhead and squat slightly. Reach to the side of the planted foot and then re-center yourself. Repeat five times on one foot, and then switch feet. Reach far enough to challenge your equilibrium. Use your core muscles to help stabilize the bending movement. Inhale as you reach overhead, and exhale as you bend to the side.

THE

PLEASE
DO NOT TOUCH
WALL MAP

The Healthy buffet at Tavarua

# CUTTING THE FAT
## Eat Like You Surf: Lean and Mean!

Martin Potter, the 'super-kid' from Durban who started his surfing career by beating future three-time World Champ Tom Curren for the 1981 NSSA International Team Challenge and then just weeks later won the final against 1978 World Champ **Shaun Tomson,** was a gregarious partier in his early days on the tour. *I could go out and have a big night, drink heaps of beer, and wake up the next morning without a hangover,* he would recall. *My body dealt with everything. There were contests I won after staying up all night.* Not enough of them though - he was as inconsistent in his first five years as he was flamboyant. Potter had the talent in spades - but not the discipline to prevail in the clutch. Then in 1989, he got serious, started training in a non-surfing fitness routine that got him in the very best shape of his young life - and promptly won an unprecedented six contest victories on his way to the World Title. The moral of the story? You can survive a lot when your body is a 24-year-old temple, but given two equally talented opponents, a well-trained, highly-fit, health-conscious competitor will triumph every time.

Diet may be one of the most debated health topics being discussed today. There are dozens of diets purported to help you lose weight or stay fit - eat only meat, don't eat carbs, eat more protein, eat only at lunch - and the list goes on and on. None of these diets will actually keep weight off, make you fit, or sustain your nutritional needs long-term. In fact most diets are harmful, either because they remove needed nutrients of some kind, or set you up with bad eating habits themselves. Studies have shown time and time again that dieters on a long-term basis end up gaining more weight than those who don't diet. Don't let anyone kid you: the only way to lose weight is to burn more calories than you eat. And there are only two ways to do this: eat a little less and exercise a little more. No diet will work properly if you do not have the balanced nutritional components. You need fruits (almost all kinds are good and much better than fruit juice) and vegetables (the green leafy kind are best) for essential nutrients; protein for strength (best to get them from fish, chicken, soy bean products, and limited lean meats); carbs for fuel (try to get your carbs from whole grains high in fiber); healthy limited fats (like salmon, nuts, peanut butter and avocado) and some dairy (skim milk, low fat cheese, a few eggs a week).

## DORIAN 'DOC' PASKOWITZ

*Set your sights right now on being a champion. Live high on the best health habits you can muster. Make greasy foods, salty snacks and sugary pops a seldom, not a frequent mischief. Follow the song in your heart that tells you that the sweet sea is the greatest high.*

## DRINK UP

As much as 60 percent of our body weight is composed of water, and after a long session, you're going to need to replace those fluids and electrolytes. How much fluid you need depends on body weight, but generally drink at least 16 ounces of fluid after you paddle in from your session. It is also a good idea to take a water break during particularly long surf to avoid dehydrating. And pass on the soda or beer at lunch, and instead drink non-caffeinated and non-alcoholic beverages throughout the day.

## BEFORE YOU PADDLE OUT

This is where you're going to want to bump up on the complex carbs; you'll need the energy if you plan on staying out very long. Think rice, pasta, potatoes with the skin left on, and whole grain breads or cereals in moderate amounts, combined with some protein (fish, poultry, soy, dairy, or beef) and fruits or vegetables. These nutrients, especially the carbohydrates, give your muscles sugar that can be stored and used when you will need it most. Don't stuff yourself before you paddle out, rather plan ahead and eat a couple hours prior to paddling out so your body can absorb the food.

## THE POST-SURF CHOW DOWN

After surfing is a critical time when your body is very efficient at absorbing nutrients, and fueling now can keep you from getting so hungry that you may over-indulge later. You're looking at trying to incorporate the same foods as the pre-surf meal, but keep variety in mind in order to maximize the nutrients you get from your food. Protein will be important for muscle-building and repair. Carbohydrates will refill your body's sugar stores.

## SUPER-SIZE IT

Fruits and vegetables are our primary source of anti-oxidants. For most athletes the critical issue is recovery. The major benefit of antioxidants (at least in terms of impacting athletic performance) is that they shorten the recovery time by minimizing damage. Some foods are better than others for this purpose, and have been dubbed 'super-foods.' Here are some of the best, recommended by the top surfers in the world:

Cranberries: Good for the heart and detoxifying the body. They've also been linked to reducing prostate problems in men.

Brussels sprouts: They may smell like crap, but they contain detoxifying enzymes and cancer fighters.

Sweet potatoes: They make great fries, plus provide beta-carotene for sharp eyes, and joint healing.

Bananas: A great snack food (you can take it with you without having to wrap it up) and it is a great source of potassium which cuts down on cramping.

Broccoli: Loaded with nutrients - one of the most vitamin-rich whole foods you can eat.

Blueberries: Super-antioxidants and great in smoothies or mixed in with yogurt and granola.

Main picture:
Boat trip dinner, Indonesia

Above:
Fruit stand, Sumatra

## HOW TO EAT YOUR VEGGIES LIKE A CHAMP

One thing about vegetables: a lot of people don't like them. But they are so good for you it is worth the effort to make them the major source of your diet. Here are some ways to make them taste better.

Spice it up: Add a little flavor by drizzling olive oil, salt and pepper, and a little sprinkling of herbs over your veggies. Garlic, basil, thyme, parsley, rosemary, and ginger are some of the best fresh herbs to use.

Secret sauce: Put a sauce on it - teriyaki, curry, melted cheese, brown gravy and pasta sauce can turn a dull vegetable into a tasty serving or two.

Grill 'em: There is a reason why you grill steaks instead of boiling them - the flame brings out and enhances the flavor. So do the same thing with the veggies. Slice up some zucchini, carrots, eggplant, asparagus, green onions, or bell peppers and throw them on the grill. Just about anything that is long to fit over the grill will work, and if you prefer mushrooms, cauliflower, beans, or other difficult to grill veggies, get a grill pan (like you would use for delicate fish) for your barbeque and set it over the grill itself.

Make a smoothie: You can get several great servings of fruit and vegetables by making a smoothie or liquid form of the food. Most everyone is familiar with fruit smoothies, but it is just as easy to do it with vegetables, using a tomato-juice base; it will be just like V8. Add a dash of soy sauce, Worcester or Tabasco and you have a killer virgin Bloody Mary that goes down really well. You can always throw in some protein powder and make a quick meal of it. Plus, if you toss some veggies in with your fruit smoothie concoction, you may never taste them at all!

### THE PRO PERSPECTIVE

Rasta says: "Drinking water is one of the few things we can never over-do. Sometimes you body needs more energy, so you include a heavier portion of carbohydrates in your meal. Sometimes your muscles need rejuvenation, so you need to eat fish, or another food high in protein, but most often your body needs hydration. Almost all of us drink less water than we need."

Andy's angle: "I go to the gym while I'm home to work with weights for strength, but I also stretch all the time. And I try to eat really healthy (lots of fish and protein), and not so much ice cream. You need lots of fuel, but it needs to be stuff that doesn't slug you out."

According to Kelly: "The typical modern diet contributes to a lethargic state of being. The amount of sugar and processed foods we now eat is unbelievable. For competing, you need fruits and super-food vegetables for your energy. I like to eat lean meals. If you eat lean, you stay lean, and that gives you a lot of power and energy to surf."

## THE PRO PERSPECTIVE

Taj's take: "I've finally gotten serious about nutrition and training. In the past I just surfed and didn't pay attention. Now I'm on a full work-out with stamina regimen and a lot of squats for core strength. I eat a lot of carb-loading food for energy, but I'm really being careful about my diet. I can't believe the difference."

Curren's comment:

"I feel the best training is with a method called plyometrics. This is a technique that focuses on bouncing and leaping to develop the same muscles and fast-twitch fibers that surfing demands."

Gerlach's observations:

"You want to surf for the rest of your life. So that means you just have to take a very disciplined approach. Surfing is an art form, as well as a sport, a lot like kung fu. There's the physical side, but also the art and mental development. If you approach surfing like the martial arts, where timing and knowledge and exacting subtle movements become refined, you will not only maintain your performance abilities as you get older but should get better. More acrobatic? Probably not, but definitely more efficient. Take care of your whole body. In surfing there are some muscle groups that are over-used and some that are under-used. Be sure you work on the whole body so you can disperse the load throughout your body."

## TAKE YOUR VITAMINS

When mom told us to take our vitamins she was on to something. Multivitamins are not just for overall health. A daily dose of vitamins and minerals before an endurance exercise like surfing will speed your muscles recovery.

## HERE AND NOW

*Living in the present tense is really the key,* says **Dave Rastovich.** *When you are surfing the best way to improve performance is to be completely instinctive, putting your mind in the here and now, taking the moment as it arises with no analysis or hesitation. Distraction is what we want to eliminate. By not thinking, but sensing, we can translate ourselves into a highly effective physical state, where peak results will naturally occur. Most great surfers know that they enter the zone and the ultimate high is when we are locked in, feeling, totally in tune. That's the joy of surfing.*

Above: Enjoying the here and now...

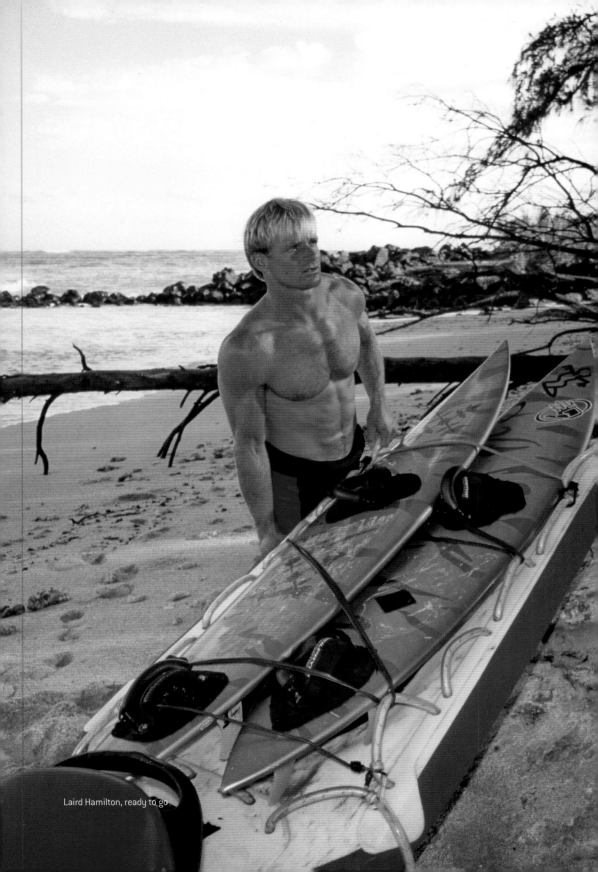

Laird Hamilton, ready to go

# TRAINING FOR D-DAY
## Laird Hamilton's Surf Training Regime

### CROSS-TRAIN WITH OTHER SPORTS

*I can surf everyday for a month if it's bombing,* says **Laird**. *But with the exception of surfing, I like to constantly be involved in new and different sports. It keeps you humble because you're always learning. Mountain biking is excellent because of the balance involved and the speed on the downhill. Wakeboarding is great, too - a really good crossover. And if you're really into trying something different, mountain boarding is awesome if you can find the right hill.*

### WORK ALL YOUR MUSCLES

**Laird** likes to work out on specific body parts each day. One day he will go on a four hour mountain bike ride up steep hills: *Technical stuff in first gear that kind of a heavy leg burner. The next day I'll do paddling or upper body lifting, and then go surf.*

### INCLUDE BREATH AND ENDURANCE TRAINING

*My workouts consist of lifting and squatting programs designed specifically for surfing. I also do circuit training combined with holding my breath for a long period of time underwater. Grabbing rocks and running underwater allows you to practice holding your breath under fatigue. Being relaxed and doing it is a whole different thing than holding your breath while getting pummeled underwater. The rock thing makes it a little more realistic.*

### BUILD STRENGTH AND MIX IT UP

Laird says he doesn't have a set routine, but when he lifts weights he gets a little more specific: He suggests doing legs one day, shoulders and back the following day, then chest and biceps another day. Then rest. *You need to break it up so you can give your body time to heal and rebuild.*

### STAY CONSISTENT

*I think the most important thing to keep in mind is that nothing happens overnight. You're not going to go down to the gym and bang iron like a monster and be in shape in a week. I think less is more. To start with, do less strenuous workouts more often. It's better to do half an hour every day than to do two three-hour sessions a week. If someone wants to get in shape, it's the consistency that pays off in the end.*

Long distance paddling; stamina building par excellence

Laird: the supreme athlete of our sport

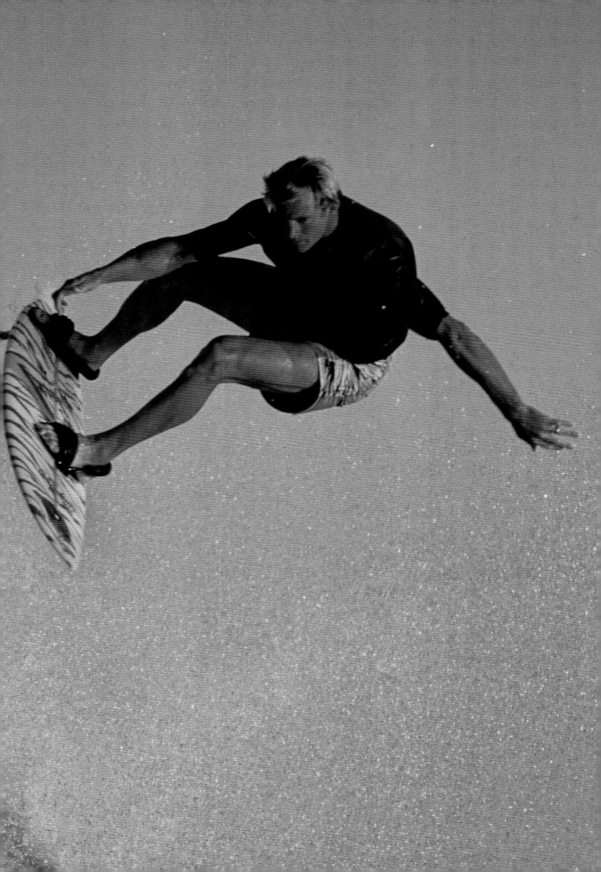

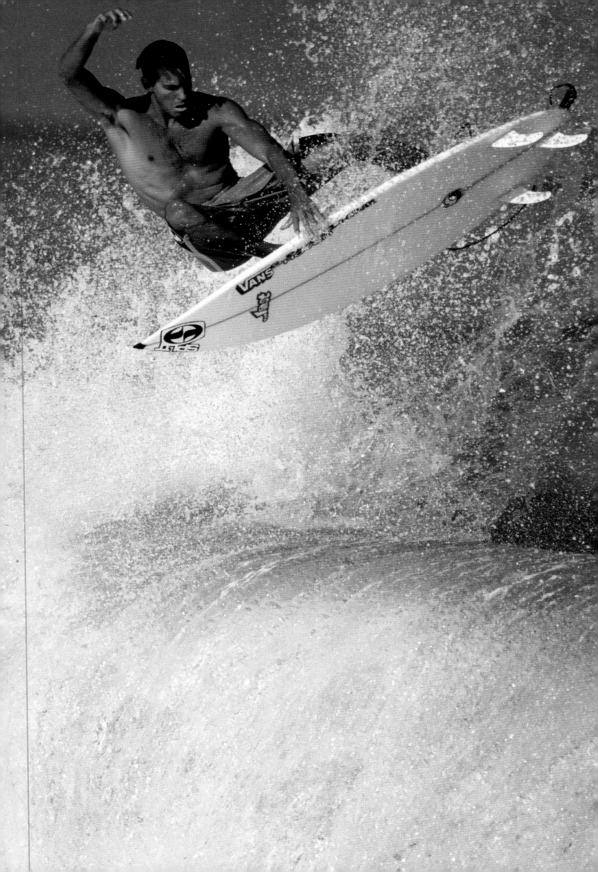

# DOWN BUT NOT OUT
## Coming Back From Injury

The bottom dropped out. Instead of landing and gliding down a smooth Backdoor slope like originally anticipated, Shea Lopez landed square and flat in the trough. A body in motion tends to stay in motion. His surfboard stopped, he kept going - all but his right leg that is. In the midst of his quarterfinal heat Lopez came down hard after hanging high along the curtain. In an instant he crumpled with a torn ACL, MCL and PCL in his right leg, and a dislocated right knee. For Pipe it was just another victim.

Most of us will never surf the Pipe Masters. Most of us probably won't even ever surf Pipe, but at some point in our surfing lives most of us will go down with an injury. According to a survey on the Surfer's Medical Association website soft musculo-skeletal sprains and strains are the most common type of chronic injury that surfers sustain (the shoulder being the most commonly affected joint). They are also the ones that will keep them out of the water the longest.

When that fateful day does come and something snaps, crackles or pops what do you do? First, assess the situation. Dr. Warren Kramer, long time healer of surf stars, approaches doctor visits as follows. *Cervical injury is*

Left page:

Cory Lopez recovered from a serious injury through proper rehab

Right page:

The North Shore has the highest level of surfing injuries

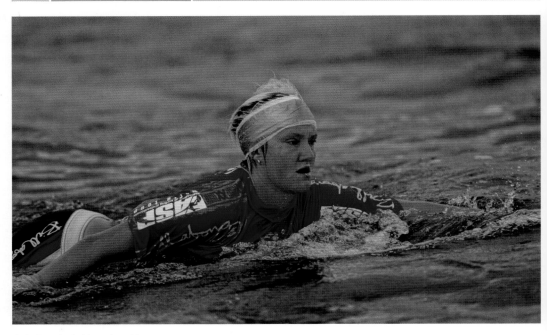

Keala Kenneley held together with tape

*first and foremost. Head trauma can also be very se-rious and may not come on right away. A subdermal hematoma can take six to eight hours to come on. It's definitely worth going to the emergency room. Common sense can tell you a lot. If there's heavy bleeding you should go. If the limb turns pale or white, something indicative of blood loss, you should see a doctor immediately. Finally if there is significant swelling to an injured area, with the exception of some joints because they don't show obvious swelling, you should go and get it checked out.*

According to Dr. Kramer, normal soft tissue injuries generally take about four to six weeks to heal with a good six to eight weeks of disciplined rehab on top of that. Kramer breaks the basic rehab process down with the acronym PRICE, which stands for protection, rest, ice, compression and elevation. Protecting the injury while it heals will help minimize further damage. Rest gives it the opportunity to heal. Icing and elevating will

help keep the swelling down. Compression assists in maintaining stabilization. This basic recipe should work for the average sprain or strain. It's when tendons are torn and ligaments frayed that the rehab process be-comes complicated.

Always consider a second or third opinion. There are a lot of doctors out there with a lot of theories and approaches. Make sure you find the right one for you - it can mean the difference of being back in the water sooner rather than later.

Six weeks after successful reconstructive surgery on his knee Shea was finally at the beginning stages of his rehab process. When asked about his progress **Shea** commented, *After the surgery, before I could start really rehabbing, I went through a lot of massage therapy to increase the circulation. Once I was able to start rehabbing I laid in a machine for about eight hours a day that slowly bent my leg through*

## THE PRO PERSPECTIVE

In August of 2003 C.J. Hobgood broke the talus and calcareous bones in his left heel in a motocross accident in Riverside, California. He humorously recalls, "Initially when they brought me in they wanted to do surgery right away. I forget the name of the hospital, but dude, there were people there in shackles walking by my room. The jail must have been close by, and all the inmates that get hurt must have been brought to that hospital. My wife was just like, 'You're not having surgery done by anyone here. Who knows what their qualifications are.'" C.J. continues, "I wanted to make sure that when the doctor opened me up he had seen my injury several hundred times, that there weren't going to be any curve balls."

*a range of motion without putting pressure on the tendon. It's really slow, like watching grass grow, but it's good to keep stretching.*

Rehabbing walks a fine line between too much and not enough. As **Dr. Kramer** puts it, *For every two steps forward you take one step back. You have to monitor your work-outs and slowly find the proper amount of stress and pressure. The nice thing about athletes is that they usually understand their bodies in terms of what good pain is and what is bad pain.*

There's a very big difference in treating your rehabilitation passively and proactively. Since surfers are generally in decent physical shape they have the luxury of treating their injury a little more aggressively than say, an 80-year-old woman. Instead of spending two or three months laid up in a cast, look into getting a brace that will offer you a little more freedom. As **Shea** comments, *One of the drawbacks to just laying*

*there is that your leg can lock up. You're not allowed to forcefully bend it because of the fear of injuring the repair job. If you're in a cast for a long time, or in anything where you can't bend your leg you can get stiff.*

The physical side is only the half of it. C.J. **Hobgood**, who's just returning to action, comments, *I just got over a huge mental thing because I just got back from Hawaii. I held up at pretty good sized Haleiwa, and then I went out and got a couple of good waves at Pipe and I was like, 'I think I'm back now.' When a challenge comes, when push comes to shove, even if you're 100 percent, you're fighting a mental battle out there at Pipe. So, coming off the injury you're fighting a double mental battle. I'm stoked with how I did out there.*

Coming back from a debilitating injury takes both mental and physical strength. It's not easy, but then nothing worth doing ever is. Take your time getting back in the water. The waves will always be there. It's not worth permanently injuring yourself because your local break was two - to three-foot. At the same time if you want to get better it's going to hurt, you're going to have to push yourself through the rehab process. Doctors and therapists can help, but it has to come from within you. If your soul's been sold to the surf you'll be back, and hopefully better than ever.

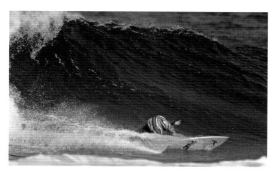

C.J. Hobgood rides again

# SHAPING UP
## Six Secrets to Consider in Selecting a Surfboard

How important is your equipment? Well, I like the story legendary Hawaiian beach boy and surfer **Conrad Canha** is credited with: *Da boards da thing. One time an old lady of mine said to me, 'Conrad, I'm sick of you surfing all da time. You gonna have to choose: it's either me or dat board.' (Pause for effect) And shoots, you know, it wasn't even dat good a board!*

As surf-riding equipment switched from balsa wood to foam for mass market production, design innovations became easier to implement; at the same time they became essential to the accelerating arc of surfing's widening popularity and expanding demand for wave-riding options. The revolutionary long to short board transformation of the late '60s undoubtedly saw more changes than any other era in surfing's history. Brave post-war explorers like Bob Simmons, Matt Kivlin and Joe Quigg became recreational spectators as the '70s visionaries whittled even more refinement into both small wave and mini-gun curves. Shapers and riders from every ocean were sharing a history with the past godfathers of the template and planer, led by renowned island craftsman and wave frontiersman, George Downing. Craftsman Dick Brewer inspired a squad of sharp shooters who flowed with Hawaii's Ben Aipa, the senior genius of Mike Diffenderfer, Barry Kanaiaupuni, Harold Iggy, the mainland's Jim 'JT' Turner, and a myriad of 'go fast' designers. Wide points

squiggled backwards every four months; noses were now drawn into more pinched and tasteful arcs. Yet only a few years after Hawaiian master Tom Parrish, South Africa's Spider Murphy and a handful of other elite shapers were tweaking single-fin rocker curves to their most highly refined shadow, Simon Anderson engineered the evo-revolutionary tri-fin design, almost overnight dissolving the past theories of propulsion. It was at this moment in design history that Pat Rawson stepped away from the dense pack of clean-line shapers, and emerged, with planer in hand and a mission aimed at the stars.

A long-time North Shore resident and Sunset point surfer, Pat worked hard, always listening to everyone and taking their ideas seriously, up front.

He had all the integral pieces of proven board and design flow linked to his shaping room and his brain: he understood Jeff Hakman's 'baseball rail' reasoning for looseness, he was clear on speed control with MR's tucked-under and defined edges, plus the need for a rocker curve to follow a flowing outline - and vice-versa.

Left page:

Rusty Long showing off his quiver

But, possibly the most positive character trait in Pat's methodology which separated him from the others was his inbred 'challenge' to consistently produce the most exacting shapes, no matter what length or custom order came to him. Rocker curves, rail taper, thickness, all the magic ingredients blended in balance. Pat has trained himself through exacting 'volume production' shaping (and as a competent surfer at Sunset) to create the most flawless and precisely etched boards and quivers seen over the last three decades. From the late '70s forward, no other individual shaper has worked with as many top pros of the era, designing from scratch, and by hand, as many responsive and winning shapes. Pat's list of clients seems endless, from local island neighbor or the promising rookie pro just coming into 'town' - the North Shore. Ultimately, the exciting honor for Pat is when an international competitor, on the cusp of winning a Hawaii championship or an ASP title comes to him for just one or quite possibly a dozen of his magic shapes. Pat's rolodex of orders and patrons covers the entire globe twice over and with as many boards that he has produced over these last three decades surely there must be a couple of lost semi-guns or magic 6'10s that have found their way mysteriously to some other galaxy's shoreline, far, far away!

Right: The shaping room

**PAT CURREN**

*Legendary North Shore Pioneer, big-wave board build-er and father to one of surfing's greatest prodigies, on how he first came to coin big-wave boards 'guns'.*

**❝ You don't hunt elephants with a BB Gun. ❞**

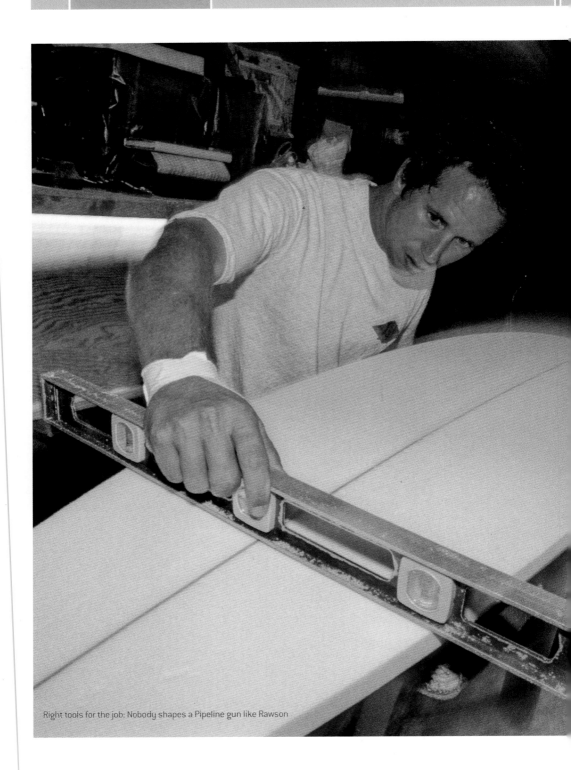

Right tools for the job: Nobody shapes a Pipeline gun like Rawson

In the following section Pat Rawson shares some of the more intricate concepts about shaping, aiding by a pantheon of the world's best shapers contributing their sage verses in the gospel of foam. Read it with a better performance in mind.

## 1.OUTLINES:
## THE SHAPE OF THINGS TO COME

**Outlines can be longer, shorter, wide, narrow, fuller nose and tail, narrower nose and tail. These are all design variables that can enhance the surfboard's overall performance. These different aspects have a profound influence on the general board design and model physics.**

Using constant parabolic outline curves result in a surfboard that can be turned hard in any position on the wave, and the more constant curves of this type of outline can help the rider maintain and hold the turn longer at higher speeds.

Elliptical curves can help the rider initiate a turn at lower speeds. Utilizing elliptical tail curves and nose curve meeting each at the flattest arc of both the curves at the center of the board. Because of this flatter arc at the center of the outline, combined with the curvier ends, this outline combo is ideal for smaller wave conditions everywhere.

You can pull the tail width at the 12" from tail mark, and tail block or end of board will accent a more drawn out feeling to the turning capabilities of any surfboard.

Widening the tail width at the 12" from tail mark only, will result in a looser feeling to the turning capabilities of the featured surfboard, due to an exaggerated hip and pronounced curve ahead of the fin area. Furthermore, the surfboard's turning capabilities can be further enhanced due to increased tail outline curve by pulling in the tail block width only, while leaving the 12" from tail width untouched.

Moving the widest point of the surfboard behind center can also increase the board's turning capabilities by having more outline curve in the foot stance area. Moving the widest point of the surfboard forward of center gives the board more drawn out turning and increased forward momentum, due to the outline curve moved forward, and the straightening out of the outline curve in the foot stance area.

Wider boards can offer better turning capabilities from increased outline curve from nose to tail due to the increased center width. Strong points are better paddling capabilities and small wave performance qualities from the fuller outline curve and extra planning from this extra width.

Larry Mabile in the green room

## 2.FINS: THE CUTTING EDGE

**Fin design and placement on the board has a profound effect on how a surfboard performs on the wave face. The fin and its function is the single least understood component of surfboard design by user and manufacturer alike.**

A center fin with double foil, acts much like a stabilizing rudder system by keeping the surfboard from sliding sideways on a wave. There are many forces at work on this fin while doing its job holding into the wave face. First, the surface of the fin from the leading edge to tapering edge has a curved convex surface. The fin also has a tapering thickness flow from thick at the base to thin at the tip. The combination of the two comprises the foil of the fin. The first curve from leading edge to tapering edge, enables the fin to 'lock in' due to the water flowing over the curved surfaces with the greatest pressure occurring where the base of the fin and the bottom of the board meet.

With the thruster fin concept and other multi-fin setups, the extra two or more side fins add to this 'holding into' the wave face concept. The side fins have a single foil on the outside of the fin, which creates lift. Because of the water flowing at the same speed over both the fin's inner and outer surfaces, the outside of the fin creates lift due to the increased water flow over the curved outside surface of the fin in contrast with the slower flowing water flow of the flat inside fin surface, creating suction or lift.

Surfboard designers use lift provided from thruster side fins in a few different ways. The water channeling through these fins at the back foot area makes the board feel faster and more positive through turns.

Fins; position is as important as plan-shape and surface area

The surfboard designer takes advantage of the extra holding and drive these side fins can offer by increasing the outline tail width, adding more tail rocker, and adding a pivot point on the outline just ahead of the side fins. This makes the thruster fin surfboard feel looser and faster than a standard single-fin design.

Clustering the fins with the back fin moved up and side fins moved back toward the tail, is a way of shortening the turning radius on a stiffer board design. Moving the back fin closer to the tail, and moving the side fins up away from the tail can help an overly loose design pick up more draw and drive.

### 3.RAILS: HYDRODYNAMICS AT WORK

**Rail shape and design, and rail volume and thickness, is the 'guitar tuning peg' of this final fine-tuning of the surfboard shape that individualizes one surfboard from the next.**

The dynamics involved in creating the rail shape and rail volume offers the builder many subtle variations to influence how a surfboard will feel before, during, and after turning in riding a wave. If all the other design components are correct in the shaping of a custom surfboard: the rail shape and rail volume can be the 'icing on the cake' in the fine tuning of all the design components working together.

Surfboard rails are like the suspension systems used in car design for better driving control and a softer ride. If the rails are designed correctly to the rider's needs and the builder is shaping the rail with the volume matched to the board design and rider's weight, this is the finale to making a great surfboard.

It is very easy to over - or under - shape, mismatching a rail design or rail volume with the rider's needs or abilities. This area is one of the greatest pitfalls in the shaping process used in building a custom surfboard.

Fuller rails have nice flotation factor built into the deck area. Normally, these rails are designed with a harder radius underneath and a slightly more tucked under edge to make up for the rail's fuller volume whilst still giving the rider good rail bite into the wave face.

With thinner box rails, water is encouraged to flow over the deck line, giving good drive and control throughout turns. This thin, yet boxy rail near the edge and softer radius underneath make this rail design more forgiving, and is great for high-speed direction changes on the wave face. This rail generally is used on the high-performance boards ridden by pro and expert surfers worldwide in all wave conditions.

Matt Moore refining his rail profile

# 4.BOTTOM ROCKER: FINDING THE FIT

**Bottom rocker is the overall stringer curve from nose to tail on the bottom of a surfboard. The wood stringer acts much like a keel of a boat, providing both strength to the foam blank, and a solid foundational reference line in which to build the bottom curve from. This major component of surfboard design is often overlooked, and less understood in concept by both surfboard builder and riders alike.**

Bottom design is comprised of contours from rail to rail. Some of these bottom contours can consist of vee, concave, tri-plane, double concave belly, and flat bottoms: sometimes all the above bottom contours can be used simultaneously in one surfboard bottom design. Constant curve rocker is a gently bowing curve from nose to tail and is used in high-performance and larger wave designs. The constant curve bottom has drive at higher speeds and is used for turning the board at high speed, full power on any wave face position, with no loading up or catching of edges, and can have more draw and hold a turn longer than the elliptical curve. This curve has the tendency to keep the board centered under the rider at all times, and the ability to turn the board in any spot on the wave without catching an edge or sticking.

Elliptical curve rocker is a compound curve with a straighter curve steadily progressing into a tighter turn at the curve's finish. An elliptical tail curve with the extra curve placed at the rear of the board can help a rider initiate a turn at low speeds. This rocker is well suited for small gutless wave conditions, and can also be preferred by lighter, less powerful riders due to its easy turning characteristics. This design generally uses a light concave bottom throughout for more drive and speed off the front foot, with a deeper concave or double concave in the tail area for better back-foot drive.

Big-wave bottom rocker has the appearance of a constant curve. But, in this combination, the curve slightly bows or 'tightens up' (more curve) at the widest point of the board, thus causing enough drag there to have the surfboard sit back on it's tail as it picks up speed. The hold and drive this combo offers is desirable in larger, powerful wave conditions, and for stronger, more powerful surfers.

Overall volume and thickness of a surfboard can be one of the most misused or mismatched components in surfboard design, because of the shaper's possible misinterpretation of the rider's overall abilities, or the rider's possible miscommunication of his needs and wants for the intended board to the shaper.

The dynamics used in thickness flow offers the builder subtle variations to influence how a surfboard will paddle, turn, or affect the momentum and drive the board may have. Volume function is directly related to a surfboard's overall flex characteristics and perceived 'snappy looseness' while being ridden on a wave.

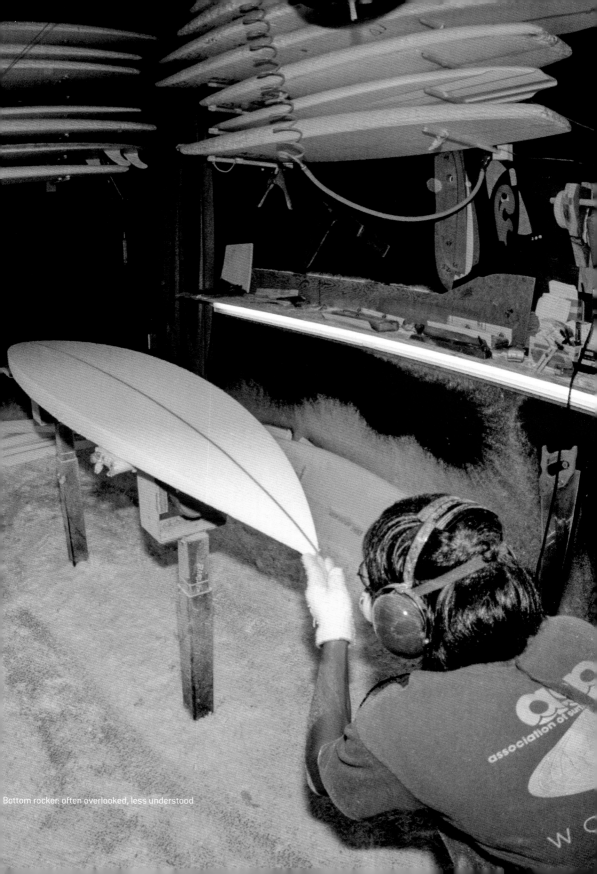

Bottom rocker: often overlooked, less understood

## 5.VOLUME: THINKING THROUGH THICK AND THIN

**Thickness, flow and volume can be mismatched components in surfboard design because of the shaper's misinterpretation of the rider's overall abilities, or the rider's miscommunication of his needs and wants to the shaper.**

Overall volume is the cubic volume of a surfboard measured by how much water is displaced when the surfboard is placed in the water. This is evaluated accurately using a water tank with measurements showing exactly how much water is displaced when the surfboard is completely submerged in the water of this tank.

The way thickness varies in a board offers the builder subtle variations to influence how it will paddle, turn, or affect the momentum and drive the board may have. Volume function is directly related to a surfboard's overall flex characteristics and perceived "snappy looseness" while being ridden on a wave.

Flex due to changing board thickness from nose to tail and deck contour and related components in the glassing process is an important concept in high-performance surfing. Different technologies and the materials used with them have differently perceived buoyancy while paddling and catching waves. Epoxy has its somewhat lighter weight concentrated at the skin of the board, and tends to feel higher in the water while paddling and surfing. This allows the board designer to use slightly less cubic volume in the board while designing it. The trick for the builder is to get this dynamic flex working together with the physics of the board's construction on a wave.

Foam waiting to be transformed

Thinner boards tend to feel lower in the water at high speeds, and generally work better in hollow, more powerful waves. On the other hand, thicker boards can paddle better and have a stiffer feel to them, giving them more momentum and mass in a large thicker wave conditions found at Waimea Bay, Maverick's and Todos Santos.

Size matters

Different waves, different boards, different performances

## 6.SIZE AND WIDTH:
## THE LONG AND THE SHORT OF IT

**The saying 'know yourself' definitely applies here. Knowledge is power and gives you more aptitude in making correct choices when buying a new surfboard. Communicating what you want and need for your surfing experience is key to picking up great custom made surfboard equipment. Popular surfboard manufacturer's web pages are a free and convenient way to start checking out what surfboard designs are available and popular in the surf world.**

For general information purposes, the following guide can be used for five generalized design categories with the suggested surfboard dimensions listed by overall length, maximum width, and maximum thickness suggested for each of the three separate rider weights listed. Please note this is meant to be a basic guide for the following category descriptions:

### HIGH PERFORMANCE DESIGNS

This design category is used more for advanced surfing abilities such as pro riders like Andy Irons, Joel Parkinson, Taj Burrows and other well known world class pro surfers, and also for advanced ability surfers desiring high-performance maneuvers in all styles and extremes of surf throughout the world.

### ALTERNATIVE HYBRID DESIGNS

This category is a middle ground crossover between high-performance designs and retro-style designs. Note that this category, along with the retro designs, have become increasingly popular in the last three to four years in the surfboard-buying public throughout the world.

### 3. RETRO DESIGNS

This category is based on previous board designs popular over the last 35 years of surfing history, and features many models designed and built in the fashion of their time, including resin color tinted fiberglass lay-ups, and glossed and polished finishes. These board designs can also be traditionally glassed as clear lay-up as well, with a more traditional sanded satin-finish on the finished product.

### 4. HYBRID MINI-LONGBOARD DESIGNS

This category describes hybrid designs morphed between alternative hybrid design and high-performance longboard design. These models can be easier to ride than most traditional small board designs, and can help the rider to catch waves easily, even with their overall smaller-than-longboard size, and are generally designed for smaller, softer-breaking waves. This feature also makes this category a great design for the beginner surfer or the older surfer looking for a fun surf session when the surf is below average in wave height.

### 5. LONGBOARD DESIGNS

This category includes traditional longboard and high-performance longboard designs. These models have been known to be extremely easy to ride and catch waves with, and generally designed for smaller, softer-breaking waves. This feature makes this category a great design for the beginner or older surfer looking for a fun ride in any surf conditions year-round.

Tim Elsner's quiver

## GENERALIZED SURFBOARD MEASUREMENT SUGGESTIONS

**High-performance designs:** normal tail design - either rounded pintail or squash tail:

150lbs. and under: 6'0"L  x  18"W x 2 3/16"T
180lbs. and under: 6'2"L x 18 5/8"W x 2 3/8"T
210lbs. and under: 6'5"L x 19 1/4"W x 2 9/16"T

**Alternative hybrid designs:** Rocket-fish type designs, racy fish type designs, or wider 'man-sized' styles used with high-performance type designs:

150lbs. and under: 5'10"L x 18 7/8"W x 2 3/8"T
180lbs. and under: 6'2"L x 19 1/2"W x 2 1/2"T
210lbs. and under: 6'8"L x 20 1/4"W x 2 11/16"T

**Retro designs:** Retro fish designs (both twin-keel and quad variations) from 1970, '70s era single-fin designs (as well as Bonzer-type bottom designs used either as three- or five-fin variations):

150lbs. and under:
Fish - 5'10"L x 19 3/8"W x 2 3/8"T
Single Fin - 6'2"L x 19 1/2"W x 2 1/2"T

180lbs. and under:
Fish - 6'1"L x 20 1/2"W x 2 1/2"T
Single Fin - 6'4"L x 19 3/4"W x 2 5/8"T

210lbs. and under:
Fish - 6'4"L x 21 1/4"W x 2 3/4"T
Single - 6'8"L x 22 1/8"W x 2 7/8"T

**Alternative hybrid designs:** This design can be either squash tail or rounder pintail, and features wider nose and tail widths:

150lbs. and under: 6'10"L x 19 7/8"W x 2 7/16"T
180lbs. and under: 7'4"L x 20 1/2"W x 2 5/8"T
210lbs. and under: 8'0"L x 21 1/8"W x 2 15/16"T

Longboard designs:

150lbs. and under:

High-performance - 9'0"L x 21 1/2"W x 2 1/2"T

Traditional - 9'2"L x 22 1/8"W x 2 3/4"T

180lbs. and under:

High-performance - 9'0"L x 21 3/4"W x 2 5/8"T

Traditional - 9'4"L x 22 1/2"W x 3 1/16"T

210lbs. and under:

High-performance - 9'2"L x 22 1/8"W x 2 3/4"T

Traditional - 9'8"L x 23 1/8"W x 3 1/4"T

## PRO TIPS

**Rusty Priesendorfer:** *The balance point is key. It's the tipping point of your board, the spot where there's basically an equal amount of weight and volume on either side of it both forward and in back. What it does is influence where you'll need to stand on the board to find its sweet spot. A surfboard's maximum volume, or balance point, should always be between your feet while riding. This point creeps forward on boards made for bigger or more power-ful waves, and back on boards for smaller waves. To find the exact spot, just hold the board in one hand like a scale and find the spot where it stays balanced in place as you hold. When the board stops moving, take a note of where your hand is, and make sure that spot is between where your feet would normally go.*

**Tyler Calloway:** *In a sense, fins work like wings on jet fighter, creating lift and forward momentum. In another sense they're a lot like tires on a race car, providing traction and cornering ability. No matter what analogy you identify with, it's undeniable that fins are the key component in modern high-performance surfing. Tyler Calloway, three-time NSSA National Champ and director of FCS Fins*

**Gary Linden:** *The secret? Volume. How deep do you want to sink the rail? How much paddling power do you want to have? It's like a shoe: do you want a running shoe that is going to move fast, or a sandal that's light and loose? The less volume, the more responsive your board will be. The more volume, the easier you will catch waves and drop in.*

**Dick Brewer:** *Always get your board for the wave you want to ride. Have your shaper build it for the specific characteristics of the wave and how the surfer wants to ride. I might shape six surfboards that all are completely different, depending on the wave that the board is intended to be ridden in. But even with the same size and shape, the placement of concaves, fins and foil can make them completely dissimilar.*

**Phil Edwards:** *Sleep with your surfboard. If nothing else it gives you a certain feeling for surfboards; you know their every nuance of bend and shape. You haven't lived until you have slept with one.*

**Mickey Muñoz:** *It's a fine balance between speed and control. Speed is only good if you can control it. Control has little value without speed. A shaper is constantly trying to achieve the one without losing the other.*

**Rusty Priesendorfer:** *Rocker has more impact on your board's performance than any other single ingredient. A flat, or straight, rocker will paddle and surf faster, but will be much stiffer and harder to control in the pocket than a board with accelerated curves in it. It affects both speed and turning power. Rail rocker also plays vital role, as it is the curve you can turn off of.*

Mark Richards and Pat Rawson designing one of the shapes that won 4 World Championships

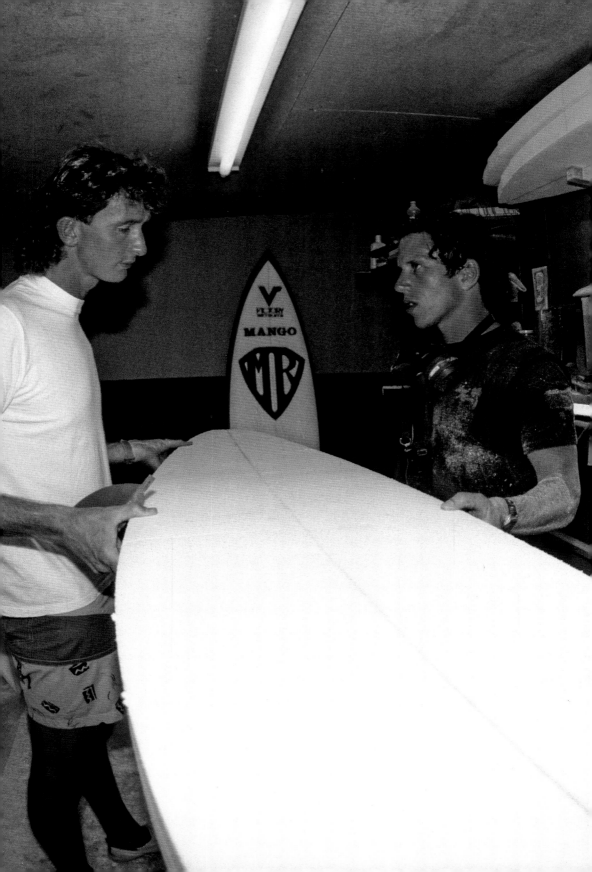

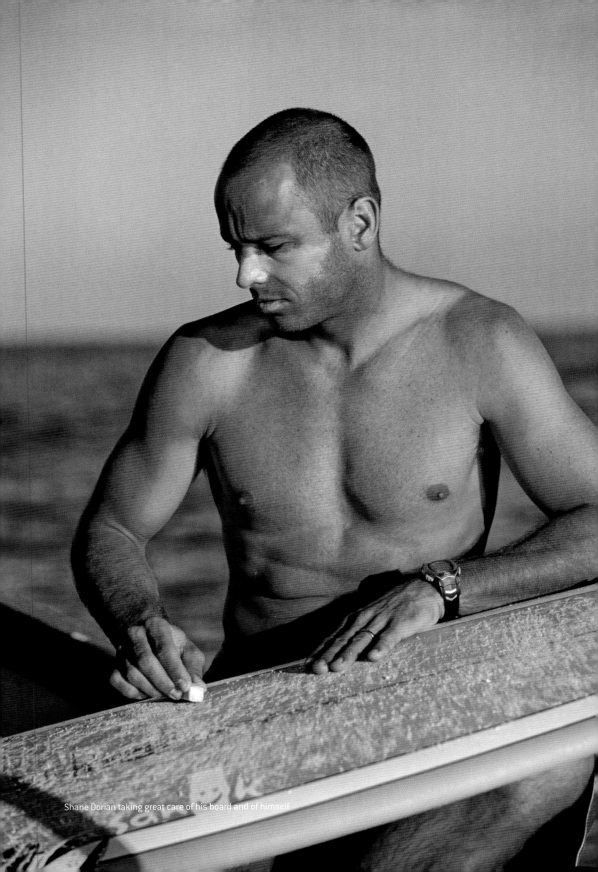
Shane Dorian taking great care of his board and of himself

# THE LITTLE THINGS
## Get Your Boards, Suits and Accessories to Work for You

## TUNE UP

When the surf goes flat it is a great time to make sure all of your boards are tuned up. This means dings are fixed, wax is cleaned and fins are checked to make sure they're still in good shape. Even something as simple as cleaning your wax will make a difference in your board's performance - old wax tends to absorb water, which in turn makes the board heavier - and will ensure that your board is fully operational the next time the surf comes up.

## WAXING PHILOSOPHICAL

The number one bane of all globetrotting surfers existence is, hand's down, without question, wax. It's uncanny - nine out of ten surfers will show up on trips expecting the other guy to bring the wax, which inevitably results in a very limited supply. Lifelong friendships have been both born and destroyed because of the stuff, work-a-day surfers have found themselves transformed into tight-lipped, hording pirates of paraffin. More than one Indo exploration has almost turned mutinous because nobody brought any wax. Next time you're packing your board bag, be part of the solution, not the problem, and stop by your local surf shop on your way out of Dodge.

## DAMAGE CONTROL

Second only to taking care of your board is taking care of your body... wait, your priorities should probably be the other way around. But you're a surfer, and we understand. Either way, a compact, fully stocked first aid kit could make a world of difference. As fun as stepping on urchins and getting staph infections is, it's probably a good idea to tend to every wound. Even the smallest cuts can serve as the perfect breeding ground for nasty bacteria, especially in the tropics. Keep limes handy for those ugly reef rashes (the citric acid in the limes kill the bacteria that grows on the reef), and make sure there's plenty of sterile gauze on hand to keep the flies off the raw flesh. Also, hardcore sunscreen should also be on this list. If you're going to sit under the sun all day long, protecting your skin is key.

## THE LITTLE THINGS

Two other huge culprits are little things: leash strings and fin keys. The leash and fins are there, how hard could it be to remember to bring something to fasten them to your board? One would assume that if you have the presence of mind to show up at a reef pass on the other side of the world just as a new swell is

starting to show and the tide is turning just right, re-membering to pack leash strings and fin keys would be a no-brainer. Well, it's not, and that's probably a good thing because there's nothing more amusing than watching an impatient photographer snap on a would-be professional when they're reduced to scur-rying about cutting off ends of shoelaces and tying them to the ends of their boards and trying to screw their fins in with Neanderthal-like tools. It's more fun than turning on the kitchen light and watching all the cockroaches make a mad dash for the darkness under the fridge.

## GET IN GEAR

Don't wait until you get to the beach to make sure you've got fins and a leash for your board. Nothing's worse than watching the swell pump while you fumble around for some miscellaneous piece of equipment or tool, which means when it's flat and onshore you should spend a little time dialing in all your gear. It'll only take a few minutes and save you tons of stress when it starts pumping. Little things like making sure your leashes and leash ropes are in good condition, checking your fins and fin boxes for any potential cracks, and of course, tending to any and all dings. Keep a couple spare bars of wax around, because again, you don't want to be paddling out with a slippery board under you. You can't surf all the time, but you can think about surfing all the time, so next time you find yourself drying up for a day or two, give all the gear a quick inspection.

Fix dings right away to prevent damage from getting worse

## DING REPAIR

If you can't count on them to bring wax, bringing sun-cure resin and a little sandpaper might be asking too much, but having something handy onboard to repair dings with is always an asset. Even if they do get their boards for free, having a way to fix a hole in the bottom of a prized 6'1" after it's been dry-docked on the reef is never a bad idea. Using stickers only works for the small stuff. Real ding repair kits will help with the big craters.

## SIX SECRETS TO WETSUITS

1. You can pee in them as long as you wash them out. Contrary to old wives tales, it doesn't eat the rubber or break down the cell structure. In fact if peeing in them helps you to remember to wash them out, then it's probably an asset to do so - because washing your wetsuit is the single best thing you can do to protect it. Urine, salt, sand and sweat all need to be rinsed out of your suit thoroughly.

2. Easy in and easy out is the way not to rip, tear or stretch the rubber. Warm water softens and loosens the cellular structure of neoprene rubber. Slip it on and peel it off. It's definitely easier to get out of a wet, warm suit than a dry cold one.

3. Don't ever pull your wetsuit zipper up while you are squatting or hunched down, (like when you are waxing your board) - you can pull the zipper right out of the bottom.

4. Keep your receipt and warranty unless you get your suits for free. Most manufacturers have excellent warranties on their suits. Since the newer, stretchier, heat-trapping rubber being built today is more susceptible to sun damage, dries out faster, and sometimes rips and tears, it's a smart move to keep your warranty where you can exercise it.

5. The best wetsuit rubber is made in Japan. Your wetsuit may be made in Asia, Latin America or the good old USA, but the best rubber will still be Japanese. Most top pros are wearing these suits - even if the ones they are wearing in the ads are something else. If you can get them, do it - if you like being warm, flexible and comfortable, it's worth the money.

6. A stitch in time. Take a look at your wetsuit to see if there are any holes or problem areas starting to develop. The quicker you get the suit in for repair the longer it will last, and you won't freeze your ass off with every duck dive.

# PERFORMANCE

Joel Parkinson flying

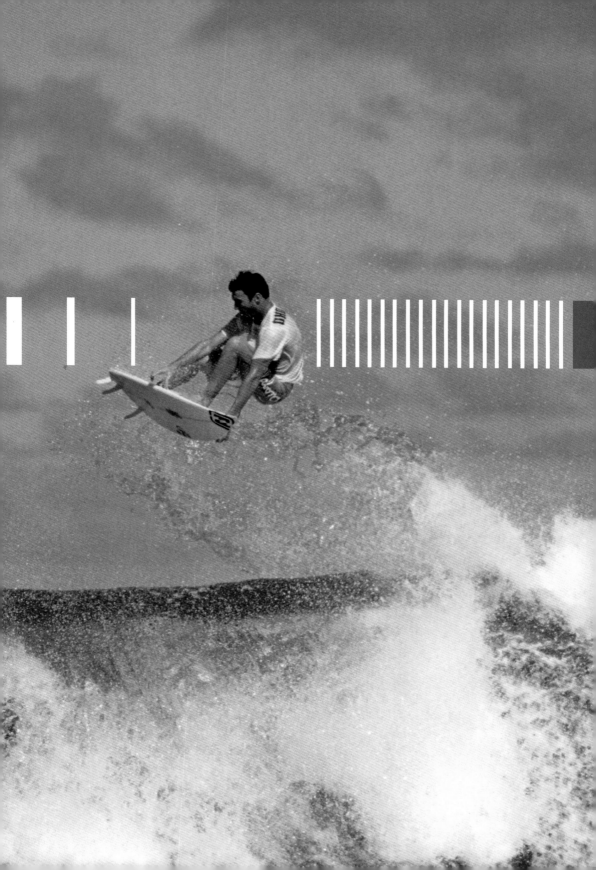

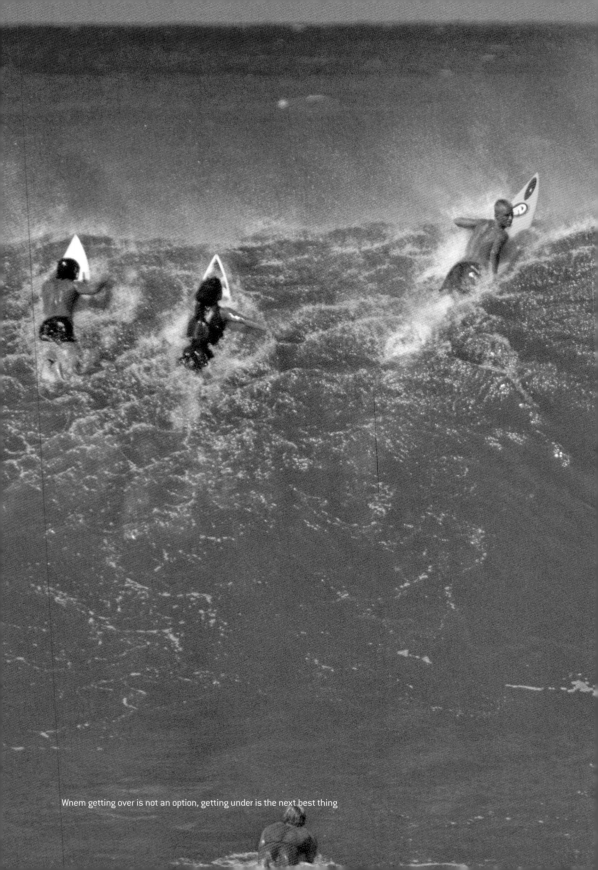

When getting over is not an option, getting under is the next best thing

# DUCK DIVING
## Avoiding Obliteration

Before leashes and short boards, the problem of getting outside was even more challenging than today. During a severe push down while getting rolled by a brutish North Shore set, U.S. National Champion Corky Carroll slammed into something hard, which he thought was the bottom. Looking down he realized he'd hit a big sea turtle who was also getting pummeled by the wave. *I was thinking, 'Look at that dude groveling around, he's in trouble.'* recalls **Corky**. *Then, with my lightning-quick mind, I realized that if he was in trouble then I must be in bigger trouble. He's a turtle.* So, doing the manly thing, Corky grabbed on and pulled himself up, launching for the surface from the top of his shell. Of course this stuffed the turtle even deeper. *When the turtle surfaced some seconds later he was just glaring at me,* **Corky** remembers. *All I could do is look back sheepishly. He was one pissed-off tortoise.*

## DUCK DIVING DONE DEFTLY

You see a massive wall of white water rumbling towards you, and there's only one place to go - under it all. If you have ever watched ducks or other water birds navigate a wave you will know where the term comes from. Using their beaks first they simply drive their necks under the breaking wave follow with their bodies and pop out the back with the most natural and elegant motion. The object of the surfer's duck dive is to do exactly the same. Getting this wired is not that easy, but mastering the duck dive will save endless battering and reduce the number of waves you have to roll substantially.

## GETTING STARTED

The best way to get a feel for the proper way to really duck dive is to first practice on flat water. Paddle quickly up to speed and prepare to grab the rails about even with the center of your chest. Push off the board, just as if you were taking off, and with your hands wrapped around the rails, shift your body weight, position forward and bury the nose as deep as possible. Aim for a 45-degree angle of penetration. Deeper usually is better, but in most small waves just getting in well under the surface will generally work. *Timing is the key element to this maneuver, and without a doubt the hardest part of the sequence,* says longtime big-wave expert and Santa Cruz local **Richard Schmidt**. *Getting yourself and the board underwater, away from the falling lip or incoming whitewater is the main objective.* The whole sequence needs to be one precise sweep, to escape the lip's impact and the turbulence just below the surface. Here is the key to the perfect duck dive: it's a saber arc, down, under and up through the surface again.

### TAJ MAHAL
*Diving Duck Blues, from his Take a Giant Step CD*

> If the ocean was whiskey, baby,
> And I was a diving duck
> I'd dive down in the water
> Lord, you know I'd never come up.

Push the tail down with the feet

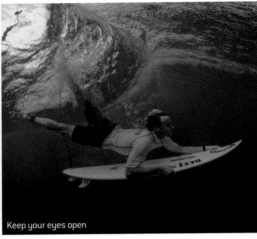

Keep your eyes open

## PUSH IT REAL GOOD

Push all your upper body weight onto your hands and arms until you feel the nose begin to go under. Point your head down and let your body follow.

As the nose submerges, slip your dominant leg forward, arching onto your toes. This will pull your butt into the air as high as possible. Just as your board begins to reach the bottom of the pendulum swing, bend your dominant leg and use that knee - or better yet, the ball of your foot - to push the tail under the water also.

## LEAN INTO IT

To maximize your leverage, throw your other leg into a frog-kick behind you. Continue to push down against the tail with the toes of your leading or dominant foot. At this point you should be in a crab-like position over your board. The board is completely underwater, one leg arched above you. Timing is critical here. Each wave will configure the components differently: speed, thickness of lip, depth of the bottom, and you need to time it so you get your body under before the lip hits you. Remember to take a quick breath before going under.

## THAT'S USING YOUR HEAD

Lead with your head (just like a duck) and pull your body underwater, pulling the board towards you. Simultaneously pull your arched back leg forward to add to the downward momentum. Maintain the momentum gained from driving the nose down under, thrusting forward and kicking with your back foot, while still pushing down on the tail with your dominant foot. Get the feel of where the sweet spot is to get maximum leverage from the foot and toes.

## PRACTICE MAKES PERFECT

Practice this until you can do the whole sequence in a singular flowing motion. The perfect duck dive uses your board and body as a pendulum, swinging under the wave in one fluid swooping movement. *It takes time, and it's a pain in the ass*, says **Joel Parkinson**. But when you get it wired, and you're trying to get out on a big day, it can be so rewarding.

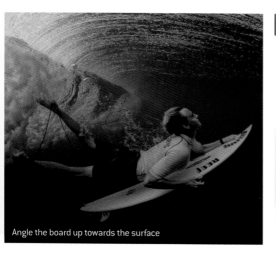
Angle the board up towards the surface

## KEEP IN MIND

As you move into the big stuff, remember to build up as much forward paddling speed as possible. Avoid where the lip is directly throwing out; try to paddle toward the part of the wave that has already broken or a spot on the wave wall that is steep but not right where the lip is landing. As the wave goes over you, push down on the tail with either your knee or foot. Your board should now be horizontal, a couple of feet underwater and powering through the bottom of its arc.

## EYES WIDE OPEN

Whenever you can, if the water is clear enough, open your eyes to look for an area that has less turbulence and aim to pop up there. This point should be timed so that the bulk of the turbulence is above you. The energy of the wave should now be pushing you back towards the surface. Maintain momentum and arch upwards using the buoyant property of your board and body to complete the swing of pendulum, and break the surface behind the wave.

## THE PRO'S PERSPECTIVE

**Shane Dorian's advice:** "There are plenty of instances where you really don't want to be anywhere near your board, and you need to know when that moment is so you don't smash in the impact zone."

**Bradshaw's point:** "The biggest single mistake I've noticed is that 90 percent of all surfers use their shins, knees, or nothing at all to push the tail of their board under. They don't penetrate deep enough and end up getting worked, pushed back and tired out. You have to use your foot to sink the tail. I don't mean your knee or shin: use the ball of your foot under your toes; that's your leverage point. I use my left foot to press down on the tail. Rather than have my left leg under though, I drag my left knee over the edge of the board and along the side, over the rail, so that the foot immediately finds the tail. People get this confused. They try to bring the knee up under them and that's wrong. I drag my knee off the edge of the board. When I push with my foot I can deliver more power by flexing my knee rather than having it jammed underneath me."

**Schmidt's rule:** "Whatever method works best for you, remember this: unless you're facing a Waimea Bay closeout, its bad etiquette to let go of your surfboard when other surfers are around you."

**Egan's angle:** "Make sure as the wave hits that it shoots the nose of your board at an angle pointed straight towards the sky."

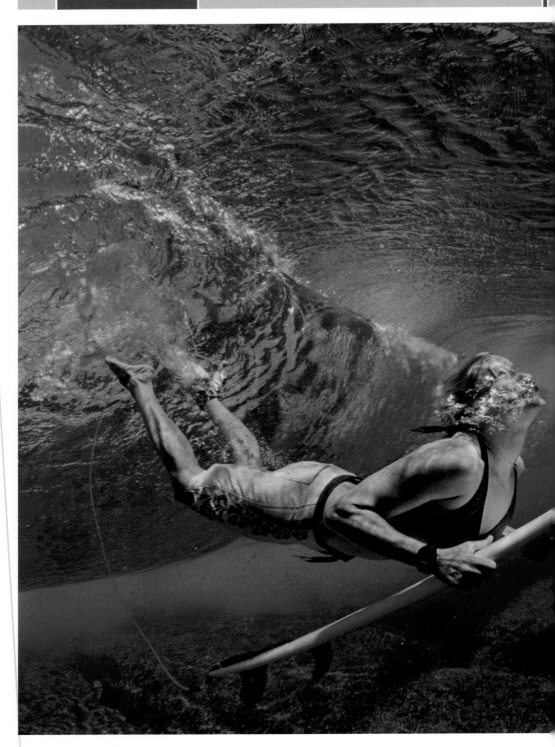

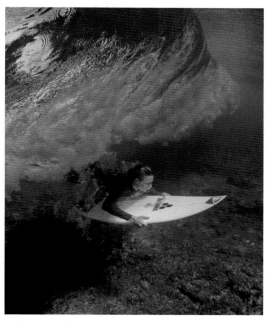

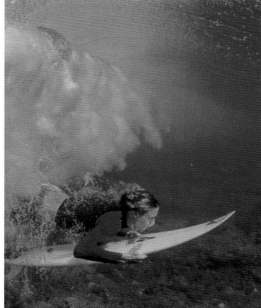

The single most important maneuver beyond the basics is the mastery of duckdiving

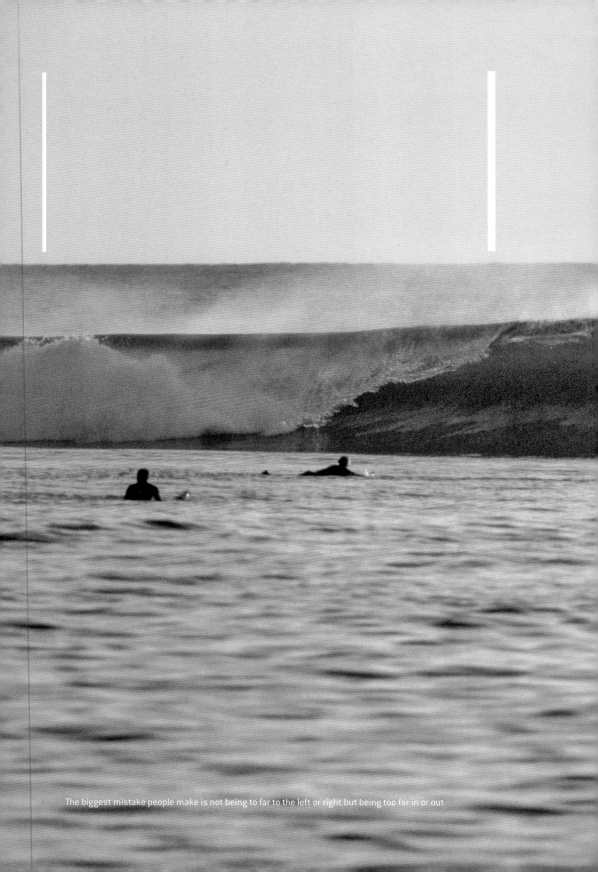

The biggest mistake people make is not being to far to the left or right but being too far in or out

# LINING UP

"IT'S NOT AN OBVIOUS SKILL LIKE PADDLING OR CUTTING BACK. RATHER, IT'S A SUBTLE, OFTEN OVERLOOKED TECHNIQUE THAT SEPARATES THE REAL WATERMAN FROM THE LEGION OF WAVE-GRUBBERS. LEARN IT, AND YOU WILL PADDLE LESS AND GET MORE WAVES. IGNORE IT, AND YOU'LL SPEND MOST OF YOUR SURFING CAREER WATCHING OTHERS TAKE OFF ON YOUR WAVE. IT'S THAT SIMPLE."

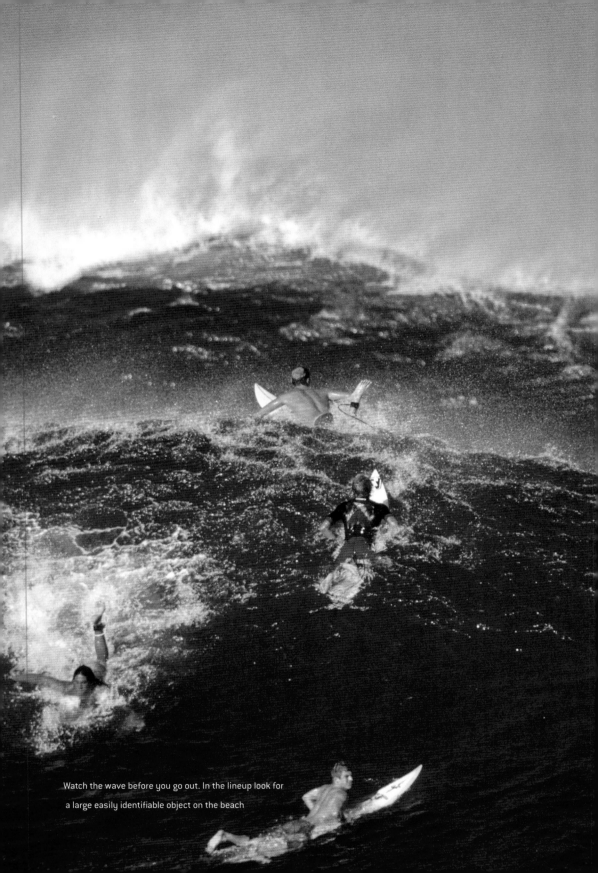

Watch the wave before you go out. In the lineup look for
a large easily identifiable object on the beach

# LINE IT UP
## How to Make Sure You're Always in the Right Spot

Mike Parsons, 'Mr. Todos,' knows the importance of lining up correctly from hard-learned experience. Being in the wrong spot at Killers or Waimea is not only frustrating, it can be dangerous. Too far out, and you paddle furiously for nothing. Too far to one side, and the wave backs off or closes out. Too far inside and you get stapled to the bottom like an errant fly. *Lining up properly sets up your whole ride,* says **Parsons**. *For instance, if you watch a local like Michael Ho take off at Sunset, you'll see he's always perfectly positioned and will get a barrel on each section. This all comes from being in the exact take-off place.*

**MICKEY MUNOZ**
*Master shaper, surfer and 70-year-old hero of his crew.*

> *There are no bad waves. There is only lack of observation, poor equipment choices, and a lousy attitude.*

## WATCH

Lining up properly starts before you even get your toes wet. Although your first impulse is usually to charge right out there when you hit the beach, **Parsons** recommends taking a little time to stretch and observe, seeing where waves are breaking best, and whether or not the take-off spot is shifting around. The result, he says, will be that you'll have a better session and catch more waves than the average slop-jockey. *What I find helpful in competition and free surfing is to spend at least a half-hour checking for swell direction and how the break is working. If you're surfing really big waves, you need to spend quite a bit of time - 15 minutes to an hour watching the break, so you don't paddle out over a dry set of rocks or reef.*

## TRIANGULATE

Lining up is essentially nothing more than rudimentary coastal navigation. You find two or more stationary reference points, then line them up visually. By facing the beach and constantly checking your position in relation to these points, you can remain in the sweet spot, catching waves and returning to the same starting point time after time. *Once I'm out in the line-up, the first thing I do is obvious: find where it's breaking best. Paddle around, catch a few waves - work it a bit. Once I feel I have wired it, I'll sit in the take off zone and look for a large, easily recognizable object like a telephone pole or a house on the beach. Then I find another reference somewhere behind the first one. I memorize how the two points relate to each other - hopefully one's directly in front of the other. That gives you your*

*left and right line-up (in relation to the beach). Then, ideally, you want to find something to gauge your distance from the beach. Keeping your left and right line-up points aligned, look to either side of you and find a landmark; a point or rock outcropping. Memorize how everything around you looks at that point - it'll give you a reference when you're paddling back out, or if a current moves you out of position. The biggest mistake people make is not being too far to one side of the break but being too far in or out.*

Oftentimes, however, there will be no side landmarks to anchor yourself to. In that case, Parsons recommends trying to find something stationary in the water to cue off of such as a boil, submerged rock or kelp patch. As an example, he points out the boil in the line-up at Killers. According to Parsons, if you're right on it, you're in prime take-off position.

## FEAR FACTOR

Where a wave will break depends on a number of variables, including type of bottom, tide, current, wave size and swell direction. Obviously, all the factors will also affect your line-up strategies. As the break moves around, your relative position to your reference points shifts as well. The palm tree and light post that worked last summer on a low-tide south swell won't work on a high-tide winter north. Each spot will have its own personality, and it's up to you to find out what works and what doesn't at a particular break. Some breaks may have a half-dozen or more different line-ups.

*Reef breaks are probably the easiest to break in the same spot all the time. Point breaks are also relatively easy. If it's peeling right, you just take off as deep as you can. Beach breaks are the toughest, because peaks are always shifting around. The best thing to do is just to watch where the most consistent wave is coming through, then give it your best shot.*

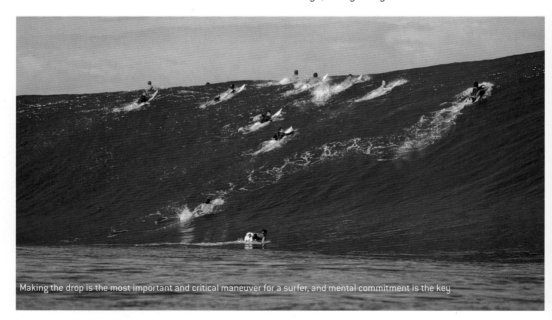

Making the drop is the most important and critical maneuver for a surfer, and mental commitment is the key

In addition to studying the spot, you might ask some friendly locals (approach with caution and tact), or watch where some of the better surfers are sitting and looking. Then verify your theories by seeing if you catch more waves at that line-up site.

*Once you've found your spot, test yourself and try to go deeper. At a place like Backdoor, you prove your positioning by going deeper and deeper, noting a line-up each time, until it is unmakeable. That's the ultimate line-up test.*

Finally after you've established your spot, Parsons says to take note of how the current is moving you around. By observing direction and speed relative to your line-up, you can stay consistently within the prime wave area. Remember to check your line-up often. Depending on the speed of the current, this can be as often as once a minute. Vigilance and accuracy are your edge.

## WORK THE CROWD

The only drawback to knowing how to line up: The pack will eventually get wise to the fact that you're catching more waves than they are. Soon they'll be dogging your trail, looking to pick up on your inside track. According to Parsons that just comes with the territory. The trick, he says, is realizing they're basing their position on you and not the line-up.

Once you have a spot wired, you might not want to cap right on the take-off spot. Sit off to one side within striking distance. When you've chosen an approaching wave, wait for the right moment, then paddle for your line-up spot. In many ways, purposeful direction or movement establishes wave rights.

Variations on this technique can include misdirection (leading the pack in one direction, then switching at the last moment), or stalling (waiting for the last possible moment, then sprinting for the take-off spot).

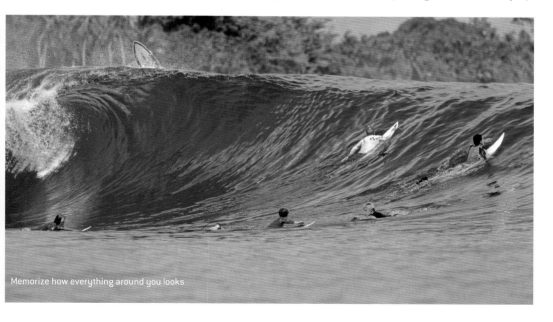

Memorize how everything around you looks

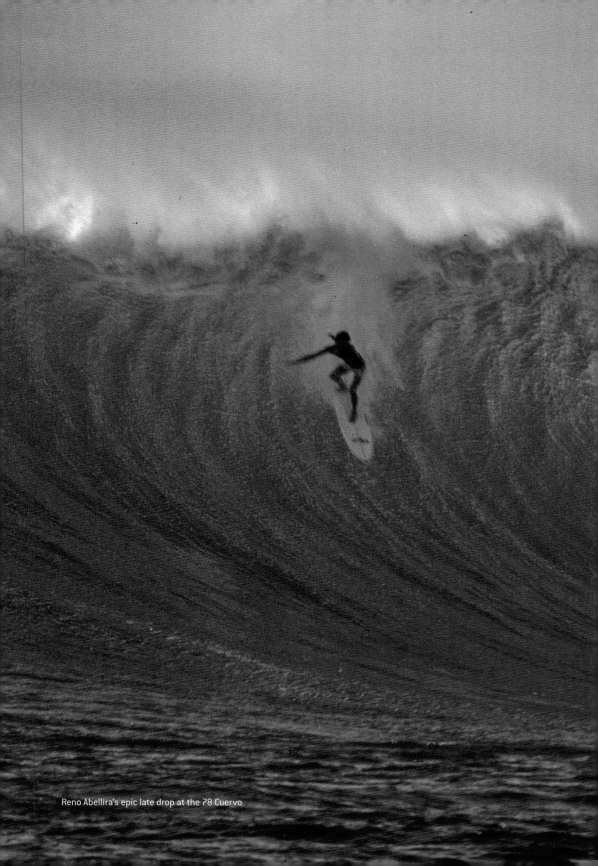

Reno Abellira's epic late drop at the 78 Cuervo

# LATE FOR THE SKY
## Making the Steep Drop

During the final of the 1978 Cuervo Contest at Sunset, Reno Abillera spun around and committed to a monster outside northwest wedging peak that made history. In front of network television cameras and hundreds of spectators watching on shore, Reno stood up on a wave that was already pitching when he started the drop. Tubed on take-off, the lip was already completely throwing over him while he was still driving down the face. As the crowd gasped, he disappeared behind the massive curtain, a certain victim of Sunset's awesome and unpredictable power. A second later, to everyone's astonishment he punched through the exploding lip shooting out into the flats to make one of his signature speed-rail bottom turns. It was nearly a magical trick which still today gets spoken of in hushed tones by those of us who witnessed the amazing feat.

In 2007 the bar was once again set a notch higher when Laurie Towner took on Shipstern's Bluff, executing drops that reverberated around the world. *All it took for him was one drop, and he's on the cover and in the history books,* said **Andy Irons** of Towner's fall from the sky. *His wave is a perfect example of what happens when you're in absolutely the right place at absolutely the right time. I was further down the line and thought about taking off but would have died. That drop practically made the kid's career.*

Making the drop is the single most important and critical maneuver for a surfer, and mental commitment is the key. *Getting to your feet fast in a balanced position sets you up for the whole rest of the wave*, says **Dave Rastovich**. *The key element is feel.*

**Joel Parkinson** agrees: *In the really steep take off anticipation is part of the process, because there is no time to think or be analytical; you need to anticipate what you board, your body and the wave are going to do all in the instant of take-off. You've got to be spontaneous: a second is a long time on a drop.*

Catching the wave requires judgment, timing, and coordination to get into the exact spot where the wave is jacking but not quite pitching. To do that, you have to get your board moving at the same speed as the moving wall of water. That means paddling intelligently and aggressively.

### PRO TIP BY DONAVON FRANKENRIETER

*Once you have decided that you are taking a wave, make a total commitment. The only reason you should hesitate or pull back on a wave you want is if it is too critical or there is somebody else in position when you get it.*

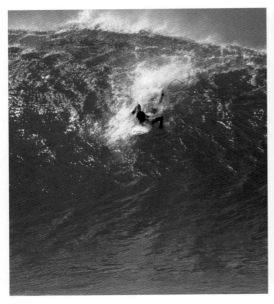

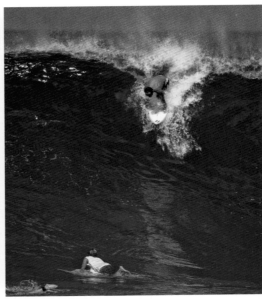

## PADDLE POWER

As obvious as it seems, *the most frequent reason somebody misses a wave is because they don't paddle hard enough for it,* says **Andy Irons**. *You have to stroke like crazy. Get your board moving as fast as possible in the water to match the speed of the wave moving through the water towards you.*

Always keep your hands on the deck of the board; don't grip the rails as you jump up. A slight shift in weight will unbalance your board and can cause you to shift the rail enough to cause problems. **Joel Parkinson** says he never thinks about the take-off, but one thing he always does is make a little top turn wiggle at the very start. *It gets my board situated and centers me,* he says.

### FLIPPY HOFFMAN

*California big-wave pioneer, when asked why he was so attracted to riding giant waves.*

❝ *I like the drop.* ❞

## FAST FEET

The most critical time for falling off is during the initial take-off. The less time spent in the period between prone and standing positions, the better. It's not only that you need to get to your feet fast to be ready for the rest of the wave - it's that the most likely time to fall off is when you are in the 'halfway up' position.

Often the critical moment is when you are trying to get your board over the edge and down the face at the same time you are trying to get up. So a good trick is pushing forward as you start your ascent, helping to get your board down the face and preventing the board from stalling at the top of the wave as you try to leap to your feet. Use that forward motion to drive into the wave and down the slope. And expect that on big days you will be doing this with spray coming up the face into your eyes.

Above : Kalani Robbs stroking hard; Shane Dorian launching himself

Right : Mark Healy, as late as it gets

One of the best ways to prepare for this is to practice squat thrusts as often as possible. Squat thrusts are simple: lay flat on your stomach with hands placed against the floor at chest level. Begin like a push up, and when arms are extended, thrust your feet under you to arrive in a squatting position. Slowly raise your your body upwards, keeping your back and head vertical and knees bent. Repeat five to ten times. Try to do this exercise two or three times per day. Not only will this help you to get to your feet quickly on a surfboard, it will keep you loose and nimble.

**There are a few exercises you can practice right at home and for free. Skateboarding, Indo-boarding and paddle-boarding, are all good conditioners.**

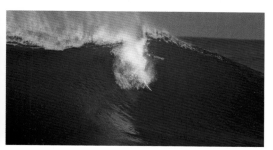

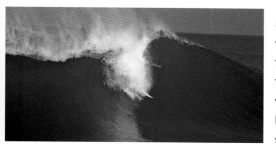

angle according to the speed and steepness of the wave. Sometimes you will not want to angle because the lip is too steep and your board will be more likely to be pitched over the falls. Sometimes you will not want to angle because the shoulder is too close to the lip and the paddle will take you out of the steep sliding section and make you miss the wave. Each wave is different, and learning how a particular spot breaks often takes time. But once you get the feel for angling, it's a great tool to help you take steeper drops.

## TOUCHDOWN

Really radical take-offs, the kind great surfing demands, are, by nature of the situation, probably going to involve some airtime. Freefalling is not hard to do; the hard part is staying with your board and making a soft touchdown. Once again, angling is the secret. Maintaining a slight flight angle on the drop will allow a smoother reconnect and make for a more controlled landing.

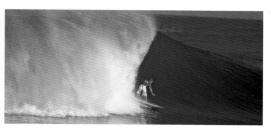

## ANGLING

Angling your board in the direction you want to go can be a great tool for increasing the chance of a successful drop-in. If the wave is rapidly moving horizontally along the break line, angle your board in the direction of the break. You will need to adjust the

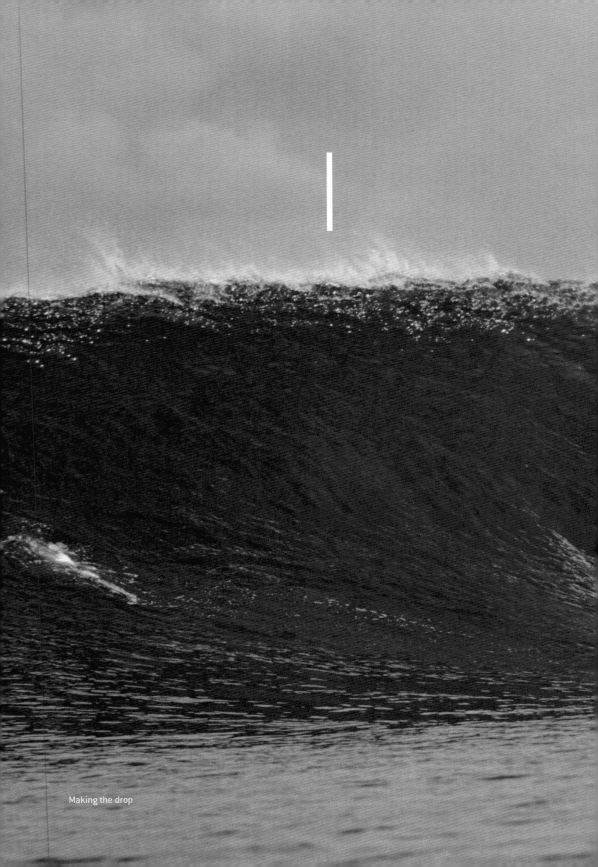

Making the drop

# THE KEY ELEMENT IS FEEL.
"GETTING TO YOUR FEET FAST IN A BALANCED POSITION SETS YOU UP FOR THE WHOLE REST OF THE WAVE." **DAVID RASTOVICH**

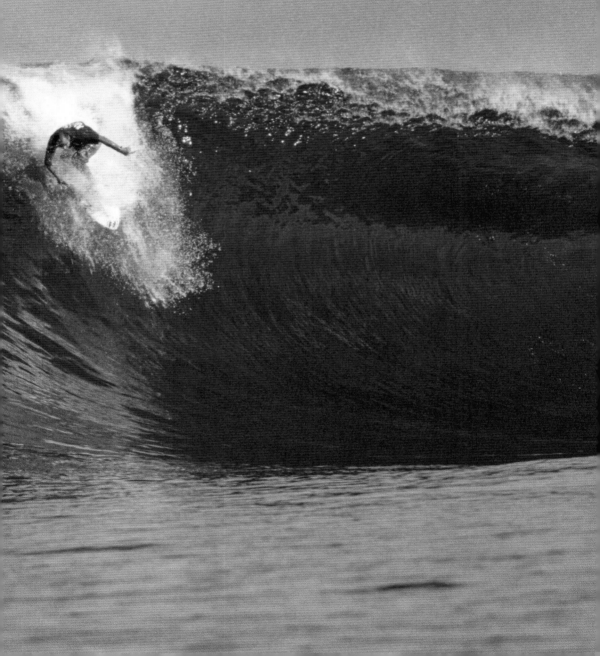

Five Easy Pieces: Speed, Timing, Power, Spring, and Foot Placement. Andy Irons executing the quintessential bottom turn using all five.

Notice how no matter what the maneuver, great surfers always focus on the next point of contact

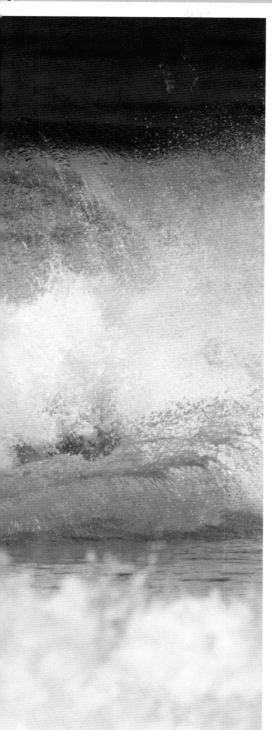

# HITTING BOTTOM
## The Bottom Turn is the Bottom Line

When Phil Edwards, the greatest master from the early '60s, first began using the rail in a radical way, it created a sensation in the established surfing society of the time. Among the very early stylists to lay it over on the rail, Edwards was quickly emulated by every young surfer worth his saltwater.

But it was Barry Kanaiaupuni at Sunset that set the standard for bottom turns in the early '70s with his impossibly late drops with the lip coming over.

**KELLY SLATER**

*Eight-time World Champion.*

*Bottom turns don't get as much attention as other aspects of riding waves, but they form the foundation for good surfing.*

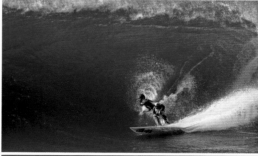

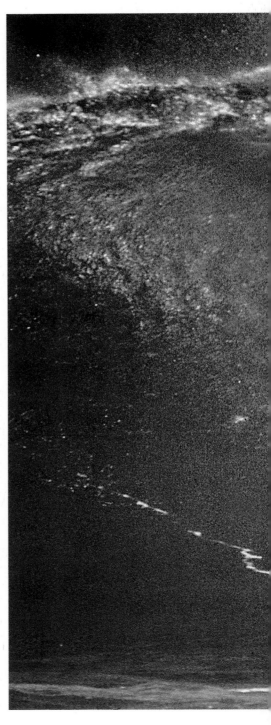

Freefalling down the face to the bottom, when everyone else was screaming 'turn!, turn!,' Barry would hang for a moment, and then fade. A second later with all the g-force loaded up on edge, he would bury the rail to the stringer, front arm and nose projecting like double tips of a spear, and slingshot out into the big open face. For a generation of young surfers it was a marvel to behold.

It would be nearly a decade before a future three-time world champion named Tommy Curren would again raise the bar on bottom turns.

Unless you've succumbed to the allure of late drops and free falls into ridiculously round pits, everything from fading, carving, top-turning and stalling is centered around your ability to take it off the bottom. While not given due credit, it could be the singular most important maneuver in your arsenal. Need proof? Watch a few waves of Andy Irons at Pipe, or Kelly Slater at J-Bay, or Joel Parkinson and Mick Fanning at Snapper, or Tom Curren anywhere. *The bottom turn is where it all begins*, **Curren** once said, *it's the foundation for the rest of your repertoire.* Plain and simple, if you're not pushing hard off of the bottom, ripping full-on, rail-grab speed turns off the top isn't even in the realm of possibility. Be it projecting into an oncoming tube section, driving down the line or ensuring you stay as close to the pocket as possible, it all begins at the bottom.

Barry Kanaiaupuni's legendary bottom turn at Sunset. In 71 he was the man

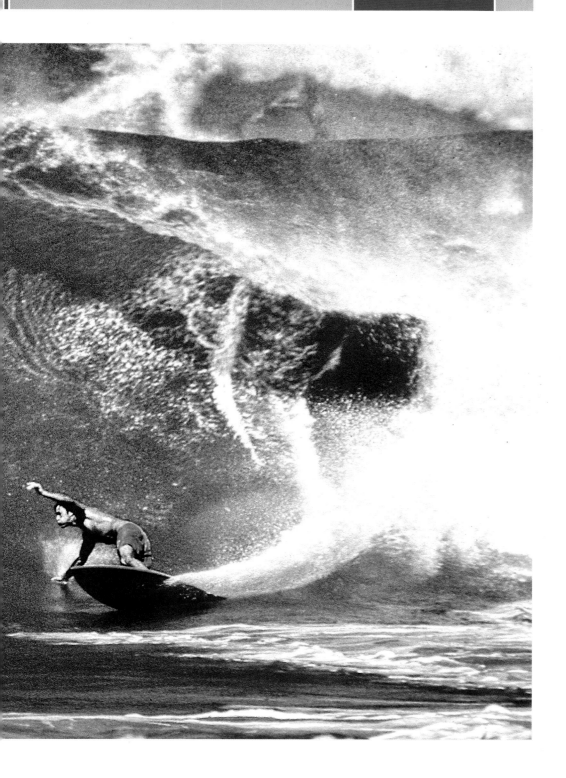

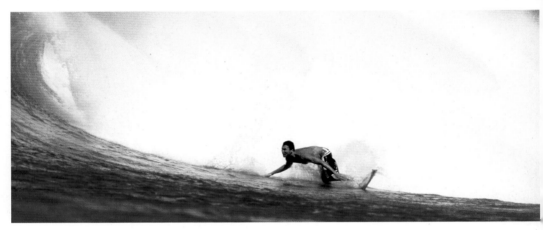

# TURN AND BURN

**How to Make Every Good Turn Deserve Another**

Top: Gary Elkerton in full speed

Bottom: Joel Parkinson setting his timing like a watch

### 1.SPEED

Step one is to drop down the wave face with all the speed you can. While important for any maneuver, speed is essential in a bottom turn. To get maximum velocity, take off as steep and late as possible while still being able to make the first section (Not only does this give you maximum speed, it also ensures your wave priority, guaranteeing a best-case scenario for the ride).

### 2.TIMING

Bottom turn timing sets up the rhythm of the whole rest of the ride. *The simple secret is to hit the turn at the moment of maximum speed,* says **Shane Dorian**: *It's easy to say, but takes a thousand practice runs to perfect.* And on the subject of practicing, any wave offers you an opportunity to rehearse a bottom turn. If it's a closeout, try timing when the wave shuts down and use the speed to feel the move. Lifelong surfer and lifeguard Rich Chew says he used to go out after school and do a hundred bottom turns just to get the one move down. And he became the Men's U.S. Champion a year later.

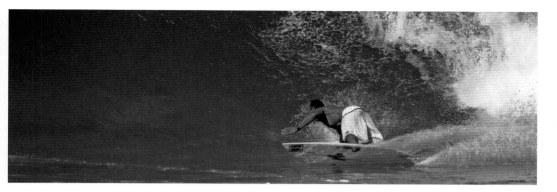

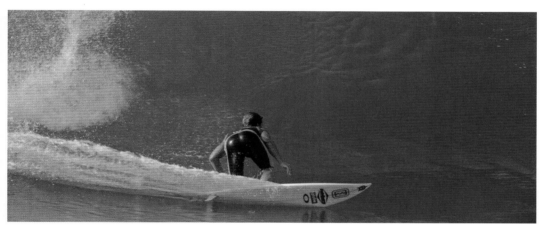

Top: Shane Dorian, Low on gravity, high on speed

Bottom: Occy, at the rigth place on his board

### 3.SPRING

Often it is advantageous to stay in the squat position you are in as you leap to your feet on the take-off. Remaining in a crouch on the drop reduces wind resistance, helps keep your balance and provides a critical element to the bottom turn: the spring/drive/ thrust of your lower body. Any shot of Tommy Curren, Kelly Slater or Mick Fanning will most likely show a low center of gravity, legs bent tightly, like a well-coiled spring. The speed, power and control these surfers get out of their initial turn provide the basis for everything that comes after.

### 4.FOOT PLACEMENT

Finding the right spot on your board takes some experimenting as you go, but once you find the 'sweet spot,' your confidence will soar. Keep your feet centered over your stringer. You can use it as a line almost like actors use marks on the floor to position themselves for their parts. If your toes are hanging off the rail, you'll be alright on the frontside rail turn, but as you reverse to the heelside rail you'll be totally off balance.  If you get your weight too far forward, your nose will tend to catch; plus the chest area of the board tends to be the thickest spot, and the most likely to bog down. If you have trouble with finding the right spot for your back foot, a pad placed perfectly in the right spot can give you the instant touch you may need.

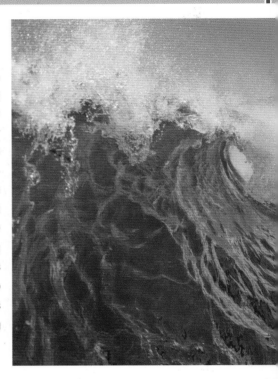

### 5.WEIGHTING AND UN-WEIGHTING

Without powerful commitment on a bottom turn, there's not much chance things are going to improve from there. Remember: for every action there is an equal and opposite reaction. This means the harder you push, the more projection you'll get from the turn. But keep in mind if your weight is too far forward, you'll most likely dig a rail. From the start of the maneuver, hold your back-foot pressure throughout your turn, and then transfer your weight a little more to the front foot toward the end of the turn. You may even feel your board want to slide. This usually means you've transferred too much front-foot pressure. Keep your weight too far back, or completely over your fins and you're likely to spin out. Find the balance point by evenly distributing your weight.

### 6.PUMP AND DROP

If the wave is walled up on the first section, throw down a few pumps before you drop down the face to turn, so that you get across the walled face and don't get caught behind the section. Be careful not to lean too hard because you will bury your front rail under water, catch an edge, lose your speed, and faceplant. A fast down-the-line turn like this means putting hard pressure on your rail and then quickly releasing so that the board's forward momentum continues without deep rail resistance. Think distance, not power.

### 7.BODY MECHANICS

*One of the most important mechanics to remember is the torso rotation on the frontside bottom turn,* says **Brad Gerlach**. *Your leading arm and chest needs to pivot parallel to the board. The solar plexus needs to face towards the stringer of your board just before making the turn.*

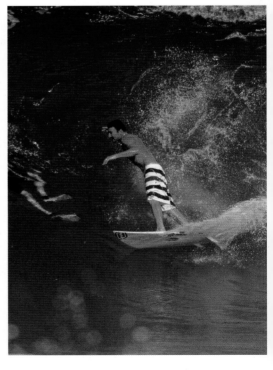

# SEPARATE BUT EQUAL
**Not All Bottom Turns Serve the Same Purpose**

The major purpose of a bottom turn is to project yourself into an oncoming section with enough speed and power to choose your next maneuver with confidence. But there are lots of options depending on the wave shape; so reading the wave well is key to determining the type of bottom turn you do. Depending on the way the wave sets up, there are a number of bottom turn approaches. Each of these will require their own timing.

Top: Austin Ware, perfect body mechanics

Left: Joel Parkinson pumping and dropping

## 1. POWER TURN

When you want to make a really huge move and potentially slam the lip, or need power to match the top of the wave you are shooting for, you need a different approach. This is the traditional description of the big bottom turn. Ride to the bottom of the wave until you reach the flats, (the area in front of the wave with no transition). At the exact moment you reach maximum speed and hit the flats, begin your bottom turn. With your knees bent, thrust out of your crouched position and spring your lower body forward and at the same time lean hard on your toeside edge to initiate the bottom turn. As you gain confidence in laying out the power turn, you can start leaning into them even harder by putting your trailing hand in the water.

Your weight should be evenly distributed between your front foot and your back foot, your front arm and shoulder shifting the body position towards the direction you want to go, keeping the back arm elevated for balance. Your head should lead and your eyes should be focused on the part of the wave where you want your board to arrive. Hold your line, keep your knees bent, and when you come off the flats on to the transition, un-weight your front foot, shifting most of your weight to your back leg. Push on your back foot in order to gain as much speed as possible while driving up the wave.

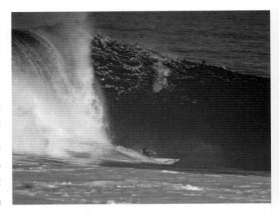

### 2. EXIT TURN

In today's crowded conditions this is often a move you find you need to make whether you like it or not - so get it down. If you want to kick out, position yourself more toward the shoulder or top of the wave, drive even harder than you might otherwise, but as you come around, don't un-weight your front foot; you'll continue up and over the shoulder, or through the lip and do a flyaway kickout.

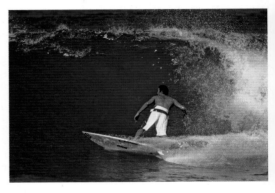

### 3. THE FADE

Mark Occhilupo says this is one of the most overlooked of the bottom turns - dropping in and doing a sharp fade before hitting the inside rail. He says the angle of the turn is super important because the fade allows you to get into the most critical part of the wave and start your committed rail release from exactly the point of the maximum power source. *It works, it powers, and it's especially stylish,* notes **Occy**.

### 4. POWER-HOOK TURN

To pull into the pocket of a wave, make your turn more quickly - a quick hook turn - and immediately reverse rails, going low again. (Almost like pulling into the tube, but instead, stick your rail right in the pocket.)

**PRO TIP BY PETER TOWNEND**

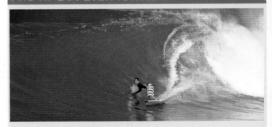

*Today the best surfers are using a double pump, sometimes even a triple pump, before setting their rail. It's a function of today's multi-finned equipment, but the effect is to load up the rail like a cocked pistol, so the explosion is just that much greater.*

Left page:

Mark Healy, power turn, Pipeline

Joel Parkinson looking for an exit

Right page:

Occy stalling in Indonesia

Donavon Frankreiter

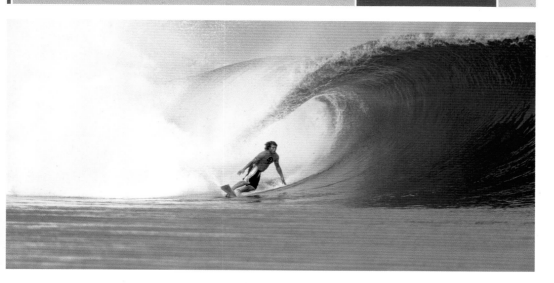

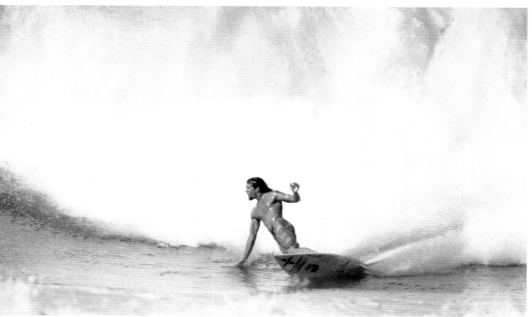

## 5.STALL - AND - DRIVE TUBE TURN

If the wave sets up hollow right away and getting barreled is an opportunity, hang back, closer to the lip, and delay your turn until it looks like the wave is pitching. Time it to snap your turn at the last second, and pull in under the curtain.

## 6.COME - FROM - BEHIND SWEEP

**Donavon** is the king of the late drop, sweep-off-the-bottom power turn: *Keep your body totally forward-weighted, and extend with your legs as you set the rail so you get maximum speed and distance from the start to the finish.*

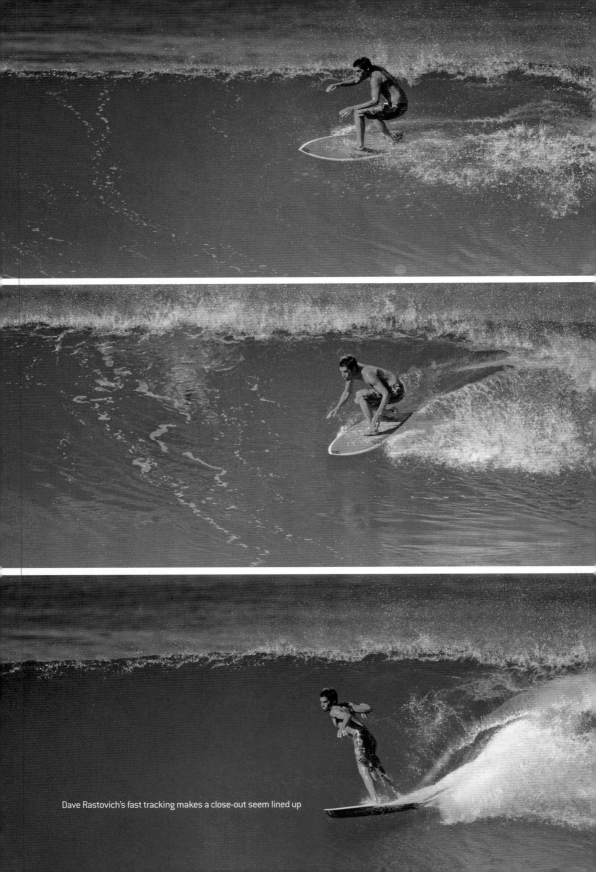

Dave Rastovich's fast tracking makes a close-out seem lined up

# HARD AND FAST RULES
## Using the Speed Line to Make Faster Waves

When boards were less maneuverable and surfers were first experimenting with angling along the line, it was called 'trimming.' Pulling into trim was considered the ultimate positioning. Rabbit Kekai and the Hawaiian beach boys first started to develop this technique in the 1930s, and Matt Kivlin adapted this rail-edge active footwork in the 40s to create the California 'Malibu style.' By the 1950s, California stylists Kemp Auberg, Lance Carson and Miki Dora were refining the art form at Rincon and Malibu, and by the early 1960s Joey Cabell had taken the speed line approach to a whole new level in the reefs of Hawaii, using the ankle and knee moves of skiing. All through the evolution of the speed line, boards were becoming shorter and more streamlined. Reno Abellira took trim to a blur at Maalaa in Maui as he and Australian Terry Fitzgerald (with his wing/swallow shapes) extended the concept of speed in the 1970s through both their equipment and style. Reno's twin-fin templates begat Mark Richards' speed performances at Honolua Bay and Off the Wall in the early '80s era that he dominated. The advent of Simon Anderson's Thruster moved performance in a far more vertical direction, making the flowing trim style almost an anachronism. As new styles and shapes emerged through the '90s, the trim line fell completely out of currency, used only in the fastest waves and out of necessity. But in the last few years with the renaissance of fish and other experimental shapes, speed lines have begun to return to the repertoire, driven by non-contest masters like Dave 'Rasta' Rastovich and maverick world title chasers like Taj Burrow.

As big-wave frontiers are pushed back, and deeper and faster waves are ridden, speed lines will remain a key approach, coupling aesthetics with function.

## FRONTSIDE FINESSE FOR FREIGHT TRAIN FUNNELS

In really fast waves making a full drop to the bottom and laying it on a rail may actually be too slow. If the waves are peeling like a freight train, it may blow right past you on the way down. The same is true of a long section where the whole lip is coming over in a ten-yard section. Sometimes the section down the line is too steep to make if you remain in the section you're in by taking a standard attack. That's when speed pumping can be the solution. *One thing that's good to do as you're paddling is to angle your board down the line and pop up turning*, says **Joel Parkinson**. *Find the rail and use your ankles and knees to project a quick initial pump*. The idea is to move

**TERRY FITZGERALD**
*Earned the late '70's moniker "Sultan of Speed".*
*The faster I go, the better it feels.*

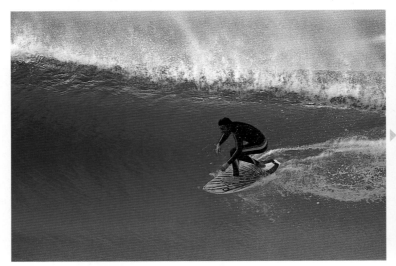

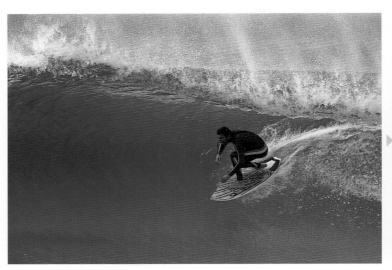

laterally across the length of the wave face, using the pressure of your toeside rail to drive up and down the face of the wave with most of your weight on the front foot. Your back foot should be a little more forward than it would be for a full-on bottom turn, since you are using the rail rather than the tail for punch. *It's a tempo, a really quick pattern of press and release,* explains **Dave Rastovich**. *Let your rail out to drop for maximum speed, but stay in the upper-middle section* *of the wave face for maximum forward momentum.* As soon as you reach the middle section resume the 'bent knees position' and pop a thrust forward again. *You're looking to cover as much ground as possible in the minimum amount of time,* says **Rasta**. *Don't get your back arm up too high; it'll throw your balance off. Be ready for a quick adjustment to your inside rail, and keep driving your direction down the line, while accelerating up the wave again. It's a fast alteration of*

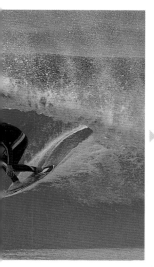

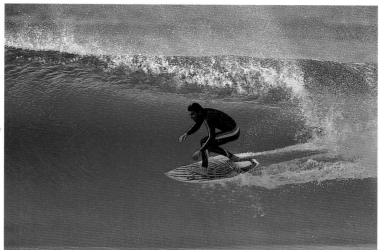

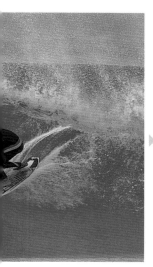

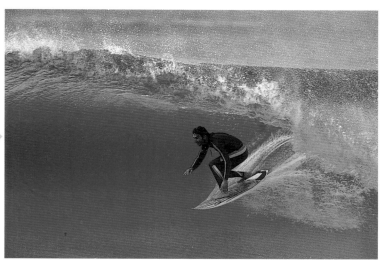

rhythmic flow, so each time you feel a little slowdown or reach the middle of the wave, start your pump up the wave again to gain even more speed. Each pump should increase your speed or at least maintain whatever speed you've generated. *You're basically racing the lip, so the more distance you cover the better position you're in*, says **Rasta**. *It's a race between you and the curl, so at the top, you want to push on the front and weight your outside rail to release the board into a drop to add acceleration. At the same time, you want to be looking where you want to go too*, says **Rasta**, *so you get to the section ahead set up for the move you want to make.*

Parko stays in the fastest part of the wave. Notice the rail-to-rail transition created by the pump, even through the trajectory is almost totally horizontal

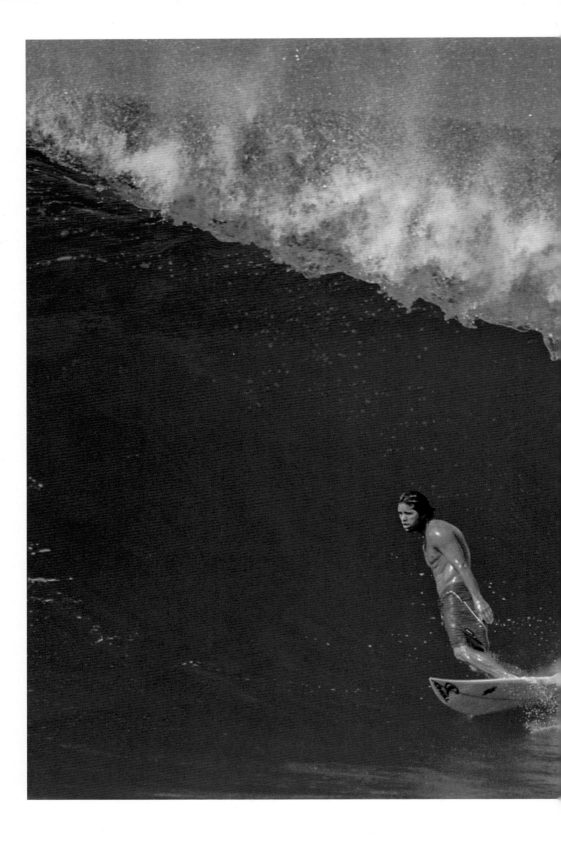

# THE PRIMARY MOVES

## Brad Gerlach's Definitive Dissection of a Top-to-Bottom to Top Series

### THE SETUP

First, try to enter the wave as early as possible. A good take-off will set you up for an easy bottom turn. After catching the wave, stand up and place your feet in the sweet spot of the board: the spot where the board provides the most stability and response. Generally, the back foot should be close to the tail, or over and between the front and back fins, with toes slightly facing the nose, like in a drop-knee cutback. This will allow easy hip rotation and keep the knees from wear and tear.

### BODY POSITIONS

Get as low as you can to the surfboard by crouching down. Make sure 80 percent of your weight is over your back foot. You do this by shifting your hips back toward the tail of the board as if you were sitting in a chair, with your butt on the edge. This will make it simple to turn. The way to put pressure on the toes properly is to push your back knee out and over your

Brad Gerlach

toes in the direction of the toeside rail. The way to put pressure on the heels is by dropping the butt down toward the Achilles tendon, and pushing it out toward the heelside rail. Both of these actions must be done by keeping the upper body over the surfboard at all times. This is your balance. Your knees and ass are like counterweights, and your body is like the scale holding the weights. The scale itself must never lean in any direction or it will tip over. Now that you're centered with the lower body, let's get you centered with the upper body. In the crouch position, have your chest face the nose of the surfboard by turning your leading shoulder toward the heelside rail. Your back shoulder should come forward to help with flow. This is one movement. While taking the drop, keep your head still and look at where you're going. Take a glance at the wave if you think it has changed since you sized it up before taking off. Keep your eyes on the spot where you'll make the bottom turn. This will help your timing.

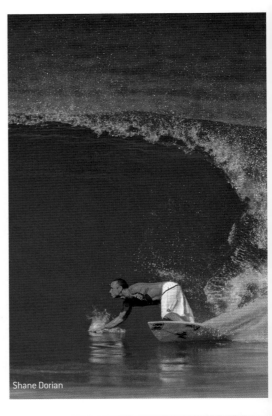

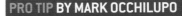
Shane Dorian

## THE TURN

As you descend down the face with your weight over your back foot, pick your spot to bottom turn before you get to the bottom of the wave. Begin to put weight on your toes, and gradually stand out of the crouch by pushing your hips forward. At the same time, turn the shoulders in the direction you want to go. Bring them across the board as you stand out of the crouch. If it's a down-the-line bottom turn, aim your leading shoulder in that direction. If it's a vertical off the lip, turn the leading shoulder toward the lip. The key to this is to pull the back shoulder at the same time. The shoulders should work together as a unit. This will help with balance and increase speed and flow. As a acceleration occurs, the bottom turn goes into full implementation.

**PRO TIP BY MARK OCCHILUPO**
*Two-time Pipeline Master winner.*

*If you want to get distance in your turn, curl up in a ball; then stretch out with a big extension. Then pull in!*

## THE DOWNSHIFT

One of the keys to doing a great off-the-lip is speed. A well-timed bottom turn should give you plenty of acceleration to perform the classic off-the-lip. After coming off the bottom, begin to stand out of the crouch. And as you climb the wave face, push your hips back by pushing off with your front foot. This will shift your weight - approximately 70 to 90 percent - to your back foot. Simultaneously twist your hips and upper body toward the point on the lip you want to go.

## AT THE LIP

As you make the transition to the heelside rail, begin to pull your leading shoulder toward the trough of the wave. At this point you should be back down into the crouch (essential for balance and acceleration). By now, you should be three-quarters of the way down the wave face, ready to change direction. Starting the turn here will make it so the apex of the turn is done on the most vertical part of the wave.

## LOWER BODY

Absorb the wave's energy by sucking your knees into your chest, and apply a minimal amount of pressure with your back foot while simultaneously twisting the hips toward the trough to make the turn. This is done at the same time you pull your leading shoulder. Why only a minimal amount? If your weight is correctly placed, and you've done a great bottom turn, you should be moving quite fast, and a small push with the rear foot is all you need for fluid execution. Too much pressure will take you off your line and thus make you look like you're trying too hard.

### PRACTICE TIP **BY BRAD GERLACH**

Practice this on land. Imagine holding a broom handle in front of you at shoulder width, elbows slightly bent and get into an imaginary bottom-turn surf stance. Now, pull your back shoulder and notice where the point of the broom handle goes. The further you pull, the more vertical you get and vice versa. This achieves two things: it gives you direction and it loads up the body for the release once you reach the lip.

Here are three wave-type scenarios (imagine the tip of the broom handle is pointing where the hips and shoulders should go):

**1. If the wave is a racing wall** (i.e., J-Bay or a closeout beach break, and you want to fit in another move), pull the leading shoulder and twist your hips so the point of the broom handle is pointing down the line and to the bottom of the wave for a speed injected off-the-top.

**2. If the wave is a slower moving wall** (i.e., Rincon; Cardiff Reef), point the broom handle toward the trough for the classic off-the-top.

**3. If the wave is a peak** (i.e., wind swell beach break), point the broom handle back toward the pocket for a snap. On completion of the turn, as you're dropping back down the wave face, the sooner you can get back into the crouch, the more control you'll have to make your next move.

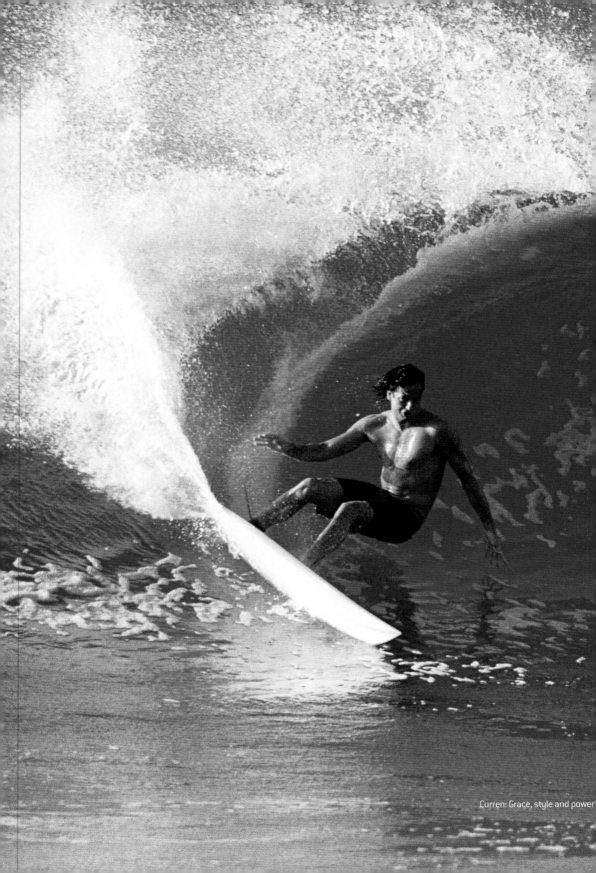

Curren: Grace, style and power

# FRONTSIDE SIGNATURE
## The Cutback: Putting Your Own Stamp on a Timeless Maneuver

A fraction of a second captured by Tom Servais on the North Shore during the winter of 1992 set a new standard for commitment in the area of radical rail transitions, which had not been exceeded since the Michael Peterson era of the mid-'70s. For the thousands who held Tom Curren in the highest regard, that moment provided explicit evidence of his grace, style and power in the water. The iconic image of Curren's grab-rail front at Backdoor helped to shape the approach of an entire generation, and still stands as possibly one of the single greatest frames ever photographed in our sport.

While one of the most essential maneuvers in a surfer's repertoire, the frontside cutback is not only functional, but also provides a rare opportunity to add your own signature. From Curren's fundamentally flawless carve, to Joel Parkinson's sweeping lines, to Andy Irons' aggressive power turns, from Donavon's come-from-behind arcs, to Rasta's soulier-than-thou

body English, all turns serve essentially the same purpose, all the pageantry is just a matter of aesthetic appeal. The difference between a cutback and other reversals of direction (like snaps and laybacks) is that the maneuver is done at continuous fluid speed. The cutback allows you to use the rail of your board, and brings you back to the source of the wave where you can generate more speed for your next hit. Like a fingerprint, no two surfers' cutbacks are the same, but there are some universal things that make for a great frontside carve.

### DALE VELZY

*One of surfing greatest innovative shapers and entrepreneurs, explaining the evolution of early modern surfboard design, referring to Bob Simmons who first used light balsa and foam for surfboards.*

*Simmons knew how to make 'em light. But I knew how to make 'em turn.*

# SIX FUNDAMENTALS OF A GOOD CUTBACK

### 1.TIMING IS EVERYTHING

Don't make your turn too early when the wave is too vertical, but conversely, don't glide too far out on the face where the wave is too flat. Keep your eyes focused on the part of the wave you want to hit. It is best to hit the section where the lip is just beginning to break at the edge of the whitewater.

### 2.GO TOE-TO-HEEL

Start bending your knees when you come up the middle of the wave face, and shift your weight from your toe-side rail to your heelside rail to initiate the cutback. As you lift out of your bottom turn, keep your board flat on the wave face to retain full speed, then un-weight your front foot and lean slightly back.

### 3.THINK RAIL-TO-RAIL

As your feet and weight shift from toe to heel, the outside rail rolls over and begins to engage the wave. The more speed, the easier the transition from inside rail to outside rail. But as you transition, your mind needs to make the change too.

### 4.KEEP YOUR MOMENTUM

Be sure to watch your board's nose as you reverse direction, because you want it to fit into the wave shape to maximize speed. As your board turns back towards the breaking wave, keep the fluid momentum going. Don't let up midway through the turn, which is tempting to do when you want to keep going down the line. This lack of follow through will make you lose speed, the all-important aspect to making your next move. Bend your knees and keep driving through what is now a backside bottom turn.

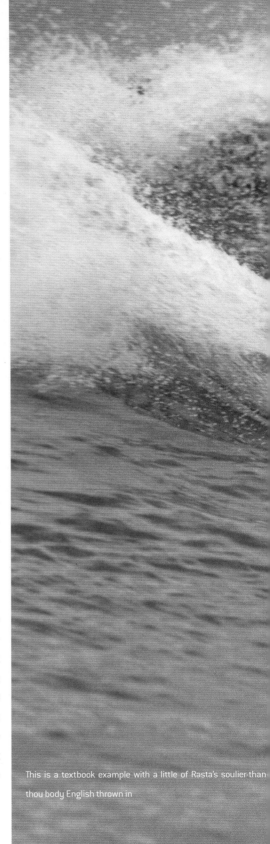

This is a textbook example with a little of Rasta's soulier-than thou body English thrown in

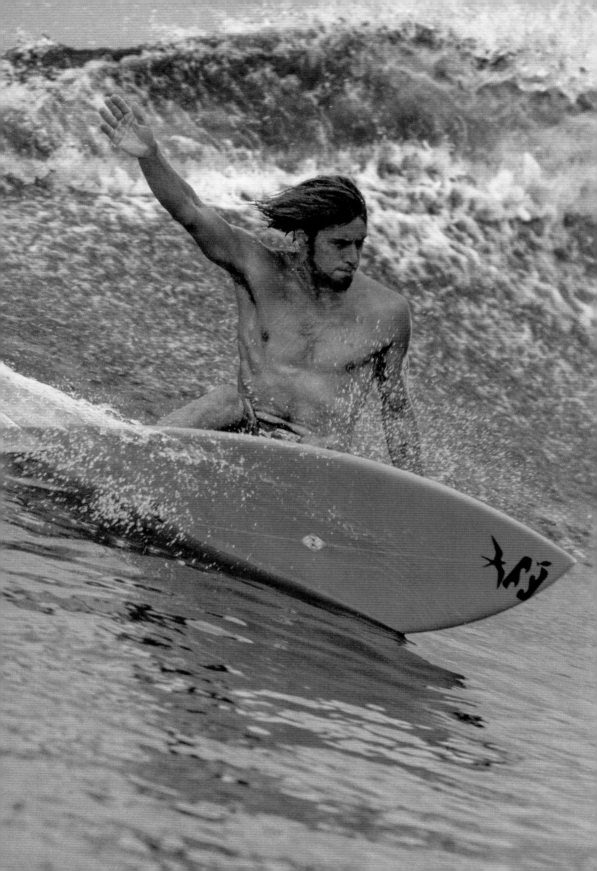

## 5. FINISH STRONG

Your board should finish with the nose pointing straight back towards the breaking wave, ready for another drop with maximum speed. Just as in your initial take-off, look down the line when you have finished the turn, read the wave to determine angle and steepness of the drop-in. The big advantage you have at this stage, is that you are already on your feet and having maintained speed through both your first moves, are much more ready to position yourself to go straight into your next bottom turn.

## 6. NEXT MOVE OPTIONS

At this point there are several approaches to the next move, and they will depend on the shape, size and power of the wave.

### 6.1. AIM HIGH FOR THE LIP

Aim high for the lip and essentially turn your cutback into a re-entry. **Occy** says this gives you the best opportunity *to get down the line if the wave is hollow and powerful. It also forces you to come down with the lip.*

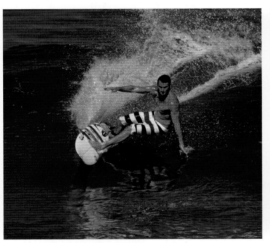
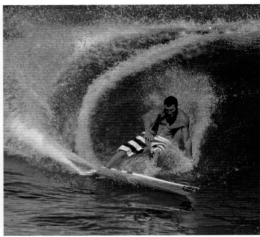
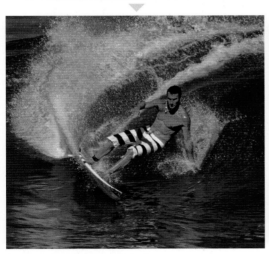
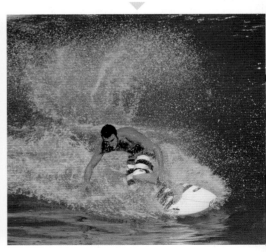

Sequence of Joel Parkinson's aiming low

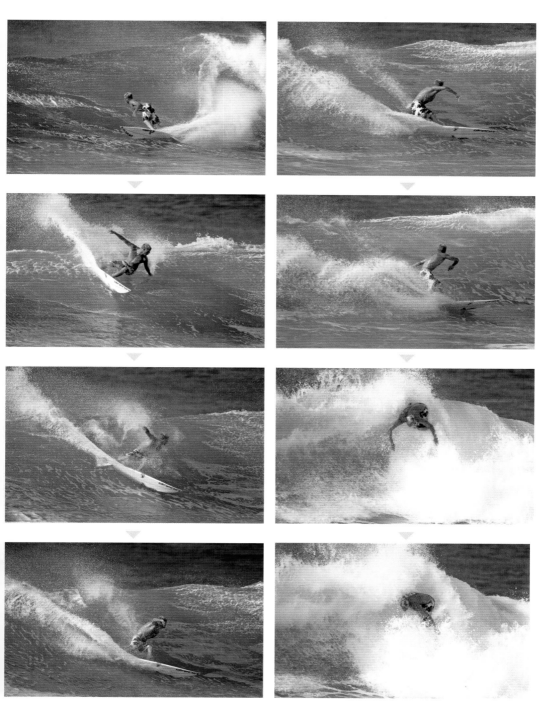

*Sequence of Mick Fanning aiming high: on rail, at speed, with power, a killer combo*

## 6.2. AIM FOR THE MID SECTION

Aim for the mid-section with a classic roundhouse cutback and catch the oncoming whitewater with power. **Joel Parkinson** says what he loves about this line of attack is holding your turn as long as possible for maximum carve factor. *It generates the most momentum,* he says, *but requires taking the brunt of the wave's power and can sometimes be risky in big surf.*

David Rastovich aiming for the mid-section

## 6.3. AIM LOW

Aim low and attempt to avoid the wave's power and avoid being knocked down by the swirling foam. This may be the safest route in bigger surf, but it does offer the best chance of losing the face of the wave and being left in the whitewater. The best way to avoid this is to take the steepest route down the face and to do a sweeping bottom turn off the flats, initiated by a drop just like the one you did on the take-off. Now you are putting moves together.

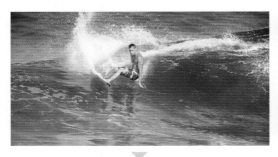

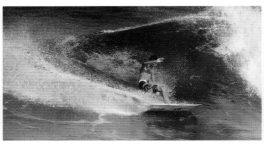

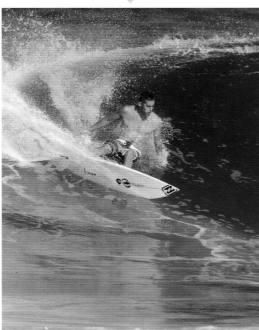

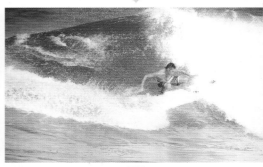

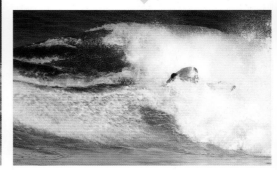

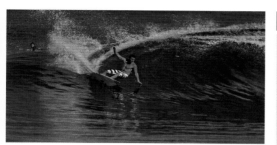

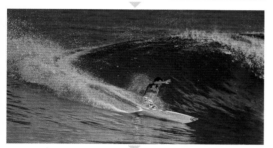

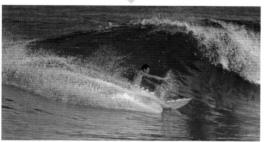

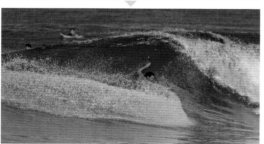

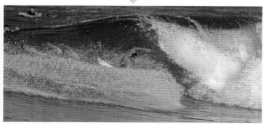

Sequence: The quintessential Parko wrap, always finishing strong

## THE PRO'S PERSPECTIVE

**Parko's point:** "Like every other move in surfing the frontside cutback starts with speed. A cutback starts with your bottom turn. By entering a cutback with a hard powerful bottom turn you will be able to lean on your rail harder, adding more spray and style to the turn. When cutting back, you put the weight on your back foot and steer with your front foot. Keep a low center of gravity, extend your front arm towards the water. Your upper body will naturally twist in the direction you are turning. This is where you need to reverse weight and rail to begin your change of direction. Shift most of your weight to your back foot while your front foot guides your board through the turn. Remember though, balance requires keeping most of your weight and body over the midpoint of your surfboard. Drive the board all the way around with continual power to keep the speed up into the oncoming section. To keep your speed on the final part of the cutback, straighten out your back leg, and center your weight over your bent front leg. This will keep you low to your board for balance, as well as adding power and style to the move."

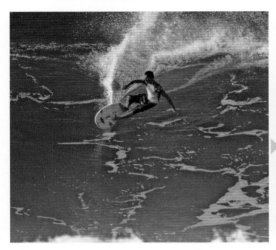
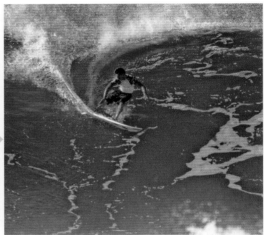

# GET YOUR ROUNDHOUSE IN ORDER
## The Roundhouse Cutback

*Having a well-played roundy in your back pocket is the mark of every good surfer* says **Brad Gerlach**. And the best make it look so easy. Richard Cram, Tom Curren, Larry Bertlemann, Kelly Slater, 'Wraparound Chris Brown;' stars from every era have made careers out of mastering this move. A beautiful, completed roundhouse cutback is the ultimate style statement. Plus, there's no better way to set yourself up for the ultimate lip assault than to re-enter the wave from a cutback.

*You don't need a point wave to do a classic roundhouse cutback. Closeouts, which are much more plentiful, require the same perfect timing and judgment,* continues **Brad**.

The best way to approach a roundhouse is to build up as much speed as possible without going out too far on the shoulder. Your goal is to go back up the wave and nail the corner of the falling lip. Remember, speed is increased when you pump in the top third of the wave.

When you feel you've reached Mach 10, turn down to just below mid-face to set your bottom turn. After the squirt from the bottom-turn, you'll need to shift onto your heelside rail. Do this quickly and get down to a crouch to load you up for the turn while pulling your leading shoulder toward the beach, allowing your back shoulder to come forward so the shoulders act as one unit.

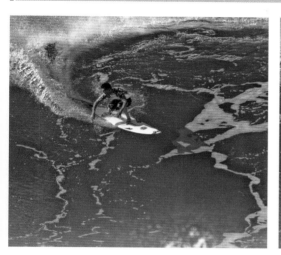

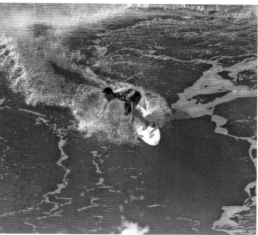

Study the weighting of feet in this sequence:

1. As Al comes off the top, he immediately weights his back foot to begin the sweep around. Notice his front foot is extended almost straight to remove weight.

2. With his board headed back towards the lip in full cutback mode, he shifts his weight forward onto his front foot.

3. Bringing his body weight over the center of the board he changes the board's trajectory. Look at his eyes, he's checking out the section in front of him.

4. Leaning hard on his rail, using the size and steepness of the wave to re-power his forward momentum, he begins a return to a down the line

flight path. Notice how his head (eyes) move from viewing the distant section to focusing on his point of contact for the next bottom turn.

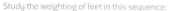

The moment your heelside rail bites into the water is the moment you begin pushing with your feet. This is crucial for acceleration. Push down into the board with your back foot, and push back with your left, which will turn your hips in the direction of the beach. Remember to keep your head over the board and not lean because it's very easy to dig rail and fall over. While still on the heelside rail and at the bottom of the wave, it's very important to keep your weight over your back foot. (This should automatically happen because of the left foot pressure). For land practice, I use a Carve Board on a nice wavey driveway and repeat this move over and over until it feels natural.

## PRO TIP **BY MATT ARCHBOLD**

*First, you must get as low to your board as possible by bending your legs. It's usually better to aim the nose of the board slightly. Try to keep your back erect, which will make your shoulder turn easier. As soon as you've moved to the heelside rail, begin applying pressure to both feet, pushing down with your back foot and pushing back with your front foot. This makes your hips twist in the direction you want to go. At the same time, pull your leading shoulder back toward the pocket of the wave.*

*Time it so you're looking back to where it's pitching out, so you can get a good bank off it. I've seen a lot of people who don't go all the way back up the face of the wave. As soon as I get around the first cutback part, then I turn it into a backside bottom turn and then a vert backside off the lip. Try to throw your weight into it. When I was a kid I used to watch Kong do that - he throws it way beyond vert, so I sort of put that into it.*

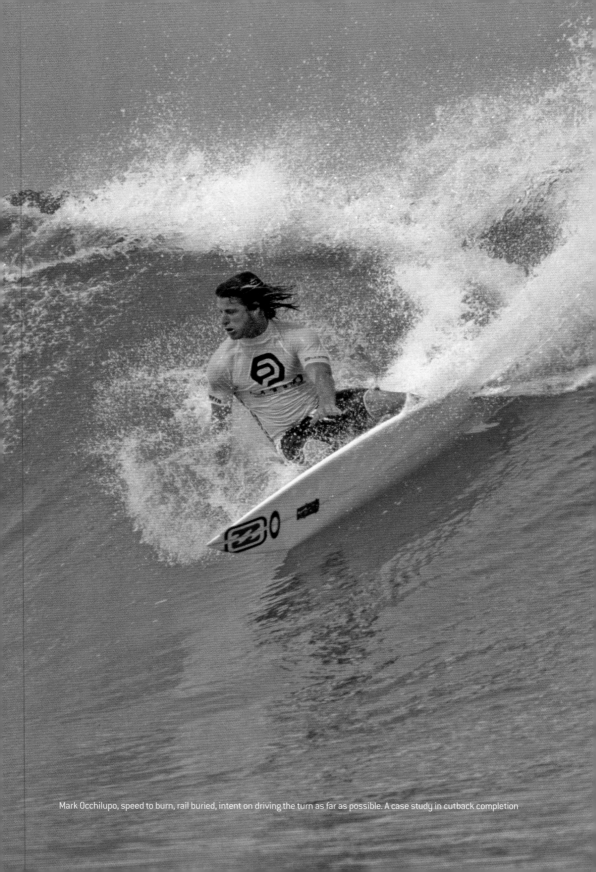

Mark Occhilupo, speed to burn, rail buried, intent on driving the turn as far as possible. A case study in cutback completion

# KNOW YOUR CUTBACK
## Five Cutbacks to Keep in Mind Next Time You've Got Speed to Burn

Before Tom Blake put a fin in his 1926 hollow 'Olo,' surfers' only means of changing direction was to drag their foot in the water. For surfers like Lorrin 'Whitey' Harrison in the 1930s, just getting a 14' redwood plank to go from one direction to the other was considered a masterful act. Initially the surf at Castles, Queens, San Onofre, Palos Verdes and Corona Del Mar encouraged wave riders to go straight, but as faster steeper breaks were explored, the equipment began to reflect the growing desire for more options for returning to the power source. Chubby Mitchell, Conrad Canha and Rabbit Kekai were a trio of the luminary young argonauts of the pre-WWII years in Hawaii, while Tommy Zahn, Les Williams and Dale Velzy experimented with form in California. Phil Edwards' drop-knee turns were the signature of the early '60s; Wayne Lynch was the first to blow away the barriers of the latter half of that distinguished decade.

In California, Billy Hamilton's elegant stylistics gave way to Mike Purpus' power-plays, and as the '70s pushed new boundaries, Michael Peterson's radical single-fin slashes leapt lightyears ahead of the pack. Larry Bertlemann's low-slung skateboard-inspired speed arcs redefined positioning in the cutback category. Rabbit Bartholomew busted down the North Shore door, and Mark Richards ripped with twin fin abandon. Aussie Richard Cram and Hawaiian Dane Keoloa buried the stringer as deep as anyone until Curren's arrival in the early '80s, but by the late '90s Taylor Knox, Mark Occhilupo and Rob Machado were considered the consummate cutback connoisseurs, alongside Kelly Slater and Joel Parkinson.

So many great surfers have been left out of this short and incomplete history that the only way to do justice is to define the move itself, in all its myriad and glorious variations.

> **TOM CARROL**
> *Two-time world champ and noted power surfer*
>
> **Power is about burying the rail, holding it - fins in the water - and driving the turn as far as possible. And I don't think we've gone as far in that direction as we can go.**

## 1.CLASSIC CARVE

After getting thoroughly spat out of yet another Backdoor pit, Shane Dorian almost instinctively knows what to do next. As the wave face holds its bowly form, this classic carve is more about technique than overpowering the ocean. Hips should be set, shoulders should be squared with the board, the board should be squared with the wave, and so on and so forth. It's a very fundamental turn, but at the same time, incredibly effective and if done right, very rewarding.

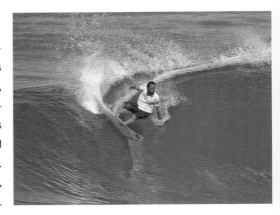

## 2.FULL-RAIL SPEED TURN

Quintessential Occy; nobody does it better. After projecting heaps of speed off the bottom, he's made the transition from his toeside rail to his heelside rail, and has fully committed to the turn. At this point it's time to hang on and let the board do the work. The rail line of the board will follow the arc of the wave face, and as Occy finishes pushing through the end of the turn with his back foot, he's putting himself back in the power zone of the wave, ready for his next bottom turn and whatever the wave may have in store after that.

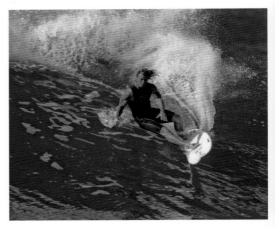

## 3.RETRO ROUNDHOUSE

The thing with riding a wide variety of boards is that it allows you to experiment with drawing different lines. Because of its wider tail and twin-keel setup, it's easy to blow the back end out on a traditional fish, which means committed cutbacks often require extending the turn along its natural rail line. But master the proper blend of pressure and body English, as demonstrated by Dave Rastovich, and you've added an entirely new aesthetic to your surfing.

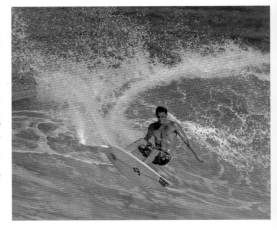

Above: classic carve with Shane Dorian, A full rail speed with Occy and a retro roundhouse by Rasta

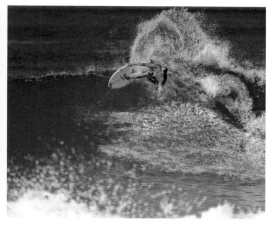

## 4.THE RAIL GRAB

Sometimes it takes a little muscle to get the job done, and Andy Irons has plenty of it. Not wanting to race out onto the flats and draw a longer turn out, instead Irons opted to stay as close to the pocket as possible. To do so he needs to dump some speed, and by grabbing his rail, he's able to make a tighter arc while still maintaining control. It's not an easy turn to make, and requires both strength and flexibility, but mastering the rail grab will allow you to pull more the next time you come flying out of the barrel.

## 5.THE WHIP

With the 21st century incarnation of the cutback, Taj Burrow and others like him have elevated the cutback by combining the smoothness of old school carve with the radical edge of impossibility, they achieve a functional way to get back to the power of the wave, while looking damn good doing it. This turn requires setting the rail line at the start of the turn, but then unweighting the back foot as you start to work through the arc. A large part of this turn is being able to keep your weight over your feet and board and not let things get too far out of your reach. Recovering with all of your speed is key, because there's no point in pulling out a turn like this if the wave's just going to pass you by.

### PRO TIP **BY MARK OCCHILUPO**

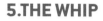

*There's a little trick called a cut-down turn; we use it a lot in competition. When you're racing down a wave you do a sharp cut-down midway down the face which gives a quick jam of speed and sets up for the big move to come.*

Above: A rail grab by Andy Irons

The whip illustrated by Taj

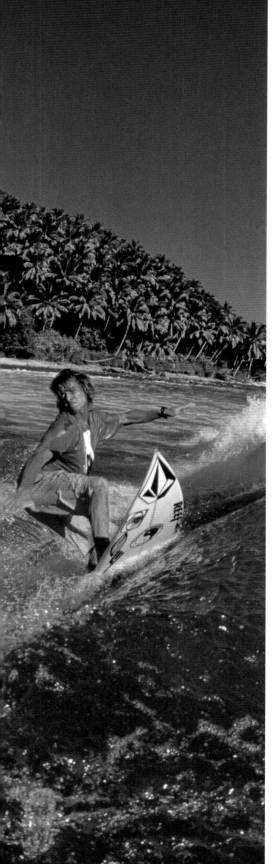

# LIP-SMACKING GOOD

## Frontside Snaps, Off-the-tops and Re-entries

Ian Cairns is generally credited with the Snapback move although there have been so many subtle variations to reversing the upward trajectory of a bottom turn that history will note everything from Dewey Weber's wheel-arounds to Nat Young's cranks on his Magic Sam board, to Rolf Arness and the rail-in rollercoaster, to Tommy Carroll's Cairns-influenced snaps as having contributed. What's more, Martin Potter's deep gouge and recoils, Occy's 'throw it all over with the lip', and Taj Burrows' reversals in thin air all display an upside to the downside. Imagine the possibilities:

### GERRY LOPEZ

*In a treatise he wrote about all the different approaches and styles of surfing*

**" Surfing is attitude dancing. "**

Look how even before the point of impact with the lip, Nate Tyler is already anticipating the whole rest of the scenario: his arms are swinging around for the fall, eyes on the landing spot, feet on rail adjusting to the impending re-direction

## TAKE IN THE WIND FACTOR

The shape and condition of the lip you're intending to destroy can vary, so take in the conditions when you're going for big moves. An onshore wind can create a whitewater bank across the wave top, and provide a softer, more stable target. Offshore winds can create a more sharply defined section with lots of arc which is moving a lot faster as it throws out and over. Depending on the wind strength and direction, adjust your target point and the angle of engagement.

## PICK YOUR POINT

Power off the bottom, and take a line directed at the spot you want to hit. Look down the line and keep your eye focused on the spot you think will be standing tall and pitching out just as you approach it. As you already know, the line and speed of your bottom turn is going to determine your point of impact with the lip. *A sharper angle straight up the face creates more power when you make contact, which maximizes your re-entry speed,* says **Occy**, *but it also covers the*

Sequences: Mark Occhilupo showing the rules of engagement

shortest distance along the section - so take into consideration the fact that making the wave is an important aspect too.

If the section is a longer one, and particularly if it is a fast breaking one, opt for a point further down the line in order to make the wave and have a chance to pull additional maneuvers. But the closer to the lip you stay the more power and speed you have to con-tinue the wave, so it's a fine line. *After coming off the bottom, begin to stand out of the crouch, and as you climb the wave face, push your hips back by pushing off with your front foot,* says **Brad Gerlach,** who has written more than once on the subject himself. *This will shift your weight - approximately 70 to 90 percent - to your back foot. Simultaneously twist your hips and upper body toward the point on the lip you want to go.*

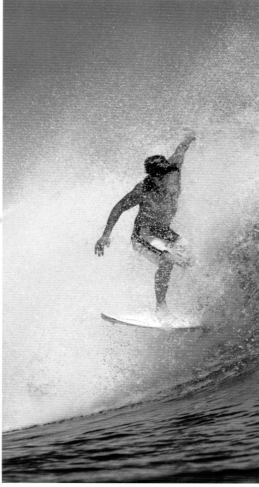

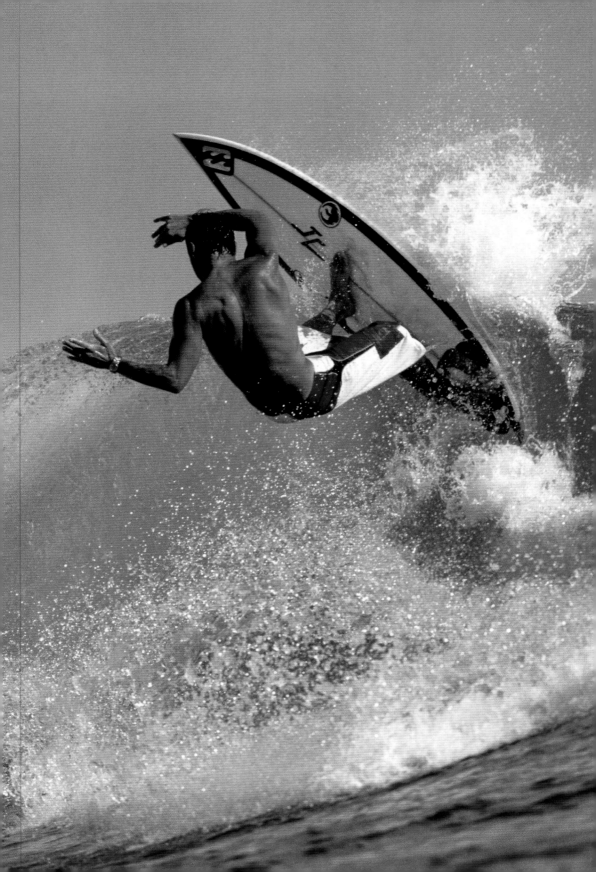

## MAKING CONTACT

In order to meet up with your corresponding section, you may have to adjust your line whether you need to ride high and wait for the wave to stand up, or get low and speed up to meet an oncoming section. As with all maneuvers in surfing, speed dictates how smoothly and powerfully you will complete your move.

Just as you approach your target zone, put more weight on your back foot in order to create a pivoting effect that will enable you to move the forward half of your board side-to-side like a windshield wiper.

## WEIGHT SHIFTS

In addition, your weighted tail will help position you squarely below the lip, *but the key is to keep your speed, so that you can shift your weight back to the midpoint of your board* says **Occhilupo** - enabling you to rotate smoothly once you feel the lip hit the bottom of your board. *It has to be instant but even,* says **Occy.**

## IN WEAK CONDITIONS

In mushy waves, you will have to use your back and knee strength to guide your board back down on to the face of the wave. Otherwise, you and your board will get stuck at the top, and you will be left standing while your wave travels on. *You've got to make your own speed and power in mushy waves* says **Occy.** In juicier waves, however, you need only to keep your weight on the crucial midpoint of your board and your feet planted firmly, letting the wave's power do all the work.

## COMING DOWN

Be careful if you hit a lip on a powerful wave because you run the risk of being thrown far out into the flats. On a bigger wave, this could mean freefalling quite a large distance. You want to end up with the lip in between your feet with your back leg extended, and pushing through the turn. Your front leg should be bent in a straight line over your body, from your leading shoulder to your knee, over your front foot. Stay low and go with the flow as your board pivots. *When doing your snap, keep your front shoulder low to the board,* says **Kelly Slater.** *Compress your front knee while transferring your weight to your front foot.*

## PART DEUX

Plan ahead and keep your eye on the vertical section you want to hit, generate as much speed as possible, use your back foot weight to pivot your board to a more vertical position, use your back and knees to guide your board back down into the wave. Look at the transition of the wave so you can get ready for your ride back down. As the lip starts to come over, you have to be in synch with it. Step on your tail if it's a heavy section to help adjust for an air drop.

If everything goes as planned, you should be standing in the trough of the wave getting ready for your next move. *There is not much difference between a normal re-entry and a fins-out reo - it's a matter of timing* says **Dave Rastovich**, *it's about how long you wait before you change direction and when to kick your fins out. Straightening out your back leg will turn it into a fins-out reentry. Turning and opening your shoulders will make it a regular off the top return.*

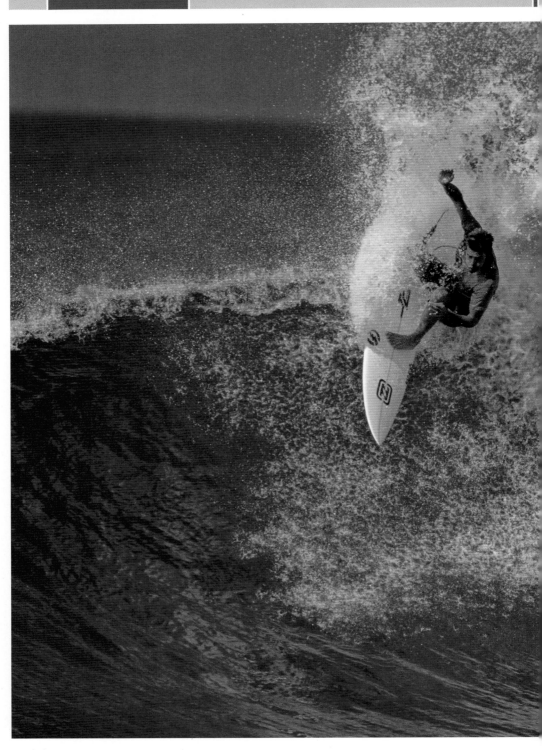

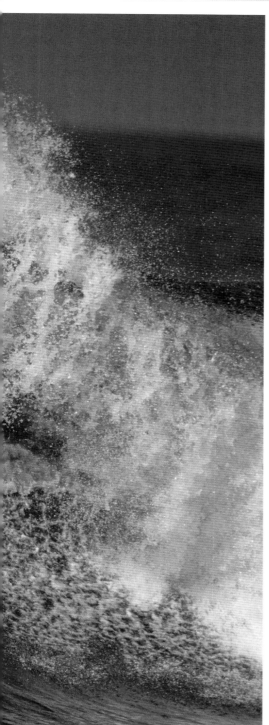

 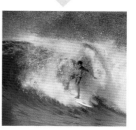

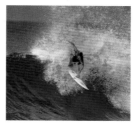 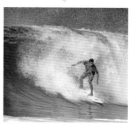

Rasta's anticipative body positioning allows a perfect landing

## PRO TIP BY KELLY SLATER

*When setting up for your frontside snap, don't lean too far back. Usually you'd want to turn your shoulders to the extent you're going to turn your board. When doing your snap, keep your front shoulder low to the board. Compress your front knee while transferring your weight to your front foot. Also, a misjudged setup will throw these things off like a chain reaction.*

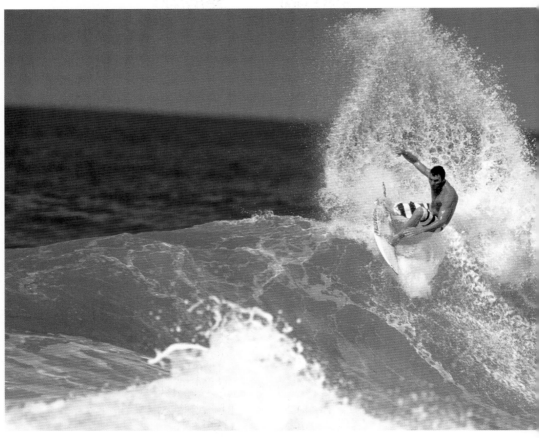

Joel Parkinson hitting a mushy one

## HITTING THE LIP ON A MUSHY WAVE

*On a mushy wave, lengthen it out a little bit. Since there's not much of a lip to hit, direct your track out toward the shoulder instead of straight up at the lip. You've got more time on a burger than on a pitching one,* says **Andy Irons**. *Adjust your track and use the face - don't go to the bottom because you'll lose your speed, whatever there is of it.*

*I use the mushy section of the wave to create speed with the use of a set-up turn going right into a backside hit that you can really put all your weight into,* says **Bruce Irons**. *The first step of this turn*

*started with a drawn-out bottom turn that placed me in the open-faced part of the wave. Remember that setting up for a big turn is just as, if not more important than the turn itself. Where else are you going to get your speed?*

*If the wave is really mushy, it's easy to bog down, I don't try to hit the turn that hard: that's where you can do the little pump turns and make your own speed from them,* says **Joel Parkinson**. *I try not to do tail slides on a mushy wave - keep your tail in the lip, otherwise it looks like you're trying too hard.*

# THE FRONTSIDE HACK

## 1.THE APPROACH

As you come off the bottom and into the open part of the wave start shifting your weight from your inside rail to your outside rail. Use your front arm to mark your pivot point, while at the same time think of using your back arm to start moving you forward in rotation, facilitating the swing of the upper body. Maximum power is applied with your back foot, as you begin banking off the top. The front foot fully extends, totally committing you to the turn. The board should be completely on-rail at this point.

## 2.THE MOMENT

At this point, when your board should be nearly perpendicular to the wave face, the spray directly behind you should be shooting straight up into the air. This will indicate you've committed with full speed and complete rail engagement. As you're coming through the turn, the pivot hand should remain anchored. Halfway through the arc is the time to start looking for what part of the wave you're going to finish the turn on. Whether you're going to wrap it around and take it straight up into the foam, or burn some speed and take it into a bottom turn, your eyes should remain glued to your eventual ending point.

## 3.THE RECOVERY

Coming around the arc, the board begins to flatten out a bit. Your rail should be from nose to tail - more so, in fact, than during any other part of the turn. It's also about here where you're going to start transferring pressure from your back foot to your front foot. The idea is to try and start letting the fins release, not so much so that you spin out, but enough to allow you to move into the next part of the turn. This is where you're going to want to follow both the curve of the wave face and the curve of your rail line. As long as you keep applying pressure in all the right places, the board should do a lot of the work. The pivot arm sinks into the wave face now for added leverage, and as soon as the fins dislodge, the back leg is also recoiled so you can keep your body over your board while it goes into its stall. Be sure to keep your head down as you begin to gain control of the slide.

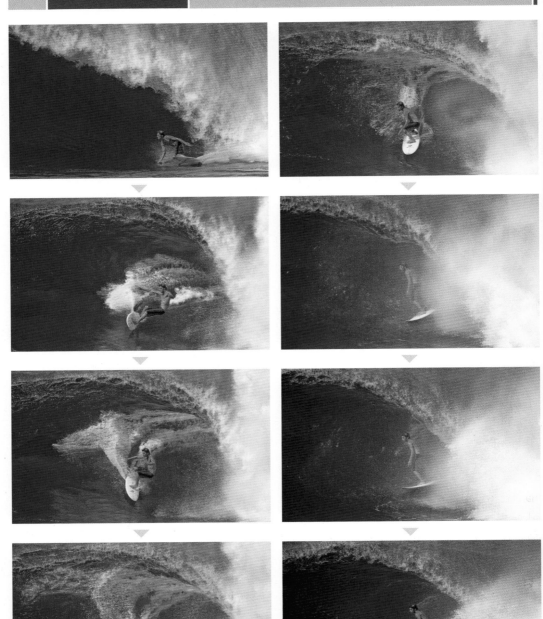

David Rastovich connecting the dots

# CONNECTING THE DOTS
## A Look at the Importance of Linking Your Moves

At the 2006 ASP California event at Lower Trestles, Joel Parkinson's display of radical banked rail turns elegantly linked at speed were employed more intensely and yet more effortlessly than anyone had previously witnessed. For many, this power, precision and poise had again set a new standard, combining the graceful with the gashing; the subtle with the slash. Connecting carving cutbacks, sweeping bottom turns, massive tail slides, precision cover-ups and tight snaps, his fluid, spontaneous repertoire left the announcers almost speechless. **Brad Gerlach** claims it was the best Trestles has ever been surfed: *I would have given him a twelve.*

Hang around enough top-flight surfers and you'll hear a lot of talk about "flow," or the ability to put a complete, coherent ride together from beginning to end. Watch a few minutes of video of any of the world's best - Kelly, Andy, Parko, Taj, Mick, Shane - and the necessity of linking maneuvers together is unmistakable. Drops should connect to bottom turns, which should extend into down-the-line projections or off-the-top snaps, which should then flow into re-entries or cutbacks, which then transition into another bottom turn to start the whole series over again. Even when it comes to aerial surfing, a genre that used to be comprised solely of pumping down the line simply for the sake

of punting a big air out of the end bowl, considering what comes next is key in deciding what part of the wave to attack. Below are a few things to get your mind working:

## PLAN TWO MOVES AHEAD

Like chess, successful maneuvers require thinking ahead. While it is important to concentrate on the immediate move in front of you, reading the wave and setting up for maneuvers down the line is essential to creating a series of smooth transitions. A great surfer will do this every time. **Joel Parkinson**, the master of smooth, connected wave riding, says, *Hold your arc for as long as you can on each move, getting on-rail*

### JOE QUIGG

*One of surfing's most important craftsmen/ innovators, recalling the radical banked turns Les Williams began doing on a lightweight balsawood board shaped by seminal shaper Matt Kivlin in 1952.*

**What they did busted the whole surfing thing wide open. When other surfers saw what Matt and Les were doing, it was the beginning of the end for old-fashioned and crude surfing.**

*and then rolling over. For instance, to finish off a good bottom turn, hit the lip hard, or do a powerful cutback, then go for something completely different but still on-edge.* Once you've completed a maneuver at the top of the wave just drive down the line and instantly start your next bottom turn. *Anticipate your next move,* he says, *and it will just happen naturally.*

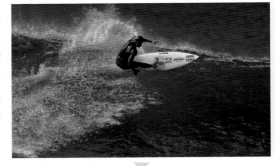

## SMOOTH IT OUT

Not only does smooth transitioning make your surfing look a lot better, it will help your ability to make a lot more sections of the wave and adjust to the ever-changing wave condition. The last thing you want to do is be the guy that fades his bottom turn so far back the wave reels off down the line and leaves him in the doldrums. Or what's the point of throwing down a massive hack if you have to sacrifice the last 100 yards of the wave? Planning ahead will dictate what maneuvers to utilize, and as mentioned, it will give your rides a more choreographed, refined feel.

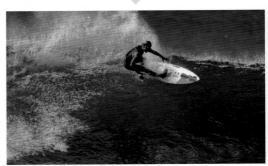

## PUTTING IT ALL TOGETHER

While practicing a specific move may require sacrificing the whole wave in order to focus on that one big maneuver, don't get in the habit of thinking that a big move is the be-all-and-end-all. It's like building a brick wall: you put all the right pieces together, and eventually you have yourself a solid structure from which to work. It's now that you can begin to experiment with taking things to new levels. For example, fading deep for more power on the bottom turn, snapping under the hook instead of drawing out a cutback, or floating across a lip to make a section instead of kicking out. And this isn't just a method of winning contests. It will also get you a lot more respect in the water, which translates into more confidence when you're up and riding. It also means that you will be much less likely to get dropped in on.

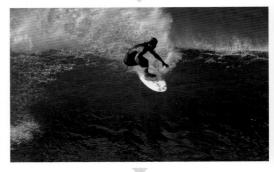

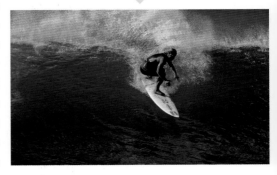

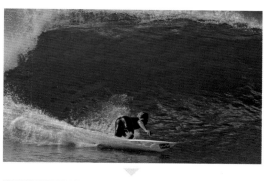
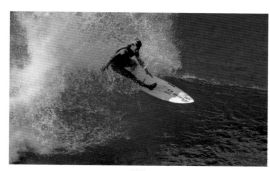
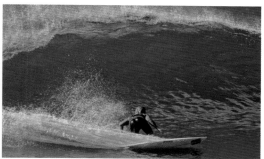
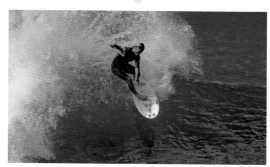
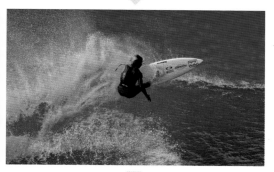
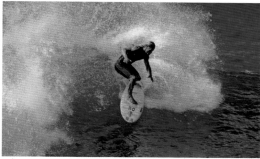
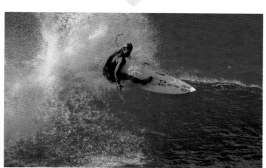
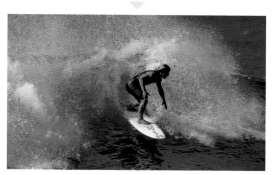

Mark Occhilupo putting it all together

## THREE FEET HIGH AND RISING

The great thing about surfing is that it's ever-changing. Be it your boards, your physical wellbeing, or the waves themselves, no two days of surfing are quite the same. And when it comes to connecting the dots this can be a bit tricky. The contrast between what's required for successfully navigating a ten-foot monster and ping-ponging around in the shorebreak on a two-foot day is stark. Here are a few things to keep in mind as the surf rises and falls:

### 1. ONE TO FOUR FEET

This is where you have to be quick to your feet and be thinking fast. Things can be thrown at you in an instant and you have to be ready to respond. As you're more or less responding to what's popping up, this is where muscle memory comes into play. Small surf is a great place to really focus on timing and understanding how your board works against varying sections of the wave.

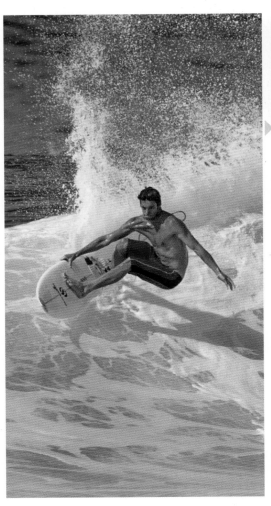

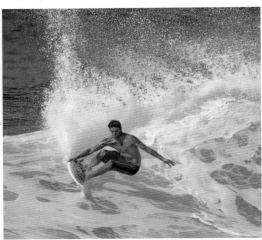

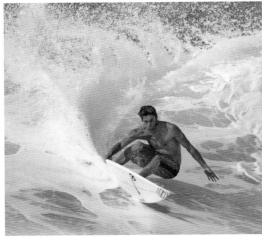

## 2.FOUR TO EIGHT FEET

For most this is the perfect, dream size. After all, who doesn't like a good day of six-foot barrels? It's not too big, not too small, and on a good day speed seems almost unlimited. It's in these kinds of solid conditions where you can really start to feel and understand the dynamics of your board. It's here where a fin's performance truly shines, as does a board's rail line and rocker.

## 3.TEN FEET AND UP

Everything happens a little bit slower in big waves, but it also happens with more power and more severe consequences. Survival in the heavy stuff requires a significant amount of planning ahead, both when it comes to what's possible on the wave itself, as well as what the best escape route is should you end up in trouble.

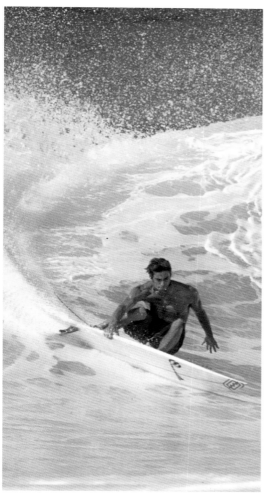

### PRACTICE TIP BY MARK OCCHILUPO

"Surf a long point wave where you are forced to make connecting moves. Gordon Merchant really helped me by bringing me to Jeffreys, where I was forced to put it all together and my surfing changed forever. Burleigh Australia, J-Bay South Africa; Mundaka Spain; Rincon, California; Uluwatu, Indonesia; Tamarind Bay, Boca Barranca, Pavones, Scorpion Bay, and numerous others fit the bill. A little bit of extra point wave speed and power will allow you to make all your maneuvers faster and more committed, i.e., more radical."

Rasta's effortless, flowing cutbacks never seem to cost him any speed

# BACKHAND ACROSS THE FACE
## A Successful Backside Attack Begins With Your Bottom Turn

Your ability on your backhand begins and ends with the proficiency of your bottom turn. And while, in terms of projection and speed, the basic physics behind a backside bottom turn are relatively similar to a frontside bottom turn, it's the mechanics that are completely different. Frontside bottom turns are considerably less technical for the simple fact that when you commit to the turn, you're facing the wave. There's much more of an unknown factor when you're setting things up on your backhand, and there's no better place in the world to study this than Pipeline. Watch the best frontside surfers there, and you'll notice that they practically fall into the pit, waiting for the ocean to throw over them before setting their rail. There are very few long, drawn-out turns. But backside surfers don't have this luxury; they have to rely on experience, instinct and one hell of a bottom turn.

Either one of the Irons brothers serve as a perfect example. Bruce Irons stays low over his board, grabs his rail, sort of sideslips under the hook and about halfway down the face engages his inside rail and fins. This sets him up for the tube almost immediately, which allows him to sit far back on the foam ball from the beginning to end of his ride. On the other hand, Andy Irons will often drop straight down the face, and as he starts to get to the bottom of the wave really leans into the turn, and depending on the situation, he either projects out of the turn and down the line, or picks a more straight-up path into the pocket. Considering Bruce and Andy are both Pipe Masters, either approach is more than suitable. But before you go hucking yourself over the ledge at Pipe, you'd better understand the fundamentals first. Here are a few ideas to get you thinking:

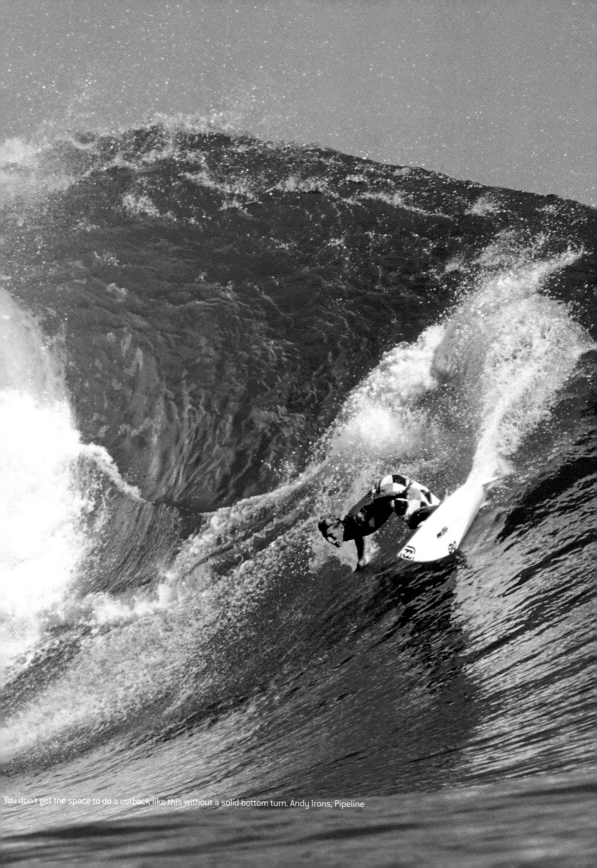

You don't get the space to do a cutback like this without a solid bottom turn. Andy Irons, Pipeline

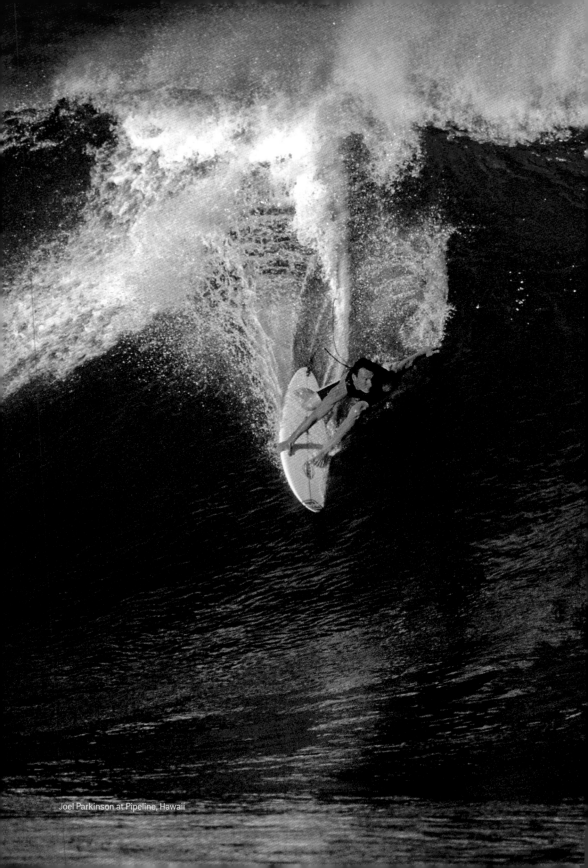

Joel Parkinson at Pipeline, Hawaii

## THE APPROACH

As with every other maneuver in surfing, a good backside bottom turn starts with your ability to successfully make the drop. Of course, there are exceptions. On particularly fast, racy waves, you're going to want to angle across the face, so as to not get stuck behind the section. But if you've got some open room to roam, you should try and stay as straight and close to the power zone as possible.

## THE TURN

Start your bottom turn the instant you reach the flats and at the point of maximum speed on your drop. *Get low and lead off your front foot,* says **Mark Occhilupo**. To begin your bottom turn keep your knees bent, lean on your heelside edge, and turn your upper body in, looking over your front shoulder. This will initiate the turn and allow you to see the lip in front of you. It's here that you'll be able to decide whether you want to crush the lip or drive down the line. Your weight should be evenly distributed between your front and back feet. Ride through the beginning of the turn without dragging your heels in the water in order to maximize your speed. It is very important to keep your original line through the turn so you don't lose any speed. Try to pick the right line from the beginning, maintaining one long, flowing arc. If you're really pushing the turn it should be almost like you're sitting in a chair, your butt just a few inches off the water's surface.

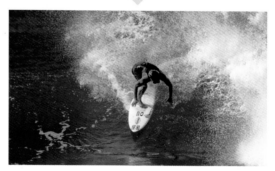

## THE NEXT STEP

When you begin to go back up the wave, transfer most of your weight to your back foot, and drive up the wave face to gain the maximum amount of speed possible for the wave. *My back hand will just touch the rail on the upward swing,* **says Occhilupo**. *Focus on the section of the lip you want to hit, and on pushing with your back leg.*

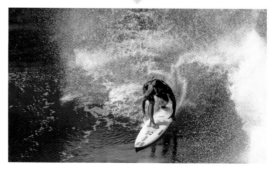

Occy's power off the bottom is the start point for his high-energy cutbacks

## THE DETAILS

Just like the frontside bottom turn, paying attention to the details the most important thing. *An immediate transfer of weight is the secret, says* **Occy**. *With the right track, the correct punch off the bottom and the right angle of rail, you should be generating the speed and positioning you need for your next move. From here you're off and running.*

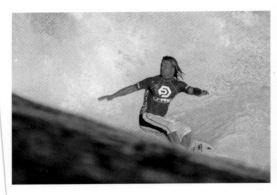

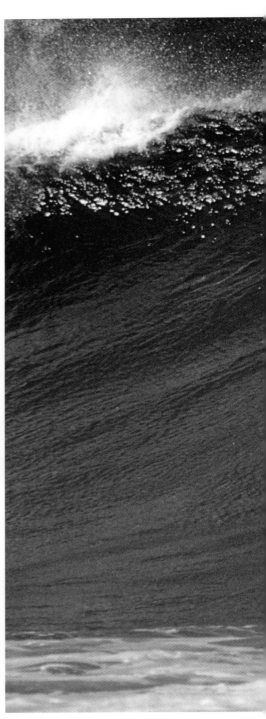

Above:

Occy eyes up the next move

Right:

Occy compressed, Sunset

**PRO TIP BY LUKE EGAN**

*Surf the wave. Your bottom turn should set a line for where you want to be when you engage the top of the wave; short pivotal snaps for quick, vertical punches and longer drawn out lines for longer, sweeping off the tops.*

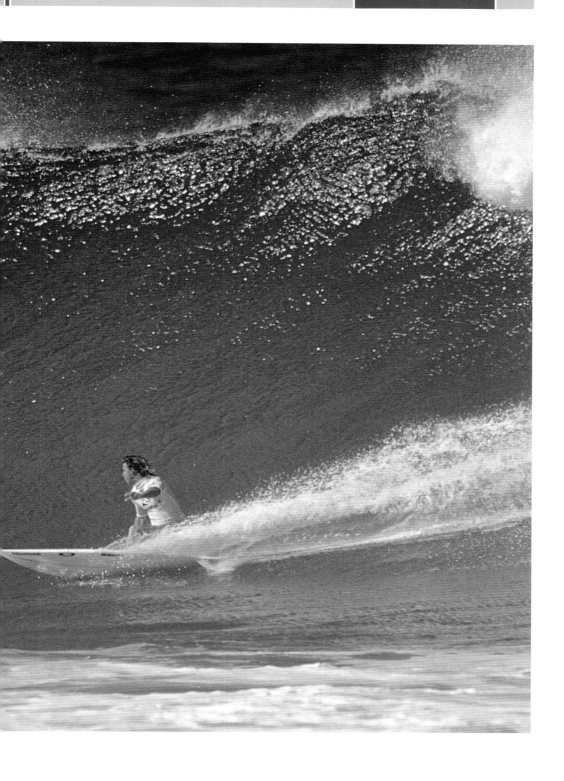

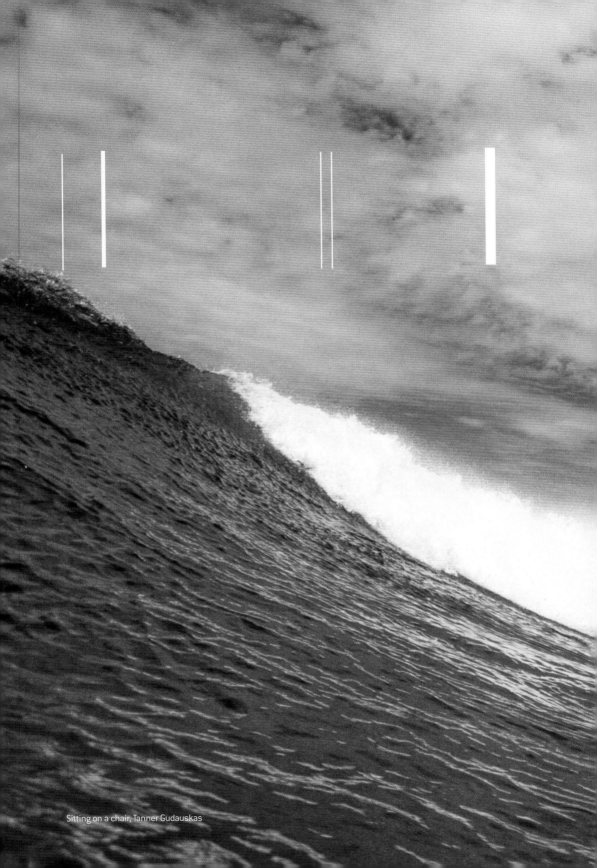

Sitting on a chair, Tanner Gudauskas

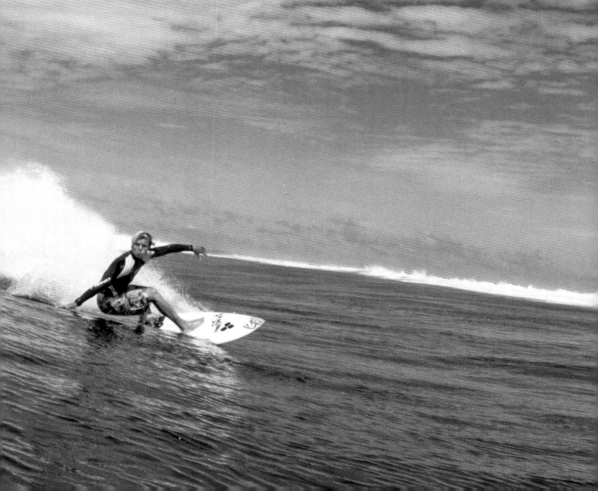

# THE CONCEPT OF BOTTOM TURNING
## "FINALLY ONE DAY, I REMEMBERED THE IDEA OF FLEXING MY LEGS, THEN TURNING AND DRIVING ITS KNIFE-LIKE RAIL INTO THE WAVE. AND SUDDENLY WE COULD DO ANYTHING!"

PHIL EDWARDS, DESCRIBING HOW IN THE EARLY 1950S HE DISCOVERED THE CONCEPT OF BOTTOM TURNING IN ORDER TO SURVIVE SURFING A HOLLOW WAVE.

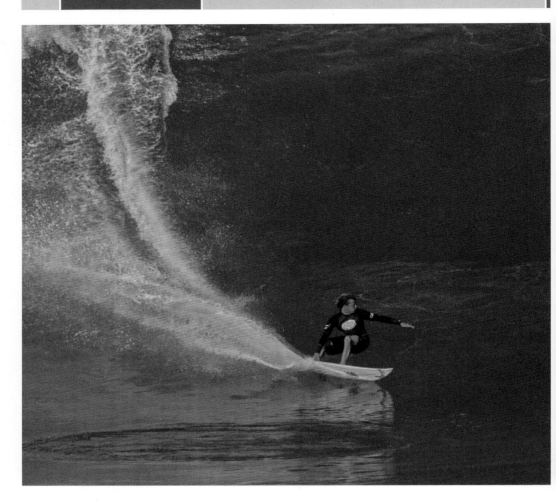

# TAKE THE HIGH ROAD
## Pumping for Backside Speed

If you have ever watched Taj Burrow's segment in the surf video Untitled, you almost don't have to read this. But since Taj was good enough to talk about it, read what he says then watch the video. About 20 times.

The biggest difference backside is you have to remember to stay high on the face, don't let you're your line fall too low, and you'll get all the speed you need to make sections. It's a little more difficult getting speed backside than front side, but just like on your front side, a little angle and a quick top turn pump sets you up.

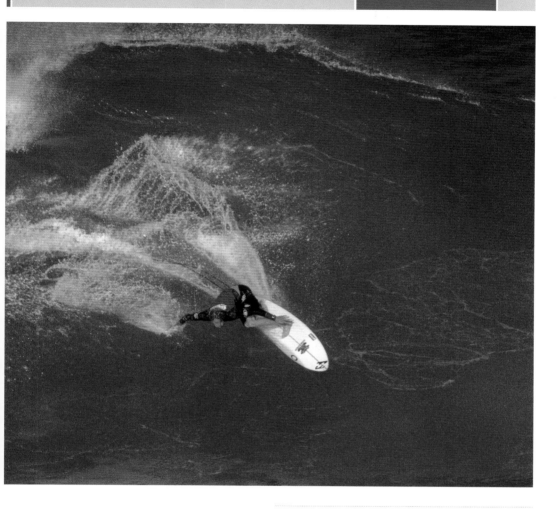

Taj Burrow using his front foot as an accelerator

*Your first mini-pump is super-important because you need the speed you get from it to make the rest of the wave,* explains **Taj Burrow**. *Keep your back foot farther forward than it would be if you were doing a turn. Your front foot becomes your accelerator and drives your board.* At the top of the wave you can do your first full pump. Bend your knees and get farther forward on the flat portion of your board.

## MARK OCCHILUPO
### *World Champion.*

❝ **The secret is that the speed is at the top of the wave, so you want to get right back up to the top of the wave as soon as possible. And keep finding the top.** ❞

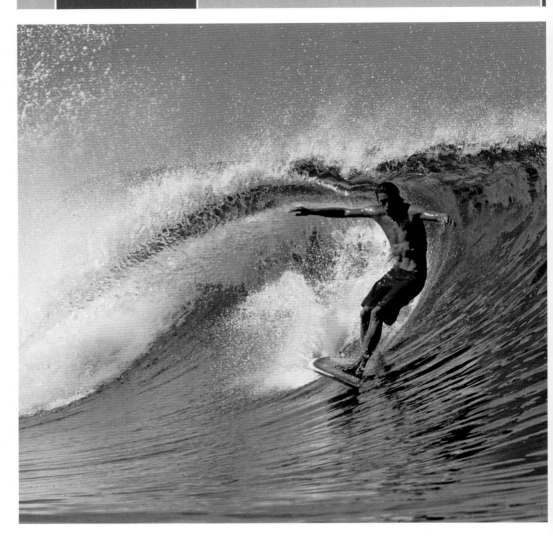

*It's like a fulcrum point, where you use your front foot as gas and your back foot as the brake,* says **Marc Occhilupo,** who learned how to use this technique in the freight train tracks of Jeffrey's Bay, where pumping down the line is a necessity for even making the wave. *You put pressure on the edge of your front foot, and as you bend your knees, drive down toward the middle of the wave with as much power as you can.* For **Occy,** that's a lot of power. He has the knack of looking over his leading shoulder, and almost intuiting the shape of the oncoming section. But if you watch closely, he uses a very simple technique to keep his momentum always going forward: he stays low, with his arms in front of his body pointing down the line. And he stays in constant motion.

*When I reach the middle of the wave, I try and weight the side edge of my front foot and drive back up to the top. You've got to always be watching the lip as*

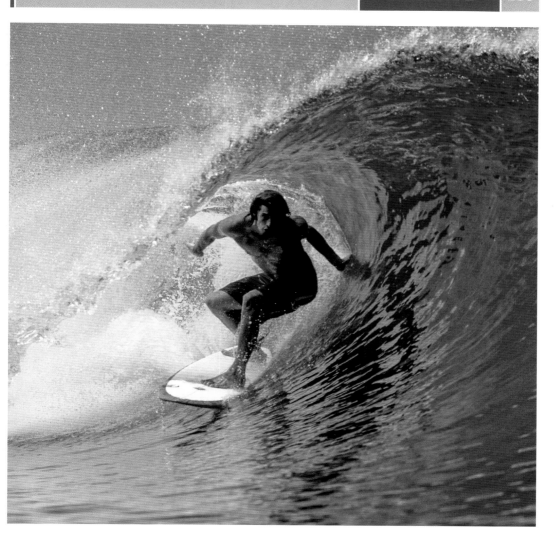

well as the section in front of you, says **Taj Burrow**. Push hard on your back foot while lifting your front foot. Your body will extend when you go up the wave, so you want to keep your arms in front of your chest pointed down the line.

Push hard on your front foot when going down the wave, and pull up on it when going up the wave, Taj continues. Drive up the wave as hard as you can to get as much speed out of the pump as possible. Use your knees and your ankles to pop a bit of momentum as you crouch and extend. When you reach the top of the wave go straight into your next pump to get even more speed. What you want to do backside is keep using the top of the wave for speed. You can't just pump through the middle of the face like you can on your frontside. When you get the speed you need pumping through a few sections you can slam a power turn or boost an air.

David Rastovich in the Mentawaii's

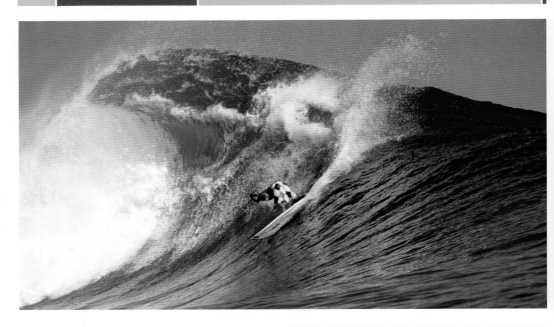

# IT'S A SNAP

Above: Andy Irons' trademark cutback

## Rooster-tail Redirectionals and Back-side Snaps with Speed and Power

**PRO TIP BY ANDY IRONS**

*Keep the bottom quarter of your board dug into the face of the wave. Put as much torque into the lower part of your board, as much power as you can, without breaking your fins free. Keep a low center of gravity and hook a super-tight arc. Strong legs like Luke has obviously help, but the technique works for anyone: By simply varying the weight dispersion on the tail of your board with a sharp pressure, you can create loads of spray.*

Luke Egan has been famous for throwing enough spray to put out brushfires. His signature backside snaps have been compared to snowmaking machinery. It's one of the reasons he was able to stay competitive on the ASP tour for nine brilliant seasons.

On Luke's bottom turns, he says he projects around the pitch of the wave and keeps as much speed as possible. Big spray requires a lot of speed, and Luke's got it in spades. Even his bottom turns produce big sprays, as he uses his back arm, and turns his torso into the wave.

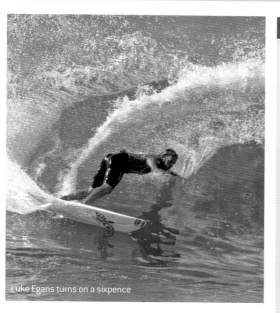
Luke Egans turns on a sixpence

*Timing is pretty much everything at this point of the turn. Once you've committed to the bottom turn, you need to make sure that you'll be able to get up to the lip in time to throw your tail as the wave breaks and pushes you straight back down.*

What's his secret? Here's what Luke says: *The key is your bottom turn - it sets up all the positioning and speed. For a vertical line, make your bottom turn super-short, with a tight pivot. You want to get vert as quick as possible. If you've got a longer wall, where you are going for a long sweeping snap, then go to the bottom and make the turn more drawn out. As you project toward the lip, begin the start of your turn with a weight shift. Your back leg needs to push really hard, and at the same time turn your shoulders parallel with your board. Keep most of your weight on the tail. Your outside rail wants to be unconnected, but the inside rail fully connected and driving. What happens is a huge pressure point between the fins, that as it releases, fires water like a cannon hose.*

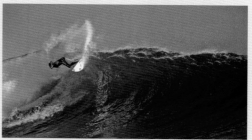

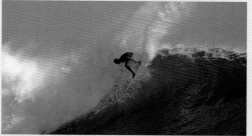

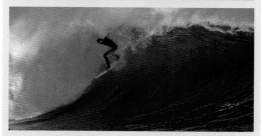

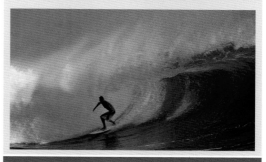

## MICKY DORA

*Explaining to me in 1976 why he had developed his exquisite down-the-line right point wave style in Malibu, Jeffreys Bay and Noosa.*

*I can't go left.*

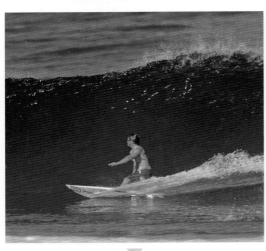
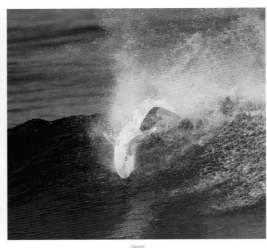
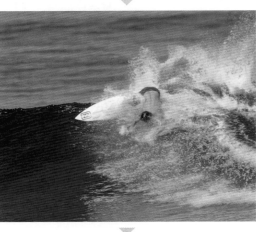
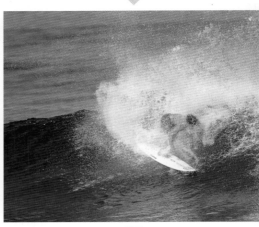
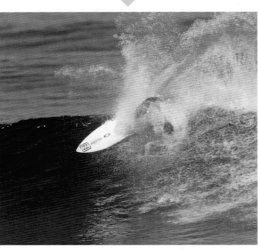
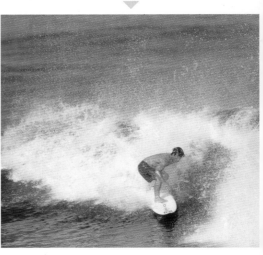

# STICK AND MOVE
## Analyzing the One-Two Combo of Backhand Re-entries and Off-the-tops

It's one of the first real tricks that you probably learned, but done with full commitment at speed, re-entries and off-the-tops can get dicey, especially when you're going for it on a wave of consequence. Take for example some of the top guys in the world who go for one final snap over the dry reef that is the end bowl of Teahupoo. You see it a lot in the contest there, regular-footers like Kelly and Andy trying to eek out a few more hundredths of a point, and as they come flying out of the tube they set up off the bottom for one last little punch. And while for them it may seem like a routine act of muscle memory and coordination, the underlying mechanics can be quite complicated.

*When setting up for a backside off-the-lip, keep your arms open and your chest facing the wave, staying on the heelside rail before you drive up the face (end of bottom turn). It's important to begin shifting your weight from a 50-50 stance entirely to your back foot before you reach the top of the wave, says* **Brad Gerlach.** *To do this, push with your front foot to move your hips and the majority of your weight over your back foot. Exactly when to do this can vary depending on the wave, but it's usually as soon as the nose of your board is pointing toward your target.*

When that happens, you'll begin to move up the face. Start to shift your weight by pushing your back knee over your toeside rail. Then pull your back shoulder gradually, like you're rowing with one arm. Immediately after the bottom turn, drop low to the board. *The lower you can get to the board, the better balance you'll have, giving you a greater margin of error if you happen to overshoot or the wave does something tricky, which happens a lot, says* **Gerr.** *This stance also gives you more power to really gouge a chunk out of the lip.*

When you begin to pull your back shoulder, push into the back foot and begin to twist your hips in the direction you want to go. If you time this move correctly, your weight will give you all the power you'll need. Visualize a pinball bouncing against a bumper. Don't over-exert yourself; this will only take away from the move.

*Read the wave by feel. If the lip is there, hit it, but I prefer to get just below it and get a nice curve in the turn, says* **Occy.**

Left page:

Mark Ochilupo's power one-two

# THREE POSSIBLE BACKSIDE SCENARIOS

### 1.DOWN-THE-LINE SPEED CURVE
**(Point Waves and Fast Beach Breaks)**

Midway up the face, pull your back shoulder slightly, push on your back foot and twist your hips, keeping your eyes focused down the line. (If you twist your hips when pushing on your back foot, you'll end up with all your weight on your front foot and you'll pearl.) When this turn is finished, the nose should be facing diagonally down the line.

### 2.SPEED-CURVE HOOK

Midway up the face, pull your back shoulder with a medium amount of torque, push with your back foot and twist your hips toward the trough of the wave. You can still look down the line or turn your head toward the trough. Usually if the wave is really steep, I look toward the trough. When finished, the nose should be facing the trough.

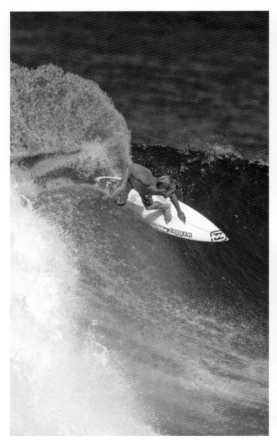

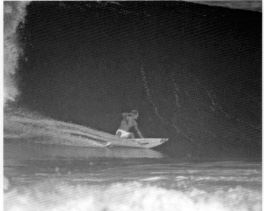

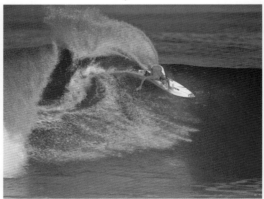

Taj Burrow, twist and shoot

### 3.OFF-THE-LIP

A little after the midway point, pull your back shoulder more and begin the turn a millisecond later than options one and two. Keep your head still, either looking at the nose or the tail. Twist your hips back toward the foam. The nose should end up pointing toward the foam. The success of this move depends on how much torque you put into it with your hips and shoulders and how much you push with your back foot. Do this move when you've built up enough speed and you'll put it with ease. The keyword here is grace.

**PRO TIP BY MARK OCCHILUPO**

*Read the wave by feel. If the lip is there, hit it, but I prefer to get just below it and get a nice curve in the turn.*

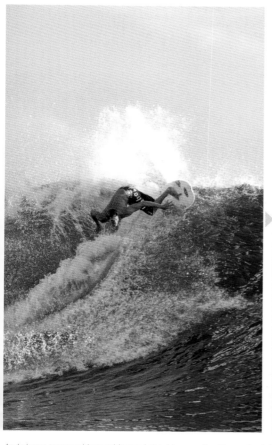 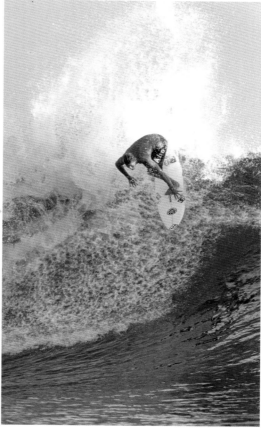

Andy Irons, torque with your hips and shoulders, push with your back foot

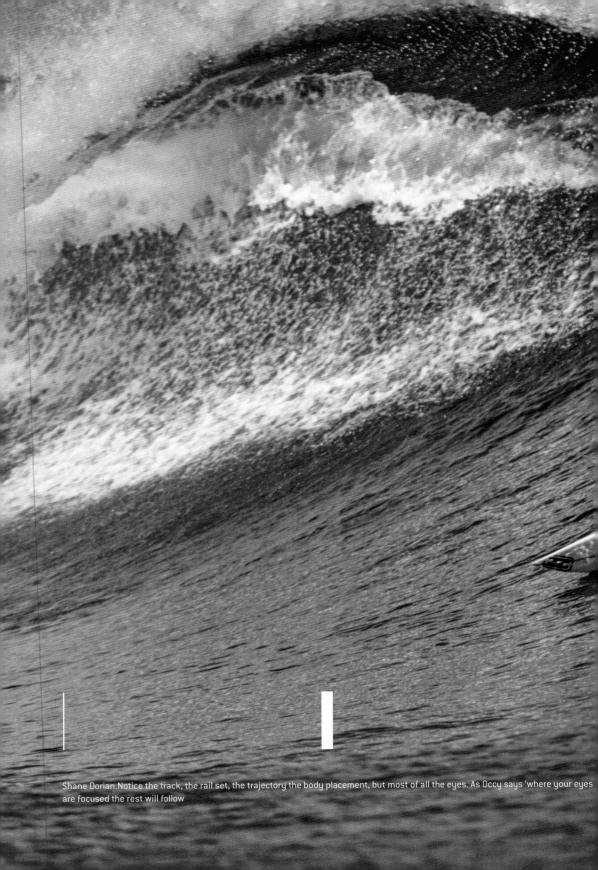

Shane Dorian. Notice the track, the rail set, the trajectory the body placement, but most of all the eyes. As Occy says 'where your eyes are focused the rest will follow

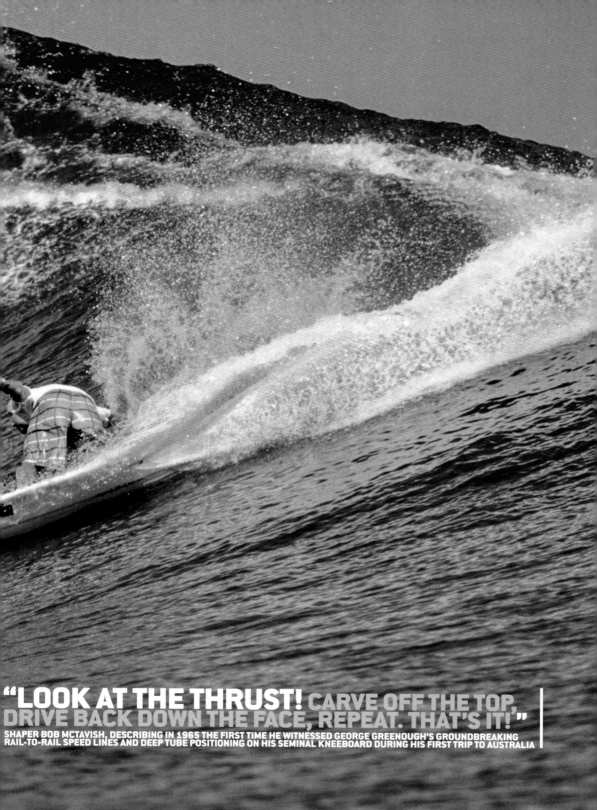

# "LOOK AT THE THRUST! CARVE OFF THE TOP, DRIVE BACK DOWN THE FACE, REPEAT. THAT'S IT!"

SHAPER BOB MCTAVISH, DESCRIBING IN 1965 THE FIRST TIME HE WITNESSED GEORGE GREENOUGH'S GROUNDBREAKING RAIL-TO-RAIL SPEED LINES AND DEEP TUBE POSITIONING ON HIS SEMINAL KNEEBOARD DURING HIS FIRST TRIP TO AUSTRALIA

# A BARREL OF FUN
## Frontside Tube Riding Distilled

**Peter Townend,** the 1976 World Champ, likes to tell the story of Gerry Lopez giving him the secret of riding the tube: *I was a grommet at Coolangatta, surfing Kirra, and I could get into the barrel, but I couldn't get out,* relates **PT**. *So Lopez showed up on the Gold Coast with Jeff Hakman and Jack McCoy. Being the brazen little grom that I was, I walked straight up to him and introduced myself. I told him I'd been surfing Kirra and he was interested in going to try the tubes there. So I straight-up told him that I was having trouble getting out of the tube. 'Let me tell you a little secret", Lopez confided. 'You see that big water pipe over there? The next time you're in the tube and you are having trouble, take your front hand and point it directly in the center of the cylinder.' I went back to Kirra that very next day, and every time I put my hand in the eye of the cylinder I started making it out of the tube! It' a simple tip, but I never forgot it.*

The history of tube riding is a storied affair primarily built around the training ground of Banzai Pipeline, where nearly all surfing's early barrel techniques were developed beginning with Butch Van Artdalen's initial encounters in 1962, earning him the first title of Mr. Pipeline. Jock Sutherland was next in a succession of regal pipe masters that was most epitomized in the early 70s by the zen-like grace of stylist Gerry Lopez. The torch was passed to Shaun Tomson in the winter of 1976, when new equipment and new vision allowed Tomson to actually begin maneuvering inside the tube at Backdoor. The Pipeline Masters contest created a forum for performance that has crowned a number of heirs to the throne, including multi-time winners, Rory Russell, Larry Blair, Derek Ho, Tom Carroll, Kelly Slater and Andy Irons.

For aspiring experts there's no other place so sought after, and dreamed about than the tube. To ride in the barrel requires commitment, skill, and the ability to read the waves in instant detail. The punishment for errors is severe; the prize is communion with the very essence of the sport of surfing.

It is estimated that only one in twenty surfers can confidently negotiate the tube. Here are some takes by the world's best, to give an edge to the upcoming 5%.

### GERRY LOPEZ
*The undisputed master of Banzai Pipeline*

❝ *Getting in the tube at Pipeline? It's a cakewalk!* ❞

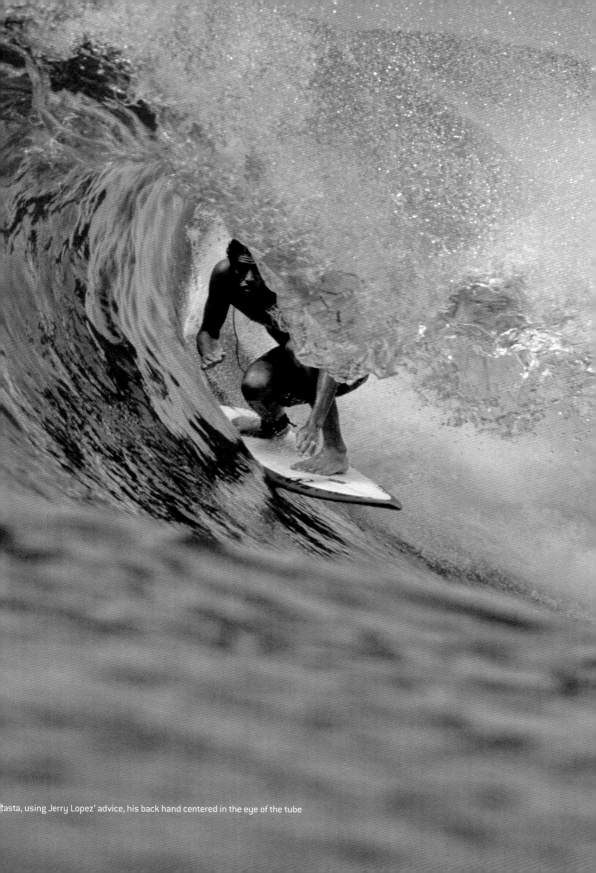

Rasta, using Jerry Lopez' advice, his back hand centered in the eye of the tube

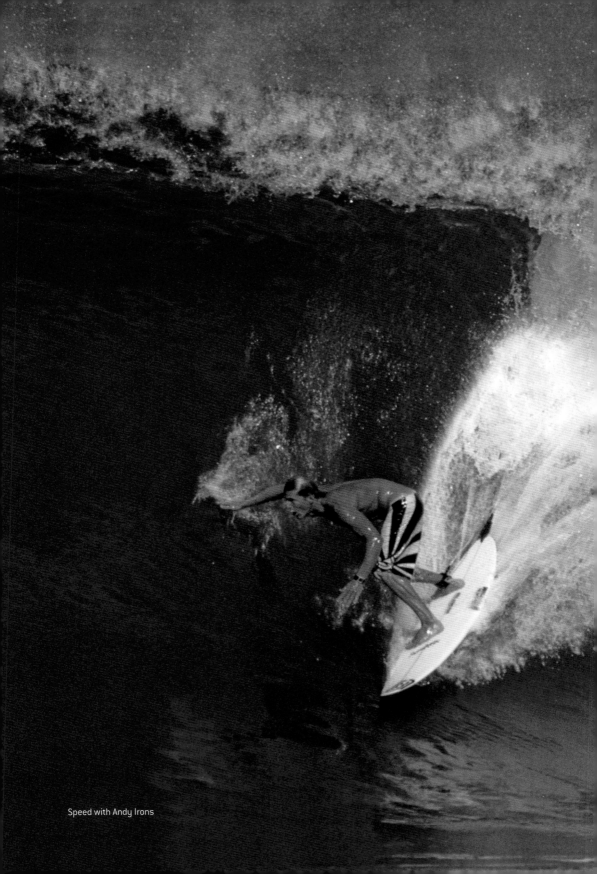

Speed with Andy Irons

## 1.SPEED

Surviving the barrel is all about speed; how to get it, and how to control it. To get deep in a barrel, you need to decelerate, but to get out, you need as much speed as you can get. Learning how to decelerate and accelerate will give you control of your tube ride and therefore allow you to get as deep as you can, and still get out.

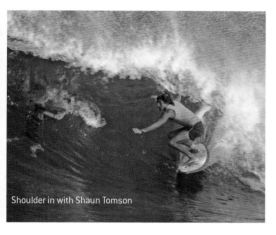

Shoulder in with Shaun Tomson

## 2.SHOULDER IN

*The best trick I can remind tube riders to remember is to keep your lead shoulder in. It completely changes the body positioning. At this point you can make adjustments in the tube. The key is to make the negotiation between not getting too high (so that you get sucked up the face and over) and not getting too low (so that you lose your speed or get caught by the falling lip.) Both Mick Fanning and Joel Parkinson have developed a new approach which puts their weight on the front foot almost exclusively. Their back foot is turned over - the heel is rarely touching the deck. They put all their weight on the front foot and with today's boards, the speed is built around weighting and un-weighting.* **Shaun Tomson**, World Champion.

## 3.SETTING UP

Another important aspect is setting up the turn to position for the tube: Sometimes a hollow section will be coming a ways down the line and you will want to make a couple of quick pumps to position yourself right where you want to be as the lip pitches. If the tube comes up quickly, sometimes it is necessary to make a quick hook turn on the face, get your rail in, and duck quickly under the lip.

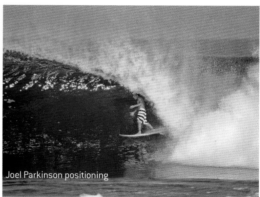

Joel Parkinson positioning

### PRO TIP **BY SHAUN TOMSON**

*My favorite tube rides are the kind where you can see the pitching lip, and the take-off is super-steep so you have all the speed down the face, and you need to make a driving turn straight in the barrel. The trick is to keep your speed up all the way through, pedal to the metal, and keep driving towards the light at the end of the tunnel. Don't ever give up, stay on your board as long as you can. Nobody ever made a tube by giving up. And if you find yourself coming out too easily because you are going so fast, well, take off a little later.*

Occy's perfect positioning in the Kandui barrel

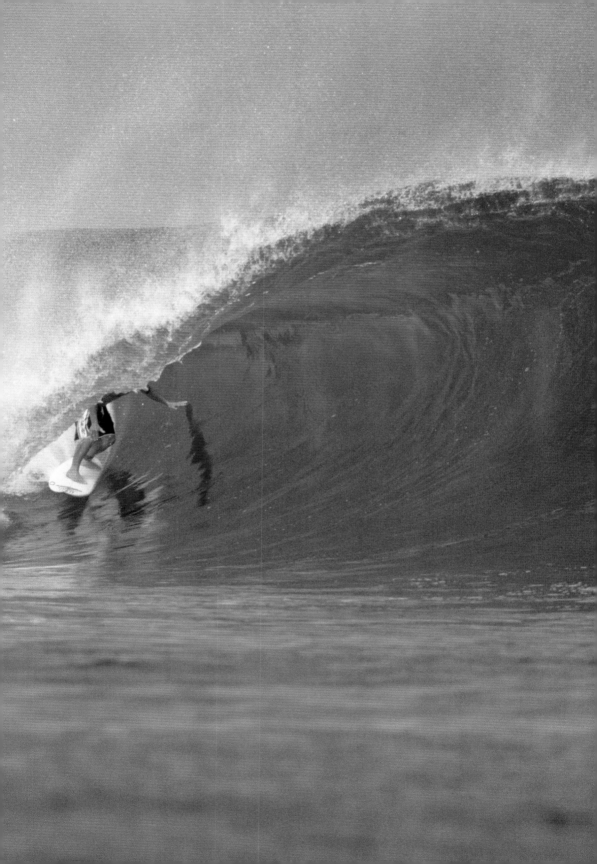

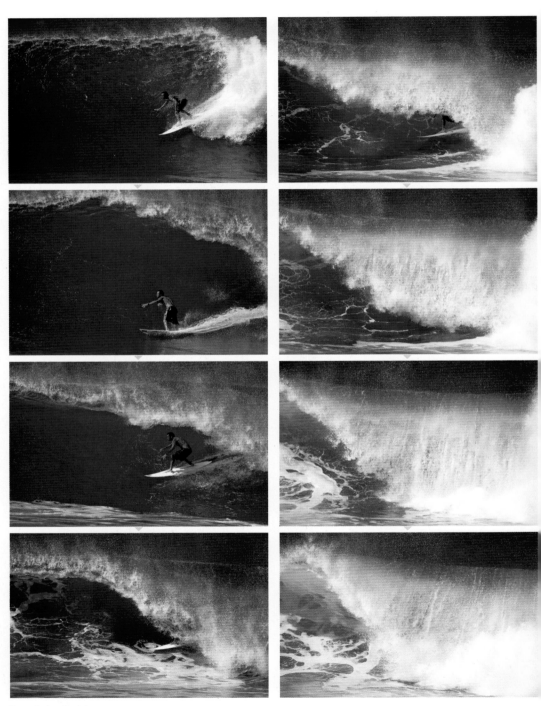

Shane Dorian, Backdoor

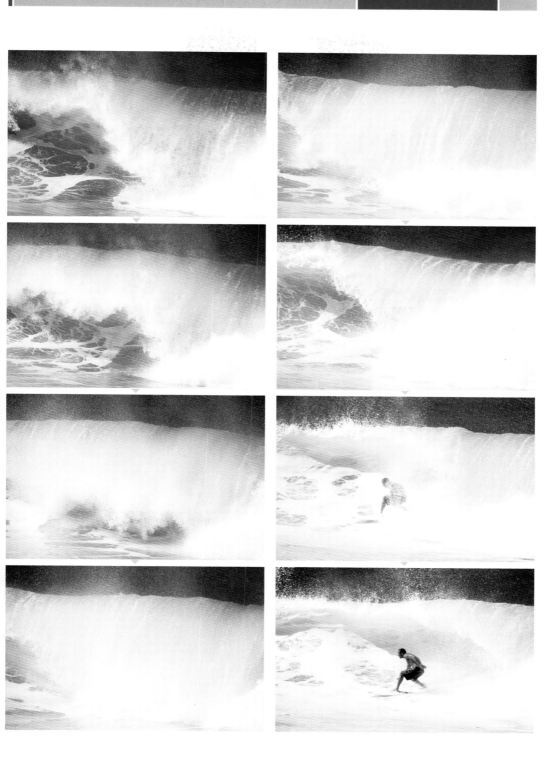

## STEP BY STEP

### 1.TAKE-OFF

Barreling waves are steep waves. Barreling waves are fast waves. Therefore, paddle fast, and at an angle. You must take off right on the peak, dropping down the face. Depending on how fast the wave is, you need to decide where to bottom turn. On fast waves like Pipe, you'll drop to the bottom with no chance of engaging a fin. You must get the fin in as soon as possible.

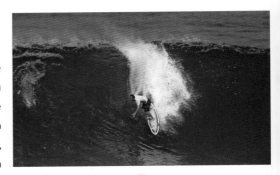

### 2.BOTTOM TURN

This step is crucial. Too late and you'll lose speed or find yourself outside the curtain. Too soon and you out-run the lip and have to stall to get back in. When you start your bottom turn, keep the knees bent like a coiled spring, and point your head in the direction you want to go next (back up the face). In small waves, now is the moment to make yourself small, to avoid decapitation.

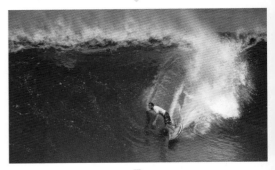

### 3.PULLING IN

This is the moment of truth, when you must get yourself into the right part of the wave. You need to be half way between the top and the bottom of the wave. Too high and you get your neck chopped by the lip. Too low and you will be drilled. Use your back foot toes to engage the fin for more height. Release the toes and weight the front foot to drop back down the face. The key success factor for this: keep the high line as long as possible; height = speed, and speed = a safe exit.

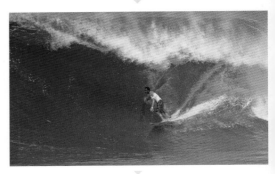

### PRO TIP **BY LARRY BLAIR**

*Two-time Pipeline Master*

" *Always, always keep your eyes looking straight ahead at the exit... never ever look at the roof collapsing in on you.* "

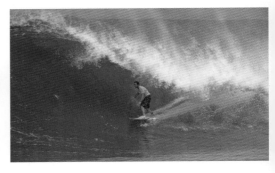

Shane Dorian, Backdoor

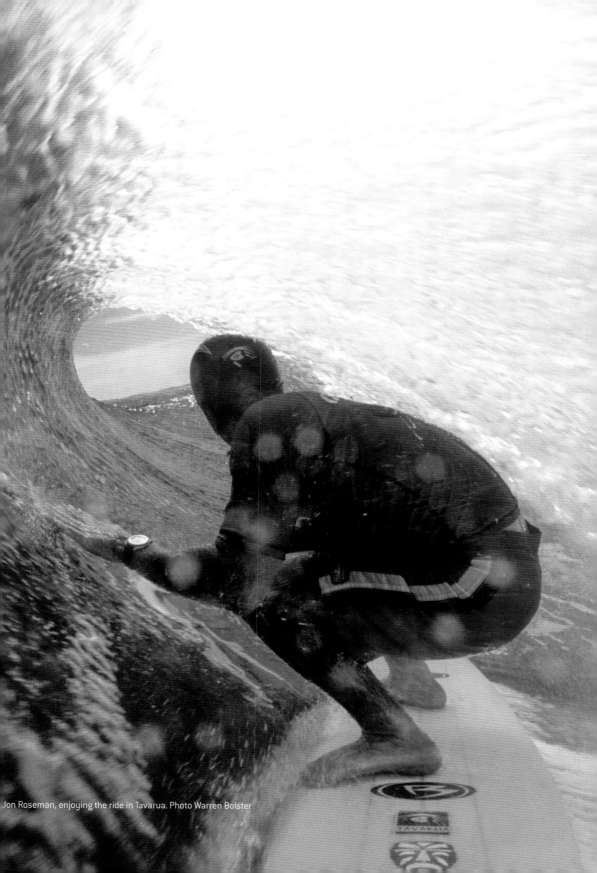
Jon Roseman, enjoying the ride in Tavarua. Photo Warren Bolster

### 4.SPEED

Surviving the barrel is all about speed; how to get it, and how to control it. To get deep in a barrel, you need to decelerate, but to get out, you need as much speed as you can get! Learning how to decelerate and accelerate will give you control of your tube ride and therefore allow you to get as deep as you can, and still get out the end.

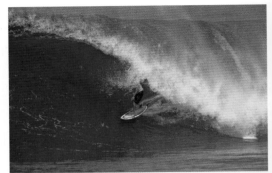

### 5.DECELERATION

To get deeper, decelerate. Hand-dragging is the most effective way to lose speed when there is little room for maneuver. Stick your back hand into the wave... Not too sharply or you are gone! Weight shifting is the cleanest but slowest way to lose speed. Rock back onto your back foot. This brings the nose up and de planes the board, creating drag. Some small s-turns or wiggling; will slow your progress and allow the lip to catch up. This is hard to do in small tubes where you are crouched over the board.

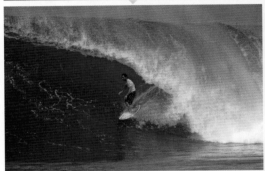

### 6.THE RIDE

Staying with the lip is all about control. Accelerate and decelerate to keep you in the slot, using the techniques in step 5. Hold your line no matter what.

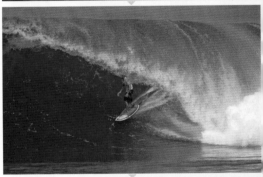

### 7.EXIT STRATEGY

You need to use all that speed you banked earlier and enough height to allow a sharp acceleration. Here are some tips on how to get the speed you need to exit:

■ Put weight on the front foot to reduce drag.

■ Rock back and forth while applying, and releasing, back-toe pressure. This engages then releases the fins and literally "squeezes" speed out of the board.

■ Keep low and tight; loose arms and heads create drag, and add to the risk of lip chop.

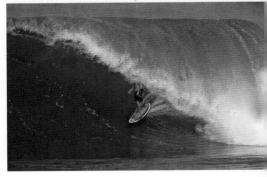

■ If you look at the exit, you will go through the exit! If you look at the roof, you will go through the roof. If you look at the board, you will drop too low.

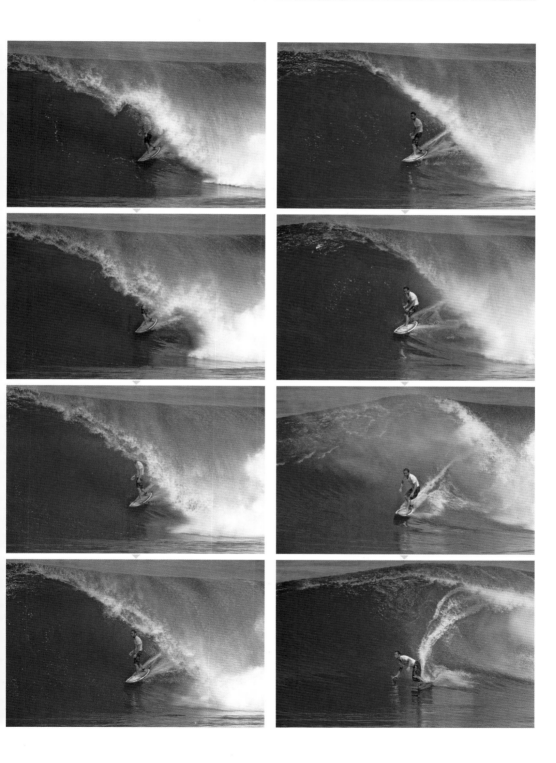

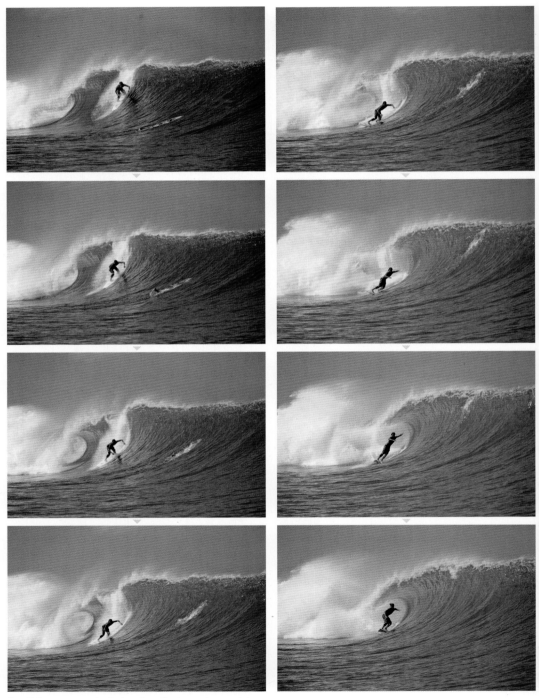

Evan Valiere, maneuvering in the tube, adjusting to shape and size

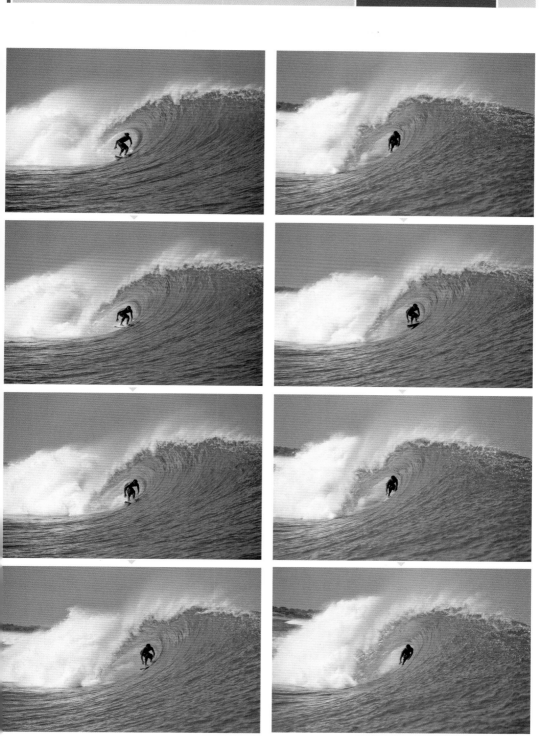

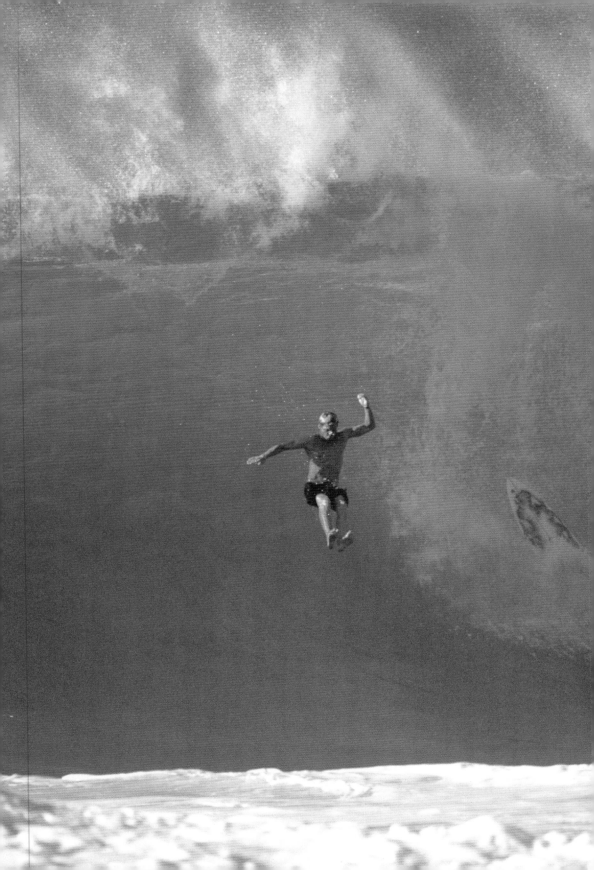

# BARREL WIPE-OUTS

The barrel is the epicenter of the wave's energy. All the power and speed of the moving water is focused right here, and for this reason, errors in the barrel are costly. A typical barrel wipe-out starts with near-decapitation by the lip, back-wrenching catapulting into the face, a slap as you hit the water, followed by a probable over-the-falls rotation. If it's not your day, this will be topped off by a flaying on the reef. So, how to minimize the impact of a fall? Here is what a number of pros have to say:

## 1.TAKE A DEEP BREATH BEFORE IMPACT

Every single pro mentions this. Some advised that if you pop up even for an instant, you can sometimes grab another quick breath of air to prepare yourself for a possible second drubbing. *Everybody says it but it's not easy to remember when you're in an intense situation,* says **Brad Gerlach**, who's had some heavy wipeouts at 50-foot Cortez Banks among others. *It sounds obvious, but it's pretty costly if you forget.*

## 2.COVER YOUR HEAD

The bottom, no matter what it's made of, will hurt your body if you hit it - but it takes a lot less to hurt your head. Always keep a hand in front of your face and head. In a wipeout situation you rarely know what you will find as you break the surface - either on the way down or the way up. *When surfacing from a wipeout, come up hands-first to protect your head*, says **Richard Schmidt**. *If you end up pearling and fall off the front of your board, stay underwater for a little longer to allow the board to pass, then surface hands-first.*

## TRAINING TIP BY JOEL PARKINSON
### ASP World Title Contender

" *The secret to getting real deep back in the slot is speed and height. I reckon if you can stay high enough, you'll have the confidence to let the lip come to you, knowing there's a good chance of powering out of the section. Practice height control on fat days, trimming, pumping, shifting your weight and hand dragging for even more accurate positioning. If you're comfortable with this in the fat stuff, it'll translate when you really need it.*

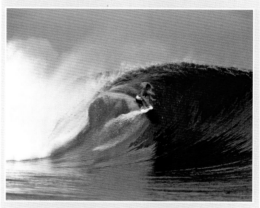

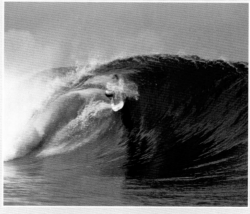

### 3.LEAD WITH YOUR FEET

If you are heading down to the bottom, get your feet down so they hit first. Reef boots are a bonus in these situations. If it's shallow, you want to flatten your body and land as softly as possible. *In shallow water it's better to dive into the wave instead of the flats,* says former top-16 pro **Todd Holland**, who broke a transverse process on his spine when he wiped out at the Box in Australia and got wedged between some rocks. *That was bad, but if I'd dived into the flats instead of the face, I would have been dust.*

### 4.JUMP THROUGH THE BACK

If you're lucky, you may be able to anticipate a fall. In these cases, try to dive through the back of the wave to avoid going over the falls. Most pros agree it's better to fall inside the barrel. Once inside, it's often easier to pop out the back and avoid being sucked over the falls. *To do it correctly, you have to really penetrate the water surface,* says big-wave expert **Buzzy Kerbox**. *In bigger waves, you need to be strong and fast under the lip.*

### 5.KEEP YOUR BOARD AWAY FROM YOU

The most dangerous thing for a surfer is his board. Body contact with a board accounts for more than 60 percent of all surfing injuries. *There's nothing more dangerous than your own loose board,* says **Shane Dorian**. *Ideally, you want to get underneath your board when the wave passes over.*

Left: Follow your feet, they say...

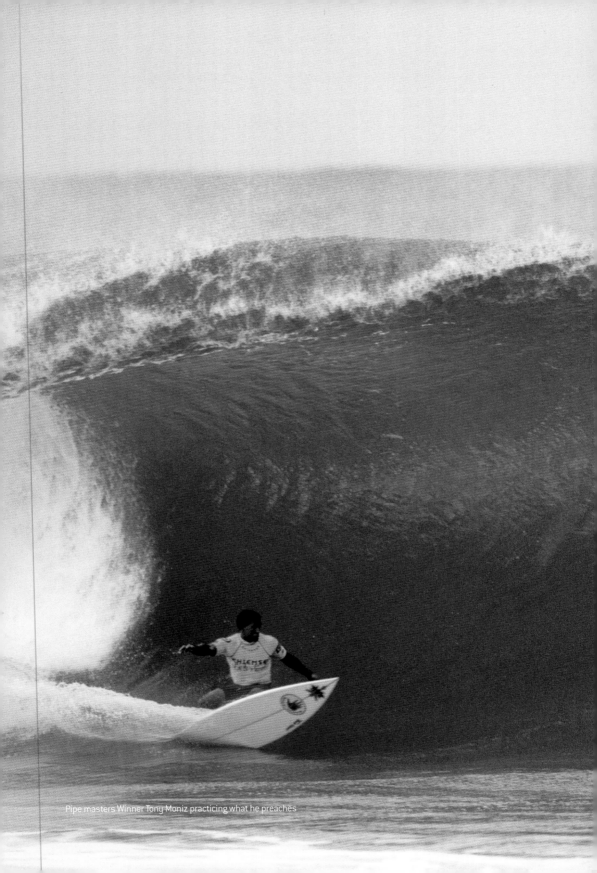

Pipe masters Winner Tony Moniz practicing what he preaches

# BACK AGAINST THE WALL
## Backside Tubes

The backside tube is probably one of the single hardest maneuvers to pull off, but come flying out with the spit and you'll understand why the risk is well worth the reward. Unlike a frontside tube where you have the luxury of watching the wave form and throw over you, not to mention the control you have over both the path you choose and the speed you're carrying, the backside tube is much more a game of chance. John Peck's iconic rail grab at Pipeline in the early '60s was the first indication that backside surfing had come of age and that there was no disgrace in using unique body positioning in the achievement of groundbreaking progression. Sam Hawk was regarded as the most advanced regular-footer during the early '70s, when few rode Pipe on their backhand. Shaun Tomson, Rabbit Bartholomew, Mark Richards, Col Smith and the other '76 revolutionaries of the Free Ride period were among the first to challenge serious tubes, initiating their famous 'backside attack' in 1975-76. A generation later, taking their cue from the great power surfer Dane Kealoa's rail grabbing, hand-dragging innovations, Hawaiians Tony Moniz, Johnny-Boy Gomes and Sunny Garcia would revolutionize the backside surfing with new approaches and new tactics, changing the very idea of what could be done in the backside barrel.

And today, while all of the top surfers in the world have a fairly refined backside act, the intricacies of pulling off a successful tube ride have seldom been more apparent than in the South Pacific leg of the 2005 ASP World Tour season, in which Kelly Slater, en-route to his record-breaking seventh world title, put on an absolute clinic. At the Billabong Pro Tahiti, with his back against the wall, thanks to his ability to recover and keep his feet and body over his board, and thanks to a seemingly impossible wave, Slater fought back from a combo situation against Bruce Irons to stay alive. In the final, he went on to tally the only perfect heat score in World Tour history, a 20 out of 20 - all based on his backside tube riding prowess.

### SHAUN TOMSON

*Tube master and World Champion, talking about the winter of 1975, when Pipe was perfect and he won the Pipe Masters as a backsider.*

> *The true test of a man is dropping down a 12-foot beast of a wave backside, coming off the bottom and just standing there in the tube.*

Skip over to Tavarua for the Globe Fiji Pro, and while Restaurants was too big and racy for some, again Slater sought sanctuary in the draining left-hand tubes, and again was rewarded with a victory. These two events, won solely by Slater's phenomenal tube-riding ability, put him squarely in the driver's seat for the rest of the year.

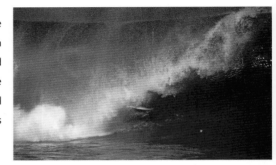

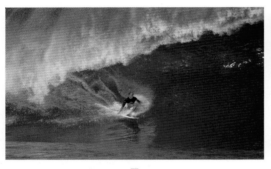

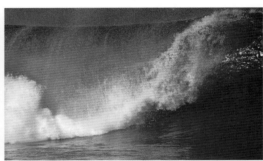

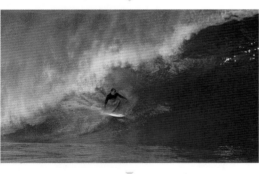

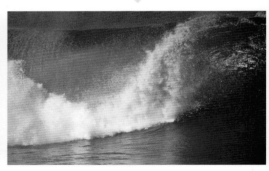

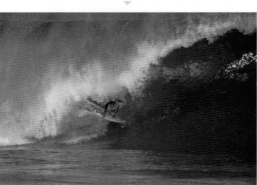

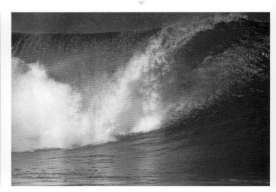

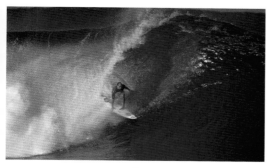
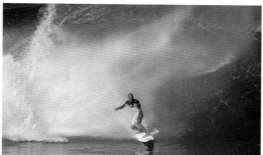
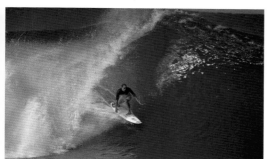
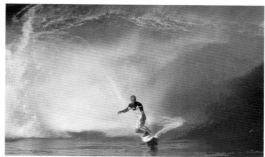

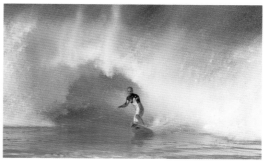
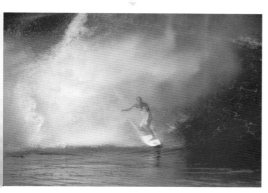

Whether talking about Teahupoo, Restaurants or Pipeline, Slater has often remarked that it's easier to sit deeper in the tube on your backside than it is your frontside. And while that may be true for the best surfer in the world, here are, on the 10 next pages a few things for you to consider next time it gets hollow.

Sequence: Kelly Slater dominates Pipe on his backhand

### 1.START WITH THE RIGHT EQUIPMENT

*You need a board you can trust to stay solid when you take off late under the lip,* says **Pancho Sullivan,** a Hawaiian with one of the best contemporary backside acts in surfing. *You don't need a loose board; you're better off with one that's slightly longer and thicker that goes well without the tail sliding out.*

*A little more rail is good on a steep hollow tube,* **adds Andy Irons.** *You want to keep a harder line when you're riding in the barrel.*

### 2.SET UP FROM THE BEGINNING

*It starts from the beginning - the take-off,* says **Tony Moniz,** whose backside charging at Pipe broke the barrier for regular-foot surfers at the world's most challenging wave. *It's a quick, spontaneous reaction that varies with the way the wave appears to be bowling. Whether you take off early or late depends on what situation you want to put yourself in. A late take-off allows you to pull into the tube early, just as the wave is pitching over. With an early take-off you can crank a heavy bottom turn and set up further down the line. Ideally, though, it's better to come in at an angle of 60 to 70 degrees, so you have to make a less radical transition. You want to be thinking about getting tubed from the beginning.*

**Pancho Sullivan** agrees: *If you're at a beach break or a reef, you want to take off a little behind the bowl. Basically position yourself as deep as you feel comfortable. You usually will want to grab the rail immediately from the take-off and drive into it. That way you can pull up on the rail if it's going to instantly start barreling and slide right up underneath it.*

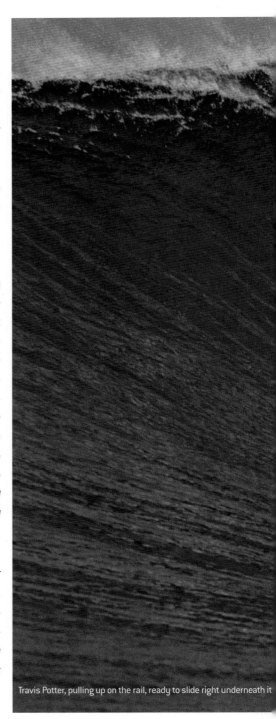

Travis Potter, pulling up on the rail, ready to slide right underneath it

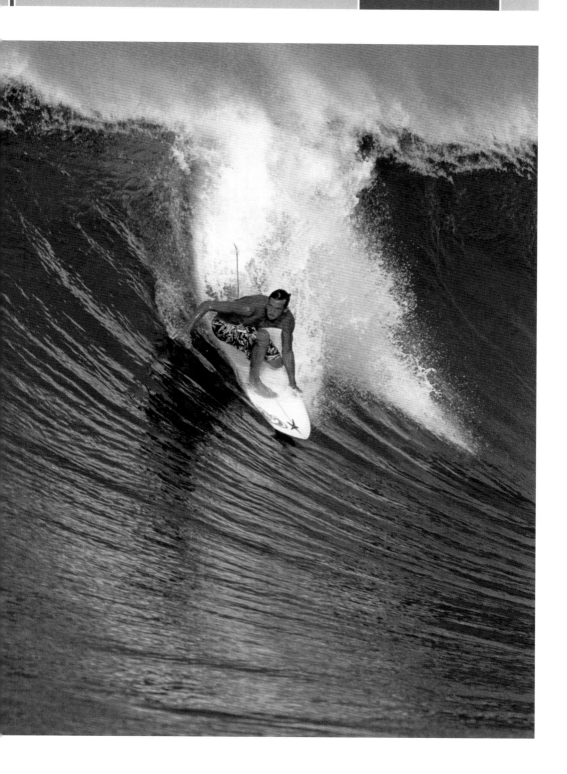

### 3.TAKING A STAND

*On my backside take-off at Pipe my weight is centered, putting my center of gravity low on the board. I'm standing on my back foot, leaning on my inside rail with my knees bent in a 45-degree crouch,* explains **Moniz**. *My stance has a pronounced back twist in it, like I'm standing goofyfoot, but with a backside stance. With this position I'm almost facing the wave without grabbing the rail.*

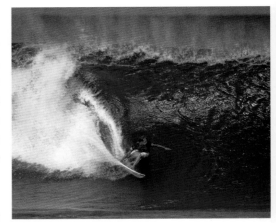

*At this point you want to lean more on your front foot; the back foot is just kind of planted,* says **Sullivan**. *Stay low and crouched over your board with your center of gravity forward. Right at the barrel entry is where you want to commit and duck in and hold your line. Just hold on and see what the wave is going to do. If it looks a little bit tight, lean forward and pick a high, fast line that will get you through into the next section without losing speed.*

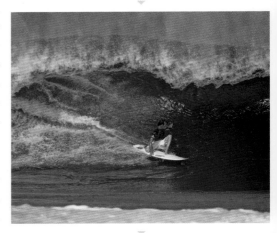

*In the single-fin days, before the rail-grab, most guys would take off crouched over with their backs to the waves,* says **Moniz**. *They'd put both hands on the outside rail and cringe with their eyes closed as the lip came down. For myself, I find rail-grabs most effective in situations where I'm pulling up high into the tube, when you want to stay up on the wall and keep control,* recounts **Moniz**. *Weight as you come off the bottom, and as you pull up to the tube, un-weight; the transition being back to the outside rail from the inside rail. From that point on it's about just lining yourself up with the tube, going parallel with the wave, staying low and concentrating on keeping your center of gravity square to the wave.*

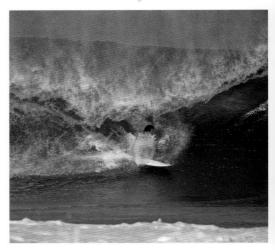

Taj Burrow, taking a stand at Pipe

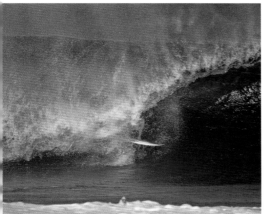

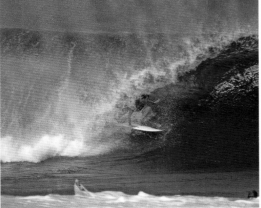

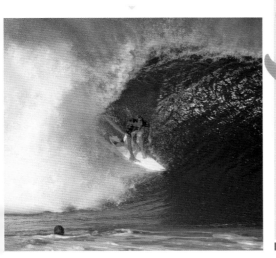

PRACTICE TIP **BY BRAD GERLACH**

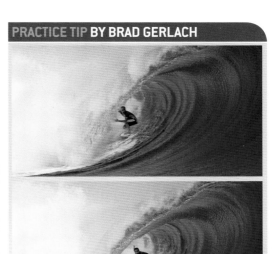

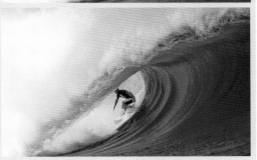

*Take off on waves and find out how to fit your body into the shape of the wave. Put your back knee on the board, weight your front foot, put your leading arm into the wall, stay compressed - try different things to fit your body in backside. You have to learn in the moment, because it's all based on the shape and size of the wave itself.*

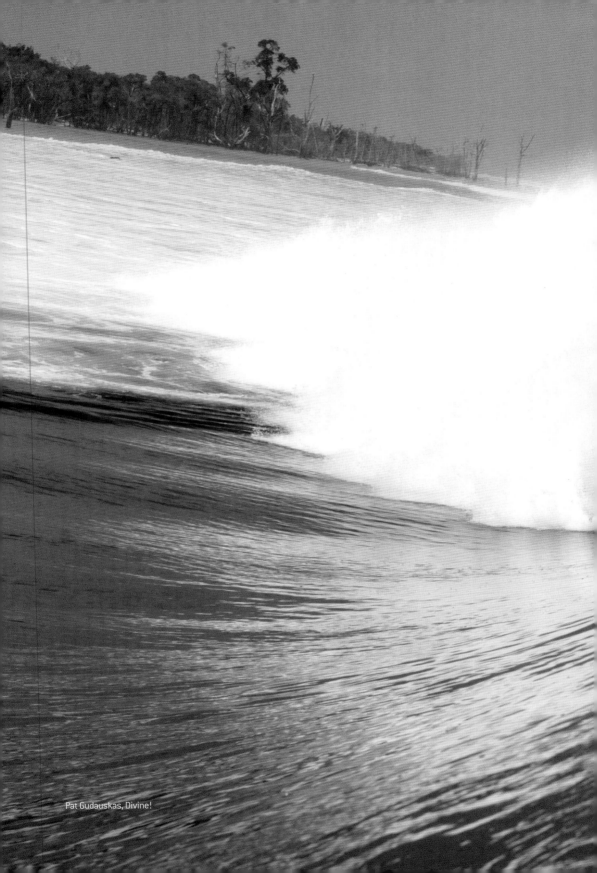
Pat Gudauskas, Divine!

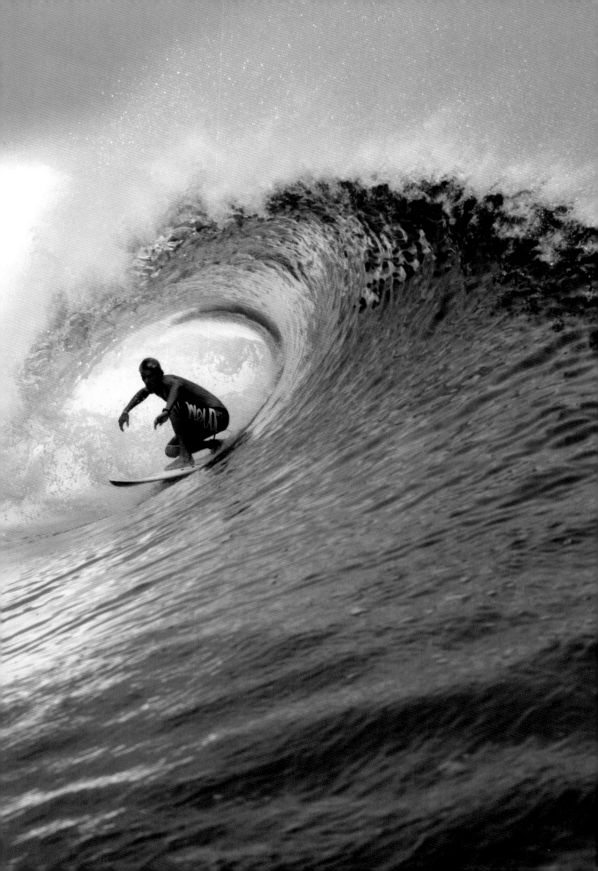

### 4.NEGOTIATING THE TUNNEL

Once you're in the tube you have the flow going with you. From there it's just a matter of keeping that rhythm going, says Moniz. You can get additional speed in the tube after your initial turn by pumping your board. You're actually turning again in the tube, following the wave. It's a lot like dancing.

You can pull up on the rail to readjust to the next section just coming over, explains **Sullivan**. When you pull up on the rail, it allows you to do a little pump without getting too high on the face. By pulling up on the rail and using your leverage on the wall, you can get up a little higher and ride back down with it, then pull back up on it, get a little higher again, then ride back down. It's like doing a little backhand rail-grab pump. It's a good way to help you feel more confident driving through big backhand barrels. Stay committed: the safest thing to do when you're in the tube is to hold on until you completely stop or you come out.

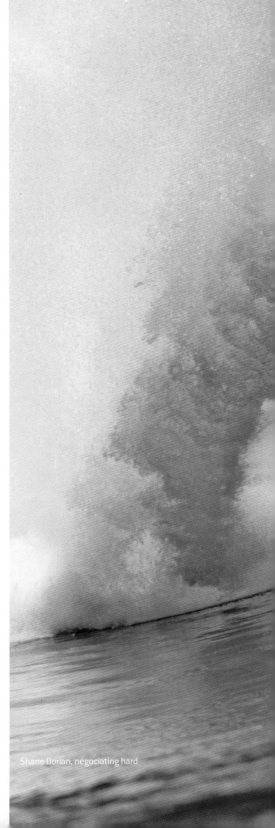

### PRO TIP BY JOEL PARKINSON

" For backside you have to watch Andy. It's all in the shoulders. The key is to rotate your shoulders so the upper body turns square. This is why people grab their rail, because it squares them up with their board - but if you can do it without grabbing rail, all the better. "

Shane Dorian, negociating hard

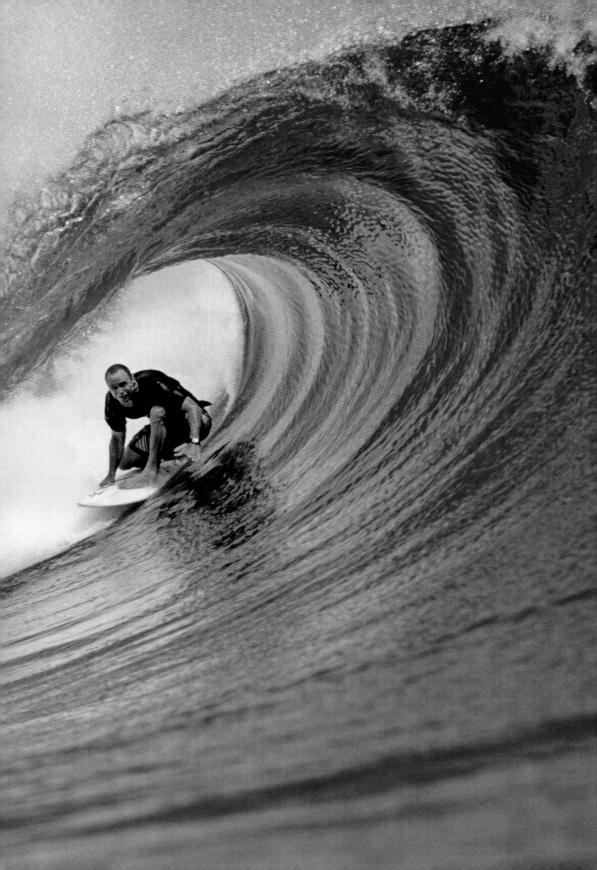

### 5. MAKING A CLEAR EXIT

*Use the wave to sling-shot you through. If you're above or on top of the foam ball, chances are it will end up pushing you out of the barrel, says* **Sullivan**. *Try to pick your line down into the bowl. If the lip is bending, angle down a little bit more, almost out of the barrel, to set up for the next section. In this kind* *of situation you want to be leaning forward as much as possible to get down into the lower part of the wave because it's about to throw and bend. Once you come out of the section, you can stall by shifting your weight to your back foot, pushing on the tail and dragging an arm.*

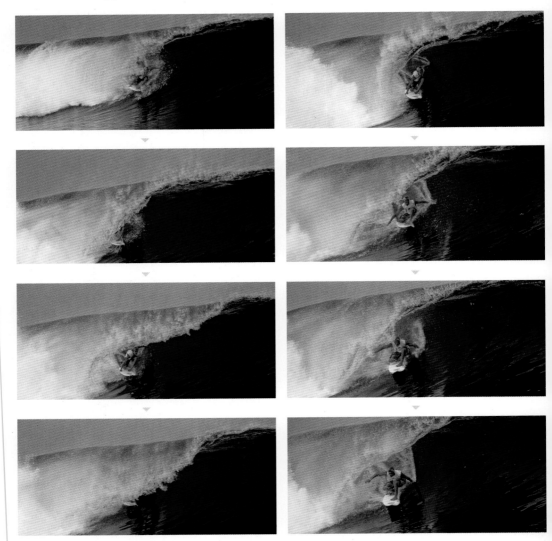

Sequence: Pat Gudauskas in the hole

## 6.HOW TO STALL

Getting tubed backside presents the same paradox as getting barreled frontside. You have to go fast enough to match wave speed and make the wave, yet slow your forward momentum sufficiently to allow the lip to cover you. Moniz recommends a number of techniques for braking long enough to slip under the curtain:

**Drag your hand:** At times I will drag my left (inside) hand to get into the tube. I'll stay low, keeping my arm by my left knee, almost hiding it. In a contest this is a strategic move, because the people on the beach can't really see what you're doing.

**Arm-anchors:** A technique I use quite a bit at Pipe is 'arm anchoring.' This is where you plant your arm in the face of the wave, stall, and pull into the barrel.

**Knee-dragging:** Another way I slow down on a really steep wave is to drag my left knee. This has to be done just right or you'll get hung up.

**Butt-dragging:** Since you're facing backside, you can drag your butt very effectively. That's a good one to use in powerful waves, because you're using your body weight to balance the force of the wave. Oftentimes, if you just use your hand, the strength of the wave will pull you off balance.

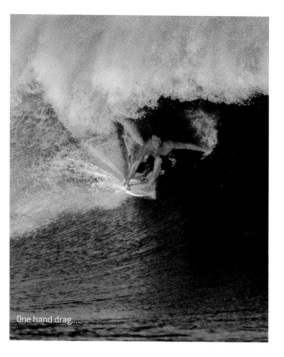
One hand drag....

### PRO TIP BY ANDY IRONS

*Butt drags help you slow down, and are the key to backside tube riding. Not too many people can do it that well. Obviously, you need good, hollow waves to practice in.*

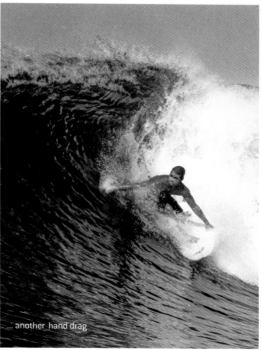
... another hand drag

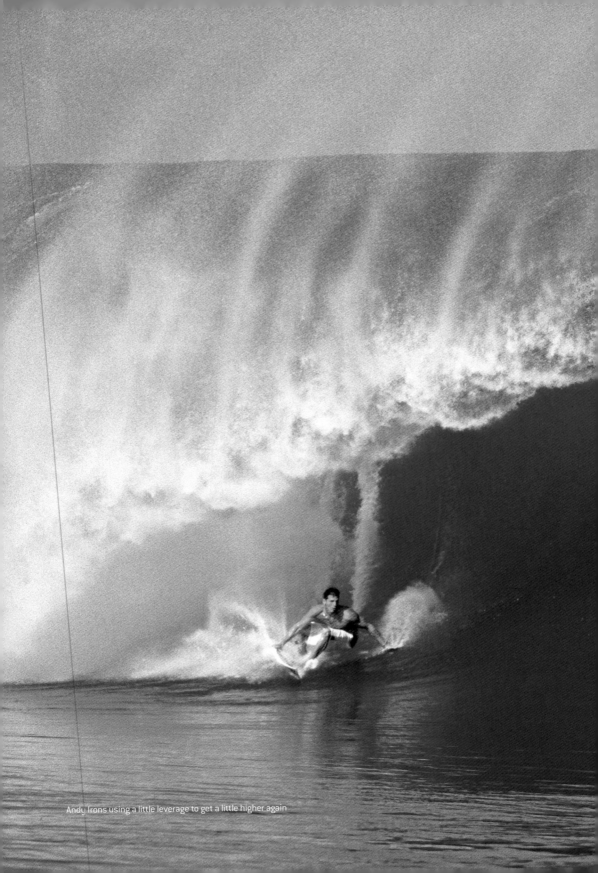

Andy Irons using a little leverage to get a little higher again

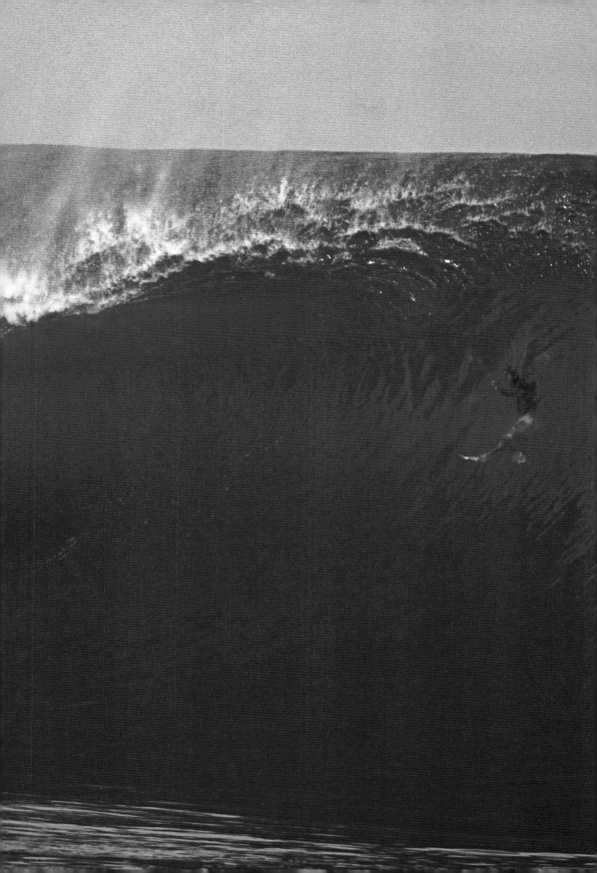

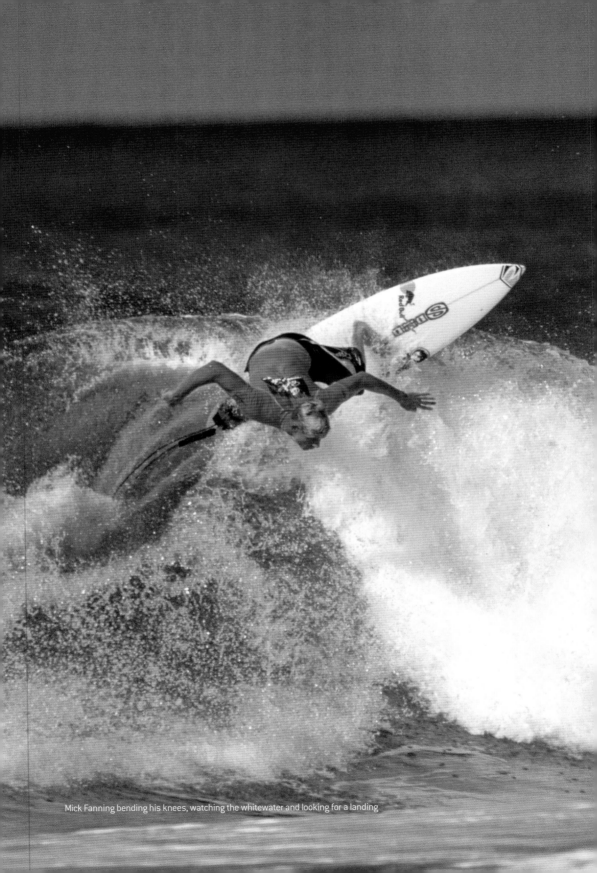

Mick Fanning bending his knees, watching the whitewater and looking for a landing

# THE GREAT ESCAPE
## Exiting the Backside Closeout with a Stylish Snap

*Escaping from a closeout is way more important than most surfers give it credit for. I learned surfing at Pine Trees that the ending of a wave is as important as the beginning - especially in the way other people judge your ride,* says **Andy Irons.**

In other words, the bros are going to give big points for ending your ride with style and flair, rather than diving off and letting your leg rope do the dirty work. Andy says the secret behind making the move work is not so much the power and speed, but the light touch behind it.

Keeping a high line on the wave as you enter the closeout section will position you with the speed and timing you need. When the lip comes at you, you have to let it do the work for you. It's like martial arts, where you let the force bypass you rather than totally confronting it: *I bank off the top corner of the section just as the lip comes at me,* says **Joel Parkinson,** *and then redirect myself until the nose is facing the beach and my body is almost horizontal.*

Keep your fins engaged in the wave, and shift your weight towards the tail. It takes finesse; but that is what separates the expert from the really good surfer.

Continue to hold pressure on the tail and look at your landing, so that as you take the freefall drop, you don't drive your nose right into the bottom. *Bend your knees*

*and let the board come up to you. Keep your knees flexed and loose,* says **Andy.** *The nose will naturally lift, and the move will be more of a drop than a slam."* Remember this is a snap, so everything is happening fast to pull it off. You can't overanalyze it.

The idea here is to get away from the impact and move ahead of it. As the lip comes over and closes, keep your eye on the landing, watch for the whitewash coming back up at you and put a little added pressure to your tail.

*One key thing to remember here is to make sure to land before the lip hits the water,* notes **Andy.** *Getting that timing wrong can have a brutal consequence. Try to let the wave guide you to your landing.* Lean back into the whitewater as it explodes; the force and momentum will push you back up. Project your weight toward the beach, letting the rocker of your board glide off of the whitewash. Once in the flats, stay low and fast, driving from rail to rail to maintain your speed.

### PRO TIP **BY ANDY IRONS**

*The key is to get to it early, so you can make use of all the speed at the end of the wave. Instead of a floater at the end section closeout, what I like to do is use my speed and once in the snap position, really put it on-rail. But you've got to get there early.*

Dave Rastovich, leaping for joy

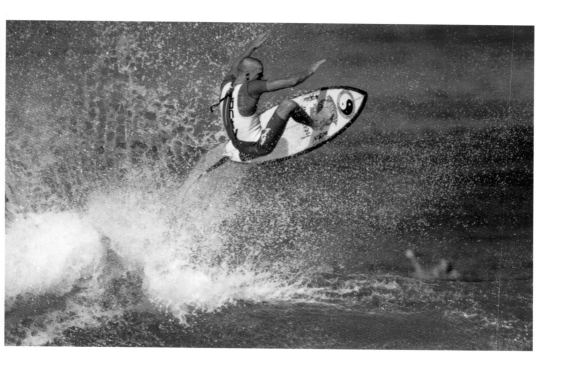

Archie was one of those guys you just couldn't take your eyes off. I wore out our copy of Wave Warriors III because I kept rewinding his segment over and over and over. He's just so radical, through and through, and you could see it even in the way he walked, his whole demeanor, admits **Andy Irons**. I did all I could to emulate his deal when I was young. I tried to hold my board like him, shake it like he did before jumping in the water, all the stuff I noticed in videos and magazines. I liked that his airs were more like extensions of giant off-the-tops instead of hops. Everything was power-based, full rail. I loved that. The only bummer was I got the worst rash ever from his pad; I had the one with the skull on it. It was a small price to pay, though.

Nobody does the whole reckless abandon thing like him, continues brother **Bruce Irons**. When we were young, on the North Shore, there were big days at Pipe with just a few guys out, and Off The Wall would be totally closing out, just crazy death-pits that nobody wanted any part of, the kind that shake the ground. But Archie would be down there stroking through huge closeouts on his way out the back, and he'd swing around and drop straight down the face. It was so heavy. Nine times out of ten he'd just get obliterated, but he kept going out for more. I'm not sure how he's still alive.

With that in mind, here are a few things to help get you flying sooner.

Left Page: Occy in a stylish frontside grab

Rigth Page: Christian Fletcher's second generation DNA helped pioneer the bionic surf-science of aerial flight. His original innovation is undeniable and worthy of credit where credit is truly due

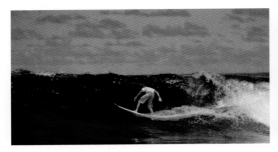
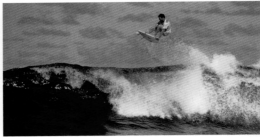
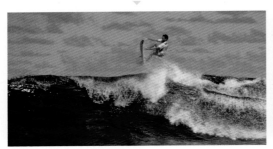
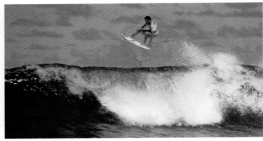

# THE FRONTSIDE PUNT

## THE APPROACH

Spying a perfect little launch section, approach with heaps of speed, and as you begin to move up the ramp shift most of your weight to your back foot, using your front foot to simply guide you up to the top of the wave. Maintain eye contact on the section you're hoping to boost from. Drive through your bottom turn into a clean launch off the top and carry your momentum off the lip into the air. Your board needs to lay flat on the lip when you take off. The key here is to get up high. *To do that you need to drive your momentum off the top of the wave by pushing off the tail of your board*, explains **Taj Burrow**.

## THE MOMENT

Once you hit the section try to completely un-weight your board by springing above the lip. Continue to keep the weight off your board during the altitude climb, and at this point think about contracting your upper body towards your lower body - this will make you more compact and centered as you fly through the air. *As you get airborne, try and turn the nose of your board towards the beach by straightening out your back leg. Just stay above your board, and pull your knees up to your chest to stay in control and to stay stylish in the air. The wind coming towards you can really make a difference here,* continues **Taj**. *"You've got to stay over the top of your board, and not lean back too far." Consider applying a little pressure with your back foot to ensure that your flight path is spot on. If you feel like your board is going to get away from you, this is the time to grab the rail. There are all kinds of different variations you can do - double grabs, mute grabs and frontside grabs; almost anything you want. I don't really plan it all out most the time. I just*

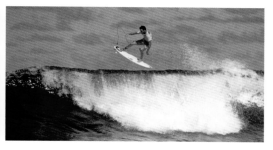

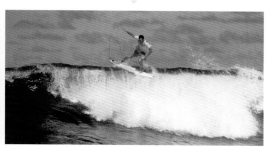
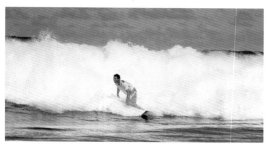

Sequence: Joel Parkinson

*experiment and learn by feel.* As you reach the apex of the air you're going to need to spot a landing zone. Staying focused on where you're coming down is the key to sticking it.

## THE RECOVERY

The toughest part of flying is undoubtedly the landing, so make sure you've got yourself together as you start coming down. Be it a busted knee or a tweaked ankle, it's really easy to get hurt landing airs, so don't be afraid to bail out if you don't feel right. If you do feel good, start coming down with weight evenly distributed and maybe just a bit more pressure on your back foot. *As I start to come back down I let go of my grab and check out the softest landing area, which is usually the whitewater,* tells **Taj**. *I try to extend my legs a little so my knees can absorb the impact.* Avoid

the temptation to 'stomp' the move down because straight-legging it at this stage is a recipe for disaster. Negotiate the whitewash by quickly squaring up your shoulders over your board, and with knees bent and tucked firmly under your torso. From there it's just a matter of not falling off.

## ADD SOME STYLE

**Parko** adds *Style is a lot more important today. It used to be guys would just throw it up into the air and let it fall where they may. But guys like Taj have made style an issue by doing it so well. There are two ways to add style,* says **Parko**. *First, use your knees as shock absorbers, and stay low to keep your center gravity and balance. And second, finish strong with more speed: connect as smoothly as possible, complete the wave, and continue to ride.*

Occy's surfeit of speed allows him a generous amount of airtime

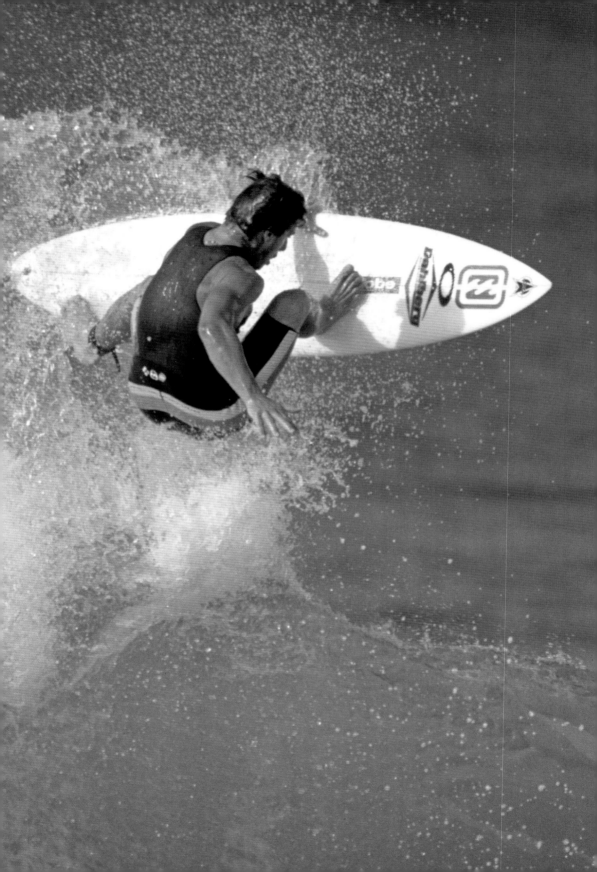

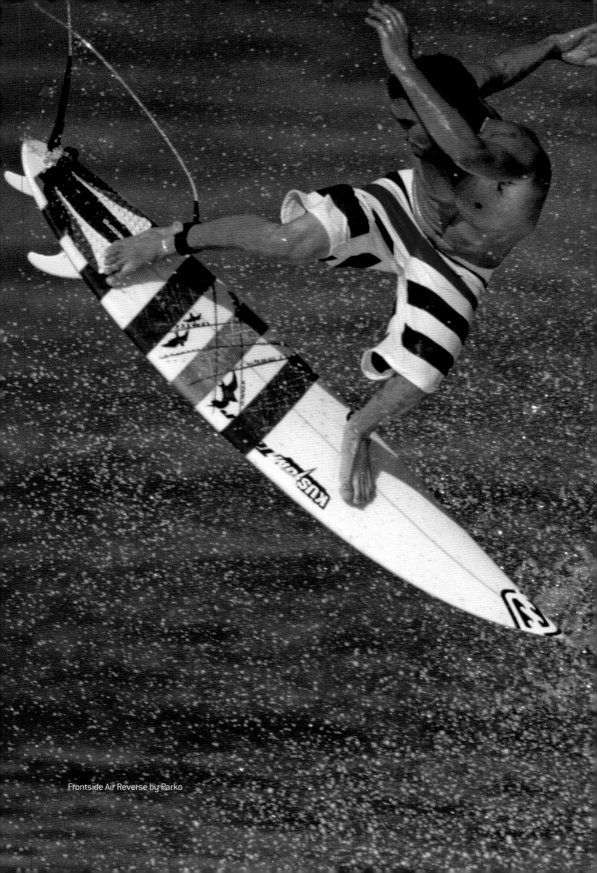

Frontside Air Reverse by Parko

# FRONTSIDE AIR REVERSE

## THE APPROACH

Even though an Air Reverse is simple to do on a closeout, you can just as easily do them on a steep open-face. On the drop-in, you need to stay between the middle and the top of the wave to generate as much speed as possible. The most important things for this trick are speed and timing. Look down the line for a section that is just about to pitch out. *Basically you come on to the section the way you would a front-side air,* explains **Taj Burrow**. *From the middle of the wave you just throw your turn and project your board at a steep angle off of the lip.* Stay low through your bottom turn, and aim straight up into the lip. Keep your eyes focused on the point of contact, and get ready to launch.

## THE MOMENT

*At that point you just throw your body into a spin* says **Taj**. *Just before you leave the lip your shoulders and upper body just start twisting.* Follow your back foot, rotating through the air as you push the tail of your board out hard towards the beach. *As I'm making my rotation, I look down over my toe side rail for my landing. I try to keep my tail a bit higher than my nose so I don't tail dive, and try to land the tail first.* Stomp the landing. Try to land with your tail pointing straight into shore, and your weight centered over your front foot.

## THE RECOVERY

*You have to keep your feet attached; solid,* **Taj** concludes. *Your feet will usually be a little farther forward, so look over your shoulder to finish the trick and get your nose pointed back towards the beach. If you land over your fins your board will want to keep spinning, so just let it spin around front-side and relax and stay balanced as you pull through the end of the move.*

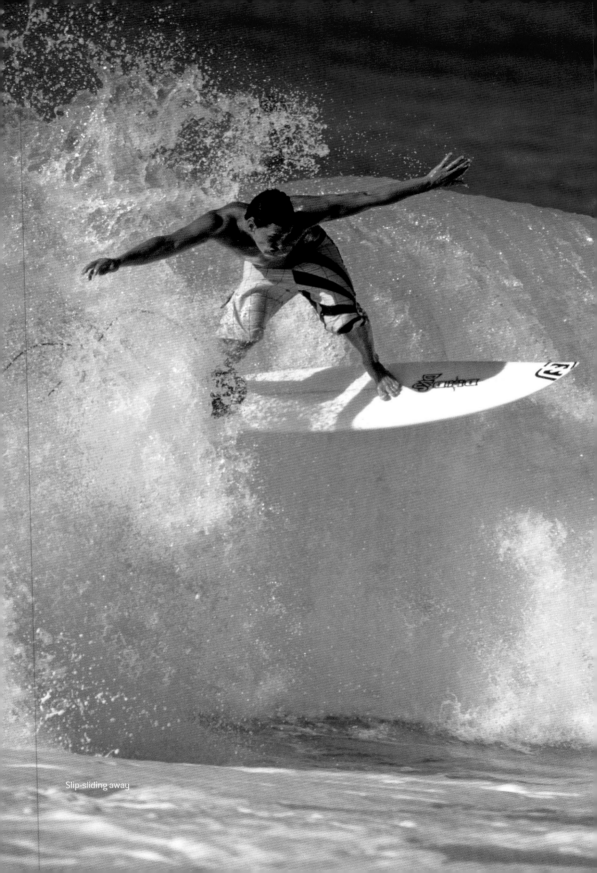

Slip-sliding away

# LET IT SLIDE
## Fin Drifts and Tail Slides:
## Keys to Keeping Your Composure When Your Fins Disconnect

Mickey 'the Mongoose' Muñoz recalls the day in the '50s when he came down to a North County San Diego campground, paddled out at Oceanside, and saw Phil Edwards surf for the first time. *Phil took off on this sizable wave and as it got steep on the face his tail just came out of the wave,* remembers **Muñoz**. *Without missing a beat, Edwards backpedaled, reconnected the tail, and then drove his rail straight back into the wall and continued down the line. It's an image burned in my memory,* says **Muñoz**. More than a simple history lesson, this is really just a reminder that expert surfers have been dreaming of or attempting variations on almost every contemporary move since the advent of foam surfboards. For a brief period during the '70s the 'sideslip' (breaking the fin loose on a steep wall, and then letting the rail of the board slide down the face) became such a popular maneuver that shapers actually designed sticks that would break free more easily from the wave face. As shapes became more maneuverable, and tri-fins allowed reconnection to elevate far beyond earlier options, breaking the fins loose at the top of the lip became a de rigueur part of the surfer's repertoire. For surfers today who want to get the drift, here are a couple of the variations:

## THE BACKSIDE FIN DRIFT

### 1.THE APPROACH

Coming off the bottom, you should be looking over your front shoulder for the area you want to crush. Since it's the speed you generate in your bottom turn that's going to push you through the ceiling of the wave, apply maximum pressure. Begin storing energy by compacting and coiling your body.

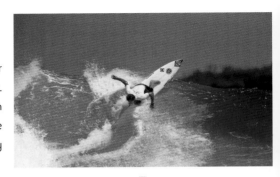

### 2.TAKE IT VERTICAL

You're going to want to project straight off the bottom and approach the lip at 12 o'clock, exactly like your straight-up snap. As you start to come off the bottom, begin directing your board back up the wave face, preferably straight up. Turning vertically, as opposed to performing a long, drawn-out bottom turn, will ensure that you arrive at the most critical section of the wave. Making contact with the lip, your board should be pointing to high noon, and now it's time to focus on rotating the board around. Timing is critical here, and relies heavily on experience and natural feel. The turn is initiated from the arms and shoulders, which cause the hips - and, consequently, the board - to follow suit.

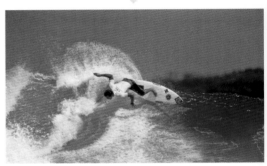

### 3.AIM HIGH

As you approach the lip, rather than beginning your turn right at the lip line, try to aim just a little higher - enough so that when you snap the turn you're pivoting right above your front fins rather than off your fin cluster. Your fins should release out the back of the lip. Make sure you stay solid and centered here. It's critical not to let your board get away from you.

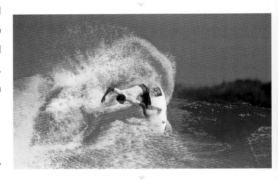

A signature backhand tailslide. Look how he pivots above the front fins and releases out the back of the lip. Notice his instant change from extended legs to squat re-entry

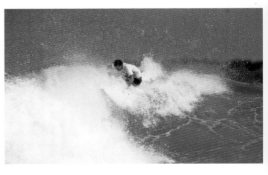

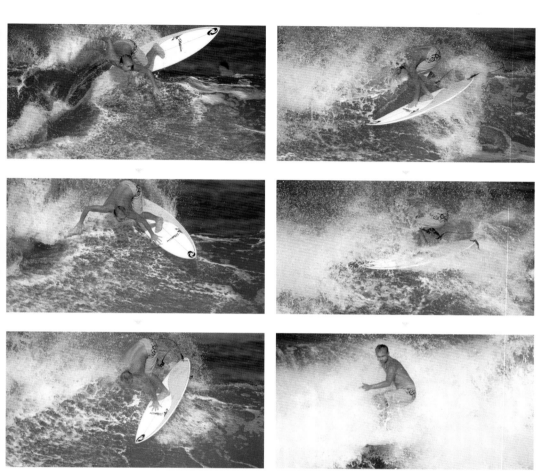

## 4.THE RECOVERY

You're not going to slip down the wave face like you would on a frontside tail slide. Rather, your fins are going to re-engage at the top of the wave. With a little back-foot pressure let them catch and spin you back around. You have to stay over your board because the wave's not going to do any of the work for you. From here on in, the success rate of the maneuver is directly proportional to the level of commitment to the turn. With the fins now free, there is no way to stop the rotation; any attempt to do so will result in the board flying away from your feet. Make sure to keep your center of gravity close over your board, which not only helps maintain control of your board but also affords you the added damage control if something goes wrong. In order to ensure the move's success, pause the rotation at just after six o'clock and wait for gravity to bring you back to the wave face. Over-rotating often results in catching a rail.

Pat O'Connell, a master at the fin drift. Notice how he aims high, stays centered, re-engages his fins at the top of the wave, stays low and lets gravity bring him down

# FRONTSIDE TAIL SLIDES

It was a signature maneuver of the 'Momentum Generation', and a staple of every talented young surfer today. More than just about any other move, with the exception of probably the aerial, the tailslide signifies the progression of the new millennium. While Mark Richards, Peter Townend, Shaun Tomson and just about every other surfer in the '70s was all about the Free Ride, and in the '80s, Tom Carroll, Tom Curren and Martin Potter, ushered in unbridled power surfing. But in the '90s, Kelly Slater, Shane Dorian and Rob Machado took a different approach - a catch and release act if you will. Whereas Curren would hold his arc all the way through his turn, thanks in large part to new potato-chipped, rockered-out boards, guys like Shane Dorian weren't afraid to initiate a turn and then halfway through blow out the back end. Here are some secrets to get you slip sliding away:

## 1.DRAWING THE LINE

Approach the wave off the bottom like you would a typical cutback, although you may want to take a more top-to-bottom line because you don't want to end up too far out on the shoulder. *The key is getting the fins free of the wave*, says **Luke Egan**. *You're looking for the sweet spot of the wave, or the bowly, vertical section that's going to help both blow out your fins, as well as support you as you slide back down the face.*

## 2.FIND THE PIVOT POINT

As you start to initiate the turn, look for the pivot point that will allow you to release your fins. Unless you're busting it out off the top, usually this comes about halfway through the turn. The key here is to stay centered over your board and not let it get too far

out in front of you. You're going to want to shift your weight from your back foot to your front foot. This will help take pressure off the fins, but still allow you the back-foot control you need to push the tail out.

## 3.OVER-PROJECT

*Pretend the lip is about a half a foot above the real lip, so you shoot higher than expected,* says **Egan**. *You want to get just that little extra bit of altitude to break your fins loose.*

## 4.SLIDE IT

As your fins release from the wave face you'll start to feel the board planing down the face. Now you're completely extended, and your tail is as far as it can slide. Start to ease up and center your weight. Here's where keeping all of your weight centered really comes into play. Now the board is mostly riding on the flat surface under your front foot, it's very easy to lose control.

## 5.REGAINING CONTROL

At this point your back should be to the wave face nearing the trough. To engage your fins, re-apply back-foot pressure and push the fins back down deep into the water. The board will naturally start to spin back around. As this is happening you need to let the wave push your body back up. *Really try to focus on letting the board do what it pleases,* **Egan** advises. *Once it's loose it will recover naturally. But you have to let it find its natural equilibrium.* This isn't a maneuver you're going to come out of with a lot of speed, and a lot of people have been critical of its lack of power, but it's still a lot of fun and is something that can be integrated into other tricks in your arsenal later on.

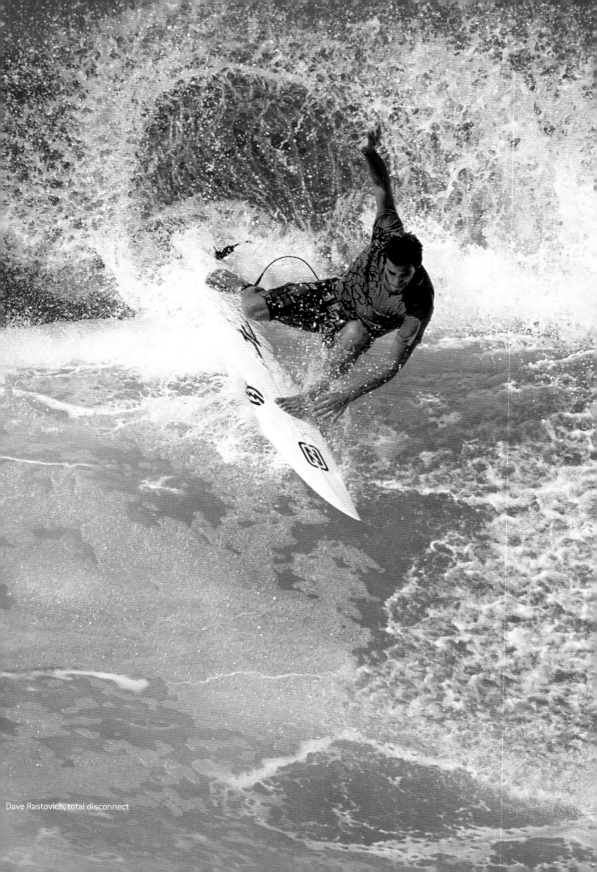

Dave Rastovich, total disconnect

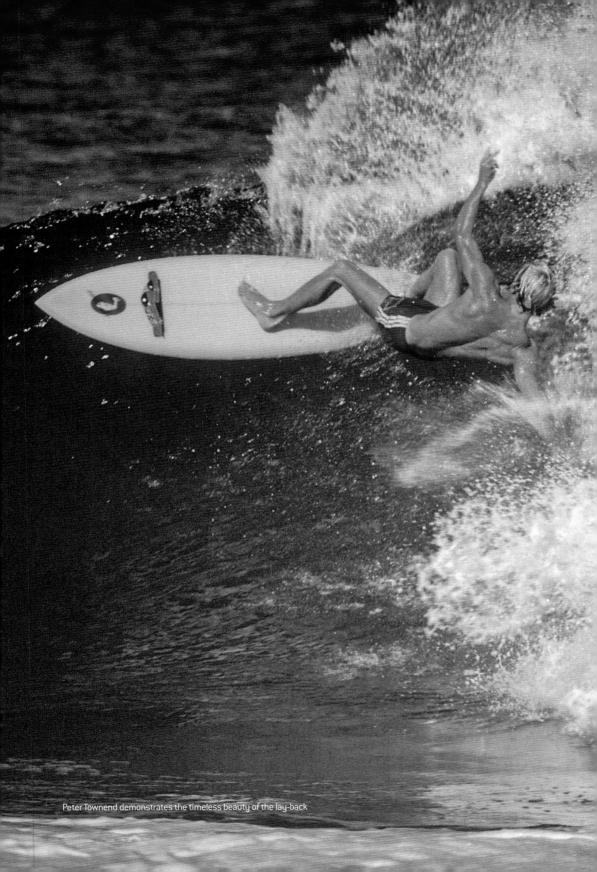

Peter Townend demonstrates the timeless beauty of the lay-back

# LAID BACK
## Adding a Little Style to Your Snap

When the big-screen version of the Malibu saga Big Wednesday hit movie theaters in 1978, Peter Townend's radical slashing layback on a sizable wave at Sunset was one of the film's stylistic sensations. But the maneuver itself had been discovered and then slowly developed for an entirely different reason. *"In the mid-70s I had made a name for myself as a stylist,"* recounts **PT**. *But then in '76 I won the world title. To remain competitive, I needed to develop a more radical maneuver.* It was on a break from the contest circuit while filming the surfing sequences for Big Wednesday that PT had the time to focus on developing creative moves in the outstanding point waves of El Salvador. *I was trying to shorten my radius on the turn - to make my moves more radical - so I tried sticking my arm into the wave face hard. The shortboard single fins would force the tailblock back into the wave, and the top-turn into bottom-turn motion made the cutback push into the turn to spring back under me. The rotation of my body would pick me back up. It was kind of an accident, but it worked, and it gave me a radical move to take back to the North Shore and the ASP Tour.*

Anybody can hit the lip, but few can do it with style. And fewer yet can invent a move by accident. *I started doing stuff different than everyone else,* says **Larry Bertlemann,** who along with Buttons Kaluhiokalani was one of the first to bring the layback to the forefront

of the surfing world. It all started in the mid '70s on the South Shore of Oahu, where Ben Aipa was shaping his patent Stinger for a whole new breed of creative types. Finally free to put their boards in places they'd only imagined a few years prior, Bert, Buttons and the gang blossomed thanks to the newfound maneuverability. And while a lot of their act was trial and error, it did result in an entirely new trick to add to the repertoire. *You mean the first time we did one?* says **Bertlemann,** referring to his classic layback. *Aww, man, it was an accident, really. We'd go up to crank a turn backside, and the fins were getting so small, the board just slid out. It was actually a recovery, just sliding down under the lip.* Accident or not, the maneuver has stuck with us.

**LARRY BERTLEMANN**

*Surf and skate innovator, and an influence on an entire generation of South Shore surfers.*

**Anything is possible**

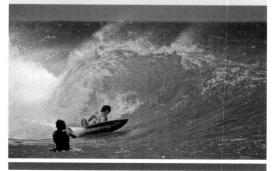

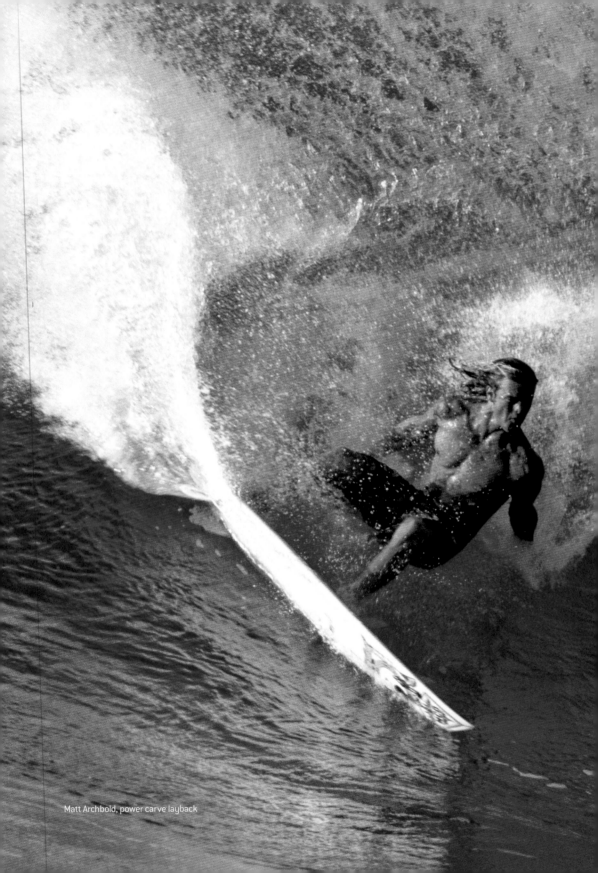

Matt Archbold, power carve layback

The layback was a controversial maneuver from the get-go, with some hailing it as a major innovation, and others labeling it a silly trick, but as it began to be explored, it was the tube-riding applications that proved most long-lasting. Simon Anderson used the tube layback to help win both the Surfabout and the Pipe Masters in 1981. From there the following generation pushed into lay-forwards and began the next phase of deep tube maneuvering.

From fun-loving days at Ala Moana, to Matt Archbold's power-layback in the '80s, to the new school board-slide recovery in the '90s, to guys like Andy Irons and Joel Parkinson putting a whole new spin on it, in one form or another the layback has remained a staple. Below are a few tips to help get you on your feet:

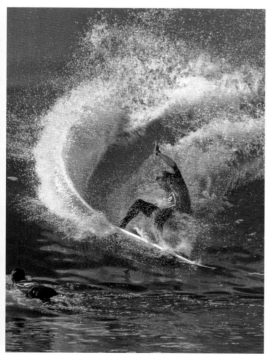

Andy Irons at Trestles

### 1.THINK BEFORE YOU ACT

Before you can throw down a layback you've got to understand what's going to be happening under your feet. *Visualization,* says **Bertlemann.** *A friend of ours used to take Super 8 movies of us, and I would watch them thinking, wow, I could cut that line shorter. Anything is possible. I knew what I wanted to do; I just had to get the boards to do it.*

### 2.DON'T FORCE IT

A proper layback shouldn't be forced; rather it should look like you intended it to happen. Approach the section of the wave where you're going to commit to the turn, just like you would any snap or carve. As you begin to engage the turn, start to put more weight and pressure on your back foot. In a sense you're just trying to blow out the tail, but at the same time you want to maintain control of your board, as well as your center of gravity over your board. Remember, laybacks originated because boards weren't always working the way they were supposed to. In the beginning it was more of a technique for recovering rather than an actual maneuver.

### 3 LET THE WAVE DO THE WORK

As your board starts to spin out, you're going to lay back onto the face of the wave. You don't want to fall through the wave; rather, just try to lie on the surface and slide down the face. As you start sliding, all the while maintaining control of your board, start to re-engage the fins and bring the board back around. This is where you want to let the wave push you back up to your feet. It sounds simple, but it's going to take balance, strength and focus to put all the components together.

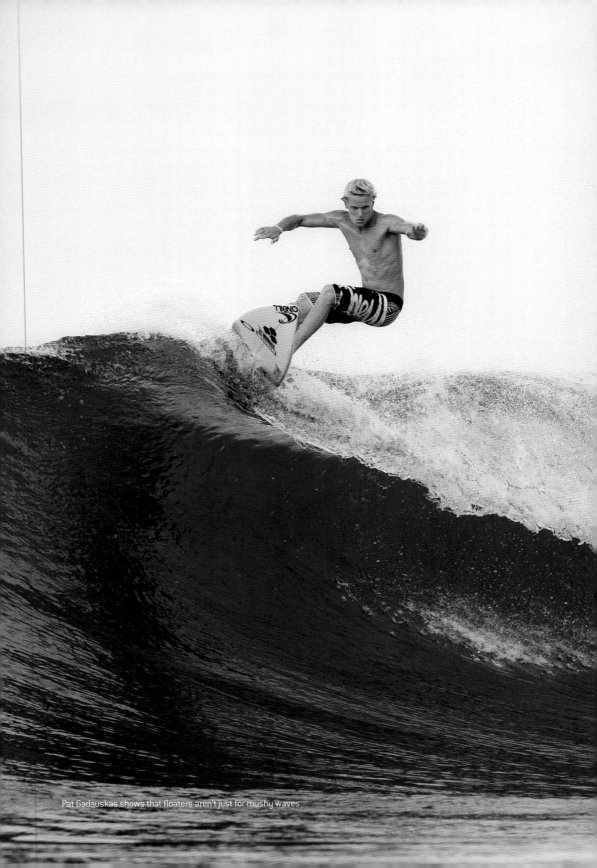

Pat Gadauskas shows that floaters aren't just for mushy waves

# OVER THE TOP
## Floaters and How to Use Them Effectively

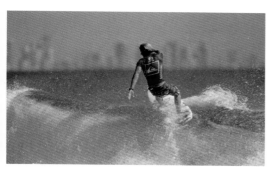 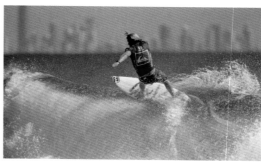

The great under-appreciated Cheyne Horan was one of the first pro surfers to experiment with floater-type maneuvers in the late '70s. Along with Davey Smith from California, and Mark Sainsbury from Australia, Cheyne broke a new barrier by riding on top of a breaking section instead of under it. Floaters expanded the sense of where and how one could traverse on a wave, which eventually led to tail slides, reverses and in due course, even aerials.

The greatest value of floaters is their ability to get past otherwise un-makeable sections. They can generate the distance and speed you need to set up an upcoming section, and they are a great way to complete a ride that turns into a close out.

*The three key elements to do successful floaters are getting up onto the lip, traversing the breaking section on the outside of the curl, and getting back down with a clean landing that leaves you with options to* continue or finish your ride, *says* **Taj Burrow**. *You just have to pop yourself right up into it from the face.*

*You need to start your turn from the middle of the wave and instead of putting so much torque or rail to it, stay flat and project up and out at about a 30-degree angle, says* **Parko**, *but you need to keep your speed full on so you get up onto it.*

*It's all about projecting onto the upper plane, kind of a geometry exercise, says* **Brad Gerlach**. *If your arc is too straight up into it, you won't go anywhere when you get on top of the lip.*

### CHEYNE HORAN
*Early floater innovator and four-time World Champion runner up.*

> **I'm not into doing the same thing that's always been done. I'm into evolution.**

*Come into it just like you would a kick-out*, says **Taj**, *but your angle is aimed onto the lip instead of out the back. You keep your knees bent and center of gravity low*, continues **Taj**. *At the beginning your weight is on your back foot. As soon as you feel yourself moving over the breaking section, shift from your toe edge to your heel edge. It's a complete release of weight at that point where you just want to project forward and have a super-light touch. You want to skim across the surface with as much speed and as little connection to the outside of the curl as possible. You're going for distance.*

*The idea is a little like the reverse of a tube*, **Gerlach** *explains, you go up and over the exploding section of the wave instead of down and under it.*

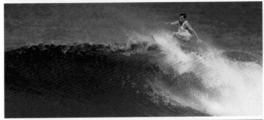

*As you skate across the top of the section, keep your focus on the breaking lip line*, adds **Gerlach**. *You're milking the thing for every inch of distance you can squeeze out of it. When you feel yourself losing the forward momentum, you can ride down the falling foamball. But if the wave is bigger, the best thing to do is ollie off the section onto the flats in front. Like any free fall, the landing is key and lightness of touch and finesse are important aspects that can only be practiced by actually doing the maneuver*, says **Taj**. *Try to land your board flat on the wave face, with a nice soft touchdown and then use your speed to go for the next section.*

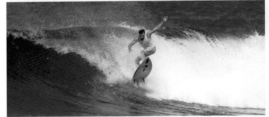

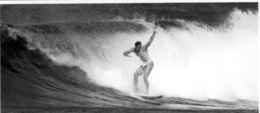

Left page:

Ross Williams

Right page

Hobgood shift his weight on his toe edge to his heel edge

Kelly Slater

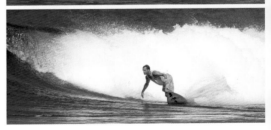

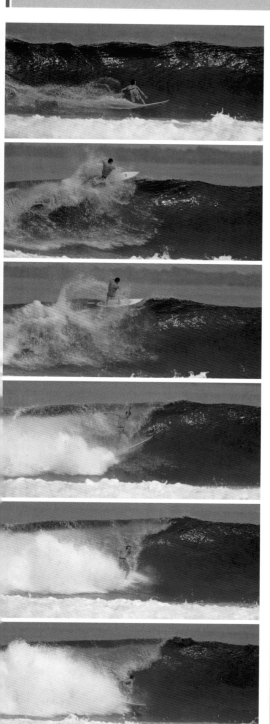

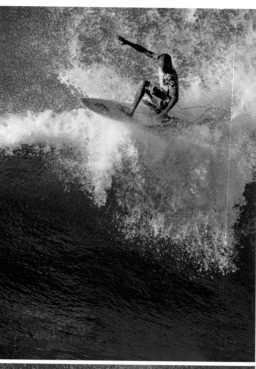

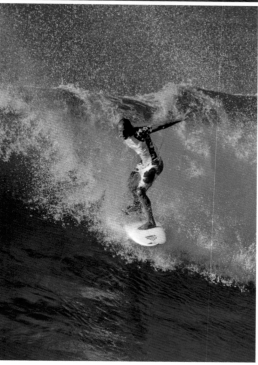

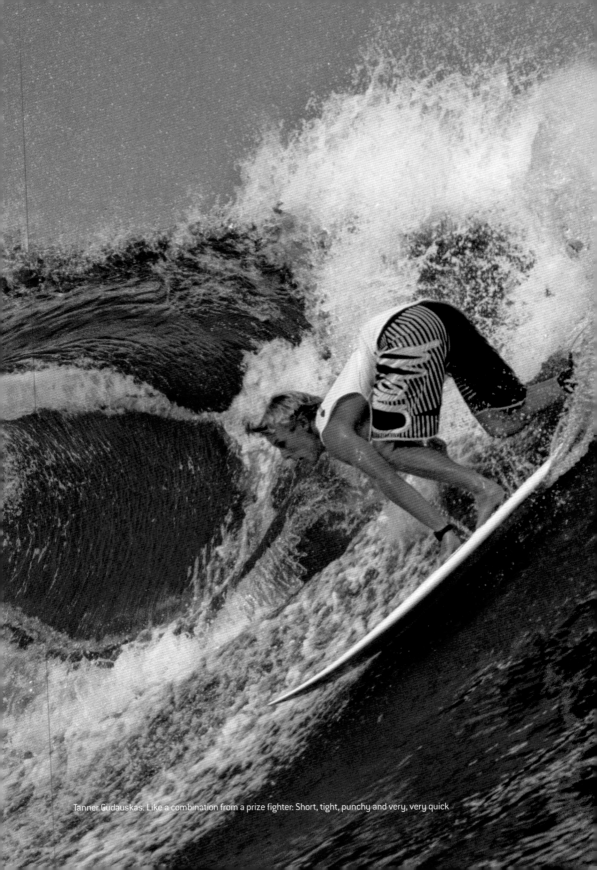

Tanner Gudauskas. Like a combination from a prize fighter: Short, tight, punchy and very, very quick

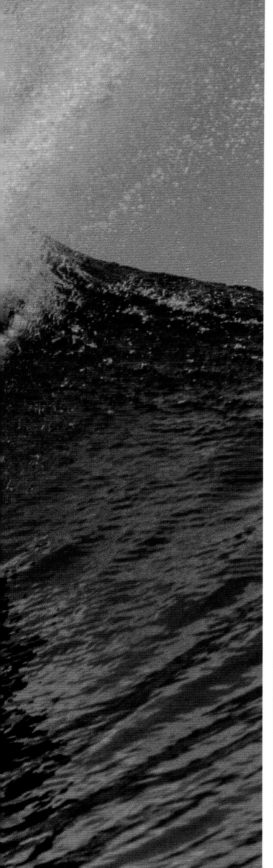

# THE MONEY TURN
## In-the-pocket Power Hooks

When you're looking to put a little more power into your game, there's no better way to show the world you've got the juice than to throw a few big power hooks in the pocket. Think Occy at J-Bay, flying a million miles an hour off the bottom straight up into a hucking lip. In his prime, nobody was better at it than Mark Occhilupo. Re-emerging on the world tour scene after a several year hiatus, it was at the famed South African point where his tack-sharp surfing clearly demonstrated to the world that he was back, and wouldn't be settling for anything other than a world title - which he won in 1999. And nearly a decade later, Occy can still strike terror in the hearts of top contenders that draw him in a heat, and terrorize a good lip with the best of them. Next page is a little advice to make the most out of the next pocket you come across.

### WAYNE LYNCH
*Taken from the movie Evolution, where he single-handedly rewrote the book on backside wave riding.*

   *The backhand teaches you to be the complete surfer. When you have your backhand down, you have your whole game.*

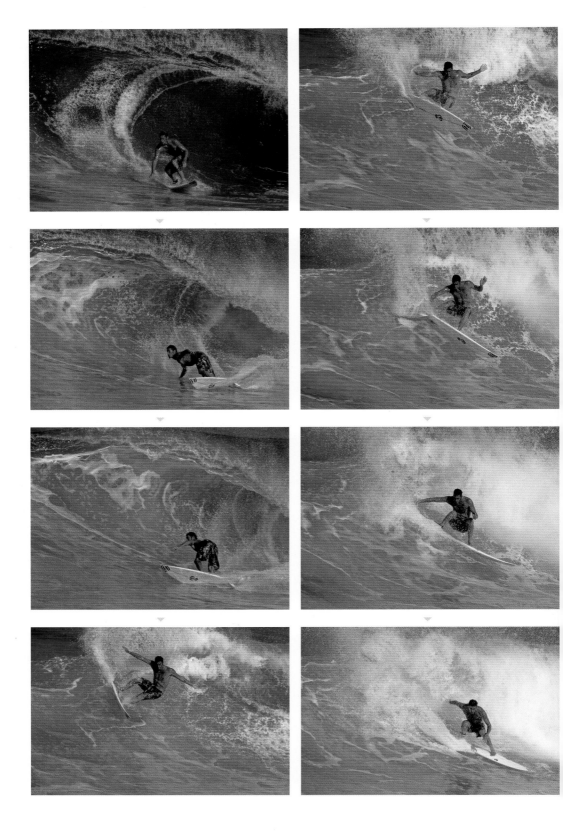

## THE WAVE

You're going to need a quality, hollow wave for this turn. You don't so much want a freight-train barrel, but you also can't have a flat, mushy wave either. Essentially, you are looking to hit the section of the wave right under the cascading lip.

## THE BEGINNING

*Power hooks in the pocket require a tighter than normal bottom turn,* says **Occy**. *You don't want to get too far out into the flats because you'll end up having to carve a roundhouse to put yourself back in the power zone. You want to come hard off the bottom, as straight up as you can go.*

## THE MEAT

From here what you want to be thinking about and looking at is what the lip's doing. If it's a thin lip or not quite throwing out far enough you may just be looking to push your board through the top of the wave and into a standard snap. But if you're lucky enough to have a good bowl above you, you're going to want to abbreviate your progress up the face of the wave and think about jamming your tail and fins into the section that's already gone past vertical, typically somewhere just over three quarters up the face. This is where commitment comes into play. By now you should have set your tail and are using it as an axis for the turn. Apply pressure with your back foot, and use the top of the lip as a base to push off of. Begin to drop your front arm and compress your body. Hook it hard. Try to jam your back foot as far into the wave as possible, while turning the nose of your board toward shore. *Keep your head up and your weight on the tail,* says **Occy**. Lean on the tail, so you don't catch the nose. You don't want your board spinning out, and you don't want to lose your center of balance either: you're in a critical section of the wave, so stay square and compact. You're putting your body in a relatively tight space, so get down low as you push through the turn.

## COMING OUT

You are freefalling now, so center your weight over your board. Shift some pressure to the front foot, leaning slightly forward to avoid losing the wave. You'll be gliding down the face of the wave at the same time as the cascading lip, which means you may have to punch through some whitewater. To maintain your balance, do your best to ride straight out of the turn, keeping your rails clean and free from anything that might cause them to catch. From here it's basically time to look ahead to the oncoming section and figure out the next best way to wow all the weirdos watching on the beach.

Power hooks: shorter bottom turn, tighter radius, faster redirection. Rasta shows you how

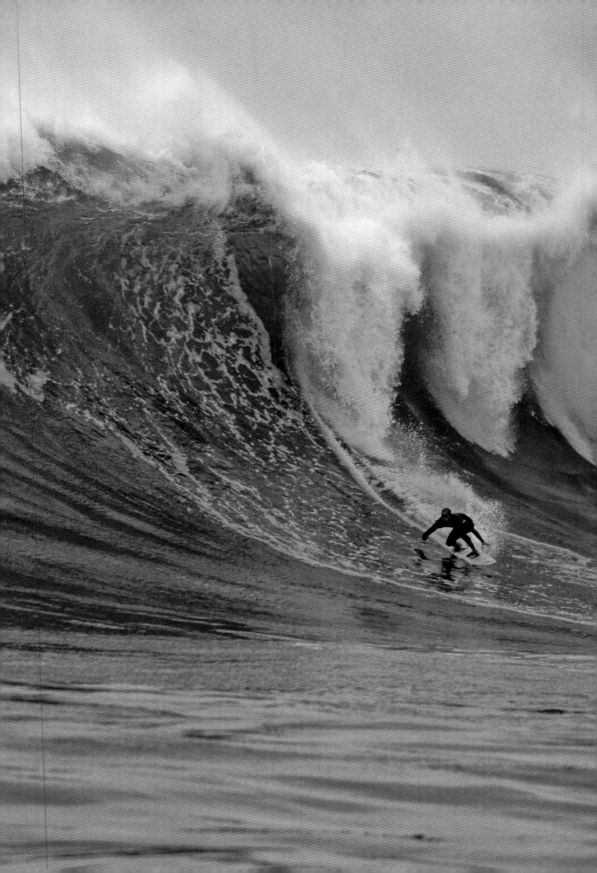

# DOUBLE EXTRA LARGE

## How to Be Better in the Really Big Stuff

Everybody has their own unique way of making their peace with heavy water. For example, World Cup Champion Ian Cairns would drive straight from the airport to Sunset, paddle out immediately into the biggest wave of a set and take the drop with total abandon. Most the time he would take it right on the head and get the beating of his life. But, as Ian was quick to note, from then on everything seemed like a piece of cake.

### RENO ABELLIRA
*Smirnoff Pro winner and legendary wave stylist.*

> There's no disgrace in turning away from big waves if you don't really want them. And to really want them you must be sure you're ready to confront the fear factor.

Kelly Slater, Cortes Banks, California

Cairns is hardly alone when it comes to understanding that getting the worst over with early is one way to prepare for challenging big surf. On Kelly Slater's first day out at big Maverick's, a jet ski offered Kelly a little assistance in getting out the back. *No thanks,* **Kelly** politely demurred, *I think I'll just paddle into one and take my lumps.*

Mastering big waves is an important but not essential element for becoming a great surfer. Not everyone is comfortable in big waves, and certainly there have been some world champions who were never bona fide big-wave riders. And there are many well-known big-wave surfers who have never excelled in competition or other specialties like tube riding or aerial-style tricks. But by and large, most surfers want to at least experience big-wave riding, and there is no question that mastery of this aspect of surfing elevates a surfer to a much higher level. For those who are intent on mastering the art of big-wave riding, get ready - it's not a quick study. The very rarity of large surfable swells makes the practice one that takes years, and each season may yield only a handful of giant days. But for those who have the time, aptitude and commitment, there is no bigger thrill.

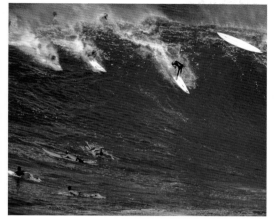
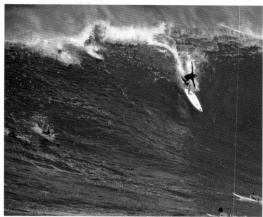
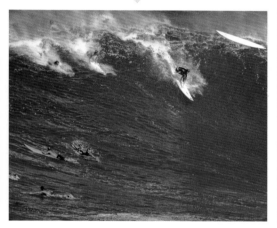
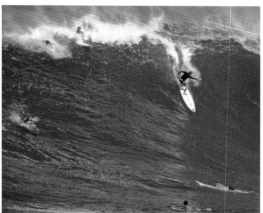

# TRY MEDIUM BEFORE YOU GO XXL

## 1. BRIDGING THE GAP BETWEEN LARGE AND SMALL SURF

Modern big-wave surfing and high profile stunts over treacherous reef passes have thrown what it means to charge completely on its head. But most surfers push their limits in the relative humdrum that typically pours into line-ups everywhere. Just because it won't make the highlight reel or wow the line-up doesn't mean it won't put your heart in your throat. So despite any teary objections, we offer these tips to push you into that prickly yet understated mid-range realm, so that when a set looms, you'll be ready to spin and go.

## 2. BABY STEPPING

It's always good to watch people who have a place wired, but to mimic them straightaway presents a very steep, agonizing learning curve. So approach a challenging session with low expectations and increase them in small, steady increments. The first step is to say, "I'll just go out and have a look." This doesn't commit you to going over the ledge, but it gets you in the water. After studying the waves, you might be ready to pick off a couple of in-between 'warm-up' ones. In doing so, you'll have already exceeded expectations. Also, set time limits. Keep sessions short and deliberate.

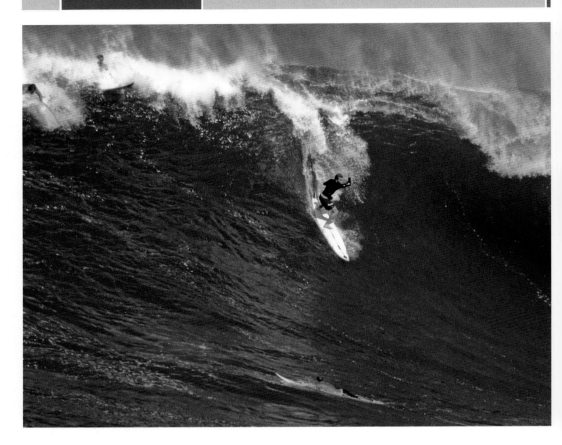

This will help you concentrate on accomplishing each small goal you set for yourself and give you the confidence to go back out. Finally, no matter how good the conditions, don't expect a banner session, and don't let hindsight or your conscience bully you. There's no shame to admit your boundaries are maxed out or let a couple good ones go by. Build on that experience to inch deeper into the line-up.

### 3.BREED FAMILIARITY

Before you went on that trip you hoped for six-foot perfection and now it's spitting at you in the face. But a slick pintail, hearty breakfast and tunes to get you psyched can't shake that sinking feeling. Now what? When you're in a foreign line-up, develop a strong sense of familiarity. Even on a micro level, dissect the set-up and pick out anything, no matter how insignificant, that reminds you of surfing at home: water temperature, lighting, wind, duck-diving; the horizon itself is a global homecoming to any surfer. Recognizing familiar clues in the surroundings will help you get into your element. Your equipment, especially, should be very familiar to you. If your last memory being on your hairy-wave board is sheer paralyzing panic, you should take it out on a more manageable day just to get reacquainted. Most importantly, don't let the occasion overwhelm you. Just the mystique of a break can root you to the ground: Backdoor, Mundaka, Desert Point, Gnaraloo; mere names of other lesser-known spots like Razors, Lacerations and Butcher's

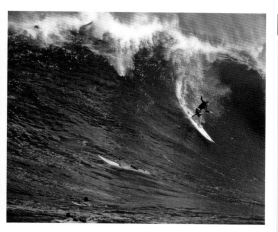

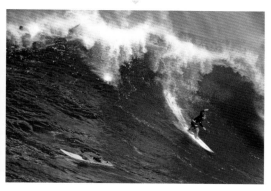

Mark Healy negociating the drop at Waimea, pages 246 to page 249

Block don't help either. Don't allow the tradition and lore of a spot derail you.

## 4. STAY IN YOUR ZONE

Everyone has a different comfort zone and someone will always go harder than you. Charging is a state of mind and improving your level is but a contest with yourself. Your comfort zone is meant to expand and that's where your focus should lie. So when you break through a personal barrier on one of those mid-range days, celebrate (quietly) your broadened comfort zone and stay intent on making more room.

### PRO TIP BY SHANE DORIAN

*Don't be too eager. Be sure you are ready for the challenge before you get in over your head. Of course as everyone soon finds out, you can't catch a bigger wave until you go where the bigger waves are breaking. So ease into the process. Push yourself, but not in giant leaps.*

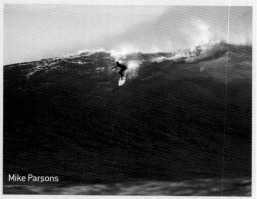

Mike Parsons

*Mental preparation is not psychological - it's physical conditioning. You have to have self-assurance, but it needs to be totally backed by fitness and overall body conditioning that can deal with extreme stress. Confidence and calm come from weeks, months and years of training. Preparation is not something you do that day - is something you do way in advance of the day you move out into really big surf.*

Rasta

## MEAT AND POTATOES
## THE BIG-WAVE FUNDAMENTALS

Figuratively, at least, all surfers start in the shorebreak. But there comes a time in everybody's development when they reach a level of expertise and confidence that demands looking out past those rows of white-water inside to greener pastures outside. And it's all relative. Those North Shore pioneers of the 1950s made damn sure they were comfortable surfing Sunset and Haleiwa before tackling Waimea Bay; Andy Irons worked his way up from the Pinetrees beach break to Pipeline barrels. All of them using some of the same strategies that can help you step up from San Elijo to Swamis, from Second Light to First Peak, from Baby Haleiwa to the real thing.

### 1.PEOPLE GET READY

It may sound clichéd but one of the best ways to gain fitness and endurance is to run underwater with a heavy rock. Swim down to the bottom, find a heavy stone or rock, pick it up, and run underwater for as long as you can. Shane Dorian does it. And nobody thinks he is crazy - or at least not that crazy. There are many, many really outstanding surfers who are not ready to attempt huge waves. Being competent in

### BRAD GERLACH

*If you are committed to big-wave surfing you should be willing to pay your dues. Great surfers are interested in challenging the power of the ocean. You have to really want to surf big waves to do it. Like Brock Little says, 'You do it for the sheer fun of it.' Big waves are part of the challenge and part of the thrill.*

Brian Keaulana, by Warren Bolster

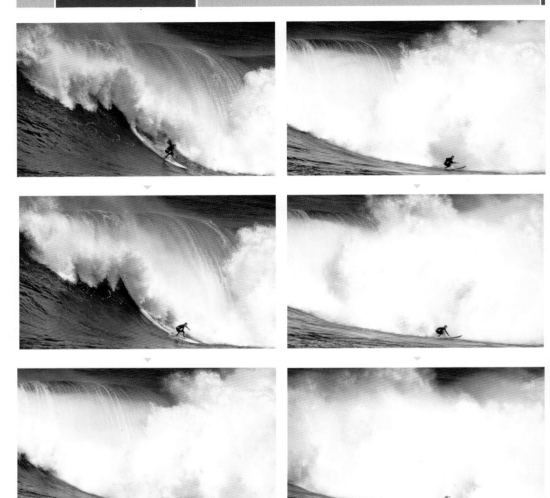

small and medium surf is essential but it is not the only prerequisite. You don't have to be in top physical condition to surf well in most conditions. Outstanding athletes with great balance, hand-to-eye co-ordination and plenty of water time can often make smaller surf seem almost effortless. Not so in big waves.

## 2. MOVING UP A GRADE

Accept that in surfing, nobody gives you a diploma. Look at it as the ultimate home school. The key to stepping up to a new, more challenging break is making sure you've learned everything required of you in the lower grade. By simply winging it at a more advanced break a surfer can actually lose ground in terms of development. So before moving up, ask yourself this: Am I completely comfortable at my regular break? Have I mastered paddling out, lining up properly and at least occasionally taking set waves? Has another surfer had to pull back from taking off because I caught the wave? Then assess your skills. Are you more confident backside or frontside? Shy away from steep, late drops or willing and ready to charge? Eager

to work up into a pecking order, or just looking for a few fun waves to ride? And be honest. The grade you give yourself on this sort of test will help determine how big a step up to take when choosing a more advanced break.

## 3.PATIENCE IS A VIRTUE

When you first walk up to a new, more advanced break the most important thing is to remain calm and patient. Fight the natural urge to just get on out there, and sit and watch long enough to identify the rhythm of the spot. And don't just watch the waves. Give your attention to the other surfers and see how they enter and exit the water. Note which path is more successful. Let a couple of sets reach the shore and note the interaction between whitewater and rocks or sand. At least consider some strategy should you get caught getting in or out. When you do paddle out for the first time, don't automatically take your place on the inside: dodging sets and careening surfers can be demoralizing. Instead sit off on the shoulder and watch a few sets roll through gauging where you might fit into the line-up most effectively. When you do take your place in the line-up, don't be too shy about it. Sit up on your board, make eye contact. Say hello, if the pack isn't too surly. Look for a wave with your name on it and go. And, most importantly, remember that when you take it step by step, approaching the challenge of wiring a more advanced break with good judgment and respect for the surfers who have already arrived at that point or beach break, you have just as much right to be out there as anybody else.

Sequence: Mark Healy at Waimea

## 4.ZONE OUT

Before the go-out, take a seat, look at the surroundings, bring yourself into the present moment, and project the environment you want so you can reduce your anxiety level. Clear your mind, so the nerves that are sending messages that may cause you to be fearful are soothed. Rasta says the more you relax and become present in the here and now, the more it becomes a natural state, and the easier it is to repeat.

## 5.WAVE SELECTION IS CRITICAL

When you are out on a day that is 20 feet, you want to catch the 20-footers. Not the 12-footers. The smaller and medium size waves are dangerous in this situation - because you paddle and miss them then it is very likely that you will take a 20-footer on the head. Another danger is that when a break gets really big the line-up changes. If a 30-foot wave is breaking outside it is probably in pretty deep water. But the 12 footer inside may be in a dangerously shallow area, or over rocks that are normally exposed. On a really big day smaller waves are likely to take you into the shorebreak or other dangerous areas. So, the wave you want on a 20-foot day is the 20-foot wave.

## EQUIPMENT TIP BY RENO ABELLIRA

*80 percent of your confidence should be based on the reliability of the board you've got. Get to know your board in smaller surf so you have it wired when the big surf comes. See how it paddles, how it catches waves, how it drives down the face. Get a feel for the fulcrum point, the way the rail engages the wall, how the nose recovers from the drop.*

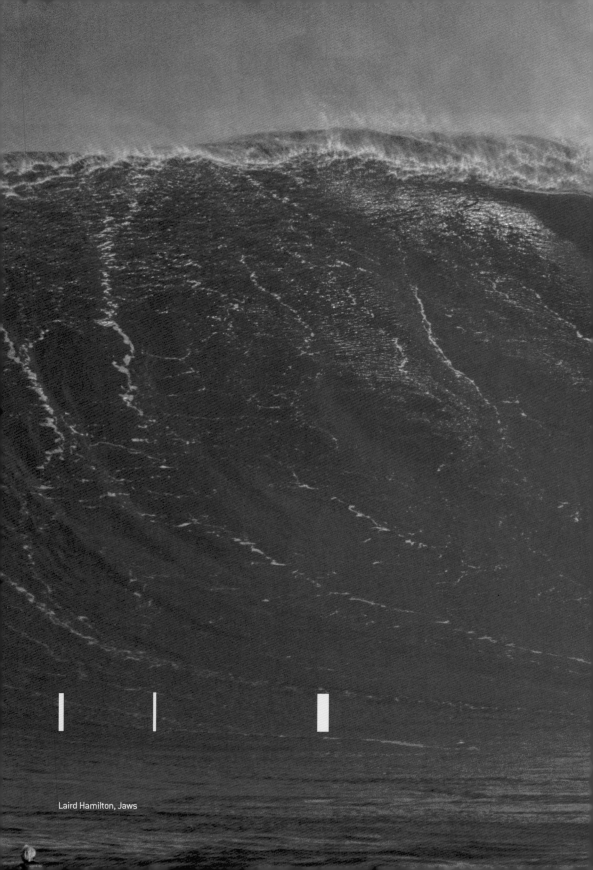

Laird Hamilton, Jaws

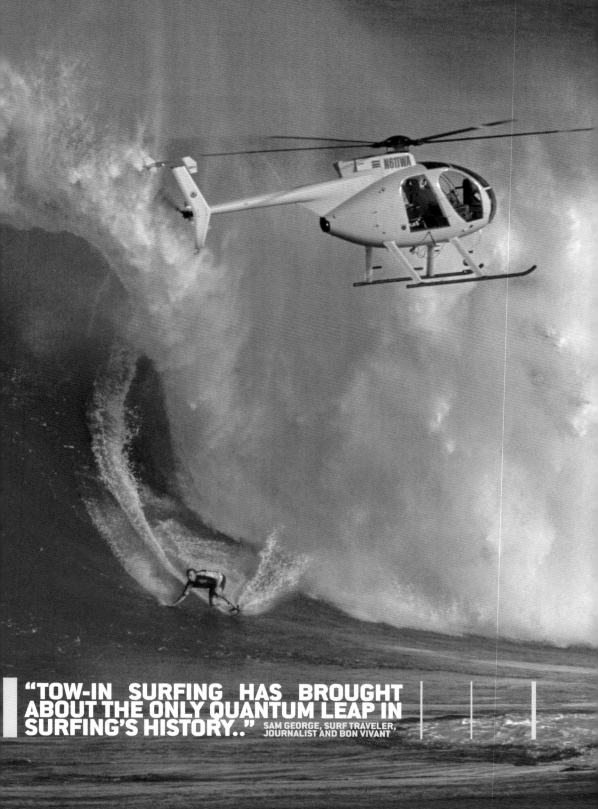

"TOW-IN SURFING HAS BROUGHT ABOUT THE ONLY QUANTUM LEAP IN SURFING'S HISTORY.." SAM GEORGE, SURF TRAVELER, JOURNALIST AND BON VIVANT

# TOWING THE LINE

*"This past winter, Laird Hamilton, Dave Kalama, Rush Randall, Pete Cabrinha, Make Waltz, Brent Lickle, Buzzy Kerbox, Darrick Doerner and Mike Angulo (not to mention Lyon Hamilton, Mike and Paul Miller, Gerry Lopez and Bob Haskin) invested a great deal of time, money and physical energy to explore this new epoch in big-wave riding. They experimented with foot straps and surfboards and jet-powered watercraft and came to the conclusion that they could ride very small boards in very large waves."*

**Ben Marcus, *Surfer Magazine 1994***

Partners in crime: Mike Parsons and Josh Loya

Skip ahead a decade and the entire big-wave arena has completely gone mad. There are more people riding more crazy waves than ever before. Without question, the relative acceptance of jet skis in line-ups around the world has broadened our collective concept of what's actually ridable. Before Laird and Darrick and the rest of the crew on Maui set about changing the surfing world, surfers were only able to catch the waves they were strong enough to paddle into, but now everything's changed. As the idea of tow-ins emigrated from Jaws to other outer reefs in the Hawaiian chain, where windsurfers like Peter Cabrinha had originally discovered the potential of such monsters, the trend

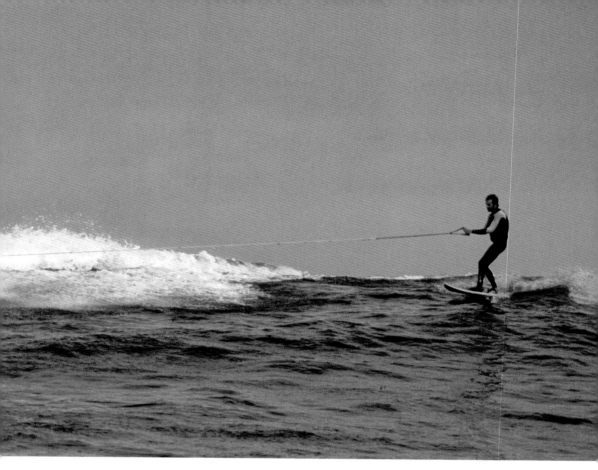

# Stepping Off Into the Great Beyond of Tow Surfing

started to catch on elsewhere. By 1998 Mike Parsons, Brad Gerlach, and friends had been to Todos Santos, and Jeff Skin Dog, and a host of limit-pushing Santa Cruz hell-men had upped the ante at Maverick's. With the advent of the Billabong XXL, big waves began to be challenged all around the world, in Chile, France, South Africa and Mexico, as new challengers like Greg Long, Brule, and Makua Rothman pushed different waves at different locations. And today, well, we sit on the sidelines and stare dumbfounded as freaks of nature like Shipstern's Bluff in Tasmania, or Cyclops and Ours in Australia, or Teahupoo in Tahiti are not only attempted but ridden with reckless abandon. Not only

has jet power allowed surfers to ride bigger waves; it has also ushered in the era of slabs, or below sea-level, stair-step mutants in which simply surviving is considered a successful ride. *It seems like these days the bigger and weirder the wave the better,* explains Maui's **Ian Walsh**, who's a leader of the next generation of mad men. *Big-wave riding's been completely redefined. And while there will always be something noble and heroic about paddling into a wave, there's a whole new perception of what's possible, and that's really exciting. The world's really opened up because of all these new possibilities.*

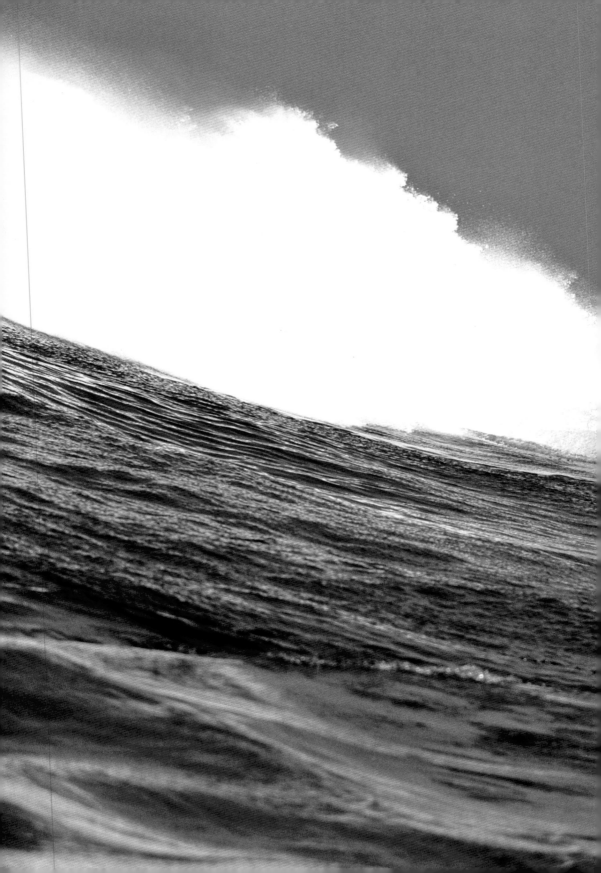

**So, you think you're ready to get whipped into a monster? Well, here are a few things to consider before putting a down payment on a Waverunner:**

## PADDLE FIRST

Ask any and all accomplished tow surfers and the first thing they'll tell you is you better damn well be an accomplished big-wave surfer before you step off into the unridden realm. Get comfortable in sizeable surf before you get in over your head. *It takes years to move from paddle-in to tow-in,* says **Ken Bradshaw.** *It's not just a bigger wave situation.* Remember, a ski is not always going to be able to buzz in and pull you out of a dangerous situation. You need to be able to trust yourself and your instincts when things get hairy.

## BOARD DESIGN

*New epoxy boards are more rigid,* says **Mike Parsons** a noted big-wave and tow-in rider. *Now many of the top guys are riding these six foot epoxies, with smaller fins and single concaves.  With the smaller four fin designs coming into the equation we've achieved less drag, and improved the line you can hold,* explains **Parsons.** *Now you can stick higher on a giant wave and not fall out of the face. These new boards allow you to draw a really high line and still beat the lip because of the speed they can attain.*

## BE CAUTIOUS

*It's not important to be the hero,* **Brad Gerlach** reiterates. *In fact people who tow will respect you way more if you show your sense of respect and awareness for what you are doing. We don't try to talk ourselves up out there,* **Gerr** confides. *We try to talk ourselves down.*

Shane Dorian, Cortes Bank, California

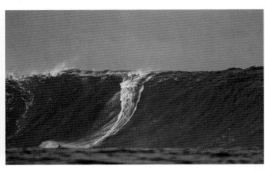

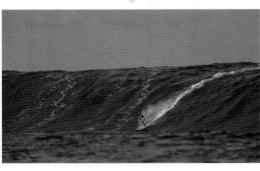
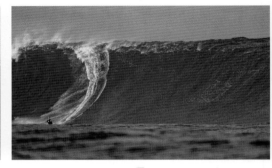

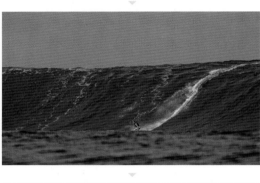
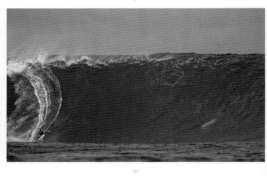

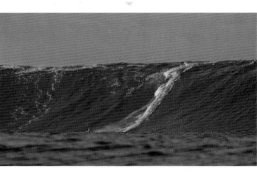
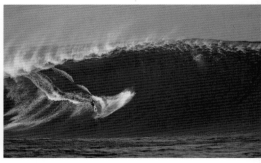

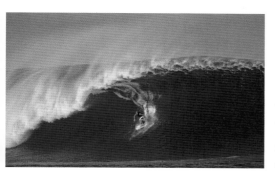

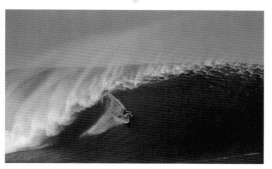

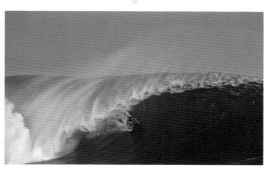

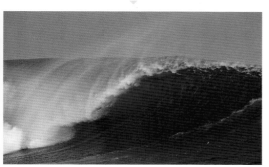

## PRACTICE WITH A PARTNER

Find a good partner and rehearse any and all scenarios. Learn everything you can about your ski. Take advantage of flat days during the summer to work on pick-ups, timing getting in and out of a wave zone and what to do if Plan A goes amiss. Dave Kalama says having a partner you trust with your life is essential to the success of this endeavor, because it's very likely that, at some point, he will have your life in his hands. *You have to know that the guys you do this with are ready to risk their lives for you,* says **Hamilton**. *And you want to know that he knows what to do so it isn't a waste of time.*

## GO OVER EMERGENCY PLANS

Come up with scenarios relating to what could go wrong with it and how to fix it in a pinch. For example, if you suck the tow rope into the jet intake, you need to know how exactly how to get it out and restart your ski. Time is of the essence in real-life situations, and chances are when a 40-foot wave is bearing down on you, you won't have time to think. *The whole goal is to not make any mistakes when you're out there,* notes XXL Biggest Wave Winner **Brad Gerlach**. *And to know what your options are if you do!*

## MAP THE TERRITORY

*Drive your ski around the break; get a bunch of different views of the wave* advises **Brad Gerlach**. *See it from all the angles: the danger zone, the take-off spots, the escape routes, and the rescue course. You want to know the territory.*

Sequence: Andy Irons, Cloudbreak, Tavarua, Fiji

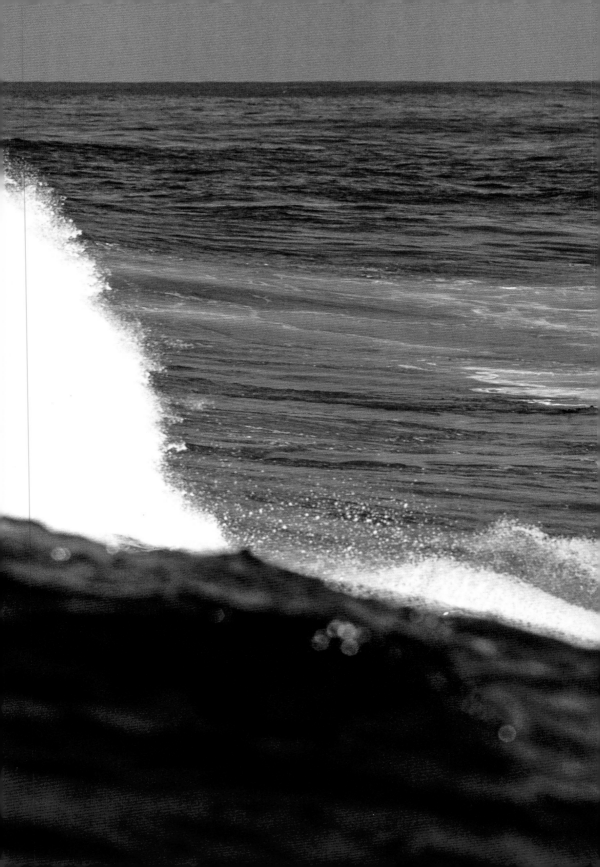

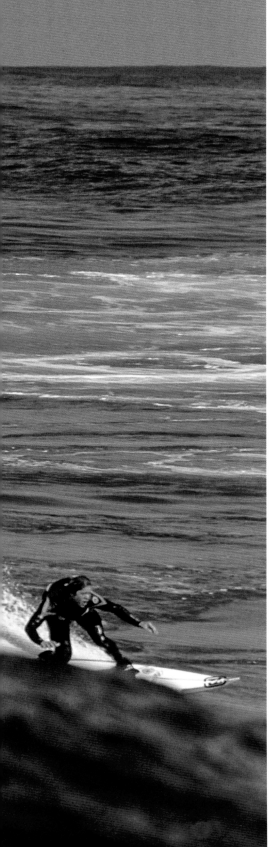

## GET FIT

Laird Hamilton looks the way he does for a reason - because he needs the strength and power to stand toe-to-toe with the biggest waves in the world. It's pretty simple, you want to ride monsters, you have to be strong. For good tips on how to make yourself more prepared for the kind of situation you might undergo tow-ins as opposed to regular big-wave riding, see the Chapter on Fitness and Training. Read what Shane Dorian has to say.

## EQUIPMENT CHECK

Every tow-in player prepares all year round, testing gear, building equipment, watching the weather reports - for the few days they might actually put all their preparation to work.

Before you ever hit the water you need to make sure that all of your equipment is sound and ready to go. Make sure your ski is gassed up, has plenty of oil, and the spark plugs are firing. Make sure your tow vest is functioning and in perfect shape. Inspect your boards and straps. You have to trust your life with this stuff, so you better sure as hell make sure it works.

## GO FOR THE RIGHT REASONS

*I learned early on that winning contests wasn't the holy grail. Neither is big-wave riding,* says **Gerlach**. *I was introduced to it by one of the best - Mike Parsons. We developed a friendship, then a trust factor, then a blood bond. Get into it for the rewards you want in the end: challenge, travel, friends and the unforgettable experience.*

Brad Gerlach, Cortes Bank, California

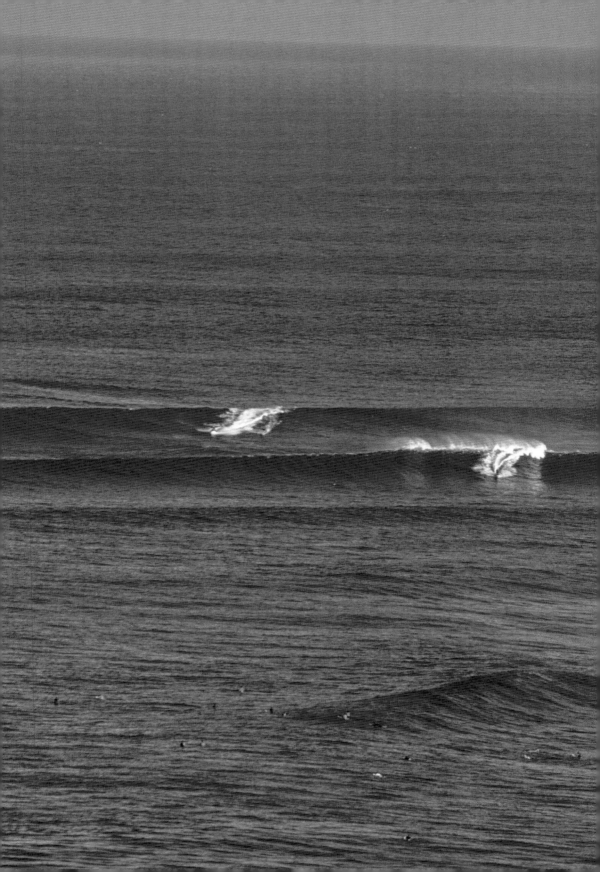

## CHECK YOUR EGO AT THE DOOR

When all is said and done, tow-in is more than just an expert's game. *The only reason we tow-in is the size,* notes **Parsons**. *There's no real purpose to using a jet ski or tow rope for anything else.* As tow-in fever heats up, more and more unqualified participants drive out into otherwise un-ridable line-ups. It may appear glamorous, and you may feel ready, but the truth is, for nearly everyone who reads this, tow surfing is not really something to pursue.

Main Picture: Outer Reef, North Shore, Oahu

Above: Mike Parsons and Shane Dorian, going through everything

Shane Dorian, Mike Parsons and Brad Gerlach on the Big Day!

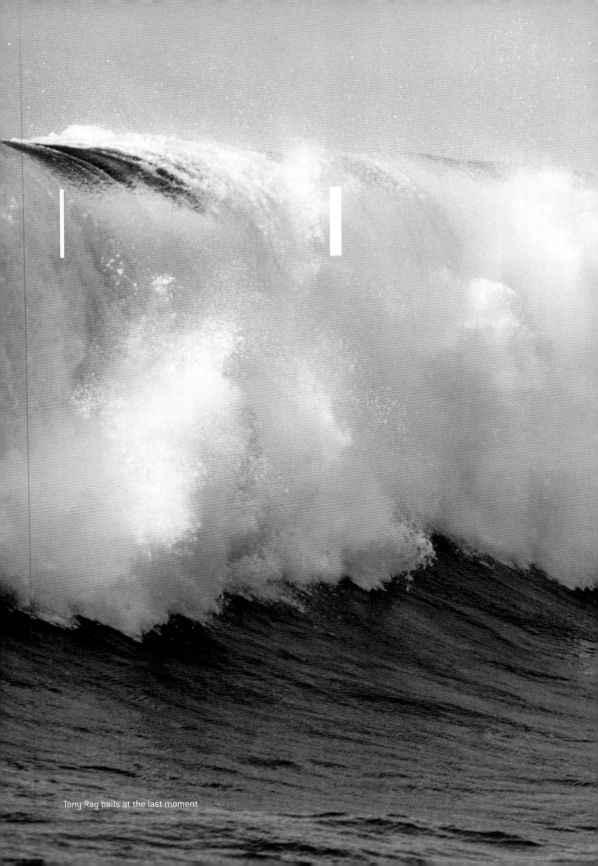

Tony Ray bails at the last moment

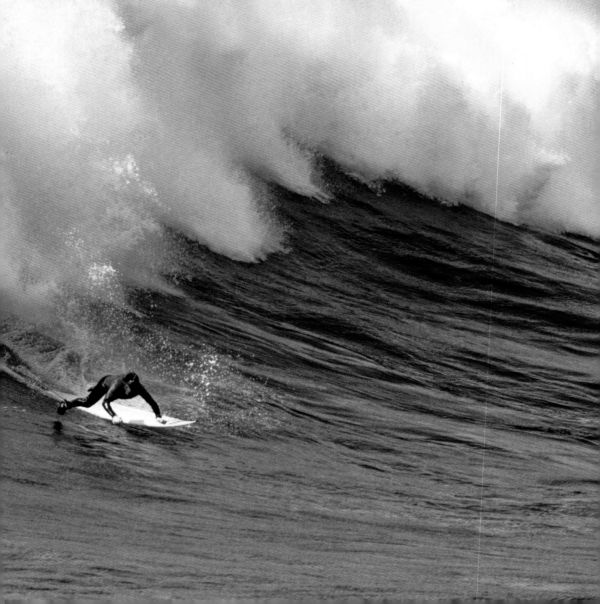

# SURVIVAL

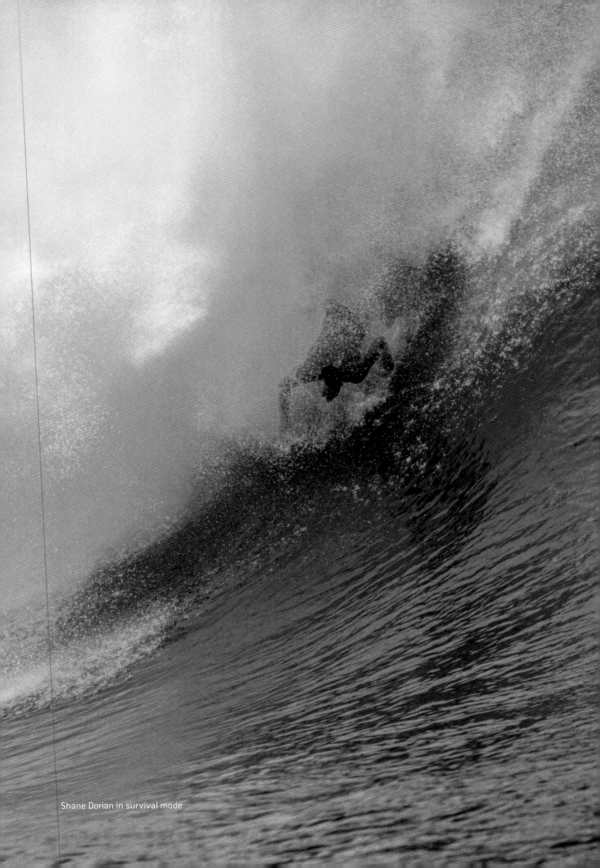

Shane Dorian in survival mode

# SOUL SURVIVORS
## Survival Skills for the Most Dangerous Games

*The best one I can ever remember was Ross Clarke Jones on that monster swell at Jaws, November 26, 2003. He was just so totally committed, and he pulled into this massive barrel, came out and pulled up into another section, basically to avoid the lip, and the face was so huge inside that I'm sure he didn't see the bump and the nose catches - and he does two full cartwheels and a spin! It was mind-blowing, he told me he hit the bottom because he was bleeding when I was talking with him about it afterward.* **Brad Gerlach** on the most memorable wipeout he ever witnessed.

If you think great surfers were born with natural survival skills, or don't feel the fear you have when you face really big waves, think again. Kelly Slater talks about the first time he was invited to surf big Sunset with Ken Bradshaw. When Kelly told Ken he was too afraid to actually paddle out there, Bradshaw took him to a less intimidating spot down the North Shore coast. But the big waves were still so scary Kelly took a closeout wave in to the beach clinging to his board in fear.

The interesting thing here is that Kelly was already a super-hot surfer winning contests and shredding small and medium waves to pieces when he first attempted Sunset. But his wave-riding skills were not what he needed - it was Bradshaw's experience. Kelly overcame his fear over the next few months and now wins contests in 20-foot surf.

This chapter is not about wipeouts, rips and reefs. Good surfers have already dealt with these, just as good surfers know how to paddle, how to surf small waves and how to deal with crowds.

**BUZZY TRENT**
*Legendary big-wave pioneer*

> *Big waves are not measured in feet. They're measured in increments of fear.*

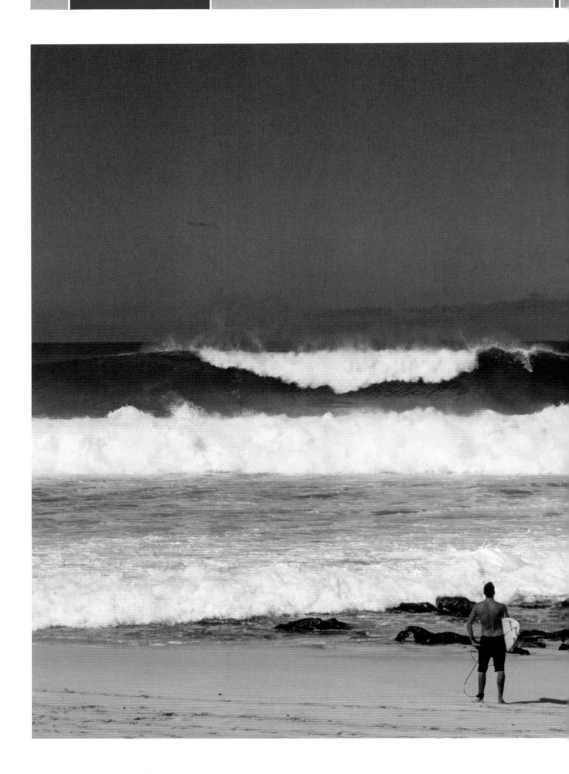

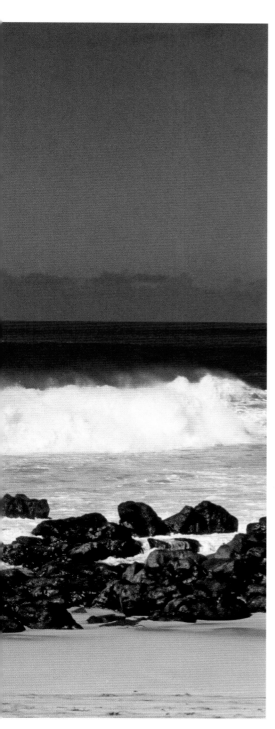

This is about how to help survive the type of things that happen in really big waves and really dangerous situations. As the great Waimea pioneer **Fred Van Dyke** told me, *The big-wave wipeout shows you how vulnerable you are. You're on the edge where the most important thing isn't the mortgage, or how much money you have or the cars, or anything - it's about getting that last little breath of air.*

## BEFORE YOU PADDLE

### 1.KNOW THE CONDITIONS

If you ask Shane Dorian what the surf conditions are, he can tell you the swell angle, the buoy readings, the wind conditions and the frequency interval - how often the sets come and how many seconds between waves in a set. Why is that important? It sets up a whole level of choices you may not have if you don't know the conditions. If there are five waves in a set, you may have to scramble after three go by, but if there are eight waves in a set you may want to hang and wait for the best one.

Main Picture: If this guy hadn't stood here for 10 minutes he wouldn't have seen this bomb set!

Above: Even Shane Dorian surveys the line up before launching himself

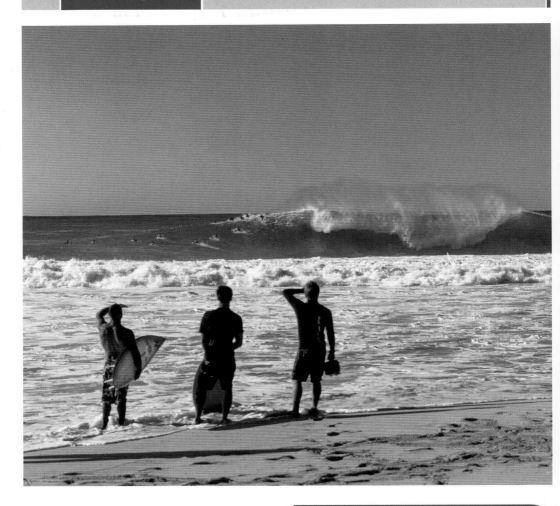

When you get to the beach, there are several things you are going to have to do: wax your board, put on your leash, and if it's not midsummer, put on some neoprene. But since that's going to take you a few minutes, do the other important things that will increase the chances for a successful go-out by ten-fold. Look at the general conditions: the first one you want to find is if there are any rips running. A rip will help you get out if it is running the right direction. It will also tell you what to stay away from once you are out. And most importantly it will tell you where not to swim in if you lose your board.

## PRO TIP **BY MIKE PARSONS**

*What is amazing is how few surfers actually pay attention to the conditions and note them before they go out. Watch a few sets come through – do they have three waves, six waves or ten? How long is the lull? Watch to see if a surfer on the inside can get back out without having to roll or push through a wave.*

### 2.BODY SURF BIG WAVES

Body surf when the waves are big; you will get used to the pounding and learn to swim in the impact zone. Feeling confident without your board builds a lot of confidence when you are out in huge surf.

### 3.SPRINT SWIM

*Sprint swim, rather than swim long distance,* suggests **Shane Dorian**. *If you can't get out of the impact zone in a hurry, it won't matter how far you can swim. The important thing is to get away from the four-story house that is collapsing in your midst. You don't need to swim a mile; you need to swim 40 yards really fast.*

## IN THE LINE-UP

### 1.CONTROL WHERE YOU FALL

It may seem obvious, but a lot of times when a guy knows a wipeout is inevitable, he resigns himself to the fall and gives up trying. In really big waves this is a mistake. Don't fall tube side - go away from the lip. Even in critical conditions you can often get yourself into a better and safer position just by knowing what to do. Whenever possible, stay away from the lip.

### 2.TRY NOT TO GET DEEP

*As counter-intuitive as it seems, getting deep on really big waves is not the best approach,* says **Shane**. *You want to be blown out of the impact zone not remain in it. You can only withstand so many impacts when it is really big, so the key is to get out of the danger zone. Staying on the surface and letting the wave push you away from the zone is the best way to remove yourself.*

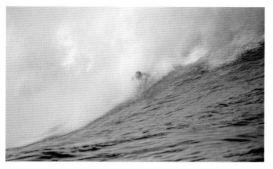

Left: Surfers waiting for the lull

Sequence: Body surfing big waves is a good practice

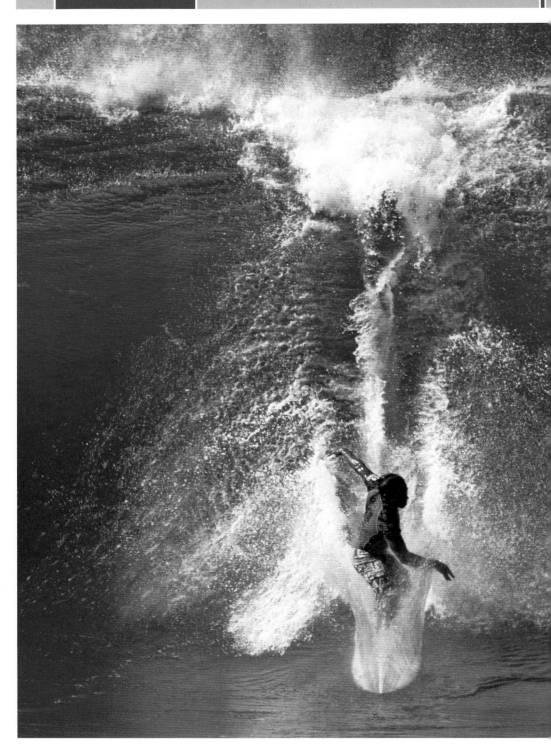

### 3.CONTROL WHEN YOU FALL

*Don't wait till the lip is coming down on your head. Avoid going over the falls at all costs if you can - take the crash instead,* says **Shane**. *It's better to bail out and land safely than to put yourself in a seriously lethal position. Remember in really big waves the consequences are vastly different than in waves up to 12 feet in size.*

### 4.THE COST OF ERROR

**Mike Parsons** recounts his heaviest wipeout experience. *It was my first time out at Maverick's, and the swell was extremely far west. I took off on a wave and it closed out. As I came up I looked out at the line-up and it appeared to me that paddling around the peak towards the left would be quicker and easier than trying to get around the whole rest of the set-up. I made a decision to scramble out around that side and try to beat the next set. It seemed like a reasonable assumption. But I hadn't done my homework - there was a monster rip coming across that path and I paddled for more than a minute before I realized I was making no progress. It was a minute too long. Before I could react I got caught by a giant set and was getting pushed directly into the rocks on the inside. It is the worst nightmare you can imagine - 15 foot walls of whitewater slamming you into 15 foot towers of jagged, barnacled rock formations - and it goes for a football field. It's like being a pinball in the arcade - being bounced off the rocks, totally destroying my board, being held under for impossible lengths of time - it was far and away the worst surfing experience, and the closest I've ever come to losing my life.*

Fred Pattachia about to use his survival skills

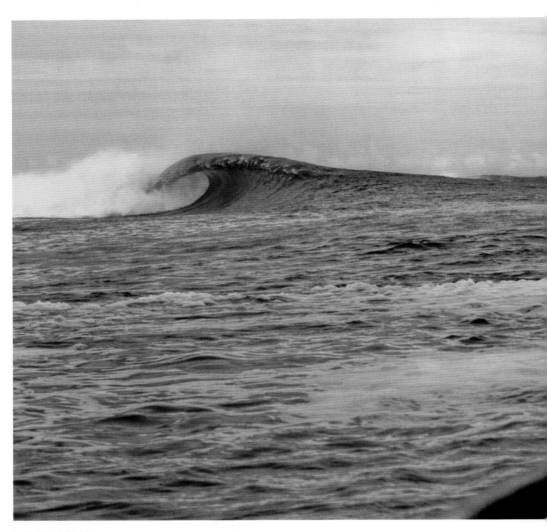

## 5.HAVE A PLAN

Just like the coaching tips **Snipps** gives on competitive surfing, his advice here is to study before the exam. Figure out every aspect of the line-up: where is the rip, where are the rocks, what happens on the inside, and are there sleeper waves sneaking in? Are there cleanup sets that can be avoided?

Watch the other surfers in the water. What are they doing successfully? Are they sitting outside and only catching the last wave? Can you paddle into the channel to avoid being caught inside? says Shane Dorian. Measure the timing - how many waves in a set, which is the biggest one, and how does it break? How long is the duration of the set, what are the intervals between waves?

Twenty minutes of focused observation and analysis can save you a lot of pounding. Parsons made a rare mistake; he didn't check the rip and observe the

fact that no other surfers were paddling his direction. It only took him a minute to figure out he was erroneous. But a minute in the wrong direction at a place like Maverick's can literally be the difference between life and death.

No matter how good a surfer you are, the ocean takes no prisoners. Although Parsons survived, his good friend Mark Foo died that same day at Maverick's.

## 6.CONSERVE ENERGY

There is a lot of punishment your body takes when you get slammed around on a big wave. The physical beating will take a lot of energy out of you. Conserving energy does two things: it keeps you calmer, and it allows you more oxygen which you can use as you begin your move to the surface.

Twenty minutes of focused observation can save you a lot of pounding

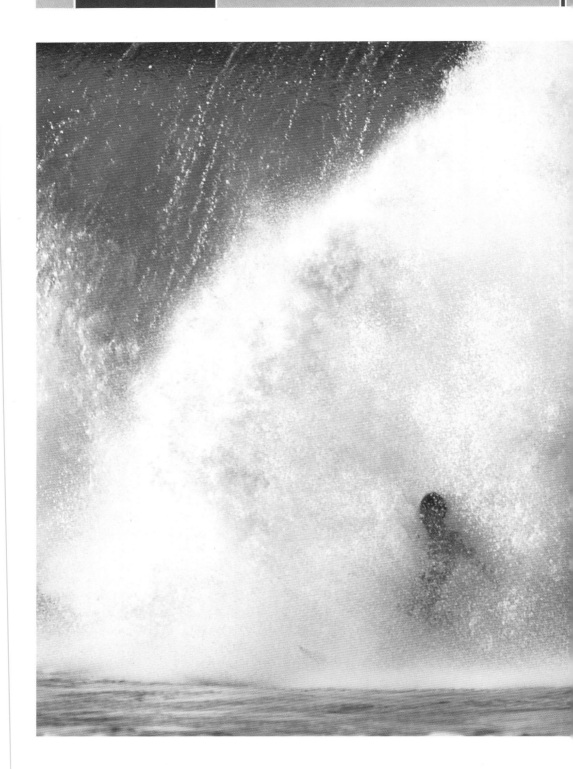

*If you are constantly struggling to get to the top, you're wearing yourself out for no reason,* says **Todd Holland**, a former top-16 ASP surfer. *Just relax and let the wave take its course. When you feel the wave start to weaken, then begin to make your way to the surface.*

### 7.DON'T PANIC

*Panic is the worst thing you can do,* says **Shane**. You have to train for the situation and just wait for the turbulence to clear. You can have fear, but don't panic. **Brock Little**, whose audacious tube riding at big Waimea has made him legendary, makes the distinction between panic and fear this way: *Fear is something you deal with. If you don't have fear in big waves you're either a kid or mad. Panic is some-thing else - it's your worst emotion, an uncontrolled energy that uses up oxygen but doesn't help you get to the surface. Panic can kill you; it's the step before drowning.*

### 8.DRAW ON PAST EXPERIENCE

*When the hold down is frighteningly long, like a rag doll when the fear factor is more than you can bear, draw on past experience,* says **Parsons**. What I always say is *I've been here before, I remember how this feels, I know it will pass,* **Snipps** says. *Thinking about the fact that you have been in a similar situation helps also to keep your mind at ease; it gives you a pivotal point of reference that allows you to relax.* This is a survival technique that should be taught to anyone in life on the surface as well: don't give up, rely on past experience, relax and let the pressure pass.

Don't panic and always conserve some energy, even at Pipeline

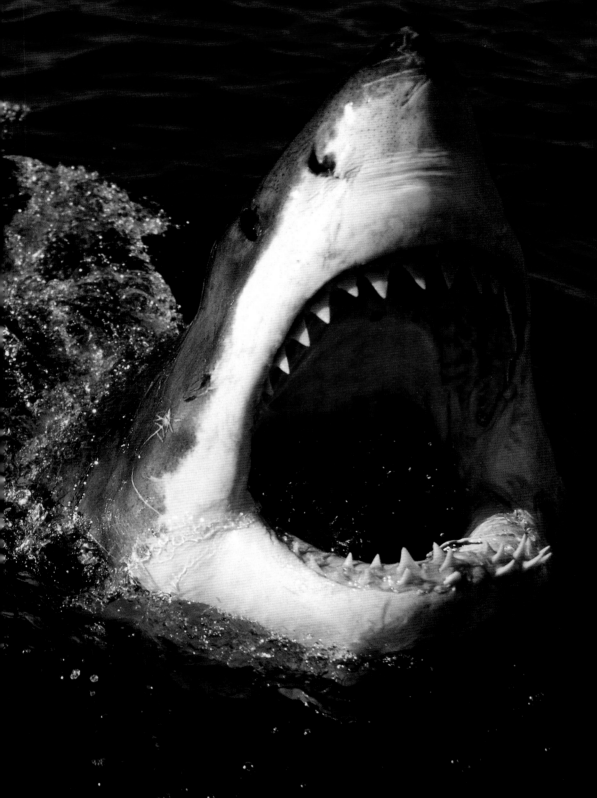

Putting some teeth in it. Shark Photos: Greg Huglin

# BITE BACK
## The Dos and Don'ts of Surviving Your Next Toothy Encounter

*Sharks will frequently investigate an object by bumping it, to see whether or not it might be edible. The difference between a predatory attack and investigatory bite are very dramatic. In a predatory attack the bull shark would violently strike with a great deal of force. Unfortunately their equipment is such that even an exploratory bite can remove an entire limb.* **Ralph Collier**, shark expert, founder of the Shark Attack Research Committee and author of 'Shark Attacks of the 20th Century'.

Any surfer worth his or her saltwater has at least one good shark story to tell. Peter Mel's stared one in the eye at Maverick's, Taj Burrow, Damien Hobgood, Mick Lowe and Phil MacDonald have all been run out of the water in the middle of heats at the Billabong Pro in Jeffreys Bay and brave young Bethany Hamilton lost her arm to a tiger. And those stories are just the ones that have made headlines.

But the good news is that contrary to the media image of sharks as cold-blooded predators, the scientific research indicates that they are very selective hunters - and they don't really like humans as food. In fact the majority of sharks spit their victims out, just as we would probably do if we blindly took a bite of a slimy shark fin.

Sharks typically have bad eyesight (smell is their primary sense) and have trouble discriminating

### BETHANY HAMILTON
*Top woman surfer on what happened the day she lost her arm in a shark attack*

We paddled out to Tunnels [on Kauai's north shore] and it was kind of small - one - to two-foot - and I was lying on my board, facing sideways toward where the waves were coming," she says. "The shark just came up from nowhere - I hadn't seen it or anything - and it just came up and grabbed hold of my arm, and slightly juggled me back and forth. And then it let go of me and I started paddling in with one arm. They thought I was joking, but then they saw my arm, and I was like, 'I got attacked by a shark.' Alana's dad [Holt] pushed me into a little whitewash wave. [Alana's brother] Byron caught the same wave and pulled me over the reef. After a while Holt took over, and he wrapped his rash guard around my arm. He wanted me to keep on talking so I was just praying to God for help. When we got to the shore, Holt used his leash as a tourniquet and tied it around really tight.

between different sizes and shapes — hence the confusion between the clear bottom of a surfboard with arms hanging over and a white-bellied seal with flippers. Sharks don't want to eat you - it's just that when they make the mistake of taking a chomp, it is never a great scenario.

Statistically, more people are killed by being struck by lightning each year than die from shark attacks. Nonetheless, if you don't want to get struck by lightning, it's a good idea not to walk on the golf course during a thunderstorm, and by the same logic, it's probably smart not to frequent places with known histories of shark sightings and avoid breaks near seal colonies and deep water.

Then there is the stealth factor. Sharks tend to stay on the bottom for the most part, out of sight and out of mind. When they head to the surface in hunting mode, they tack back and forth, just like the dorsal fin in the movies, moving in and out looking for something to ambush. The really scary thing is that they can usually get within striking distance less than four seconds after making up their mind to attack.

Sharks and surfers have to share the same ocean, but that doesn't mean we have to get along. Being the prehistoric bullies that they are, they've been keeping surfers on their toes since people first paddled out into the great blue beyond. In scientific terms, this is called being an apex predator at the top of the food chain.

And while they may have scared us out of the water more than a few times, and maybe taken a few nips here and there, the fact of the matter is, the ocean needs sharks, we need the ocean, therefore we, in some demented twist of logic, need sharks. So, what can you do to ease the tension in the surfer/shark relationship?

**Well, here are a few things to consider next time you're looking for somewhere to surf:**

## DO:
### 1. PAY ATTENTION

Some places are inevitably sharkier than others. For example, if you're looking for a big-wave thrill without the big fish, you may consider Todos or Waimea over Maverick's. Maverick's sits right in the middle of the Red Triangle, which happens to be home to one of the densest Great White populations in the world. The same goes for the coasts of South Africa, Southern and Western Australia, and a lot of the South Pacific. Cactus, Dungeons, and Christmas Island may be big-wave havens, but they have men in grey suits lurking in the shadows. And regardless of whether you're into the big waves or not, every spot has its own natural wildlife, some is just a little more carnivorous than others. So when you're in the water, keep your eyes peeled for anything particularly odd. This doesn't mean freak yourself out, just be conscious of what's out there.

When you meet the king of the sea, know what to do. And what not

## 2.KNOW BASIC FIRST AID

When a tiger shark attacked and took Bethany Hamilton's arm, if not for the immediate response of those in the water with her, her story could very easily have been much more tragic. Because her friends were able to quickly get the bleeding under control and get her to shore, she was able to receive the emergency medical help she needed right away. When it comes to shark attacks, immediate attention is critical. Veins and arteries can be severed and blood loss can be dramatic. So, if not for yourself, then for your friends, learn first aid, learn how to slow down the bleeding of wounds, and you never know, you could just save a life.

## DON'T:

### 1.BE A WOUNDED SEAL

Nothing says 'eat me' more than flailing around in the water in a panic. Should a shark find its way into your line-up, try to move slowly and methodically towards shore. Catch a wave in if you can. Whatever you do, don't start splashing about and making a huge commotion. Savvy predators can mistake this for a wounded or weak animal, which means they're looking at you as an easy meal. So, yeah, it's scary, but the more you keep your cool the safer you are.

### 2.BACK DOWN

Surprisingly, while most sharks probably wouldn't mind nibbling on you for a little snack, for the most part they aren't all that confrontational. A lot of the time they choose their prey based on how much of a struggle it's going to put up, so, should you find yourself in the unfortunate predicament of being in a shark's jaws, start swinging for the nose, eyes and gills. All of these spots are key sensory receptors for sharks, and a couple good blows may send them back into the depths.

### 3.SURF ALONE

Never go out alone at a spot where you're likely to find sharks. For one thing having a friend means having someone to call for help, get you in and treat you while you are probably going into shock. The other thing is, another person out with you cuts your odds of being the prey in half. Five people cuts it by 80 percent. Play the odds.

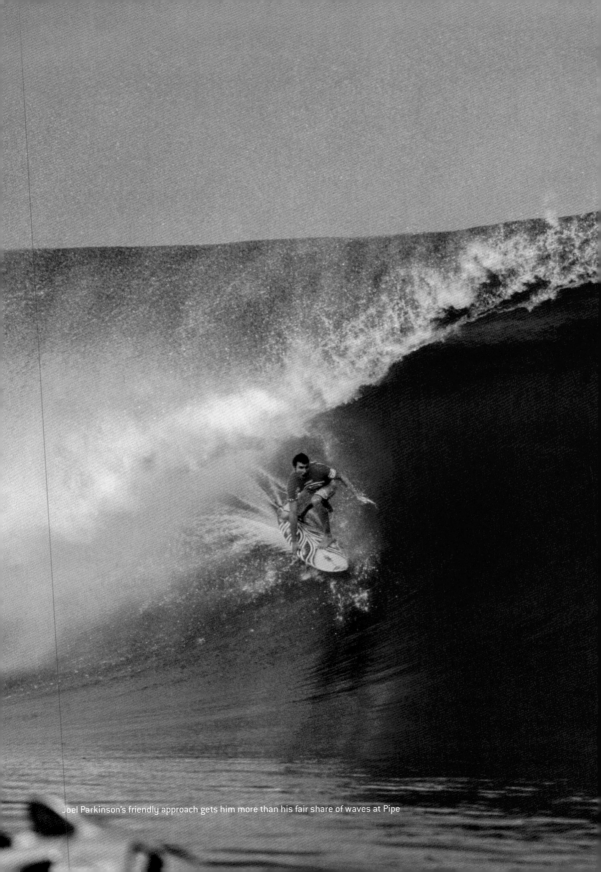

Joel Parkinson's friendly approach gets him more than his fair share of waves at Pipe

# THE BILL OF RIGHTS (AND LEFTS)
## Surfing Etiquette for the 21st Century

**Sean Collins made a lasting effect on the surfing experience when he developed the phone surf report Wave Watch in the mid-1980s.**

As his surf reporting became more accurate and widespread, the entire surf community began, in some way, to rely on the predictions on Surfline - even if it was to avoid the crowd the reports sometimes brought. But Collins is a surfer to core, and his sensitivity to the changes that he brought about is acute. So he penned this special position paper on living in the surf environment of the new millennium, where crowds are to be expected (especially at the expert spots) and competition among the top surfers is intense. Whether you are a fan of surf reports or a critic is beside the point here. Sean has zeroed in on the issues and answers, and to ignore them is to remain a less-than-expert surfer. These words of wisdom are aimed at the exceptional surfer, and are worth reading carefully.

## PICK THE RIGHT SURFING SPOTS FOR YOUR ABILITY AND ATTITUDE

*We need to be honest with ourselves about our ability, and our intentions. We also need to recognize that some surf zones are not suited to competitive skills-oriented behavior.*

Pipeline is a different wave than the tube you have wired at home. You may surf the tube well, ride very aggressively at the break you surf every day, but when you come to the top 30 or 40 waves in the world, a different protocol applies.

It's important for all of us to recognize that by charging into a line-up for which we're not suited, we're likely to be frustrated and to disrupt others' surfing

### DUKE KAHANMOKU
*The Father of Modern Surfing to young surfers he rode with.*

> **You take this one. Plenty more waves coming. Always more waves.**

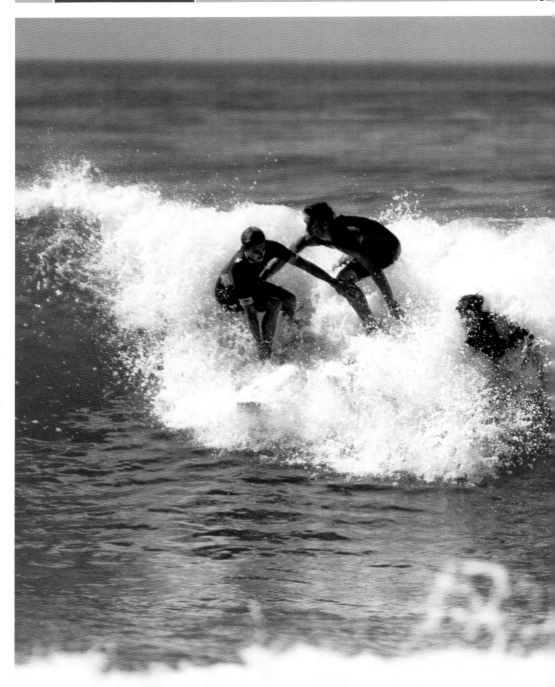

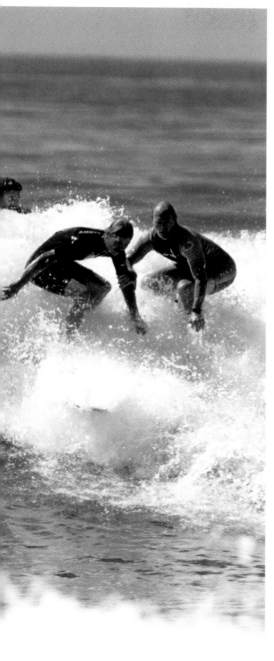

enjoyment. If you're not a high-performance ripper, but just engaging in the early learning process or feeling like a cruisy session, then tackling a hot zone will leave you feeling way out of your depth and may even place you or other surfers in danger of injury. If you're a budding hot surfer trying to develop a high skill range and eager to ride with people of a similar intent, then paddling out at a cool zone is likely to leave you feeling unsatisfied and your fellow surfers irritated by your competitive attitude. By simply making a wise choice of location, you'll head off many of surfing's more vexed etiquette decisions at the pass.

## DON'T DROP IN ON OR SNAKE YOUR FELLOW SURFER

*In other words, do not catch a wave once another surfer has claimed it by being in a deeper or more effective position at take-off.*

Dropping in and snaking are the two most common ways in which we blow each other's fun in the surf. Both are usually caused by greed, and involve a ride-crippling interference by one surfer on another.

The drop-in happens like this: Surfer A is closest to the curl, paddles into and catches the wave, only to find that Surfer B - the dropper-in - has also caught the wave, from further out on the shoulder. Surfer A is then blocked from making a successful ride. The two surfers may collide, accidentally or deliberately, but it's unlikely that either will enjoy the wave to its fullest. At some critical surf spots, Surfers A and/or B may even be placed in physical danger as a result.

Crowd at Lower Trestle, California

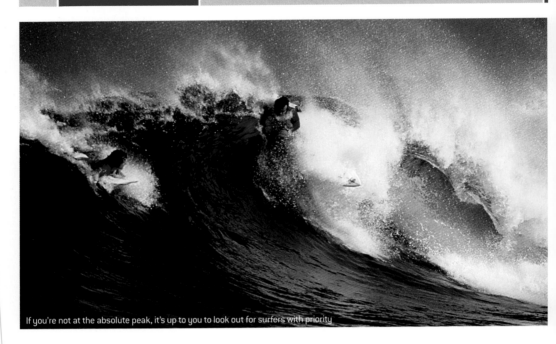

If you're not at the absolute peak, it's up to you to look out for surfers with priority

Drop-ins can and do happen by accident, as well as through frustration and confusion in a crowded line-up. To avoid dropping in, practice the three Ls: **Look, Listen, and Learn.**

**LOOK:** Look to your inside toward the curl before committing to the wave, just to make sure nobody's already in there.

**LISTEN:** Listen for the common warning - a hoot or whistle from the surfer in position.

**LEARN:** Learn from your errors - if you drop in, make sure you're off the wave as soon as possible, say sorry, and make sure the other rider is ok before going on with your session.

A more subtle, yet potentially more offensive, form of ride interference is the snake. This move is very bad etiquette, a greedy exploitation of the generally understood drop-in rule, and is usually practiced by competent and aggressive surfers. Snaking works like this: Surfer A, in position and having waited his or her turn, begins to paddle for the wave. Surfer B (the snake) waits until A's focus is purely on catching the wave, then makes a quick move to the inside and takes off, claiming the wave. If both surfers end up riding, it appears A has dropped in and is in the wrong, yet both surfers, and usually most onlookers, know otherwise.

Snaking can be distinguished from dropping in, in that it's rarely accidental. The result, however, is less predictable, and if A is also a competent surfer, bad feelings and even arguments may occur. If you're being snaked repeatedly by a single surfer, don't react - it's unlikely to be personal. Simply move to another area of the break, putting yourself and the snake out of each other's wave-catching rhythm. If you find yourself being persistently snaked by a range of surfers, you may be sitting too wide of the take-off to fully claim the wave; paddle deeper and make your intention clearer.

# WHEN PADDLING OUT, IT'S YOUR RESPONSIBILITY TO STAY OUT OF THE WAY OF RIDERS ON WAVES

*Once a rider has selected and caught a wave, all other surfers should do their best not to interfere with his or her enjoyment of the wave.*

This has its roots in the same thinking behind 'don't drop in'. It's also extremely practical. **Let's face it:** few moves make less sense than paddling close to, or directly into, the breaking line of waves on the way to the take-off zone. For one thing, natural waterflow through the line-up will make the trip a lot easier if you paddle clear and in open water. For another, not all surfers in the water will have the skills or inclination to avoid your prone board and body floating up into their paths. Therefore, always paddle out wide of the break, making sure you're not interfering with your fellow surfers' waves.

If you find yourself caught inside the whitewater line, don't cut across riders' tracks in a frantic attempt to reach the shoulder; maintain your position, pushing through the whitewater until the set passes, then go wide again into open water as quickly as possible. Paddling into the path of a surfer in the tube in order to save yourself a duckdive is extremely bad etiquette.

Never block a fellow surfer's path into a wave by paddling beneath his or her entry line. Doing so - whether or not you believe the surfer is capable of catching the wave - is a gross breach of etiquette, and if the surfer does in fact take off, you will be exposed to potential injury, or at the very least a wipeout for which you will receive little sympathy.

# LEARN TO TAKE TURNS

*Hey - we're not alone on this planet, which means sharing the wave-catching opportunities during any given surf session.*

The etiquette of break-sharing can be seen at almost any surf spot ridden by two or more people at a time, and depends very much on the nature of the spot and the skills and attitude of the riders.

At a reef break with a consistent set-wave take-off zone, the ideal situation is for everyone to simply take turns. This is most easily accomplished when the line-up is largely composed of surfers who know each other, but can be achieved at any spot under reasonable crowd conditions. In the classic turn-taking model, an informal line of surfers springs into being, with the surfer whose turn it is sitting deepest and in the logical take-off spot for the wave he or she wants to ride.

Etiquette permits some leeway here. For instance, the best surfer's skills may earn him or her an occasional extra wave, or a wider opportunity to choose the precise wave he or she wants. If surfers are taking turns with set waves and Surfer A drifts down the line out of the primary take-off zone, the other surfers may choose to allow A to catch some of the smaller waves, but in doing so A will lose rights to really good set waves that break further outside. Remember, in a taking-turns surf environment, it's your responsibility to be in a good position to catch the wave when it's your turn.

## 1.AT A POINTBREAK

With two or three sections, groups will form at the beginning of each section and take turns as at a reef, with one proviso: if a surfer is riding down from a section up the line and looks likely to make the wave, other surfers should make every effort to permit him or her a clean shot. The most common breach of etiquette here is pre-emptive paddling: Surfer A is hurtling down the line from a long way back, and Surfer B - figuring A won't make the section - begins to paddle into the wave. As A approaches, B pulls back, but his paddling efforts cause the wave to crumble and break down in front of A. Result: A wipes out or is caught behind, and the wave peels off unridden. Bad move, B.

## 2.POINT AND REEF BREAK

Etiquette can begin to break down if one or more surfers are taking off too deep and out of position, thus wasting the sections and forcing other surfers who are waiting in line to watch waves go unridden. This almost always leads to dropping in, and at the least it'll lead to pre-emptive paddling, as surfers begin to anticipate each other's failures and chase each other's waves from the shoulder.

## 3.BEACHBREAKS

Beach breaks tend to feature a shifting wave environment. The take-off zones - plural, not singular - are spread out, with more waves for everyone. This can break a beach up into several different mini-spots, each with its own turn-taking routine in place. If you're surfing one mini-spot at a beach break, keep in mind that if you move to another mini-spot on the same beach, you're entering another mini-society, and should be prepared to go to the end of the wave-sharing line.

Beach breaks, along with some reef breaks, also lead to the need for peak etiquette. If you are in position for a really good two-way peak with another surfer, you should choose to split the peak - that is, you go one way off the peak, he or she goes the other. In splitting the peak, communication is the key. You might both prefer to go the opposite way, or one of you might want to be sure he or she isn't about to commit a drop-in. The only way you'll find out is to ask each other - and then make the choice quickly!

## 4.BACKDOOR ENTRY

Surf spots of all three types can sometimes feature a method of line-up entry - jumping off rocks, perhaps, or paddling from behind a point - that provides immediate access to the inside take-off position. In such cases, you should NOT use that artificial inside positioning to jump the turn-taking rotation. Doing this is bad etiquette and will lead to bad feeling among your fellow surfers. Instead, either let the surfers already sitting and waiting to take the waves they want until the line-up's clear, or paddle wide to the outside and move into position along with everyone else.

## 5.CROWD

Sometimes there are just too many people in the line-up, without enough waves for everyone. In such cases, even with all the good will in the world, turn-taking can fall apart, the line-up tends to become a free-for-all, and the drop-in rule is just about the last thing left standing. In that situation, be prepared to adjust your attitude to what's happening. If you can't, it might be best to find another spot.

An unorthodox way to jump the queue

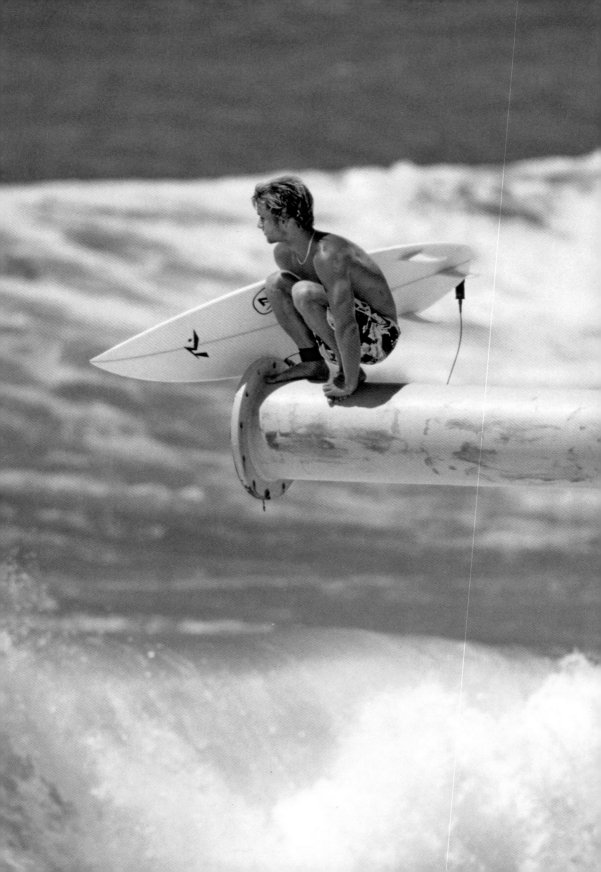

# RESPECT THE PRE-EXISTING VIBE IN THE LINE-UP

*This holds true no matter your status, equipment, or ability level.*

Hour to hour, on any given day at any given surf location, the attitude or 'vibe' in the line-up can vary greatly. Surf conditions can influence the vibe, sure, but the human element is a much broader influence. Simply speaking, attitude changes occur with each change in crowd identity. Anyone who's regularly surfed a break through its daily cycle and felt the change in mood as the various crews - the dawn patrollers, the mid-morning shift, the lunch-breakers, and the after-work rush hour pack - pass through will know precisely what we mean.

Since the line-up's vibe changes hour to hour, it's not always a good idea to make assumptions as to its nature. For instance, often at uncrowded point or reef breaks with specific take-off zones, surfers will develop a natural rotation of sharing waves. In this situation, there's nothing worse than one person, all unawares, just crashing through the rotation. Such actions can turn an ideal session into a hassling, ugly free-for-all.

Therefore, before jumping in, you should always attempt to gain a feel for the vibe in the line-up. Ways of doing this include:

## 1. ASKING QUESTIONS

Ask the surfers who've just finished a session. 'Hey, how's the crowd factor?' 'Get plenty of waves?' 'Much room out there?' A simple question or two will earn you some valuable inside information and maybe save you (and others) a lot of trouble.

## 2. WATCHING AND LISTENING

Aggressive crowds are full of 'yellers' - people who raise their voices to each other during and after rides. They also rarely feature just one paddler for a wave; there are almost always a bunch of people trying to gain the initiative on any single ride. These are two quick-and-easy giveaways, observable by any surfer within ten minutes of setting eyes on a spot. In mellower line-ups, single surfers are given a clear paddle-in passage, and you're likely to see a number of waves go unridden.

In any case, once you do paddle out, it's your responsibility to adjust to the current vibe, not expect it to change to suit you. If you find it difficult to make this adjustment, it might be a good idea to find a spot where the vibe matches your attitude, instead of vice versa.

## 3. HELPING ANOTHER SURFER IN TROUBLE

But don't put yourself in a situation over your head. Two surfers in need of help are in a much worse a state than one. Unlike most other sports, surfing is often practiced in places where, and at times when, medical or paramedical assistance may not be instantly available. It's also practiced in a medium (the ocean) where a human, if rendered helpless, can be literally out of his or her depth, fast.

This longboarder is about to do some serious damage

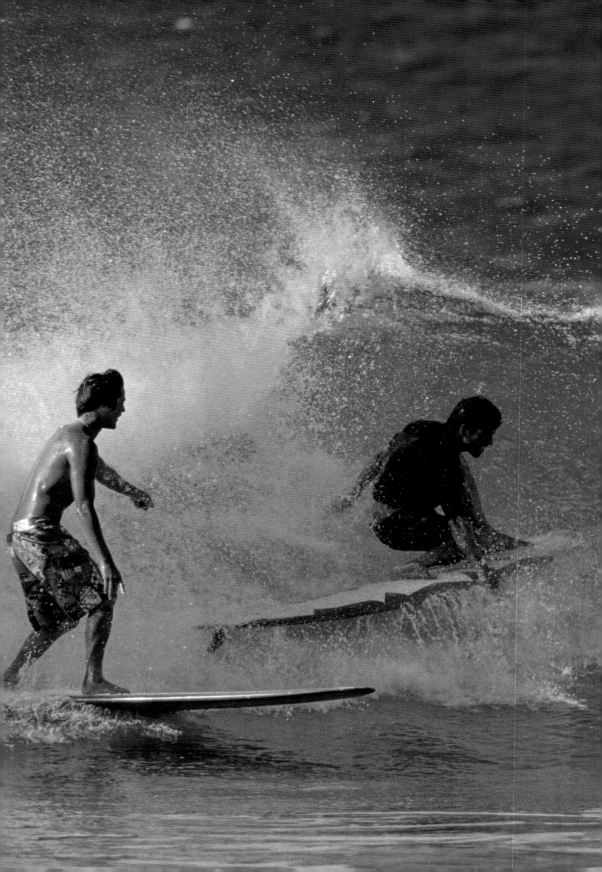

Peeling waves waiting to be surfed with respect

This means we have only one real safety net in times of danger: each other. The physical safety of your fellow surfer should be a paramount concern, overriding any disputes or bad feelings that may already have occurred between you.

The luxury of easy access to doctors and an emergency crew available to land-dwellers is not as easy to come by in the ocean. And the nature of any line-up - turbulent, shifty, always moving - means that other surfers may not see a surfer in trouble right away. As a result, it's very important to react quickly as soon as you see a fellow surfer is in trouble. As you go to the surfer's aid, recruit others and work as a team, using boards and wave energy, to help the injured surfer to shore as soon as possible. Teamwork doesn't just ensure a quicker result in almost all situations: it's also a way of making sure you don't get into the same trouble as the already endangered surfer.

If you're a beginner, always try to surf in front of a manned lifeguard tower - and never surf alone. Remember, it could be you.

## RESPECT THE RIGHTS AND CUSTOMS OF LOCAL SURFERS WITHOUT FORFEITING YOUR RIGHT TO RIDE

The term 'local' has nothing to do with where a surfer's home is located, yet everything to do with his or her long-term history at a particular surf location. If the surfer in question is committed to the spot, his history will very likely include epic days of surf and days of sloppy onshore junk; waves ridden with crowds and with one or two buddies; 'fish stories' about the biggest swell ever; sessions when the top local out-surfed some well-known visiting pro; sessions when for a precious hour or so, the surfer himself felt like he rode like Curren, or Slater, or Lopez. All of this—along with local camaraderie, the coming-of-age of the local grommets, maybe the death of one or more senior regulars will have passed unnoticed by the casual visitor (i.e., YOU). This 'knowledge gap' becomes more and more marked the further you choose to travel from your own regular surfing zone. Travel to another country, and the gap can yawn much wider than your skills can cross. That gap can only be crossed by

nurturing trust between traveler and local. Therefore, it is most important for the traveling surfer to observe some particular points of etiquette when approaching a spot for the first time. Here are the key points:

## 1.TAKE YOUR TIME

Whether you've spent an hour on the freeway or a couple of days on a plane to get there, the basic rule is the same - there's no need to rush. Watch the line-up closely for at least an hour, taking mental notes on how many waves are being ridden, from which area of the break they're being ridden, and who's doing the riding.

## 2.DON'T TRAVEL IN LARGE NUMBERS

Consider the impact of your arrival at a spot. Five or six surfers all showing up together and charging out into surf where only a few people are riding will change everything about the session. If you're traveling in such numbers to a new spot, be sensitive to those already in the water. Again, take your time - the surfers already out will eventually come in and make room for you. A good rule of thumb if there are a few guys out: avoid increasing the numbers in the water by more than 25 percent.

## 3.LET THE LOCALS SET THE PACE

How do things work in this new line-up? While almost all the world's surf spots are run by similar basic rules, there are a hundred localized versions of surfing etiquette. At some (not many!) spots, it's even considered ok to drop-in. The point is, it's up to you to observe and accept that localized version. Fit into the regular surfers' rhythm, catching the waves they give to you and giving them all the room they require. As you do so, watch closely for possible variations on the basic line-up codes, and take your cues from the local surfers' actions. This may take more than one session to achieve.

## 4.DON'T TRY TO OUTSURF THE LOCALS

It doesn't matter if they seem less skilled or sharp than you and your friends. Try to take over the waves at that spot, and a local (or more than one) will almost certainly use his or her superior knowledge of the spot to confuse and frustrate you. Keep trying, and you're likely to ruin everyone's enjoyment of the session. Instead, again, take a back seat and let the local surfers dictate the pace of your surf, until they're confident enough of your intentions to give you a couple of set waves.

## 5.LEAVE THE PLACE CLEAN

Not just in terms of physical garbage, though that obviously matters too. Your visit should end on a good note for all sorts of reasons, a big one being that every uncouth, uncool action in the water will strengthen any local ill-feeling toward the next traveling surfer. Therefore, after your surf or surfs, say thanks to your fellow surfers for sharing the spot, sorry to anyone you might have dropped in on by mistake, and let them know they're welcome to visit the spot you call home in return. A simple act of etiquette, yet it can and will work wonders.

# DO NOT USE YOUR SURFING ADVANTAGES TO ABUSE YOUR FELLOW SURFERS

*This includes advantages such as surfboard length, surfing fitness and skill, local knowledge and authority, and (lamest of all) physical aggression and strength.*

Getting your head around this profound and quite complex piece of etiquette involves a willingness to acknowledge the advantage itself. Not every long-board rider, for instance, knows he or she has an extraordinary paddling advantage over almost every

shortboard rider in any line-up, anywhere. But he or she DOES; as does every experienced local surfer surrounded by familiar faces and waves at his or her local break; as does every pro surfer at almost every Joe Average break on the planet; as does every large muscle-bound martial arts expert or violent felon loose in the waves of Hawaii, SoCal or southern Australia, for that matter.

Since we're all in the habit of chasing waves for personal gain, it's only natural that during the chase, we'd wish to use whatever advantages we possess. Here's the big, indeed, the insurmountable problem with that kind of thinking: There's always someone who's got a bigger advantage than you. There's always someone better, with a longer board, with more authority, with more inherent violence in his soul. Do you really want to live in a world where that person can come along and take all your waves? Of course you don't.

The whole idea of such mad social Darwinism is exactly the opposite of what makes surfing fun in the first place. We're trying to escape the rat-race, not become part of it!

**Therefore, surfing etiquette requires that you be fully aware of your advantages in the water, and conduct yourself appropriately. Here is a short list of such advantages, and appropriate actions:**

### 1.THE CORE LOCAL
The Core Local should at all times understand that other surfers have a right to ride at the spot he knows so well, and that his enhanced knowledge of the break gives him a responsibility as much as a reward. His responsibility involves leading the wave-sharing rhythm, keeping an eye on surfers who look like they might get into trouble, putting a lid on any bullying of kids by older surfers, and providing an example to the grommets and beginners of

Few surf spots have more need for etiquette than super-crowded Steame

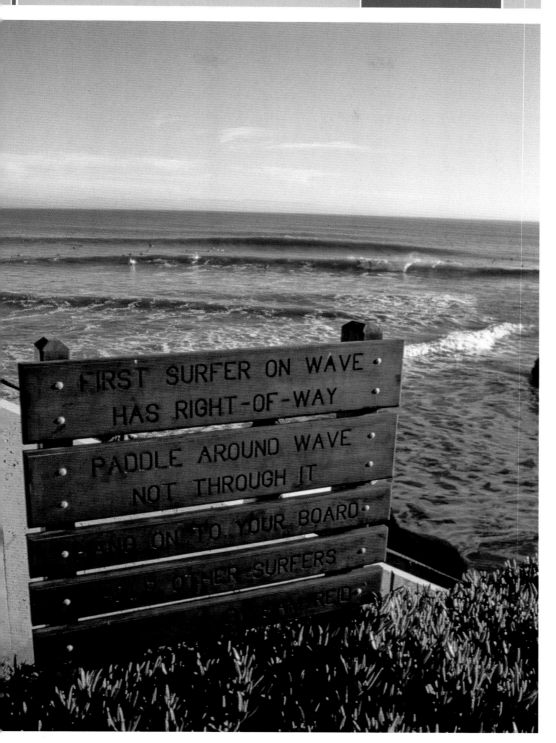

how to behave in a wide range of surfing circumstances. Taking care of these responsibilities will guarantee the reward (uninterrupted choice of the best set waves). Ignoring them and taking the reward anyway will guarantee ongoing ill-feeling in the line-up.

### 2.THE LONGBOARD RIDER

He should be absolutely clear that his or her craft provides an unfair paddling advantage, which, if abused, will quickly lead to resentment and hostility from surfers who choose to ride shorter, more high-performance equipment. He or she should therefore be highly aware of the wave-sharing rhythm, and be careful not to misuse paddling speed in a way that breaks down that rhythm. Using the longboard to paddle in early from the shoulder, or to 'lap' other surfers by racing to the take-off zone, is bad etiquette.

### 3.THE HIGHLY SKILLED PRO

The Pro holds a natural advantage over almost everyone else in any line-up, thanks to his or her greater paddling speed and wave judgment, and ability to take off deeper with relative ease. The Pro should remember at all times that not everybody in the water is engaged in a competitive surfing career, and that this does not rule out others' right to a fair share of waves. He or she should also be aware that fellow surfers may feel uncertain, shy, or even humiliated by a pro's skill level and presence in the line-up, and where possible, should break the ice with a smile, a hello, and/or an offer of a wave or two.

### 4.THE BIGGER, OLDER SURFER

He should be aware that whether he intends it or not, his physical presence may intimidate younger smaller surfers, and should thus avoid any behavior that may - unintentionally or otherwise - create fear in the hearts of his fellow surfers. Instead, he should adopt the approach suggested for the Pro, above: deliberate friendliness designed to foster a good example.

# AT ALL TIMES, BE RESPONSIBLE FOR YOUR EQUIPMENT AND RESPECTFUL OF OTHERS'

*If it's ignored or treated as something other than a wave-riding craft, a surfboard can be damaged - or do severe damage to other boards and people.*

First and simplest to recall: never let your surfboard go. Throwing your board and relying on your leash to get through a closeout or broken wave's whitewater is a very bad call in all but the least crowded and most critical of circumstances. Any other surfer within ten or even more yards, particularly behind you, is immediately placed in serious danger; and there's a chance the leash may break or otherwise unattach itself, in which case your board's a loose cannon. This especially applies to riders of thick, heavy equipment, such as traditional longboards and some bigger-wave guns. You should consider the possibility that if you can't negotiate a surf spot without throwing your board away, the spot may not be for you.

An outrider to this key thought is the need to take good care of your board. We're all free to endanger ourselves as much as we like, but super sharp fin edges, broken glass poking out of unfixed dings, and snapped-off noses can be dangerous to other surfers too. Such flaws can result in nicks or cuts to your leash, increasing the likelihood of a loose board in the line-up.

Always do your best to make good on any damage caused by your surfboard to someone else's board by arranging for a repair job or in some other manner agreeable to both of you.

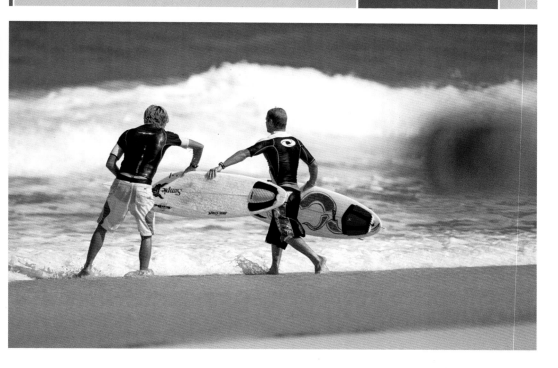

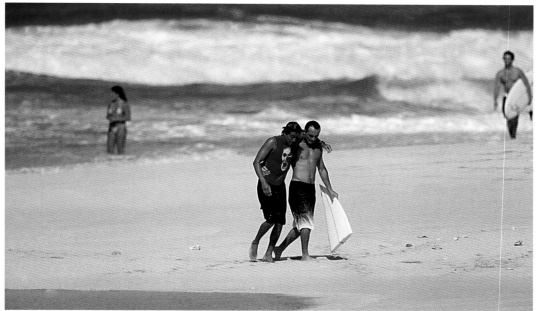

Top: He may be a world champ, but Mick Fanning will still give anybody the time of day

Above: Surfer helps surfer

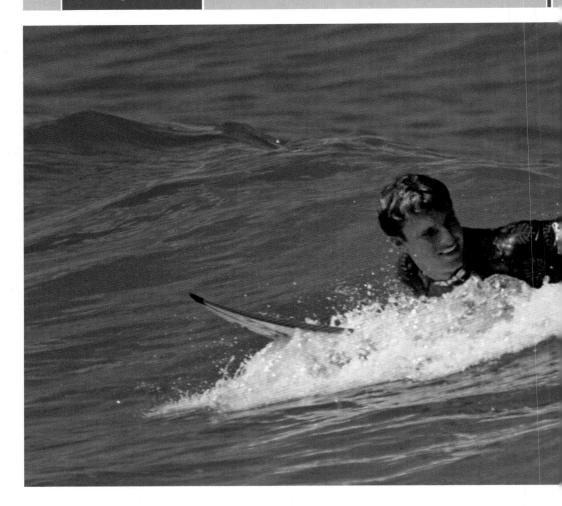

## RELAX AND ENJOY YOUR SURFING AND THAT OF YOUR FELLOW SURFER

*It can be done! The presence of others in the water is an ongoing fact of life in line-ups worldwide. Accepting this is the key to a healthy, flexible attitude in the water.*

As Surfline.com's great old buddy **Drew Kampion** says *Life is a wave, and your attitude is your surfboard!* More than anything else, crowd tensions in the surf can be eased by our individual ability to flow through situations and react positively when it's needed.

A positive attitude may seem to come naturally to some people and less so to others, but the truth is that attitudes - in the water, as on land - are made, not born. Here's a hint or two for rearing a positive attitude.

Surf a range of spots, not just one place. Instead of settling - and eventually wallowing - into a comfy, well-protected wave catching groove, you'll automatically develop crowd-reading skills and learn to deal with (and appreciate) a wider range of other surfers. Give every other surfer in the line-up the same credit as you supply to yourself. A conscious effort may be

required on this one, since a surfer's natural instinct is to place him or herself at the head of any wave-catching line. Simply say to yourself regarding your fellow surfer: "He counts as much as me." You'd be surprised at how much difference this can make to your own mood in a crowded situation.

Smile. This particularly goes for the better, older surfers in any line-up. Although at times your patience is likely to be tried by first-stage surfers who don't yet have your surf awareness or skills, you can't influence a beginner in a constructive way by yelling at him or her - you'll only instill fear and anger, and wreck your own session through the bad vibe thus created in the line-up. Beginner surfers are normally a bit scared and excessively on their guard anyway. They'll never forget a kind word or good advice from a skilled surfer, and down the line, they'll pay it forward.

In the long run, that's truly the only way we can help make crowded line-ups easier places to be.

Cory lopez and Myles Palaca enjoying the here and now

# GOING PRO

Joel Parkinson

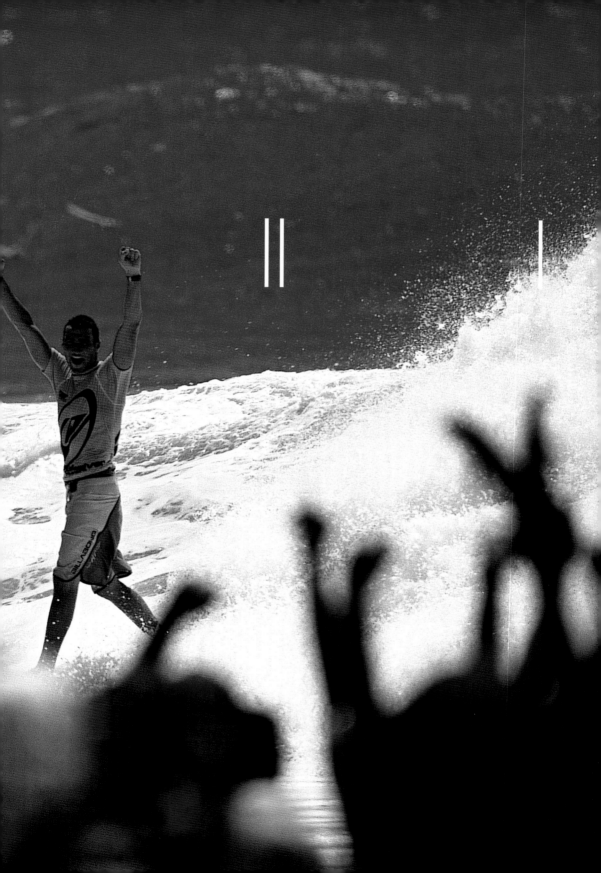

# COMPETING THEORIES
## Honing Skills for the Winning Edge

One of the most unrestrained displays of raw competitive confidence is recorded in a story told by photographer Peter Crawford about a contest at Burleigh Heads. During a raging pre-contest party, Gary Elkerton, then a meteorically rising surf star, was claiming that he would win the following day. *How do you know?* **Crawford** taunted him, in typical Aussie fashion. Elkerton walked out onto the balcony eight stories up (or 15, the way Elko tells it) and did a handstand on the railing. While Crawford and the other witnesses tried to stuff their hearts back down their throats, **Elkerton** lowered himself down and responded *That's how I know.*

Nobody is suggesting handstands on high balcony railings as a sane method of preparing for competitive jousts, but a healthy level of self-assured presence cannot be underestimated. Mike Parsons says when he traveled with Dave Parmenter during his ASP competitive years, the keenly observant and sagacious Parmenter would pump him so full of confidence that he won heat after heat against some of his toughest rivals.

**MARK RICHARDS**

*Four-ime world champion.*

❝ *In surfing, good preparation equals good luck.* ❞

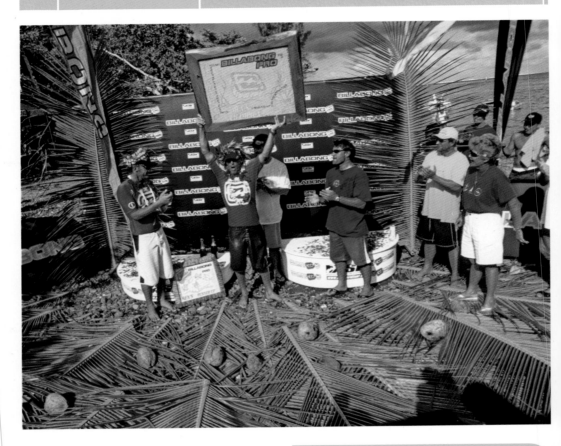

## PREPARATION CAN TRUMP TALENT

If luck is the meeting of preparation and opportunity, then preparing for the surf contest is one of the most missed opportunities imaginable. Even in the top pro ranks, surfers frequently stay up late, eat poorly and consume more than one drink of alcohol the night before the contest. Andy Irons can tell you flat out that he has been guilty of these mistakes. Here's the interesting secret though - he wasn't making them when he won his three world titles. If you really want to be serious about competitive surfing, discipline and preparation can take you much further than just athletic ability alone.

### PRO TIP BY ANDY IRONS

When I'm on the road I try to surf a lot at the spot the contest is at so I get a lot of practice, and have the spot pretty well figured out by the time the event starts. Stay motivated and stoked on surfing regardless of the conditions. I'm goal-oriented, and these are a must if I want to get another title. That's my secret!

## BE IN TUNE

If you have ever watched a professional contest, you have seen that the most focused competitors will arrive early, go through a series of serious stretching moves, check their heat time, and get a feel for the conditions of a contest, both physically and mentally.

Kolohe Andino, the U.S. U14 Boys Champion, has observed that many top surfers hang around all day, even when they aren't required to, scrutinizing conditions, sizing up the competition, and becoming familiar with the contest venue. By observing the winners, good competitors can observe the methods and mentality that creates the conditions to win. Kohlohe says he regularly does this now as a matter of course.

## OBSERVE EVERYTHING

Mike Parsons who operates a Surf Academy that coaches top amateurs on improving their skills, says the most important aspect of the competition is the fact that it is only 15 minutes. Mike suggests analyzing the best waves, where they are breaking, what the frequency is between sets, and between the best set waves. Sometimes you will notice that the best waves are being caught closer to the beach, or the rights nearer the pier may be breaking with more power, or that the rip is running on the south side of the break.

Left: It's no surprises for Andy Irons

Above: Love Hodel knows what time it is...

Observing the judging is more important than most surfers realize as well. You may notice that certain maneuvers are getting higher scores. You can learn a lot by watching other heats, especially those preceding your own. You may find the tide or wind may be affecting the approach needed to win: adjust your strategy accordingly. What worked in the morning may not work in the afternoon, and what worked at high tide may be disastrous as it goes low. All these factors can give you an edge, help you position yourself better for wave selection, and therefore provide higher scores.

### PRACTICE TIP

*Remember it is not the best surfer in the water who wins a heat. It is the best surfer for that 15 minutes. When practicing for a contest, time a 15 minute period as if you were being judged in a heat. Work with another one or two other competitively-minded surfers so you get the feel of being in a heat situation, where they fight for position and try to out-surf you. Hans Hedemann, Michael Ho, and his brother Derrick used to practice this exercise in their early, struggling pro careers. Every day after school they would do three 15 minute heats with friends as judges keeping score. Within weeks they had improved their whole approach to competitive surfing as opposed to hot free surfing. They all became top ten ASP rated, and went on to a long string of successful contest victories.*

## UNDERSTANDING THE SCORING SYSTEM

If you want to score high on a test, studying the test questions is a great start. Surf competition is no different: you can't do well in a heat if you don't know what the judges are looking for. Bigger, better waves give you the potential of a higher score. Judges generally score the most difficult maneuvers that are completed with the greatest amount of speed in the most critical part of the wave. So wave selection is obviously a major factor in winning the heat.

But here is a secret from **Tom Curren:** *the quality of the performance is more important than the quality of the wave.* Judges in surfing are looking for some way to set competitors apart. With today's high level of talent, everyone gives outstanding performances and has a full repertoire of moves. Often there is very little difference between two waves and the two riders who run the gamut of moves on each. You need something to set you apart and judges consistently say it is the big move that allows them to set one wave apart from another.

**Tom Curren** says *judges like to see some abandon in a performance, but obviously it's not as easy as it sounds. And as hard as it is to do,* **Curren** says, t*he secret is to approach each wave in a heat like you're free surfing.*

Hawaiian Hans Hedemann, a retired ASP pro who had a highly successful competitive career, calls it the 51-49 position. For a long time he was losing his heats by half a point. It was close every time, but he was getting scored 4.9 and the winner was getting scored 5.1.

Cut Back, Tom Curren

What he realized was the highest scores were being given to the surfers who use the wave's potential. He could see that you don't automatically get a better score for catching the biggest wave, you have to capitalize on it to outscore the competition. So Hans concentrated not on trying to revamp his whole style, or catch more waves, but focused purely on getting his performance a half a point better on every ride. It worked. That year he vaulted from the lower half of the top 44 into the top ten. And he was simply winning each heat by half a point instead of losing by the same margin.

## PRO TIP BY TAJ BURROW

*Judges love big moves. When I'm down a few points in a heat, I'll try a grab air reverse or something really big like that to put me straight back into the mix. When they see you try something and pull it off, they can't help but give you a big score.*

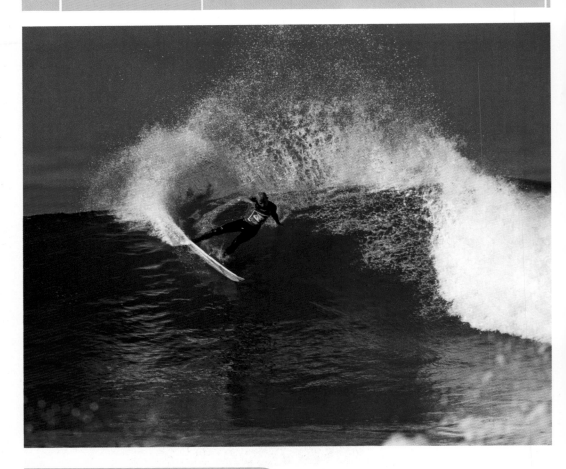

## PRO TIP **BY DINO ANDINO**

*Practice your tactics - how you do every move, and how they are related. Focus on your body mechanics, make sure you physically perform the maneuvers and continue to refine their subtleties. Don't worry too much about style; that will come as the move becomes second nature and you can do it with less effort. Style is too subjective, so surfers should concentrate on completing the most radical maneuvers in the most powerful section closest to the curl, with the maximum amount of speed. Dino Andino.* Surf Academy training school owner and PSSA Champion.

## KNOW YOUR EQUIPMENT

Most pro surfers at the top of the ratings get their boards for free, but that doesn't mean that if you have to pay for boards you shouldn't invest in a solid relationship with a proven shaper. Any contest surfer must consider personal equipment, and being able to get the board that pushes your performance is an important and valuable asset. So when it comes to investing in your surfing, spend the money for the equipment you need - there is no substitute for confidence in your board. Be sure to ride a shape you are familiar with, whether it is a new one or one you have been surfing for a while. A new untested shape might hold some performance surprises that you don't want to discover in the middle of your heat.

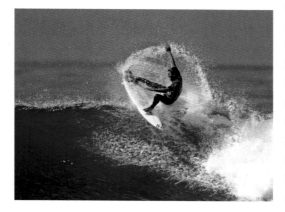

Left: Mick Fanning, well trained

Right top to bottom:

Checking your equipment could save you a win

Joel Parkinson, showing strength and flexibility at Trestles

Also, Shane Dorian suggests experimenting with fin size and configuration to see what small changes might improve performance. Make sure the wax application is right and that every aspect of your board is how you want it - any distraction will cost you when the heat is on. A board wants to be able to deliver the big move, the extra snap, crackle and pop that sets your wave apart from the competitors in your heat.

As Parko can tell you, being spontaneous may be the essence of free-surfing, but competition takes a much more disciplined approach, applying both board and maneuvers to the judging template. Think ahead and be proactive in your contest strategies.

## STRENGTH AND FLEXIBILITY

Ask Andy Irons about winning strategies and there is no question he will mention being strong and flexible. Andy stretches before every go-out, and he can easily touch his palms flat on the sand with his legs locked. It may seem like a small thing, but the difference in performance is huge. Parko and Andy both recommend a daily routine consisting of high repetitions of low to medium weight and comprehensive stretching with a focus on the legs and back. This sort of fitness increases your ability to power paddle back out to the line-up and can be critical if it saves you two minutes in the paddling process - that's a ten-percent increase in wave-catching time in a 20-minute heat. And 20 to 30 minutes is not much time to get four good waves when you factor in the paddling and waiting in the line-up. Strength matters, says Parsons, and you need to build it.

Flexibility is equally important. The elasticity to recover from critical moves in tight close-out situations or generate points in small waves can make a close heat a winning one. And having the suppleness to pull off maximum-torque maneuvers and knee twisting landings are all about flex training to master the pressure.

And best yet, strength and flexibility are characteristics that are not only valuable in surfing but also for long-term health and enjoyment in later life.

## PUTTING IT ALL TOGETHER

If you have been an observer of the ASP Pro circuit, you have no doubt observed Kelly Slater pulling a do-or-die win out of a heat with just seconds to go. Most people assume that his great surfing ability pulls him through, and that he's a lucky man with fortune on his side. What they don't know is that very little of that is

fate. **Kelly** times sets and calculates winning waves with an uncanny precision and uses his knowledge to *know when to hold 'em and know when to fold 'em.* If he knows that a wave is coming in every four minutes and 30 seconds, and that his competitor just got one, and that there is five minutes left in the heat, he will wait. While other surfers are scrambling to try to grab something before the heat is over, just to have another wave under their belt, Kelly will sit patiently waiting for the winning bump to arrive on the horizon, sometimes with only seconds to spare. It takes steely nerves, it's true. It also takes brilliant, disciplined powers of observation. Kelly works harder than any competitor on the tour, in and out of the water.

In Tahiti this winter, astute observers witnessed Kelly arriving early to the contest site, surfing on a variety of boards before the contest, adhering to a strict health diet, practicing a new stretching technique, and reading several books - on topics like improving mental powers to relieving stress. That's putting it all together: preparation, equipment, desire, diet, exercise, and mental focus.

At 38, Kelly is one of the oldest surfers on the tour, and yet he is feared more than almost any other surfer a competitor can draw in a heat. There's a reason for that. And it's not just his athletic gift.

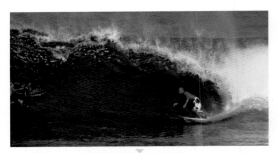
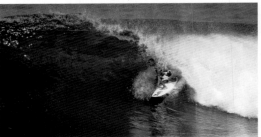
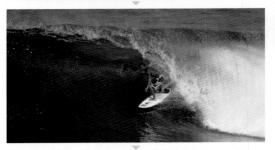
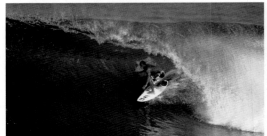
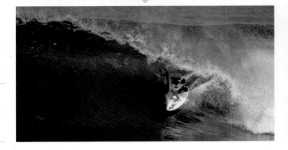

Sequence:

Kelly Slater scores a perfect ten

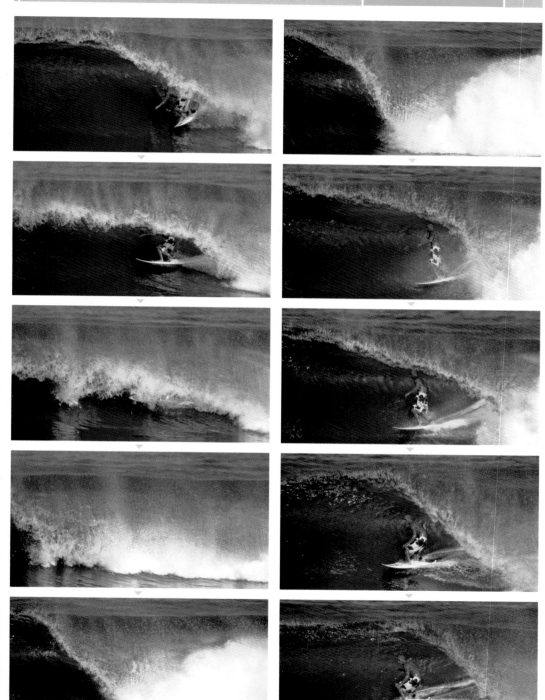

**1. TAJ BURROW ON WINNING**

*Here's a key thing I have learned - you only need to win six heats to win the contest. One thing you don't want to do is look at the whole pack. I get to a contest and see the top 44 and it can psyche me out. I look at everyone's form and it's intimidating. They are all so good, it's easy to get down on yourself if you aren't surfing in perfect form. The secret: just surf your heat. I've had victories when I wasn't the best guy in the contest. I just concentrated on beating six guys, not 44. That's all it takes."*

> *The judging standards today can still use improvement, but they are a lot more objective and consistent than in the past. Judges today have strict and specific criteria for evaluating a surfer's performance. In that regard, they are just like legal judges - and judges interpret the law. You would think that professional surfers would know the rules of their profession, just like a lawyer knows his rules when he goes before a judge. But it's unbelievable how many pros don't know the intricacies of the official rule book. If I had any pearls of wisdom to pass along to the competitive surfer, I'd give them these two: First, read the rule book cover to cover, learn it and apply it to your life. And secondly, work on giving your repertoire a different flair, show as many variations of moves as possible that are put together in a combination of flow and explosiveness.*

*Mike Ginsberg, ASP Head Judge, Hawaii.*

**2. PARE AWAY DISTRACTIONS**

*Eliminate everything from your mind except what you need to zero in on. Your board, food, heat time, leashes, wetsuit, girlfriend and personal issues should all be taken care of way early. When your heat comes you need to just focus on strategy and conditions.* **Luke Egan**

**3. SUPERSTITION GROOVE**

*Competition will make you superstitious. Every athlete in every sport does little things to give himself what he thinks is an edge. I'll start out with a routine, with a certain pair of boardshorts, a way of putting everything in place. And if I win, I just keep doing the same thing; I won't change my boardshorts or tee shirt color, I'll stay with that same routine, the same board. And I'll change it all up if I'm off. People won't usually talk about it, but they all have something they use to get in the zone. If it works, use it. And keep winning.* **Mark Occhilupo**

Top: Taj Burrow

Bottom: Luke Egan

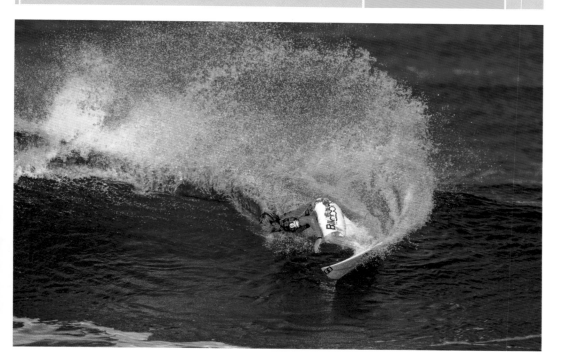

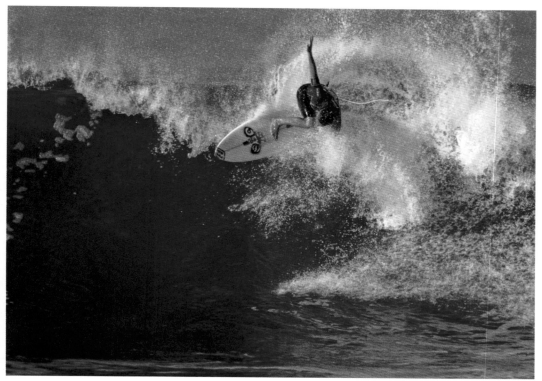

Chris Davidson and Mick Lowe

# FINAL CONTESTANTS
## A Cram Course in Advanced Contest Strategy

At the 1967 Malibu Invitational Surf Classic, Miki Dora, by now alienated by the crowded conditions, and contemptuous of the judging standards of the day, took off on a wave from the outside point, swept across the long wall, cross-stepping and nose-riding in his inimitable style. As he came into direct proximity of the judges, 'Da Cat' pulled into perfect trim, bent over, and dropped his black shorts, exposing his naked ass to the gathered dignitaries and spectators. It was his last act of defiance in the contest scene - Dora never entered another competition.

The current level of surfing talent has risen so high, that for many serious competitors today, professional training is often seen as an almost obligatory requirement to provide the kind of significant advantage necessary to compete in the WQS and on to the WCT. Mike Parsons and Dino Andino saw the demand and opened a Surf Academy for the express purpose of providing the kind of expert coaching capable of elevating a hot surfer to the level necessary to break into the pro ranks. Now in its fourth year, the Academy offers a range of courses from two-day power weekends to week-long power sessions in private point wave locales like El Salvador. Snipps and Dino were both champion surfers, and although neither of them were world title holders, their coaching talents have become highly respected and their Surf Academy has been so well received that they now have a waiting list for young competitors who want to take their game to the next level.

Their program is divided into two sections:
- **Technique:** which covers body placement, timing, weight distribution, style and the execution of speed, power and flow;
- **Strategies:** which covers wave selection, time management, scoring potential, and judging criteria.

On the following pages is a performance evaluation list, with very explicit critiques of each aspect of competition. These seven topics provide a comprehensive compilation of requirements needed to win contests. For serious competitors this section alone is worth the price of admission. Read it. Memorize it. Implement it.

### TOM CURREN
*Three-time world champion on the importance of winning contests*

*All it signifies is who's best at getting four waves to the beach, and when you look at it in that form, it's really insignificant.*

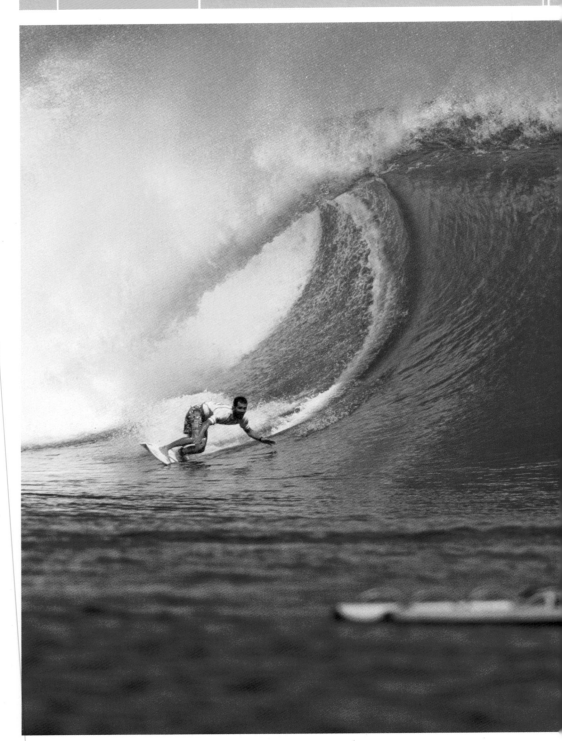

## WINNING PERFORMANCE CRITERIA
Seven Requirements the Judges Will Evaluate

### 1.WAVE SELECTION

Take a hard look at each wave and analyze its scoring potential. This goes back to studying the line-up before your heat and figuring out where the best waves are coming through, then visualizing yourself riding the really good ones. You only need two quality waves per heat. Think sevens and eights every time you take off.

### 2.FIRST TURN COMMITMENT

It's your opening statement to the judges, and the most important part of every ride. Concentrate on a big opening turn, and make it count. This means deeper off the bottom and more vertical off the top. Just as importantly, this also sets you up for the rest of the wave, providing speed, strength and positioning from the initial move.

Derik Ho, G-Land

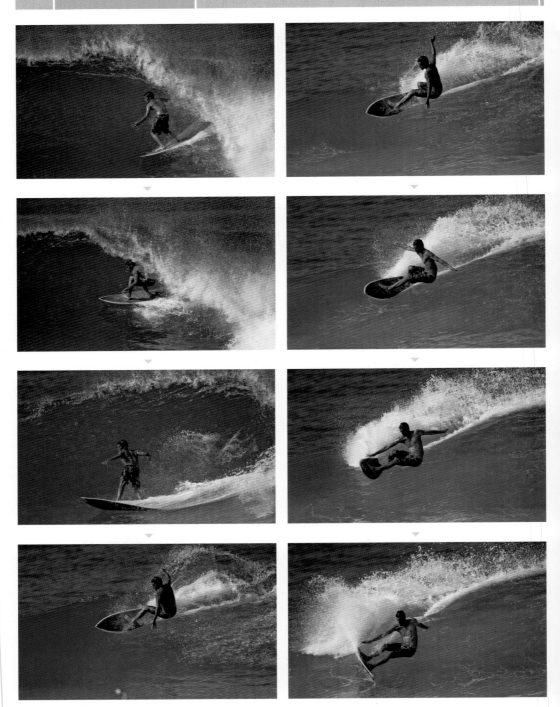

In every frame of this sequence Dave Rastovich uses variety, style, creativity, rhythm, flow and linkage

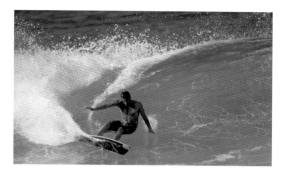

## 4.STYLE AND TECHNIQUE

Focus on specific maneuvers and fully commit to each one. Remember to stay balanced over your board, knees loose but bent, back straight and hips centered. Follow your body through the entire turn. Relax; don't let your body tense up, so you can keep an effortless appearance in the moves even though you use maximum power and precision.

## 5.COMPETITIVE STRATEGY

Keep track of your position in the heat, on priority and time management. Know the score, and concentrate on maximizing your scoring potential. Don't get distracted by worrying about other factors. Expect to win every heat that you surf in, and believe in your ability to do so. Confidence is linked to performance, and judges notice it too.

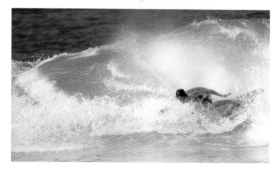

## 6.CREATIVITY

Keep trying new and more difficult moves. Develop flow without being repetitive or doing any one maneuver too much. Remember that judging criteria has changed to reward variety and inventiveness. Mix it up, go big as often as possible and have fun in front of the judges. It's a secret edge no judge can resist rewarding.

## 3.RHYTHM, FLOW AND LINKAGE

Carve through your turns. Link maneuver to maneuver. No hopping. Remember not to force your turns, but instead concentrate on flowing with the wave and linking each move. Use the face as a canvas and throw paint right where you want it, contrasting big bold colors with subtle shadings, unexpected highlights and solid primary foundations.

## PRO TIP BY OCCY

*Judges love variety. So just go out and string together as many different moves as you can, one after another. Do a fin-out slide, a big carve, an under-the-lip snap, and a solid off the top. After a while, mixing it up will become natural, and you will lose the habit of repetitive moves.*

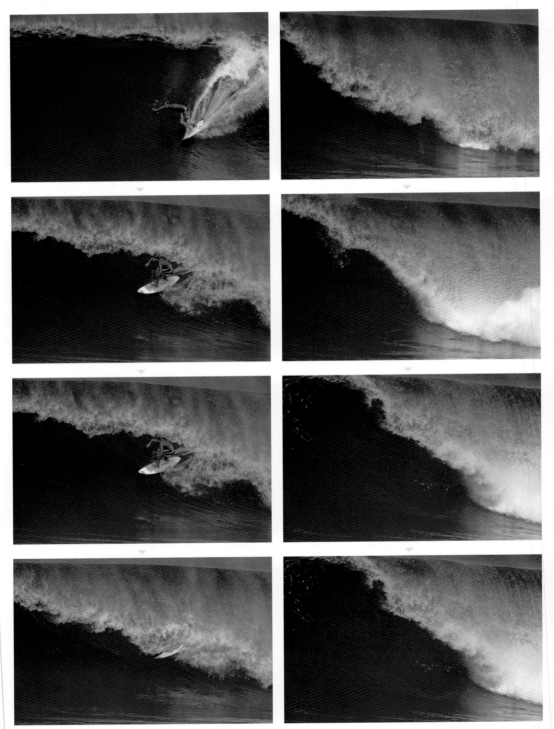

Andy Irons, clean and covered from entrance to exit

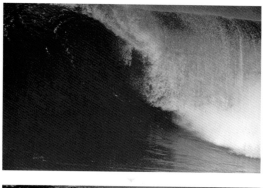
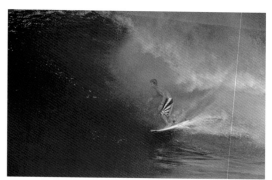
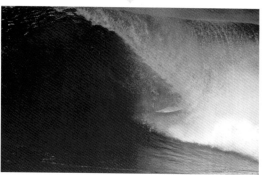
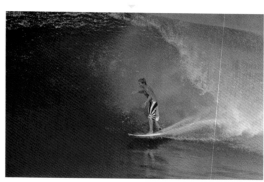
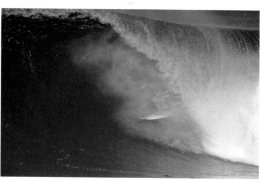

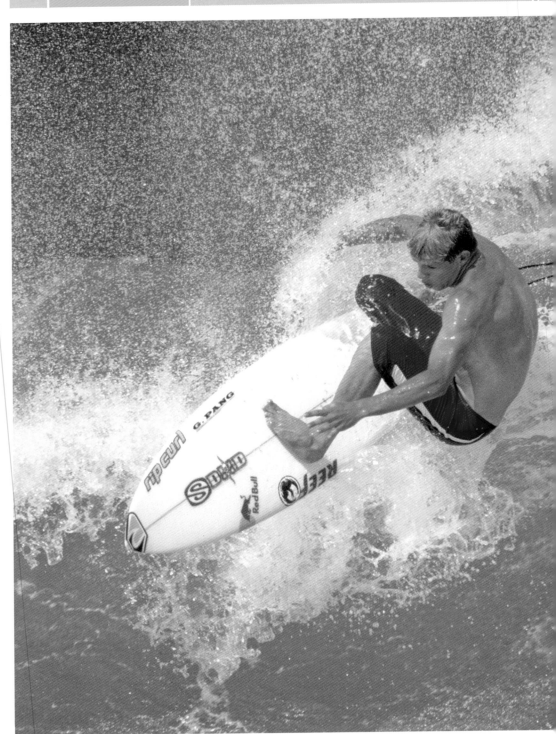

### PRO TIP BY PETER TOWNEND

*Coach of the Surfing America world team & former ASP Champion.*

It's all about scoring opportunity. Wave selectivity becomes all-important. The philosophy I taught when training the American team was: 'Carve, Flash, Finish.' In other words, give me a strong opener, then show me your best move and close with power and style. If you have those three things with an excellent wave choice you're going to win.

### 7.FINISH

This is the final statement to the judges. Stay in the game mentally through the entire ride and finish strong on every wave. Always appear like you are putting in 100 percent. Falling off or kooking out seriously hurts your score, so make sure that you do a strong move, but more importantly, make sure you complete it solidly.

Feet firmly planted with weight shift evenly distributed to bring a softer level landing; knees bent to keep gravity low and absorb impact at touchdown; body shifting from over board to over where board will land; arms tight in, but prepared to adjust balance; eyes focused on trajectory, moving right to left with the flight path. Mick Fanning, photo finish by a World Champion

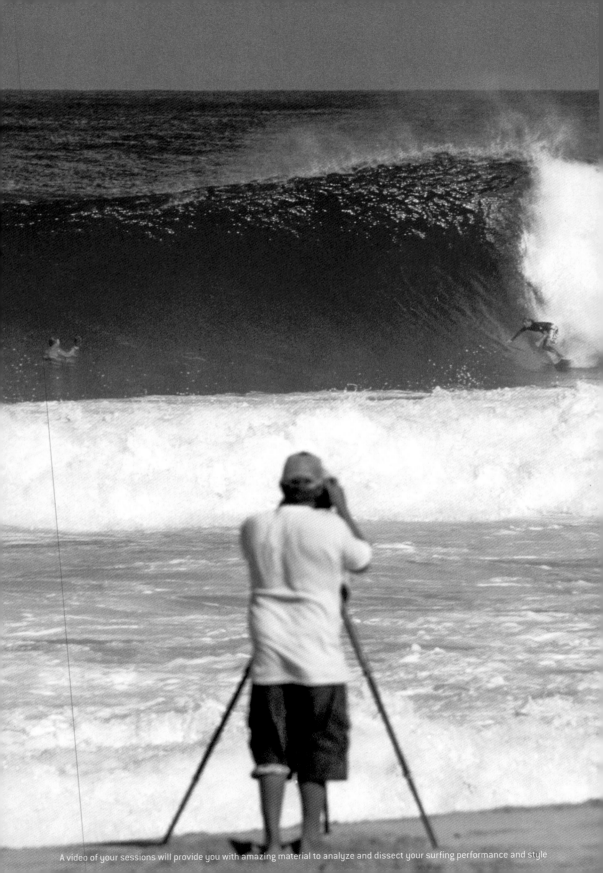

A video of your sessions will provide you with amazing material to analyze and dissect your surfing performance and style

# FINE TUNING
## Going the Extra Mile to Reach Your Full Potential

You're not going to be the second coming of Kelly simply by surfing everyday. You may become a really, really good surfer, but by taking time to do all the extra, often mundane little things you are going to be able to elevate your surfing to a level you never figured possible. Simple chores like video analysis, mental preparation, and making sure your equipment's in top shape can make all the difference in the world. It sounds like a pretty simple mantra: have surfboard, will travel. And for the most part it is, but there's a lot of little things that go into making a surf trip memorable. And whether you're Andy Irons, Joel Parkinson or Joe Blow, showing up prepared will make the trip all the better. Here are a few hints to get you started:

### BE YOUR OWN VIDEO STAR

One of the best things you can do to truly improve is to watch video of yourself with a critical and unflinching eye. Mike Parsons and Dino Andino run their Surf Academy where they take some of the most promising young competitors to a remote spot with good waves and literally practice with them for a week surfing every condition they can find for seven days straight. Their methodology has been highly successful,

and video analysis is one of the essential components. Every evening they view the film from that day, studying every rider's wave and each move on it. *Get a video with your favorite surfer in it, and try to find him or her doing this move. Watch it over and over in fast and slow motion,* says **Brad Gerlach**. *Visualize yourself doing this same move. Do this every day as many times as you want (before you go surfing, before you go to sleep, etc.) Don't try to think about these moves while actually surfing. If you work on this enough on land, it will eventually come naturally when you surf.*

### BODY LANGUAGE

Like in tennis, golf and other movement specific sports, there are some habits most surfers have that need to be corrected in order to make a break-though in their wave-riding. Here are a few that seem to be mentioned by most of the pros: keep your head still, your knees bent, your back straight and your hips centered. Don't bend at the waist, reach with your trunk, or let your legs get locked. These are simple, solid, incontestable methodologies. Yet pros say 90 percent of the best surfers fail to consistently employ them.

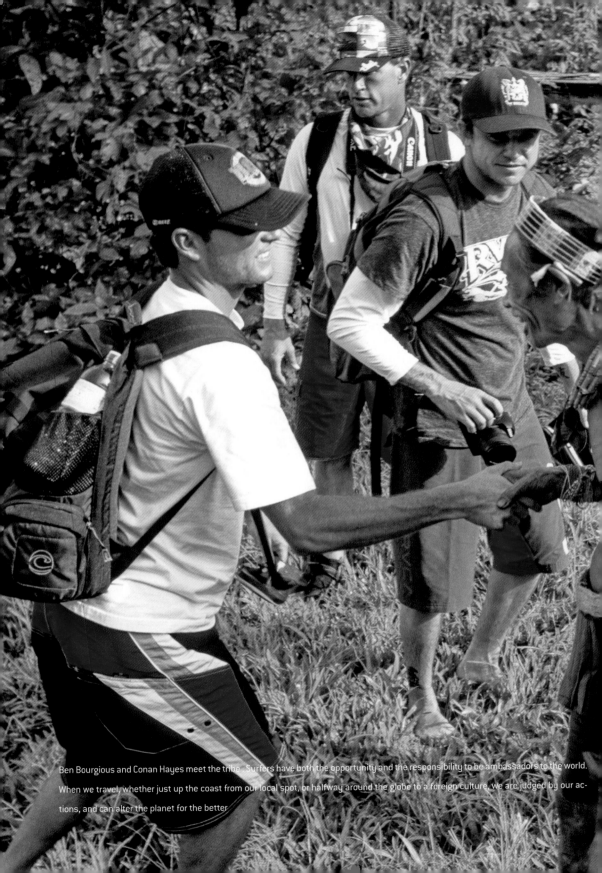

Ben Bourgious and Conan Hayes meet the tribe. Surfers have both the opportunity and the responsibility to be ambassadors to the world. When we travel, whether just up the coast from our local spot, or halfway around the globe to a foreign culture, we are judged by our actions, and can alter the planet for the better.

## PLAY THE GAME

As vital as having your act together in the water is, having a land act is equally important. It's pretty plain and simple, be a good ambassador or representative of the sport and lifestyle of surfing. If surfing's something you're going to be trying to make a career at, learn how to work with photographers, carry yourself well in interviews, and be an all around positive role model for the community around you. It's amazing how far a little aloha can take you.

## LEARN SOMETHING

Surfing has a rich and storied tradition. The history of the sport and culture is fascinating, so after you've checked the forecast online, pick up a book and jump in. There's some great literature out there. Here are a six particularly insightful titles:

*A Royal Sport: Surfing at Waikiki*
by **Jack London**, *Published in 1907.*

*Hawaiian Surfriders*
by **Tom Blake**, *Published in 1935.*

*California Surfriders*
by **Doc Ball,** *Published in 1946.*

*History of Surfing*
by **Nat Young,** *Published in 1979.*

*Surfing, the Ultimate Pleasure*
by **Leonard Lueras,** *published in 1984*

*The Book of Waves*
by **Drew Kampion,** *Published in 1995.*

*The Surfing Encyclopedia*
by **Matt Warshaw,** *Published in 2005.*

ACKNOW

Boat trip in El Salvador

Nothing could have been more of a pleasure than working with the characters that provided content to this book. The array of talent and expertise assembled on these pages spans the lifetime of the sport. There are so many people to thank for this endeavor, so let me start with the most involved first:

Jeff Divine, my collaborator on this project and good friend for life, knew just what was needed in photos. I owe the success of this book to him. For 30 years we have surfed and traveled the world together and enjoyed each other's company. One of the truly great artistic talents of the surfing world, JD's photos capture a vast range of the surfing culture including the bulk of the images seen in this book. And thanks for all the late-night and early-morning light table sessions.

Tom Servais, whose backgammon skills are only eclipsed by his photographic gift, was a major contributor to the images seen herein, and part of a trio with Divine and me at Surfer back in the day. View his images and enjoy beauty. Study his images and you'll learn from every one. He tells me he envies my happy family life, but Tom has been the one that lived everyone's dreams, chasing the elusive waves all over the globe as free and easy as a seabird.

Jake Howard, senior editor at Surfer magazine and collaborator on this project, should perhaps receive the biggest thanks. Providing not only editing and research, Jake was both the inspiration and perspiration for many of the ideas found herein. Without Jake's immense help, I could not have completed this book on time, let alone with the meat and potatoes it serves up.

Steve Pezman, my mentor and long time friend, was kind enough to write the foreword, as well as allowing me to use the offices of The Surfer's Journal as my writing and research center. No one has been more instrumental in my professional life, or in shaping the culture of surfing than Pez. In a sea of chaotic hype, Pez is a patient, perceptive voice of intellect.

Sean Collins, my colleague and compadre, along with his staff at Surfline, contributed the great chapter on surfing etiquette which should be a part of every expert surfer's knowledge. Their vision of sharing the 'rules of the road' with as many surfers as possible is both farsighted and generous. Sean, I still owe you a wave.

Drew Kampion inspired me to begin my surf journalist career nearly 30 years ago. His contribution on waves, beaches, refraction, and all things oceanic was invaluable to the book. His simple response of 'it's about time' energized my efforts to create something he would find praiseworthy. Drew, you remain an inspiration to me and the surfing world.

Brad Gerlach, who I have watched grow from wunder-kind grom to standard-bearing big-wave aficionado, provided some of the most insightful and specific material on a number of topics, illustrating both the breadth of his expertise and analytical nature;

some of it previously presented, some fresh from the fertile frontiers of his maverick mind - a great younger link to our cultural heritage.

Mike Parson's knowledge of fields as diverse as professional competition and tow-in innovation supplied a wide range of information, well thought-out and expert in both personal experience and sharp-edged observation. Mike contributed to more topics than any other single expert in the book. His multiple talents were as finely honed as they were invaluable.

For personal inspiration, support, and assistance: Debbie Pezman, Steve Clark, Bree Andrews, Hunter Joslin, Peter Lewis, John Mossop, Paul Naude, Ricky Irons, Ken McNight, Jack Shipley, Mace Hulet, Duke Boyd, Graham Stapelberg, Royce Cansler, Alan Gardinier, Brent and Kirk Schlea, Blair Marlin, Matt Warshaw, Chris Mauro, Michael Davis, Mark Cunningham, Buddy Purel, Pierre Gascogne, Art Brewer, Enich Harris, Simon Barrett, Ira Opper, Bruce Raymond, Mark Warren, Chris Evans, Cass Husted, Jason Jackson. Leonard Brady, Bruce Vogen, Bob McKnight, Michael Tomson, Hans Hedemann, John Severson, the Johnson family, Rabbit Bartholomew, Jericho Poplar, Rell Sunn, Derik O'Neill, Nat Young, Pat Rawson, the Gudauskas family, Alan Seymour, Dane Kealoa, R.G., Keala Kennelly, Randy Rarick, Ian Cairns, the Ho's, Bob Mignogna, Gary Ward, Jack McCoy, Dick Baker, Fred Hemmings, the Richardson's, Don Eulert, G.T., Leonard Lueras, David Rensin, the Balma's, Lyndie Dupuis Irons, Martin Daly, MMX, Kevin Kinnear, Norb Garrett, Mike Gerard, Jason Shibata, Tom Whitiker, Craig Stecyk III, Eric Diamond, Tara Torburn, Dana Mesenbrink, Mark Lewis, Dave Carson, the McInerney's, Gary McNabb,

the Beachamps, Brian Bulkley, Gary Dapelo, Mike Garratt, Dave Gilovich, Luke Thorpe, the Hoffman family, Sli-Dawg, Warren Bolster, Sonny Miller, Kevin Naughton, Jaquette Joyeaux, Paul Comstock, the entire Cal Western crew, Linda Cuy, Guy Motil, the O'Connells, Jann Sunn, Leland Dao, Andeaux Borunda, the Lalo's, Liam Fergeson, Mark Samuels, Robert Gerard, the Aguirre brothers, Matt McClain, Jason Borte, Romeu, the Crowes, Don Craig, Rodney Kilborn, Shaheen Sadeghi, the Kempton's, Pierre Tostee, Rich Pavel, Moj Mahdara, the Romans, Robbie Frank, Stewert Copeland, Tak Kawahara, Zeldo, Mike Wallace, the Aeder's, Rob Donnell, Serge Dedina, Paul Holmes, the Mercer's, Tom Pezman, Francis Odiorne, Chris Darrow, the Squires, Chris Kyprotis, Gary Saavedra, Patrick Castinet, Sam George and all my good friends I have forgotten.

For contributions to the book: Taj Burrow, Tony Moniz, Joel Parkinson, Reno Abellira, Shaun Tomson, Kelly Slater, Andy Irons, Mike Parsons, Luke Egan, Shane Dorian, Brad Gerlach, Rusty Preisendorfer, Gary Linden, Gerry Lopez, George Downing, Kolohe Andino, Dave Rastovich, Donavon Frankenreiter, Larry Blair, Steve Barilotti, Corky Carroll, Dave Rochlin, Mark Occhilupo, Mickey Muñoz, Cheyne Horan, Mike Ginsberg, Rabbit Kekai, Mick Fanning, Laurie Townend, Terry Fitzgerald, Phil Edwards, Tom Curren, Corky Carroll, Joe Quigg, Matt Kivlin, Dorian "Doc" Paskowitz, Bruce Irons, Luke Egan, Miki Dora, Bob McTavish, George Greenough, Wayne Lynch, Mark Richards, Dino Andino, Mike Latronic, Chelsea Johns, Dick Brewer, Pat O'Neill, Bernie Baker, Keone Downing, Steve Lis, and most of all to my family, Jann, Kim, Sam and James.

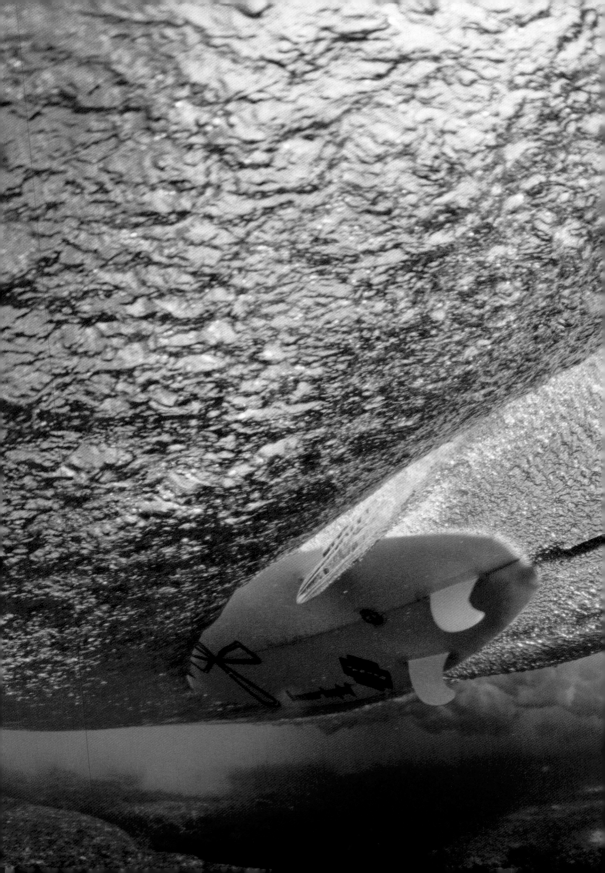

**Published by Wavefinder Ltd**

**Surfing is a dangerous sport.**

info@wave-finder.com
**www.wave-finder.com**

*Publisher of the award winning Pocket size*
*Wavefinder and Snowfinder guides*

| Wavefinder guides: | Snowfinder guides: |
| --- | --- |
| Australia | France |
| USA and Hawaii | USA |
| Indonesia | Austria |
| Mexico | Canada |
| Central America | |
| Uk & Ireland | |

To be published soon

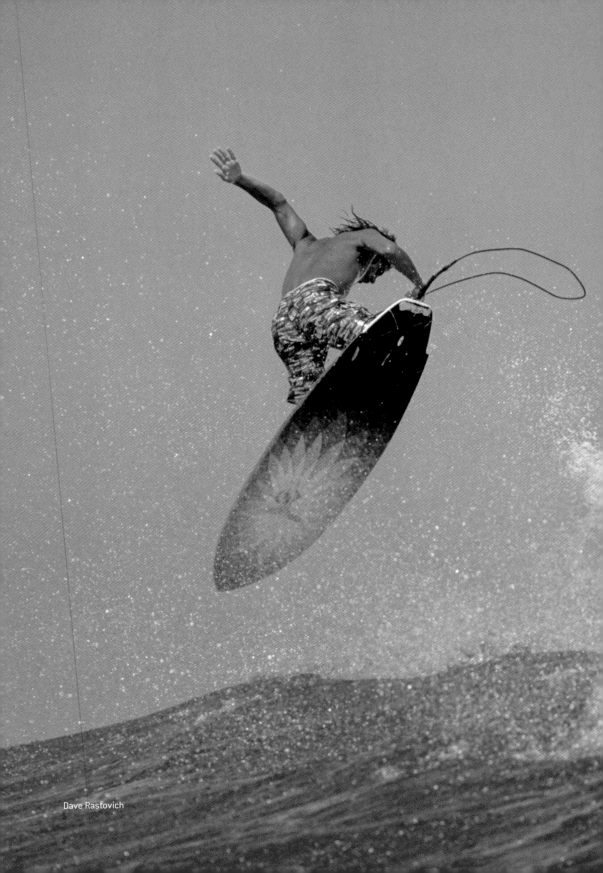

Dave Rastovich